PC Wars

D1354660

PC Wars

Politics and Theory in
the Academy

Edited by Jeffrey Williams

Routledge/New York London

Published in 1995 by

Routledge
29 West 35th Street
New York, NY 10001

Published in Great Britain by

Routledge
11 New Fetter Lane
London EC4P 4EE

Copyright © 1995 by Routledge, Inc.

Printed in the United States of America on acid-free paper.

All rights reserved. No part of this book may be reprinted or reproduced or utilized in any form
or by any electronic, mechanical, or other means, now known or hereafter invented, including
photocopying and recording, or in any information storage retrieval system, without permission in
writing from the publishers.

Library of Congress Cataloging-in-Publication Data

PC wars : politics and theory in the academy / edited by Jeffrey
 Williams.
 p. cm.
 Includes bibliographical references and index.
 ISBN 0-415-91072-2 (cloth).—ISBN 0-415-91073-0 (paper).
 1. Political correctness. 2. Education, Humanistic—United
States. 3. Education, Higher—United States—Philosophy. 4. Theory
(Philosophy) I. Williams, Jeffrey.
BD175.5.P65P3 1994
378.73—dc20 94-3735
 CIP

British Library Cataloguing-in-Publication Data also available.

Contents

Acknowledgments

This collection had its impetus in a special issue of *minnesota review* n.s. 39 (1992), "PC Wars." Richard Ohmann's "On 'PC' and Related Matters," Tom Lewis's " 'Political Correctness': A Class Issue," Michael Sprinker's "The War against Theory," and Barry Sarchett's "Russell Jacoby, Antiprofessionalism, and the Politics of Cultural Nostalgia" orginally appeared there and are reprinted here with minor revision. Thanks to their authors for placing them in *minnesota review* and in this collection.

Joan Wallach Scott's "The Campaign against Political Correctness: What's Really at Stake" originally appeared in *Change* 23.6 (1991) in a slightly different version. Christopher Newfield's "What Was 'Political Correctness?' Race, the Right, and Managerial Democracy in the Humanities" appeared in *Critical Inquiry* 19 (1993) and is reprinted with permission of the University of Chicago Press. Frank Farmer's "Not Theory . . . But a Sense of Theory," commissioned for this volume, also appears in *Symplokē* 2 (1994). Bruce Robbins' "Othering the Academy: Professionalism and Multiculturalism" appeared in *Social Research* 58 (1991). Gerald Graff's "A Paradox of the Culture War" draws on work that appeared in *Narrative* 1 (1993) in a substantially different form. Thanks to these journals for their courtesy.

I would especially like to thank the team of assistants who work on *minnesota review* for their help in getting the manuscript of this together in record time: Denise Machala, for getting the thing together on one disk and always proficient management; John Bullard, for help in consolidating the bibliography; and particularly Jan Forehand, for proofreading, indexing, and a plethora of other, usually thankless, tasks. A debt of gratitude is due William

Cain for initial encouragement of this project. Thanks to Routledgians William Germano for his typical flair in taking up this project expeditiously and especially Eric Zinner for his acuity and his dispensing trade secrets regularly. I'd also like to thank my daughter, Virginia Williams, for bearing with a tired and cranky parent. Her intellectual courage in espousing left critique in North Carolina public schools is altogether heartening.

1

Introduction

Jeffrey Williams

At first, I thought it would go away. Like last week's news.

I mean, of course, the PC debacle, and the aggregate of factors that is usually associated with it: the massive PC sightings, primarily in the university; the castigation of academics, especially in the humanities, as stalinistically PC; the denunciation of contemporary critical theory (all those dirty words, like feminism, deconstruction, *et al.*); outrage at the purportedly pinko slant of intellectuals; fear and trembling at the corruption of Western civilization under the banner of multiculturalism, a perverse plot perpetrated by Afrocentric scholars; and so on. In short, the very public backlash against what's gone on in the humanities and in critical social thought these past twenty-five years.

At first, I chalked up books like Allan Bloom's *Closing of the American Mind,* probably the most prominent early siren call in the current conflagration, to the all-too-predictable tradition of the jeremiad against the university (the universities are going to hell, corrupting our young, ruining our civilization, etc.). After all, Bloom's book—and the string of trailers, such as Kimball's *Tenured Radicals,* Sykes' *Profscam,* and D'Souza's *Illiberal Education*—merely take up the torch from William F. Buckley's *God and Man at Yale,* updating the story of the academic fall with a few spicy present-day anecdotes.

I thought all of this would prompt a round of alternately outraged, thoughtful, and depressing editorials (and perhaps an episode of *20–20*) about the state of education, today's youth, the decline of family values, and the three Rs, and then be over. To paraphrase the story of Chicken Little, the clouds would clear, the sky would still be there, and universities would carry on.

But it hasn't gone away. In fact, it's become more entrenched and entered that ethereal zone of common knowledge and accepted belief, that, yes, there's a PC conspiracy and the university is permeated with *them*. The issue of and charges against PC have indelibly marked the terms of political debate and commentary in the U. S. Whether or not PC actually exists or if it's an accurate charge, the rubric of PC has come to define a broad spectrum of liberal-left positions. Affirmative action, deconstruction, feminism, and multiculturalism are all conflated under the banner of PC. And the aspersion of PC has become a shorthand way to dismiss these positions out-of-hand, as ridiculous or tyrannical, shortcircuiting any sort of more elaborated debate or discussion.

It has become so pervasive that you can see it when you check out at the grocery store on this month's cover of *GQ*, a magazine not noted for its political commentary, announcing the decade as the "PC Nineties." You can hear it on sitcoms fairly regularly, and in fact a recent *Beavis and Butthead* carries a segment called "Politically Correct," in which Butthead runs for class office and starts saying things like "Share your feelings."

It's not just a convenient media label, though. Beyond these examples, the PC slur has had material consequences in national politics, in policies that very directly bear on the humanities. I'll give two instances. First, last summer's Senate confirmation hearing for Sheldon Hackney as Chairman of the National Endowment for the Humanities (NEH). Hackney went out of his way to denounce the "intellectual form of political correctness"—specifically naming deconstruction and poststructuralism—that maintain "that every thought is a political thought, that every statement is a political statement, so that there can be no objective tests for truth" (Burd, "Hackney Attacked"). After his tenure at Penn, during which a student was punished for yelling an allegedly racist remark at a group of black women, Hackney was compelled to make a sort of "I am not now, nor have I ever been" statement, distancing himself from PC and contemporary theory, of all things. His confirmation went smoothly after his strong anti-PC stand, even garnering the support of Senator Orrin Hatch. It is fairly clear that he would have had a much more difficult time and possibly not been confirmed, had he not named the name of and denounced deconstruction *et al.*

Second, one can see it in the new guidelines for applying to NEH "Centers for Advanced Study," which explicitly state that:

> The Centers for Advanced Study Program does not provide support for fellow-ships for . . . projects that are directed at persuading an audience to a particular political, philosophical, religious, or ideological point of view, or that advocate a particular program of social action or change, and projects that examine controversial issues without taking into account competing perspectives.

How this works out is a complicated matter, but how it translates in terms of the current climate, I think, is more simple: if your project carries the new dirty words—the words Hackney mentioned, deconstruction and poststructur-alism—as well as the old dirty words—feminism and marxism—you may as well kiss a grant good-bye. In other words, this disclaimer excludes the great deal of work done these past twenty-five years under the auspices of those dirty words, what most scholars in the humanities consider pathbreaking developments. I won't begin to argue here about the inherent political nature of any position, even a seemingly "neutral" aesthetic one—some of the essays that follow take this up far better than I can—but the point, again, is that the campaign against PC is more than just a function of a media fixation.

So, after all this and with the benefit of retrospective distance, what's hap-pened? Why this barrage, and why has it persisted? Why the extreme charge on PC and why are the political stakes so severe? Why now? This collection poses some answers to these questions, taking a number of different angles on this thing called PC and its allied outlaws, theory and the university. Overall, the essays collected here offer the following interrelated explanations of the PC troubles:

(1) the fruition of the right turn in politics through the eighties under Reagan-Bush;

(2) the right reversal of "the sixties" and what they have come to represent, notably the social policies associated with the sixties (civil rights, women's rights, welfare, etc.);

(3) a manifestation of class and of the massive shifting of wealth accomplished through the eighties, in part tied to the reversal of sixties social programs, providing an ideological or public relations program to justify this shift (talk of equal rights can then be dismissed as hopelessly PC, so the money slide can go on relatively unimpeded);

(4) a result of the techniques and ideology of managerial democracy in late capitalism, whereby power is maintained in a flexible, decentered economic system by the maintenance of a common culture;

(5) the general bias of the media to a conservative-right politics and to unexamined explanations from "official" sources (contrary to the common belief that the media represents liberal concerns, it is owned and controlled largely by conservative corporate interests and draws on a cadre of establishment sources);

(6) a backlash against any oppositional or left critical discourses that can be encompassed by "theory" (again, obviously marxism and feminism, but deconstruction also carried with it the gesture of critique of "Western metaphysics" and all that entails);

(7) a backlash against "theory" as a symptom of the sixties and its radicalized discourse and social thought;

(8) a result of the residual strand of anti-intellectualism in American life;

(9) a bias against the academy, related to anti-intellectualism, as otherworldly (an ivory tower), as outside or unaware of real world concerns (as the columnist Lewis Grizzard puts it, "head of the sociology department at some large, liberal-thinking college or university like Harvard or Stanford or Pussy Willow A & M, who says a lot of things you don't understand. And for good reason. What people like that say rarely makes sense" [9]);

(10) a bias against the academy, on the other hand, as a bed of radicals, lefties, and other enemies of the free world (the fear is that academics or intellectuals make too much sense and have too much effect, and aren't cloistered enough);

(11) a manifestation of the right turn in taking back social programs, also in taking back universities from their populist and reasonably democratic use in the sixties and seventies (as evidenced by reductions in aid under Reagan);

(12) a figural displacement or substitute for communism, thereby filling a prime need and place as a right ideological target.[1]

Overall, the PC debacle or the culture war occurs at the confluence of all of these factors. In part, the message of this collection is that there's no simple answer—that it's a reactionary conspiracy, that's it's just a flashy media story—to why this has come about. However, I would locate these changes within the general context of post-Fordism, a context that David Harvey amply details in *The Condition of Postmodernity*. In other words, the impulse to demonize PC is not just about taking back the sixties, out of spleen or whatever else. Rather, at the risk of blatant economic determinism, I would say that the sixties were enabled by the moment of Fordism, of a relatively successful Keynesian economy that permitted a certain luxury, whereas the eighties and nineties show a turn to a different economic moment, to the bleak Hobbesian corporate climate that has promulgated a severe division of labor among the employed and unemployed, and even more so among the employed (but overworked) middle class and the underemployed, those who have available to them only what Douglas Coupland calls "McJobs." In the present multinational, consumerist, postmodern corporate climate, socialist or populist critique is sidestepped or flat out banned as PC. Any talk of egalitarian principles is scorned or spurned as hopelessly PC. Further, in this context, the democratized university is an inefficient, obsolete notion and not cost-effective, so the PC scare gives a rationale for dismantling it, or at least as it is currently constituted. In sum, the PC scare is a savvy ideological power play that negates any opposition or critique from the outset, a highly successful public relations campaign that cushions and justifies the current corporate redistribution of wealth and organization of life.

While I think that this is a particularly ominous sign of the times, there is one salutary lesson we can take from this morass: intellectuals do have some cards. The ideological fervor against PC is a register of the power

that intellectuals, particularly those in the university and even those in the humanities, hold. Believe it or not.

Let me put this in a slightly different way. Think of all the lawyer jokes. For instance, the one about a lawyer, a doctor, a priest, and a ship's captain being stranded on a life raft. I don't know if I have the joke quite right, but I think it goes something like this: there's no food or water on the boat, but there's a storage locker loaded with supplies floating about a hundred feet off. Unfortunately, they don't have any oars, and their raft can barely move with all of them in it anyway. So someone has to swim to the supplies to bring them back. There's one problem, though: sharks are circling ominously.

They have trouble deciding who's going to go. The priest selflessly volunteers first, but he's elderly so they rule him out. Next, the ship's captain says he'll go. After all, it's his duty. He dives into the water and before he's halfway there, he's torn apart by sharks. Alas, someone else has to go. The doctor confesses he can't swim, so the lawyer reluctantly says he'll do it. He dives in, swims to the storage locker, pulls it back, and climbs into the raft. They're all amazed and ask him how he made it, how he avoided the sharks. He tersely replies, "Professional courtesy."

This might be an example of lawyerism, of the rampant bias against lawyers, but let that lie for now. The point I would take from this is that lawyers are perceived as powerful, as having real and effectual force in the world and among those around them. Even though it might not be especially flattering to be compared to a shark, they have *juice* that even sharks regard.

Think about this joke in a slightly different way. What would happen to a humanities professor? Before the PC thing, one might guess that the professor wouldn't get very far (although the sharks might spit him or her out for being too prissily tweedy). On the other hand, one can imagine the joke updated with a feminist jumping in. *À la* Lorena Bobbitt, that joke might have it that the feminist cuts off the shark's fin and swims back unscathed. Now, this is conjectural and I'm not trying to dis feminists; rather, the point is that feminists are perceived as having some consequence and material effect in the world. Jokes like this are registers of public place and political power. Feminists are now perceived as having some weapons, as carrying some means

to fight back, in the public sphere. Granted, there are a lot of sharks, but this change isn't negligible.

To go back to the humanities professor, the new-breed PC humanities professor would perhaps wash the sharks' mouths out with soap or charge them with harassment. Whether or not these seem particularly heroic responses, they at least have the effect of countering the sharks. In this, the PC thing provides a register of the power of the critique that the humanities can offer, the power and place that intellectuals hold, the potential force and effect of theory and its affiliated social discourses, and the public place and forum the university offers in current political debate.

At one point, I thought an apt title for this collection would be "The Academy Speaks Back." For it sets straight some of the charges against a PC-infiltrated university. Further, it gives voice precisely to those people in universities—all of the authors here are university-affiliated (in a variety of places and at different levels)—and their more measured, reasoned, and documented responses to charges of PC felonies. In that way, I hope the collection serves to provide an antidote to the superficial and blatantly slanted public coverage of the issues imbricated in PC.

However, I would desist from that title now because I would identify many of the contributors here as *public* intellectuals. To take up Henry Giroux's argument, we are in a public sphere just by virtue of being in a classroom. And rather than apologizing for or having a bad conscience about being located in a university, I would argue that the university is currently one of the few open public spaces available to Americans, offering a plethora of public voices and conversations, of positions and arguments, of theories and debates. In some ways, the attention to universities is a register of their prospect as a public sphere, as a locus for critical debate on public issues that can, in turn, affect and alter public policy.

Additionally, people like Richard Ohmann, Joan Scott, Michael Bérubé, Bruce Robbins, Gerald Graff, and the other authors here have a more than tunnel-visioned "academic" purview and don't just write in arcane journals about vowel pronunciation in middle English—or about deconstructive *ab-*

ymes in Milton, for that matter. By their writing here and elsewhere, they expand the normally limited notion of what it means to be an academic, and push that notion to public significance. If I were to give it a name, I would call this intermediate genre of writing, somewhere between journalism and high criticism, *public theory*. That is, it doesn't desist from theory, but on the other hand, its use of theory isn't obscure and arcane, merely an intra-academic game. The discourses collected under and enabled by the relatively new discipline of theory have relevance to and intervene in debates on public issues. (This is a lesson we could have learned from an unlikely source, Bush policy analyst Francis Fukuyama.) Whether or not theory is foundational or its consequences can be determined in advance, our theoretical commitments indicate where we stand, where we weigh in on those debates. The recent turn from theory—in literary debates in the new historicism (a history without politics or denuded of political valence), in the "against theory" movement, as well as in the backlash against theory in more popular discourse—is a move of bad faith precisely because it enables the neutralizing of intellectuals, and their removal from any public function. While this might be consoling news to the right, it doesn't sit well with the contributors here.

To quote Michael Bérubé from another context, "It's a beastly rough crowd I run with" ("Discipline and Theory"), and we didn't go into the university to escape from the vissicitudes and stakes of public issues. More likely, to engage them.

<div align="right">February 1994</div>

Note

1. Carol Iannone's recent article in *Commentary* plays off this analogy to communism gratuitously. Entitled "PC with a Human Face," it mimics Henri-Claude Lévy's influential 1976 *Barbarisme avec une visage humaine*. Lévy's book was a rallying call for the French left in turning against Communism as Stalinism, and represents an end of much significant debate on marxism in France. How the values of PC—presumably, against racism, sexism, etc.—turn out to be a sort of barbarism defies explanation (one would think over-refinement, if anything), and how saying chairperson instead of chairman compares to Stalinism seems not only ludicrous but intellectually in bad faith, akin to comparing a sports loss to the Holocaust. Such scruples fall beyond Iannone's ken, though.

I

The Campaign Against PC

2

On "PC" and Related Matters

Richard Ohmann

The PC spasm has been an odd experience, to say the least, for the left and feminist people with whom I spend much of my political time.[1] In this essay I will try to describe the oddness and venture an explanation of it, speaking from a position that sets off radical politics both from the scandalized attacks on political correctness and from PC itself.

I will assume readers' familiarity with the assault on multiculturalism and political correctness that simmered through the Reagan years, gained bestsellerdom with Bloom's *Closing of the American Mind,* then burst into the pages of *Newsweek, New York Magazine,* the *New York Times,* and many other periodicals, as well as onto TV screens, beginning late in 1990. Right wingers of various stripes piled on: academics and former academics like Peter Shaw, Roger Kimball, Stephen Balch, Carol Iannone, many of them gathered in the National Association of Scholars (NAS); pundits like George Will, William Safire, and Richard Bernstein; official and semi-official intellectuals of the Reagan-Bush regime like William Bennett, Lynne Cheney, Herbert London, and Dinesh D' Souza; and the education President himself, in his 1991 University of Michigan commencement speech, declaring war against political correctness and "the boring politics of division and derision."

Most of these analyses and polemics either argued or just took it as given that an unholy alliance of radicals had staged a successful coup on the campuses: migrants from sixties movements into the tenured ranks of faculties, aided by a clamorous minority and other students in racial and subcultural groupings; by administrations caving in to the pressure for speech codes and frivolous anticanonical curricula; by affirmative action policies that jeopard-

ized standards and the fortunes of qualified white males; by professional societies infiltrated by feminists, marxists, homosexuals, and other enemies of traditional knowledge, intellectual rigor, and American values. This premise of a left dominant in the universities and endangering the openness of American intellectual life, with only a few conservative voices in the wilderness to sound warning, was passing strange on the face of it. The previous decade had been a time of conservative ascendency in the nation, after all. And while universities without question harbored many dissident instructors, students from previously excluded groups, and ideas derived from sixties movements, few calm observers saw them as achieving a new reigning orthodoxy, or in fact much more than a beachhead.

A few random takes on the PC university, circa 1990: about six percent of faculty members identified their politics as "left," a proportion that hadn't changed significantly in thirty years. Ninety percent of tenure track faculty members were white; four percent were black; that latter percentage is declining, along with the population of black graduate and undergraduate students. In the humanities, heartland of political correctness in the opinion of the right, the agency that supports more research than all others taken together—the National Endowment for the Humanities—was firmly in the control of conservatives. Lynne Cheney was packing its board (the National Humanities Council) with NAS members and their political allies, and intervening directly in the funding of scholarly and curricular proposals.[2] Feminist and left projects will be starved for years to come by her appointees, even though she has passed from the scene. I could go on, but readers of this book know well that, however welcome to many of us the diversification of thought and personnel in colleges since 1965, those changes have been modest, far from revolutionary, and under siege at the moment when the right chose to represent us as bullies in power.

The PC campaign was odd in another way to people like me. We think of our politics as radical, and quite a few of us have tenure, so we would seem to be the target of Roger Kimball's *Tenured Radicals* and other alarmist commentaries. Yet by and large we didn't find our names on their hit lists or recognize ourselves in their descriptions.

Not to put too fine a point on it, we work in whatever small ways we can toward the end of capitalist patriarchy: not just canon reform or a deconstruction of *Paradise Lost*, but the transformation of society. Most of us don't expect it to happen with a bang, or indeed within our lifetimes, but the horizon of our hopes is dismantling the corporate structure; taking away the money and power of those who own most of productive capital, and thus the right to decide the future of this beleaguered planet; eliminating the war machines and the death squads; ending male and white supremacy; and building a social order around the ideals of full equality and democratic planning. We don't know how to do all this. We have no blueprint for the future. We belong to no vanguard parties. Of the "us" among whom I locate myself, few are Leninists, only some are marxists. We didn't rest our hopes in the Soviet Union. We are socialists and feminists convinced that the present economic and social system has finished its historical work—including some good and much evil—and entered a phase of disorder and destruction whose outcroppings are everywhere plain. Just read the news.

We think ordinary people can make something new, something better. We ally ourselves with the millions in this country and around the world working for something that would be worth calling democracy, whether it's called socialism or not. And most of us join in that work, outside of classrooms and academic conferences. We work in peace organizations, women's groups, Central American support networks, tenants' organizing groups, gay rights groups, progressive unions, groups for Palestinian autonomy, reproductive rights groups, environmental groups, and so on and on. I don't want this to sound too virtuous and risky. We are professors. We grade papers and go to committee meetings. We are middle class people who live in decent homes and, if we are arrested at a demonstration, are quickly and safely out of jail: we don't suffer beatings, torture, and rape there, as do many of our brothers and sisters who are political prisoners. To claim for ourselves the name of revolutionaries would strike us as rather too grand. But we think in those terms, and we are active. Tenured radicals, in short.

So what charges does the right lay against us? That we want to smash the state and eat the rich? Not at all. It says that we care only about theory. That

we write in elitist jargons. That we don't believe texts have meanings. That we hate literary classics. That we think culture no more than an expression of economic relations and prejudices of race, class, and gender. That we endorse the claims of every oppressed subculture, including the claim to separatism. That we don't believe in values. That we dissolve history into texts. That, in sum, we are clowning mandarins—even when occasionally seen as "dangerous" (thank you, George Will).

Putting aside injured dignity, I would stress that the PC frenzy has given politics a bizarre twist. Bush intellectuals and their NAS allies, with help from the befuddled media, gained an astonishing amount of national attention for mischaracterization of academic radicals and an absurdly inflated account of their power. Why this strategy? Why now? Why so effective?

To work toward some conjectures, I refer these questions to the familiar understanding of education as figuring importantly in the hegemonic process. In a working hegemony, power filters through innumerable laws, institutions, daily practices, attitudes, and needs, so that except to those directly under the heel of the policeman it feels less like rule than like what Gramsci called common sense. It saturates experience, consciousness, and customary relations with other people to the extent that inequality and domination seem normal or invisible. In this process, education helps reproduce the inequities of the social order, but it still does so in ways widely accepted as fair and natural. The ideology of equal opportunity and merit rewarded has been quite serviceable toward that end through large parts of our history, obscuring the decisive advantages of family position and wealth, the differential access of young people to cultural capital and networks of privilege, the politics of tracking, and the operation of the hidden curriculum to discourage and derogate those not adapted by birth and rearing to the culture of school. When the system is working smoothly, not just its main beneficiaries, but also its victims understand their life chances and trajectories as resulting from differences in individual ability, effort, and choice.

No hegemony stays automatically in place or unproblematically retains its appearance as common sense. As Raymond Williams put it:

a lived hegemony . . . has continually to be renewed, recreated, defended, and modified. It is also continually resisted, limited, altered, challenged by pressures not at all its own. . . . At any time, forms of alternative or directly oppositional politics and culture exist as significant elements in the society. (112–13)

Surely we are living in a time of strenuous effort to renew, recreate, defend, and modify the hegemony of the U.S. ruling class and its confederate elites; the wars of education and culture are part of this effort, and of resistance to it.

I think the reconstructive effort, including the PC campaign, to be overdetermined in some obvious and some less obvious ways. First, there is of course the long decline of American capitalism since the postwar boom began to taper off at the end of the 1960s, while European and East Asian economies rapidly expanded. Although our country still dominates the world militarily, it is evident that the economic base of that power is eroding. Attempts to rebuild it on new terms through the 1980s led to an increase in inequality that is now a cliché even in mainstream media, and to deepening social and environmental pathologies, also a subject of regular analysis and lament in the public arena.

Second, just when the economic system was reaching the limit of its ability to improve material life for each successive generation, 1960s political movements came along to demand more equal shares in the distribution of goods and in political power. Whatever the willingness of those in charge to respond to such demands, increasing stagnation in the productive apparatus made it impossible to cut in these new claimants, even to the grudging extent that the white, male, industrial workforce had been cut in during the 1940s and 1950s. But the new movements did establish the state as an arena of struggle over entitlements and fix the social categories—blacks, women, Latinos, etc.—by whose fortunes the legitimacy of the social order would in part be measured. Thus, for instance, the widespread perception of the Rodney King affair and the Los Angeles riots not as isolated outrages but as symptoms of profound social failure.

Sixties movements had also enabled that kind of critique through later decades, by insisting that the Vietnam War, white supremacy, male domination, environmental damage, and so on, were problems to be solved by liberal management. Comprehensive analyses—marxist, feminist, ecological— gained currency and remained available as challenges to mainstream common sense, even through the right-wing resurgency of the 1980s.

Needless to say, these strains of critical thought took root especially in universities. Among their targets were the educational system itself and the official knowledges it produced and purveyed. Taken together, challenges to the authority of high culture, to bourgeois political economy, to the exclusions and blind spots of traditional history, to Eurocentrism, to male and hetero-sexist assumptions in many disciplines, and to the power relations embedded in the educational institution and its pedagogies amounted to a running contest over cultural capital. Far from hegemonic even in universities, these projects have at best constituted an embryonic counter-hegemony, linked as they have been to new and sometimes militant groups of students in the universities and to social movements outside.

I would add a fourth point: as the contemporary university system took shape in the postwar period, it became a much more critical site of social reproduction than before, and a central locus too for the vastly expanded professional-managerial class (PMC) whose activities mediate and shore up capitalist rule in innumerable ways. The 1960s showed that the loyalty of this class, especially of its youth, is far from secure. So the questions of who might function as organic intellectuals of the PMC and what forms its cultural capital might assume have taken on a good deal of political importance— the more so in a time when the place one may attain in the social hierarchy depends more and more on access to education.[3]

In short, our recent history has provided more than enough reasons for those seeking to defend and recreate the domestic hegemony of capitalism to engage in battle over the content and practices of higher education. The right had undertaken the battle as a matter of conscious policy, starting within the Heritage Foundation and other strategic planning centers, pursuing a flawed tactic through Accuracy in Academia, and finally hitting its stride with

the National Association of Scholars and the media success of its attacks on political correctness and multiculturalism. But why has it framed its attacks in this way, rather than directing its fire toward the nascent counter-hegemony of the anticapitalist left and its academic counterparts? And why has the tactic worked so well at least in the short run?

I suggest two related answers. First, as a result of the dissolution of the Soviet empire, the right has finally been able to see beyond communism as *the* portmanteau threat to "freedom." The demise of actually existing socialism abroad may have reduced the conservative obsession with the prospect of socialism in the U.S.—a small threat indeed just now—and allowed more attention to the forms that native dissidence was in fact taking. Second, those forms had long since splintered off from whatever coherent center "the movement" might have claimed in 1970, and were carrying opposition forward in a variety of new social movements, only intermittently and loosely brought together in nonce coalitions. Furthermore, each of these social movements has generated a variant or a strain that emphasizes subcultural identity and a politics of lifestyle.[4] From identity politics has sprung a particular kind of multiculturalism and the drive toward political correctness, which may be best understood as the effort—by people in social movements and by others who are not in them but see them as authentic challenges to hierarchy and injustice—to respect each politically constructed identity, culture, and lifestyle on its own terms. The right has, I think, recognized both the strength and the weakness of identity politics, and chosen to attack it at the point where it offers least promise of an embracing, transformative vision, least promise of genuinely threatening solidarity.

The battle thus joined has been, to say the least, a frustrating spectacle for those with hopes and allegiances like mine. Let me encapsulate the frustration a bit overschematically, with respect to multiculturalism and political correctness, two issues on which many of us disagree with both so-called sides. The right sees multiculturalism as an eroding of "the" Western tradition, an attack on esthetic values and on value generally, a privileging of the third-rate, a campaign for ignorance, and a desecration of culture. I read through these concerns to a wish that the same people who managed cultural capital seventy-

five years ago would again be in uncontested charge of it, and would not have to sit in meeting rooms with women, minorities, and radicals who might challenge its authority—might want to study it as a particular historical construction rather than as the embodiment of timeless universals. Given only the choices presented to us by the media, my political friends and I would grit our teeth and choose multiculturalism, which at least weighs in against the blindness of the dominant to what they dominate, fosters respectful interest in the variety of the world's peoples, adheres to such ideals as that of affirmative action, and argues an emancipatory project for education.

But we are not that keen for what often presents itself as multiculturalism. There is a version of it that takes the people of the world to be parceled out into cultures and subcultures, each self-contained and uniform, and each knowable only to its members, so that, for instance, only a Chicana would have the authority to teach about Chicana poetry. On the contrary, we think that all cultures are in continuous exchange with others, and that even the smallest societies are not homogeneous but embrace their own hierarchies and conflicts. The search for purity is futile. Worse, it precludes learning about cultures from outside and certifies only the "other" as a source of knowledge about other cultures. It also tends to valorize raw experience as the privileged foundation of knowledge, and to forbid critique of cultures except from within. This sort of multiculturalism sees people as always intrinsically what they are—black lesbians, white male homosexuals, and so on. Its essentialism is almost as disturbing as the fatuous universalism of the right. On top of that, it leads to a politics of identity that makes any encompassing solidarity against capitalist patriarchy hard indeed to imagine. The fact that multiculturalism has become a slogan of many college administrations and funding sources suggests how unthreatening it is to the holders of power, and how easy to contain and control in the guise of "diversity," not to mention its usefulness in training global corporate managers.

As for political correctness, the right apparently feels not only itself but the very possibility of civilized discourse to be under siege by a phalanx of rude and stone-faced thought-cops who enforce a tyranny of newspeak, censorship, and fear. Pardon me again if I read through these touching tales

of martyrdom, these ringing defenses of free speech, and see behind them an undying enmity toward sixties movements, toward whatever remains of their democratizing force in universities, and toward any challenge to dominant groups and ideas. Whatever else happened in the sixties, universities opened then to new students and to critical ideas, both new and long silenced. The right would like to cancel those gains. Given the choice presented by it and by the complaisant media, my friends and I would swallow hard and line up with the politically correct, who at least unambiguously dislike white supremacy, male supremacy, and all the "isms" that disrespect and demean.

But much about the PC phenomenon drives us up the ivied walls. Censorship, of course: we'll all take a loyalty oath to free speech. I pay dues to the American Civil Liberties Union and endorse most of its positions. And if it's OK for the Klan to speak on campus, it's surely OK for our NAS colleagues to teach their classes (with unaccustomed responsibility for their ideas, of course). The few incidents of actual censorship, however, incidents recycled endlessly through the media, and those of egregious bad manners (with *no* censorship involved) that draw headlines like "Return of the Storm Troopers" are not what we mainly hold against PC, much as we deplore them. We object to PC because it is often a self-indulgent substitute for politics, a holier-than-thou moralism of the good, a politics of surfaces and gestures. In this extreme form it amounts to a conviction that the ills of the social order will be cured when executives no longer call their secretaries "girls" and thin people stop using the word "fat." As the right correctly (!) perceives, this is also a politics of separate issues, a catechism that can be memorized by sophomore year, a "cluster of opinions about race, ecology, feminism, culture, and foreign policy" (Bernstein).

What's missing is any perception that these issues are knit together in a whole system of domination, which might be grasped as a totality and strategically opposed. To be sure, in everyday life we in the socialist feminist left also spend a lot of energy fighting specific injustices. Nobody can totalize much of the time. But unless local actions are guided by a unifying analysis and vision, they will forever be a discrete series of defensive maneuvers. And certainly discrete *attitudes* don't add up to a radical politics; they aren't even

politically correct, in the bad old Stalinist sense that we have evoked for years, always ironically, when we have used the now useless term.

These debates will block understanding, if carried forward in their present terms. For instance, they hide the role of the right itself in generating excesses of PC multiculturalism, by trimming alternative programs until the dispossessed are left fighting one another for jobs and turf. More broadly, the media spasm about PC obscures the fact that battles over the canon and insulting language take place in just a small corner of the university, and an even smaller corner of the overall educational system. In the university as a whole, the core curriculum is neither Shakespeare nor Alice Walker. It is accounting, computer programming, training for service jobs or for Wall Street high flying, and acceptance of such divisions of labor as natural and unchangeable: in short, the quiet reproduction of inequality and political hopelessness. Add K–12, and the whole curriculum reveals itself as a far-from-benign neglect of most students and teachers. That's the only curriculum the right has proposed for just about everyone who doesn't make it to Harvard.

But we won't get far in opposing their program by lining up with the politically correct. We must defend them when cornered: they are not our enemy, and the right-wing intellectuals are. But let's remember that our aim is not to affirm cultural identities and enforce correct attitudes; it is to scrap the tired yet violent project of capitalist patriarchy and move on to a new one that will allow human beings to flourish in their common weal.

Notes

1. Throughout this essay I draw on conversations with a group of left academics from southern New England, the editorial board of *Radical Teacher*, and the planning committee at the Center for the Humanities at Wesleyan University. A different version of the essay appeared in *Radical Teacher*.

2. According to one former staffer, Cheney was "starting to tell the division heads who they can have on their panels" of reviewers. According to another, the name of even one "undesirable, leftist scholar" attached to a proposal could kill it (see Burd, "Chairman"). I think in retrospect that opponents of Carol Iannone's nomination to the Council (including me) were wrong to take the apolitical "high road" and object only to her credentials.

Cheney saw the opposition as political anyhow, and learned an easy lesson from the fight: her eight later nominees were uniformly conservative and impeccably credentialed.

3. Along the way I have drawn on ideas from Denning and Plotke.

4. Many have made this kind of observation; a good critical statement of it is L. A. Kauffman. As Kauffman pointedly suggests, in the values it expresses, "individual solutions to social problems, attention to lifestyle, choice," identity politics "mirror[s] the ideology of the marketplace" (78).

3

The Campaign Against
Political Correctness
What's Really at Stake

Joan Wallach Scott

If there were any doubt that the production of knowledge is a political enterprise that involves contest among conflicting interests, the raging debates of the last few years should have dispelled them.[1] What counts as knowledge? Who gets to define what counts as knowledge? These are difficult problems, never easy to resolve, but it is the function of universities to grapple with them.

Those who deny the existence of these problems and who would suppress discussion of them are not without their politics; they simply promote their orthodoxy in the name of an unquestioned and unquestionable tradition, universality, or history. They attack those who challenge their ideas as dangerous and subversive, antithetical to the academic enterprise. They offer themselves as apostles of timeless truths, when in fact they are enemies of change. The cry that politics has recently invaded the university, imported by sixties radicals, is an example of the defense of orthodoxy; it is itself a political attempt to distract attention from the fact that there are serious issues at stake and more than one valid side to the story in the current debates about knowledge.

What we are witnessing these days is not simply a set of internal debates about what universities should teach and what students should learn. Journalists and politicians have joined the fray and added a new dimension to it. There is much more at stake in their campaign against "political correctness" than a concern with excessive moralism, affirmative action, and freedom of speech in the academy. Rather, the entire enterprise of the university has come under attack, and with it that aspect that intellectuals most value and

that the humanities most typically represent: a critical, skeptical approach to all that a society takes most for granted.

The far-ranging scrutiny of university practices—curricular change, admissions standards, fellowship awards, disciplinary codes, hiring and tenure procedures, teaching loads, "useless" time spent on research, accreditation standards—attempts to delegitimize the philosophical and institutional bases from which social and cultural criticism have come. We are experiencing another phase of the ongoing Reagan-Bush revolution which, having packed the courts and privatized the economy, now seeks to neutralize the space of ideological and cultural nonconformity by discrediting it.

Academics ought to be alarmed at the onslaught, for the conservative agenda would deny us our most valuable—and pleasurable—activity: thinking hard about everything, from obscure texts to our present condition, and teaching others how to think that way. The current situation requires this kind of critical thinking. It calls for an attempt to understand what is going on, to enter the fray, not necessarily by choosing sides exactly as they have been defined by others, but by analyzing the entire situation and looking for new ways to address questions about the production and transmission of knowledge in increasingly diverse and, for that reason, necessarily conflicted academic communities. This essay aims less at taking sides—though you will have gathered already that I am not neutral—than at provoking thoughts about what is needed to guarantee the future of universities as centers of inquiry and critical reflection.

Since provocation can take many forms, there are five parts to this essay, each a preliminary mapping of a complex and contradictory field.

Paranoids, Fetishists, and Imposters

I was tempted, in a fit of rhetorical excess, to follow the sensationalist lead of Camille Paglia and call this entire article "Paranoids, Fetishists, and Imposters." What better way to characterize the small band of publicists who have taken it upon themselves to banish "political correctness" from the academy, and with it affirmative action, multiculturalism, curricular innovation, and all serious attention to those *institutional* structures of inequality that produce

racism, sexism, and other forms of discrimination? I would have used the terms *paranoids*, *festishists*, and *imposters* not as epithets but as diagnoses, because they seem to me to capture something of the doubleness at play in the publicists' game. Such an analysis would have gone something like this:

Paranoia involves the projection of one's own fears outward. The sense of one's own weakness and instability becomes the perception of an external danger; instead of acknowledging the limits, even the fictional qualities of his power, the paranoid attributes these to a threat from outside.

The result is an extreme polarization. On the one side there is a flawless, innocent victim, on the other an aggressive, destructive force. Much of the critique of multiculturalism and "political correctness" is structured exactly in these terms. The danger is depicted as coming from outsiders, often minorities ("minority," in the publicists' usage, alludes to those who have lost in democratic elections and so are justifiably outside; in that way the issue is shifted from race and discrimination to individuals and democracy), people who are somehow sore losers and seek revenge by attacking the university, Western civilization, democracy, its representatives, and its values.

Rarely is the historic inhospitability of universities to various minorities mentioned. To read Dinesh D'Souza, one would never know that Jews were deliberately excluded from university faculties until after World War II, that women were until recently systematically denied appointment at most research universities because of their sex, and that blacks were not admitted as students or hired as faculty at many public and private universities until the 1960s. Nor would they know of the campaigns he participated in during the last decade to make blacks, women, and homosexuals unwelcome at Dartmouth and Princeton. One would think only that universities were completely accessible communities for those excellent individuals who deserved to be in them until the radicals arrived.

Rarely, too, are the difficulties of minorities acknowledged to have been produced by the democratic institutions that are being ardently defended. Reading the *New Republic*'s special issue on campus racism, one forgets that racism is a problem internal (but not unique) to democracy and Western

civilization; instead those proposing reform are depicted as outsiders whose agenda will only subvert an essentially good system. The danger to society, or at least to the university, one concludes from reading that issue, is not its own racism but an alien multiculturalism that is being imposed "from outside."

The *fetishist* worships an object that both avows and obscures the real stimulus to his desire. The displacement of erotic attention from, say, the female genitals to the foot covers the fetishist's shame about his initial desire, but allows him to pursue it by substituting a part for the whole.

In the current controversies, the publicists have substituted "tradition" (the embodiment of taste, culture, and cumulative wisdom) for the white male privilege they so deeply desire and want to protect. To read their accounts of "tradition," one would not know that it is largely invented, always contested, and that what has counted as tradition has changed from generation to generation. Canons are, after all, heuristic devices for exemplifying the literary or the philosophical or the artistic, they are not—as the publicists would have it—timeless and unique repositories of human truths.

The fetishizing of "tradition" allows the publicists to present a particular version of culture—one that does give priority to the writing and viewpoints of European white men—as if it were the only true version, without, however, acknowledging its particularity and exclusiveness. This kind of practice, which discounts and silences the voices and experiences of others, is profoundly undemocratic. In the guise of protecting an objectively established "tradition," the publicists can disavow any association with undemocratic practices while still engaging in them.

Imposters are those who pretend to be what they are not. Those they imitate are the objects both of their deep desire and their jealous resentment. Their imitative behavior conveys both admiration and hatred.

In the current situation, those leading the campaign against the university and making judgments about its theoretical debates are posing as knowledgeable scholars and hoping to be mistaken for them. Serious intellectuals have only to read the self-assured, hopelessly ill-informed, and simply wrong descriptions of deconstruction, psychoanalysis, feminism or any other serious

theory by the likes of D'Souza, Richard Bernstein, David Lehman, Roger Kimball, Hilton Kramer, George Will—and even Camille Paglia—to understand the scam. They will recognize people for whom teaching has no real value, for whom literature is a pawn in a political argument but not a passionate commitment to the play of language and the pleasure of reading.

It is in their ambivalent stance of attraction and resentment that one can detect the imposters. The superficiality of their accounts, their large generalizations based on a few scattered (but repeatedly cited) examples, and their obvious ignorance of the topics they write about suggest that their project is motivated not by serious intellectual concern, but by another kind of personal and political agenda.

For those who have some familiarity with the operation of universities and with the intellectual matters under discussion, the imposters' writings are an embarrassment, lacking as they do any serious historical and philosophical foundations and all grasp, therefore, of the issues. But their anger at the very scholars they long to emulate, as well as their superficial comprehension of what is often difficult, specialized, and abstruse writing, seems to have worked in some quarters. That is partly because the publicists have assumed another persona beside that of the intellectual: they pretend to represent the common man—whom, as elitists, they also loathe. They claim to speak for a democratic public that knows truth when it sees it, that is suspicious of elitism and shrewd in its ability to detect falsehood.

That marginal intellectuals, conservative journalists, and disaffected scholars are taken to represent this public is hardly credible from one perspective; from another—that of history—it becomes understandable. The fraud works because it taps into a deep tendency in American culture, that of suspicion and hostility to intellectuals, a tendency of long-standing, that is ever available for political battles. An examination of that tendency provides perspective on the appeal that the paranoids, fetishists, and imposters seem to be having these days. And it shows why thinking about the small band of publicists only in clinical terms, or focusing on them as the key to the current "crisis," is not enough.

Anti-Intellectualism in American Life

In 1962, as McCarthyism waned, the economy expanded, and hopes ran high for social justice, Richard Hofstadter published a book that attempted to explain in broad, historical terms "the political and intellectual conditions of the 1950's" (3). Hofstadter argued that the anti-intellectualism of the fifties, expressed in contempt for "egg-heads" and carried out by malicious inquisitions into the activities of university professors, was not new but a recurring feature of American life. "Our anti-intellectualism," he wrote, "is older than our national identity, and has a long historical background" (6).

Hofstadter defined anti-intellectualism as "a resentment and suspicion of the life of the mind and of those who are considered to represent it; and a disposition constantly to minimize the value of that life" (7). What was most feared about intellectuals was their critical relationship to society, their insistence on independence, and their freedom from practical restrictions. "The intellect is always on the move against something: some oppression, fraud, illusion, dogma, or interest is constantly falling under the scrutiny of the intellectual class and becoming the object of exposure, indignation, or ridicule" (45). This has led intellectuals to support movements for social justice, to embrace avant-garde artistic experimentation, to question government policy, and to challenge assumptions about what counts as nature, science, morals, and politics.

Suspicion of intellectual work and its critical impulses has come from many quarters: from evangelical religious leaders who stressed the power of spirit over reason, heart over mind; from those cultural leaders who saw American uniqueness in its closeness to nature and the land; from businessmen who extolled masculine practicality, efficiency, and a cult of action; from politicians who insisted that education serve the needs of democracy by providing a common denominator of "useful knowledge" for all citizens; and (most interesting from our perspective) from educational reformers whose egalitarianism associated intellectual work with elitism and whose sense of democracy focused on developing the inner resources and personality of the child.

According to Hofstadter, there has been a paradoxical relationship between

27

democracy and anti-intellectualism that has led to the consistent undervalua-
tion of teaching as a profession and of critical intelligence as a national
resource. The result is a chronically impoverished educational system that
prefers rote learning to the cultivation of critical thinking, and that—as is
now about to be the case—would rather spend money on national testing
than on substantive programs or teachers' salaries. Periodic cries of alarm
about the lack of preparation of students—the inability of the United States
to compete with Germany in the heyday of its industrial development, with
the Soviet Union at the time of Sputnik, or now with Japan in these days of
economic competition—lead again and again to proposals for reform; but
even in these periods, the proponents of Hofstadter's vision of education as
the cultivation of intellect have a hard time making themselves heard.

One of the fascinating aspects of Hofstadter's analysis is the point that
anti-intellectualism is often expressed by those in some way responsible for
education. It is sometimes incorporated by intellectuals themselves into anxi-
ety about the social utility (the relevance) of their intellectual work. It is
often, too, expressed in proposals for undergraduate reform: the perpetuation
of an ossified classical curriculum in liberal arts colleges in the early nineteenth
century in the name of "tradition" is one example Hofstadter offers. In those
times, for patrician or "mugwump culture," reform meant resistance to change,
the inculcation of "correct taste" and "sound morals"—"and taste and morals
were carefully defined in such a way as to establish disapproval of any
rebelliousness, political or esthetic, against the existing order. Literature was
to be a firm custodian of 'morality'; and what was meant by morality was always
conventional social morality" (402). The point was to curb any independent
creative critical spirit, to prevent that unlimited, sometimes necessarily exces-
sive, experimentation with new forms and ideas that Hofstadter sees as the
hallmark of intellectualism.

Today's "mugwumps" are not defending a declining patrician class but
are pushing an orthodoxy that is fundamentally anti-intellectual, in the name,
of course, of educational improvement. William Bennett's 1984 report on
humanities education in America, called *To Reclaim a Legacy,* laid the founda-
tions of an argument that has been taken up by conservatives within and

outside the academic establishment. In it, he bemoaned the fact that the classic texts of Western civilization were being criticized and sometimes replaced by texts of lesser quality and dubious importance. A legacy was being lost, he warned, one that consisted of timeless truths and values that must be transmitted intact from generation to generation.

Lynne Cheney's reports after she took over as chairman (sic) of the NEH have elaborated these themes. In 1988, she attacked the "politicizing" of the humanities by groups asking that their experience be included in representations of history and literature. Their demands, she wrote, ignore the fact that there are timeless truths "transcending accidents of class, race and gender, [that] speak to us all" (*Humanities*). In 1990, Cheney wrote *Tyrannical Machines: A Report on Educational Practices Gone Wrong and Our Best Hopes for Setting Them Right*. In it she continued to stress timeless truths, defining the primary role of education as the transmission of them. While the report pinpoints a number of genuine problems in schools and universities, its solutions rest on a vision of education that illustrates many of Hofstadter's points.

For example, although research is acknowledged to be an important function of universities, it is also blamed for diverting professors' attention from teaching. In itself this is not inaccurate; many universities reward only publication as professional achievement. But it is the definition of teaching that reveals the report's anti-intellectual agenda. Teaching involves the diffusion and transmission of knowledge, Cheney maintains, not its production (27, 37). What counts for her as knowledge is uncontested; it is information purveyed through "comprehensive treatment of important subjects," "rigorous and coherent curricula," and a core curriculum. The fact that standards of importance and comprehensiveness are variable and have always been contested is not mentioned. (I don't think, for example, that we would all agree on what a "coherent" curriculum would look like.) Rather, Cheney tells us, the test of a university's commitment to teaching is the existence of requirements for broad-based courses that will introduce students to "the great deeds and ideas that have shaped the world" (41). (Are "great" deeds self-evidently so?) There is no value placed on the interpretation of texts, the exploration

of new ideas, or the opening of the mind to new ways of thinking. Rather teaching means the induction of the student into a set of received values and ideas. The word "critical," in Hofstadter's notion of the dissenting, nonconformist spirit, is translated by Cheney into a question of taste, an ability to appreciate (she quotes William James here) the "excellent and the durable," to "admire the really admirable," and to scorn "what is cheap and trashy and impermanent." These attitudes, she says, must be shared by citizens of a democracy; they provide the wisdom needed to make sound political and personal judgments and to secure the future.

The tone of Cheney's report is judicious and calm. It bears little resemblance to the hysterical pronouncements of members of the National Association of Scholars who, using the language of the followers of Senator McCarthy, talk about fending off the "barbarians" who are storming the gates of academe and who would deprive us of our individual freedom. Yet, if Hofstadter is right (and I think he is), Cheney, the NAS, and the highly visible band of journalists and publicists who are promoting the conservative agenda have in common the intention to control thought, to prescribe its contents and boundaries, to police its operations, and above all to reign in the critical spirit that must be unfettered in a truly free society. That this is all done in the name of democracy is, according to Hofstadter, a characteristic of anti-intellectualism.

All of this ought to give us great pause. For there can be no democracy worthy of the name that does not entertain criticism, that suppresses disagreement, that refuses to acknowledge difference as inevitably disruptive of consensus, and that villifies the search for new knowledge (about say, the place of minority history in "general" history courses).

In typical paranoid fashion, the leaders of the campaign against change in the universities have labelled all critics and advocates of change "thought police." And while it is surely true that there are within universities—on the left and right—people who would impose their ways of thinking on everyone else, they do not represent the majority and they have never gained control. One of the tricks of the publicists has been to conflate serious criticism and intolerant dogmatism under the label of "political correctness," and thereby

discredit *all* critical efforts. The worst aspect of this conflation is that it misrepresents intellectual life and intrudes upon it by, for example, mobilizing extensive support in the form of alumni gifts (such as George Bass's to Yale) to support courses whose content will uphold "the values of Western civilization" as defined by conservative scholars.

What is being so misrepresented in all of this is the way universities actually operate. They are, of course, political institutions, in which individuals and groups compete for predominance and resources. But they are also unusually open spaces in which criticism and self-criticism can flourish. The more open the space, the better the process works; the more constricted the space (as it becomes when anti-intellectualism is ascendant) the less well the self-correcting mechanisms operate. These mechanisms involve a set of procedures and standards for argumentation and research that requires a certain familiarity and expertise. Those who lack this familiarity and expertise (whether they work inside or outside the university) cannot claim to understand or speak for academic life; indeed when they do speak about it they misrepresent and distort it.

At the heart of intellectual activity there *is* a commitment to pursuing truth, however provisional it is understood to be. Indeed truth can be defined as an ever-receding horizon—not a fixed quality that can ever be finally known—that is approached through a communal enterprise of hard work, conflict, and argument. This communal enterprise, which at its best does not rest on or expect consensus, takes place in classrooms, seminars, lectures, faculty meetings, and conferences that are scenes of exploration and disagreement. They are places where critical ideas are tried out, often in extreme, dogmatic, and outrageous form. They are places where, ideally, despite enormous differences, opinions are exchanged and ideas expressed. The appearance at the AHA or MLA of critical papers with sexually explicit titles and provocative interpretations, however many of them there are, does not mean a new orthodoxy is being enforced, but rather that ideas are being tested and the horizons of knowledge expanded. The preoccupation of some humanists with poststructuralist theory is similar. Their sometimes highly abstract articles, full of technical language, don't signal the end of the possibility of simple

communication among scholars, but are rather an attempt—hotly contested—to bring new kinds of philosophical ideas to older enterprises.

It was in the university, after all, that "political correctness"—as a behavior, as a critique of doctrinaire leftist attitudes, and as a subject of scholarly analysis—was produced. Left there, it would have been dealt with as another form of academic dispute. In the hands first of *New York Times* reporter Richard Bernstein, and then of other journalists, joined by conservative scholars, businessmen, and politicians, it has been escalated into a political "crisis" of "major proportions;" it was a theme in the 1992 Bush presidential campaign. This kind of pressure on universities, mobilizing as it does deep-seated anti-intellectual sentiments, is far more dangerous to the academic enterprise than are debates about the limits of free speech, the rights of minorities, and the politics of knowledge.

Diversity

Universities have changed dramatically since the 1960s and much of the present controversy has roots in those changes. In 1960, ninety-four percent of college students were white; the figure was ninety-six percent for private universities. Of the remaining six percent, a third attended predominantly black institutions. A number of public and private universities did not admit blacks at all, and some of the most highly regarded centers of learning did not admit women. Colleges tended to be white male enclaves for students and faculty: sixty-three percent of college students were men, ninety percent of Ph.D.s were men, and eighty percent of university faculties were men. (When I was a graduate student in this period, the Woodrow Wilson Foundation stated explicitly that no more than one fourth of their graduate fellowships would be awarded to women.) In 1991, twenty percent of all college students are nonwhite or hispanic and fifty-five percent were women (Menand, "Illiberalisms"). Women make up over a third of all graduate students and are even more highly represented as Ph.D. candidates in the humanities; they now represent about twenty-seven to twenty-eight percent of university faculties.

The change in university populations follows in part from a general increase in college attendance during the past several decades, and this has been

accompanied by changes in recruitment policies. The expansion of the university has not so much altered admission policies as it has added more considerations to them and made them more visible. Admission, even to the most prestigious schools, was never based on merit alone, although that is the myth being advanced now in the anti-university campaign; rather, merit was one among many factors that included athletic skill, wealth, geographic location, and family connections to alumni, the famous, and the powerful. The special treatment that came with high social status never seems to have been seen as a compromise of university standards. (One has to wonder why it was that, for example, the test scores of blacks were stolen from the admissions office at Georgetown Law School and published by disgruntled conservatives, while those of alumni children or influential politicians were not. One can only conclude that the call for a return to a meritocracy that never was is a thinly veiled manifestation of racism.)

The new populations in the universities bring with them histories of their own that have not been part of the traditional curriculum; their presence challenges many of the prevailing assumptions about what counts as knowledge and how it is produced. This is so first because of the sheer numbers, as well as the new kinds, of students and faculty on campuses. Is critical thinking possible when masses of students are attending college, instead of only the children of elites? Is critical thinking advisable for the masses of students or should they (as the reports of Bennett and Cheney suggest) be given a prescribed education that they will passively receive? Can critical thinking take place in communities that are no longer elite and homogeneous?

There have also been, in the last decades, major political and philosophical developments that have changed the way we think about relationships of difference in the world. These include decolonization of the Third World and the emergence of national identities that positively value histories and cultural practices once obscured or demeaned by colonizers who equated European standards with civilization; philosophical critiques of universalism and foundationalism and of the idea of community as a consensual, homogeneous institution; and analyses of power and difference that call attention to how "we" construct ourselves in relation to "others" (West, "Minority"). If,

in earlier generations, minorities adjusted to college life by assimilating to prevailing standards and accepting as universal norms that had not previously been their own, now they have the means to question the very notion of universality and insist that their experience be taken into account.

But how is this to be done? Perhaps it is better to ask the question more historically, how has it been attempted? How have universities attempted to accommodate their different and "diverse" populations? How have demands for new approaches to knowledge been received? In some ways, the overall process today has not been all that different from previous contests about knowledge: there has been pressure for change, powerful resistance to it, as well as accommodation.

But there are also differences. Contests about knowledge are now understood to be political, not only because they are contests, but because they are explicitly about the interests of groups (rather than the opinions of individuals) in the substance and form of what counts as knowledge. It is the question of group interest and power that has been introduced into the knowledge debates and so "politicized" them in new ways. Although it sometimes takes extreme and tendentious forms, I think the explicit discussion of interest is inevitable, and it is not only minority voices that are responsible for this politicization.

A crucial point, one regularly overlooked in hysterical pronouncements about the takeover of the curriculum, is that power is unequally distributed—those demanding change must contend with disciplinary and pedagogic practices that are institutionalized, command resources, and claim to have truth, rigor, and objectivity on their side. The emergence of separate courses and programs of women's studies, African-American studies, Chicano studies, and the like testifies to this situation: they were created in the face of the refusal of departments to include material on these groups in existing courses and in an effort to demonstrate that they were subjects worth studying. The programs and courses, in turn, taught and attended largely by members of the groups being studied, underscored the differences in perspectives and interests that existed across the curriculum. They also gave rise to a series of observations, highly contested, but quite serious in their philosophical as

well as practical implications, about the relationships between knowledge and group identity. Does one have to be of the group to care about its history? To teach its literature? Are intellectual perspectives expressions of particular social standpoints? Does understanding require firsthand experience? What are legitimate grounds for objecting to the exclusion of whole realms of experience from so-called mainstream courses in the humanities or social sciences? What gives authority to claims for inclusion? Is it possible to teach mainstream courses from a perspective different from the one traditionally taken?

There are many answers being offered to these questions, even if the sensationalist press only reports the insistence by some blacks or women that they are uniquely qualified to teach black history or women's literature. And since they are not easy questions, the discussions are necessarily full of conflict. What is least reported these days is the fact that the disciplines, too, have exclusionary notions about who is capable of teaching what. History departments regularly refuse to consider for positions in general American history, for example, scholars who write on women or African-Americans (or homosexuals or other particular groups), arguing that they are not generalists, unlike those who are no less specialists but have written about national elections or politicians' lives—subjects that are taken to stand for what the whole discipline is about.

Recently a literature department at a major university proposed to hire in a generalist slot a scholar, some of whose work was in feminist theory. Their argument that feminist theory was central to their departmental mission was not accepted as plausible by the administrative oversight committee, which turned down the recommendation.

These kinds of decisions distinguish between general and particularized knowledge according to gendered, racial, and ethnic criteria, but they refuse to acknowledge that these are the terms of definition. In so doing, they perpetuate the balkanization of knowledge, creating the conditions that necessitate separatist claims on the part of excluded groups and that fuel their frustration and anger.

My point is not to justify separatism, nor to endorse standpoint epistemolog-

ies. Rather I want to suggest here that separatism is a simultaneous refusal and imitation of the powerful and must be understood in the context of the universities' accommodation to diversity.

The nature of the university's accommodation to diversity can be seen in the words used to describe campuses and curricula: "diversity," "multiculturalism," "pluralism." All take into account the existence of different populations with different needs and interests, but none of the words registers the fact that difference is not simply a state of separate being, it is a hierarchally constructed relationship. Being black or female or gay isn't inhabiting or acknowledging membership in a preexisting sociological category; rather it is being constituted into a particular subject position and this constitution (or interpellation) is always in process.

An example of the relational nature of difference comes from a comment made by a white middle-class student who lived in a predominantly Latino dormitory at Stanford:

> "Sometimes I'd get confused," she said because she never knew when a simple comment she made would offend someone else. She finally appreciated the difference between herself and the Hispanic students when one of them asked her what it felt like to be an Anglo. "I'd never heard anyone use the word Anglo for me before. . . . Where I came from no one was Anglo; everyone was just Irish Catholic. But after being [here] awhile I realized that an Anglo can be an Anglo only if there's someone who's not." (de Palma 7)

A pluralism or multiculturalism that fails to recognize that difference is a relationship of power achieved through a process of signification encourages separatism. Indeed it provides the conceptual basis for it, an essentialism that denies the historicity of processes of differentiation. Each group claims a fixed, transcendental identity and argues for its unique ability to present and interpret itself. It then establishes its own canon, its own history, thereby denying the relational nature of difference and the interconnectedness—however asymmetrical and oppressive—of different groups.

S. P. Mohanty, taking up an argument made by Cornel West against a

notion of separate canons, of new canons entirely replacing old, puts it this way:

> How do we negotiate between my history and yours? How would it be possible for us to recover our commonality, not the ambiguous imperial-humanist myth of our shared human attributes, which are supposed to distinguish us from animals, but, more significantly, the imbrication of our various pasts and presents, the ineluctable relationships of shared and contested meanings, values and material resources? It is necessary to assert our dense particularities, our lived and imagined differences; but could we afford to leave untheorized the question of how our differences are intertwined and, indeed, hierarchically organized? Could we, in other words, afford to have *entirely* different histories, to see ourselves as living—and having lived—in entirely heterogeneous and discrete spaces? (13)

His answer is obviously no. Instead he calls for an alternative to pluralism that would make difference and conflict the center of a history "we" all share, "A history whose very terms and definitions are now being openly contested and formulated" (25).

Individualism

University populations began to change in the 1960s and 70s, a period in which concerns for social justice were widespread and plans were implemented to increase the possibilities for equality. Affirmative action was based on the notion that certain classes of individuals had historically been treated differently from others not on the basis of merit or ability but because they were perceived to be members of groups with undesirable traits and characteristics. Affirmative action took into account these historic prejudices and attempted to reverse some of their most pernicious effects, not by reversing discrimination but by extending to blacks and women access that had historically been reserved for whites or men *as groups*.

The conceptualization of the problem in terms of groups was difficult in a society with deep individualistic strains, but not insurmountable, in part

because there are also deep egalitarian impulses that could be appealed to. In the 1980s and early 1990s, the ideological pendulum swung back to individualism. The courts reversed affirmative action decisions, the President vetoed civil rights legislation, and the history of discrimination as evident in statistics or group experience was denied. All this was done in the name of justice for individuals, who are conceived to be entirely equal units, living in a cultural and historical vacuum.

The logic of individualism has structured the approach to multiculturalism within the university—on many sides of the question. The call for tolerance of difference is framed in terms of respect for individual characteristics and attitudes; group differences are conceived categorically and not relationally, as distinct entities rather than interconnected structures or systems. Administrators have hired psychological consulting firms to hold diversity workshops that teach that conflict resolution is a negotiation between dissatisfied individuals. Disciplinary codes that punish "hate-speech" justify prohibitions in terms of the protection of individuals from abuse by other individuals, not in terms of the protection of members of historically mistreated groups from discrimination. The language of protection, moreover, is conceptualized in terms of victimization; the way to make a claim or to justify one's protest against perceived mistreatment is to take on the mantle of the victim. And everyone, whether an insulted minority or the perpetrator of the insult who feels he is being unjustly accused, becomes an equal victim before the law. Here we have not only an extreme form of individualizing, but a conception of individuals without agency.

There is nothing wrong, on the face of it, with teaching individuals about how to behave decently in relation to others and about how to empathize with each other's pain. The problem is that difficult analyses of how history and social standing, privilege, and subordination are involved in personal behavior entirely drop out. Chandra Mohanty puts it this way:

> There has been an erosion of the politics of collectivity through the reformulation of race and difference in individualistic terms. The 1960's and 70's slogan "the personal is political," has been recrafted in the 1980's as "the political is

personal." In other words, all politics is collapsed into the personal and questions of individual behaviors, attitudes and life styles stand in for political analysis of the social. Individual political struggles are seen as the only relevant and legitimate form of political struggle. (204)

Paradoxically, individuals then generalize their perceptions and claim to speak for a whole group. This individualizing, personalizing conception has also been behind some of the identity politics of minorities; indeed it gave rise to the intolerant and moralizing dogmatism that was dubbed, initially by its internal critics, "political correctness."

It is particularly in the notion of "experience" that one sees this operating. In much current usage of "experience," references to structure and history are implied but not made explicit; instead personal testimony of oppression replaces analysis and explanation and it comes to stand for the experience of the group. The fact of belonging to an identity group is taken as authority enough for one's speech; the direct experience of a group or culture—that is, membership in it—becomes the only test of true knowledge.

The exclusionary implications of this are twofold: all those not of the group are denied even intellectual access to it, and those within the group whose experiences or interpretations do not conform to the established terms of identity must either suppress their views or drop out. An appeal to "experience" of this kind forecloses discussion and criticism and turns politics into a policing operation: the borders of identity are patrolled for signs of disapproval or disagreement, the test of hostility or support for a group becomes less one's political actions and relationships of power than one's words.

I do not want to suggest that language has no bearing on relationships of power, far from it. Instead I want to warn against the reduction of language to words, the reduction of "experience" to an idea of unmediated, direct access to truth, and the reduction of politics to individual interactions.

Furthermore, I do think that different groups have different experiences and that they offer new perspectives on knowledge that have been neglected and must be included. It is true that whiteness and femaleness set conditions of possibility and an interpretive frame for my life that they don't for a black

woman or any man. But if, as S. P. Mohanty has suggested, our histories are entwined in one another, then no group is without connection or relation to any other, even if these are hierarchical, conflicted, and contradictory relationships. Groups are not isolated, separate entities, nor are individuals. I don't believe that my subjectivity sets complete limits on my ability to think about things and people other than myself, in part because who and what I am has something to do with how I am differentiated from them.

That kind of thinking about others is hard; I sometimes must be pressured to do it; and the terms of encounter with others who challenge the way I am used to thinking are not always pleasant and calm. Civility and politeness probably cannot be expected to characterize these exchanges. But the encounters are at least possible when the issues are framed as issues of cognition and not of personality, when analysis and interpretation are the medium of exchange, when ideas are what is traded (however heightened the rhetorical expressions of them), and, above all, when the encounters are understood to be taking place not between discrete individuals or atomized groups, but between people who share a history, however contradictory it is.

Is it possible for universities to be centers of intellectual conflict when there are differences that cannot be resolved? I think so, but only if diversity is not conceived in individualistic terms and if our notions of community are redefined.

Community

If universities are to adapt to the new conditions of diversity, the notion of community according to which they operate must change. Some of the extraordinary tensions evident on campuses these days stem from attempts to impose universalist ideas of community that presume homogeneity and that stress consensus and shared values on a situation in which differences seem fundamental and irreducible. The consensual idea assumes that some commonality of interest allows "us" to articulate our common concerns and regulate our disagreements; those who do not accept the consensus are necessarily outside the community.

This is the idea that, in the name of a common culture, is invoked by

those who defend the superiority of Shakespeare to, say, Toni Morrison (as if anyone were insisting that contemporary literature entirely replace "the classics"); it is the idea that underlies some disciplinary codes as well as some of the most extreme demands for "political correctness." This vision of consensus ultimately requires, indeed imposes homogeneity—not of persons, but of point of view. It rests on a set of exclusions of "others."

Something else is needed in these days of diversity and difference, and not only for the university. But the university is the best place from which to search for a different understanding of what a community might be. First of all, universities can be seen to already exemplify an alternative. They are, after all, places where separate and contingent, contradictory and heterogeneous spheres of thought have long coexisted; the grounds for that coexistence are acceptance of difference and an aversion to orthodoxy. This doesn't mean there aren't continuing battles for resources, influence, and predominance; indeed, these kinds of politics are the way differences are negotiated. It does mean that there is ultimately no resolution, no final triumph for any particular brand of thought or knowledge.

Second, within the universities, the humanities in particular offer the possibility of thinking about difference and community in new ways. There is one approach within the humanities, to be sure, that would reify a particular canon as the defining mark of our common humanity. But there is another, more complicated approach, equally available in the very fact that humanities is "humanity in the plural." Jonathan Culler puts it this way:

> A particular virtue of literature, of history, of anthropology is instruction in otherness: vivid, compelling evidence of differences in cultures, mores, assumptions, values. At their best, these subjects make otherness palpable and make it comprehensible without reducing it to an inferior version of the same, as a universalizing humanism threatens to do. (Brooks *et al.* 187)

Add to this the fact that interpretation is the name of the game in the humanities, that meanings are always contested, reworked, revoked, and redefined, and there is at least a basis for thinking about communities in which consensus cannot prevail. Thought of in these terms, the humanities

become a starting point for discussion of the reconceptualization of community in the age of diversity.

I do not have a blueprint for that idea of community, but I think there are points it must address. Here is a partial list:

(1) "Community is not a referential sign; but an appeal to a collective praxis" (Van Den Abbeele xiii). Community is not an essence, but a strategically organized set of relationships.

(2) Differences are often irreducible and must be accepted as such. The introduction to a new book on community puts it this way: "What we have in common is the commonality of our difference" (Van Den Abbeele xxv).

(3) Differences are relational, and involve hierarchy and differentials of power that will be constantly contested.

(4) Conflict and contest are therefore inherent in communities of difference. The play of difference is unavoidable and it is not a game; it is both the basis for and the necessarily destabilizing aspect of community.

Christopher Fynsk, following Jean-Luc Nancy, suggests that the French word *partage* inform our notion of community. *Partage* means both to divide and to share; this double and contradictory meaning insists on what Fynsk calls "openings to the other" as a condition of existence. In contrast, conformity that rules out the other, substituting one set of beliefs for another, brings us the regime of yellow ribbons and American flags as the test of patriotism. It leads students to condemn dissent, as one student did at Princeton last fall, as treasonous and un-American.

Partage is a more difficult concept than consensus, but a better one, I submit. It accepts difference as a condition of our lives and suggests ways we might well live with it. It lets us accommodate one another as we strive on a large scale for what is already possible in the classroom, at least in classrooms such as the one described by Elsa Barkley Brown. For her teaching African-American women's history is not, she says,

merely an intellectual process. It is not merely a question of whether or not we have learned to analyze in particular kinds of ways, or whether people

are able to intellectualize about a variety of experiences. It is also about coming to believe in the possibility of a variety of experiences, a variety of ways of understanding the world, a variety of frameworks of operation, without imposing consciously or unconsciously a notion of the norm. (921)

Can we achieve this kind of opening to difference in our teaching? Can universities become the place where communities of difference—irreducible and unreconcilable difference—are conceptualized and exemplified? This is the challenge we all face in the next years. It is a challenge that must be carried on, even in the face of outrageous, threatening, and punitive attacks. It is a challenge that requires the kind of critical intellectual work universities are supposed to encourage. Such critical work is, after all, the university's *raison d'être* and its highest form of achievement.

Note

1. This article was first given as the keynote address at the Mellon Fellows' Conference on Scholarship and Society, Bryn Mawr College, June 15, 1991. It was published in *Change* in a slightly different version in November/ December 1991. I am thankful to the many students there who demonstrated their commitment to critical inquiry by asking hard questions and refusing to let me off any number of philosophical and political hooks. Their comments make this revision a far better version than the original talk. I am also grateful for their suggestions to Alison Bernstein, Sylvia Schafer and Catharine Stimpson. My biggest debt is to Tony Scott for the many long discussions we had as I prepared this essay. When I got stuck he was always willing to help; his insights have immeasurably enriched my own.

4

Truth, Justice, and
the American Way

A Response to
Joan Wallach Scott

Michael Bérubé

There's so much to like in Joan Scott's account of what's at stake in the conservative campaign against higher education that when I was asked to reply to it, I feared I had only two options: the first was to write simply, "Scott's is the most serious and useful response I've yet seen to the current crises of the universities. Listen to her." The second was to concoct some *faux*-oppositional rejoinder just for the hell of it, wherein I would accuse Scott of unwitting complicity with the hegemonic (stereo)scopic (un)imaginary of the late, late capitalism show. This would be counterproductive in political and intellectual terms, I thought, but of a piece with my own academic training, which has taught me to deal with arguments by finding the flaws, the exclusions, the contradictions. I'm just now learning better. What this means is that my response is going to be fairly undramatic. Even where I've found points of nuanced disagreement with Joan Scott's essay, my disagreements are going to turn out to be amplifications.

First and foremost, let's get to what's at stake. Scott writes: "We are experiencing another phase of the ongoing Reagan-Bush revolution which, having packed the courts and privatized the economy, now seeks to neutralize the space of ideological and cultural nonconformity by discrediting it." The culture wars over PC are not just academic squabbles over speech codes, water buffalo, or the direction of the National Endowment for the Humanities. The real issue is the right's attempt to undermine everything "public," from legal aid to elementary education to public television, in order to solidify private (a.k.a. plutocratic) control over not only the economy, but over the relatively autonomous spaces of civil society as well. It is precisely because

universities have greater autonomy from the state than does the federal judiciary that they have come under such savage attack from privately financed conservative foundations and their mouthpieces. These foundations cannot by themselves remake the function of universities as quickly as Reagan and Bush packed the courts, gutted social services, and unwrote legislation designed to protect the environment and guarantee occupational safety; that's why, for now, conservatives' chief strategy is that of delegitimation. But as Ellen Messer-Davidow has pointed out, their long-term strategy is to redirect the university by buying their way into it, especially in those academic fields that have most to do with public policy, by endowing fellowships, chairs, and entire programs sponsored and directed by the Olin, Bradley, and Scaife Foundations, among others (see Messer-Davidow).

I grant that the corporate capture of American universities, like the corporate capture of many of the nominal spaces of civil society since 1945, is already so far advanced that we in the humanities seem to purchase our autonomy at the price of our irrelevance. That is, we're more autonomous from, say, the militarization of scientific research only because we're less important to the apparatus of the national security state. Comparing ourselves to our colleagues in academic fields that subsidize research and development for the state and for private industry, we literary critics and historians are often tempted to discount our cultural/political importance—or to exaggerate it wildly, which seems to me a rebound symptom of the same general phenomenon. At the same time, it's because we have some autonomy from the Reagan-Bush revolution that there now exists a politics of the university that is more than "academic" (where "academic" is a well-known synonym for "useless"), a politics of the university in which academic intellectuals can debate the social and material consequences of their work. For example, academic feminism, in its many manifestations and to its considerable credit, has shown us that strong reformism can change both the substantive content of cultural institutions *and* the future means of public access to those institutions; and it's no accident that universities are among the few managerial institutions where feminist activism and feminist cultural criticism have operated side by side even through the bleakest years of the 1980s.

Still, Scott's essay reminds us that if the academic production of knowledge is going to have beneficial social effects in the culture at large, we need pragmatically to assess our relation, as progressive intellectuals in the humanities, both to the university as a whole and to the larger intellectual and popular formations outside academe. What's most important here is that we recognize and contest the ways the right has sought to split the left along academic and nonacademic lines, in order to make the academic left appear a liability to, rather than the intellectual ally of, progressive forces outside the university. If we're concerned, as liberals or progressives, with the "public"—which means (among other things) working to revalidate and rejuvenate public education, public health care, public housing, and the idea of public ownership—then we cannot afford to let the defense of our enterprises degenerate merely into a defense of our own professional autonomy as academics.

More immediately, we are increasingly pressed to defend that which should be the *sine qua non* of the intellectual life: as Scott puts it, "thinking hard about everything, from obscure texts to our present condition, and teaching others how to think that way." Sad to say, there are many American intellectuals who dissent from the proposition that we should teach others to think this way; in the recent writings of Arthur Schlesinger no less than in the work of Lynne Cheney, one finds that the function of education is to socialize the young into our "common culture" and reinforce their "common sense," but emphatically *not* to teach them to question concepts like "common sense" or "common culture."[1] It's not hard to explain these fears of a critically aware student body and populace. We're facing an emergent social formation that is in one respect not unlike that of the early nineteenth century in Great Britain, when you could still hear the gentry inveigh against the dangers of teaching the poor to read: in the early twenty-first century, too much *cultural* literacy may destabilize the economy by raising people's expectations too high. The last thing the privateers want, if they're going to compete economically in a post-NAFTA world where American wages drop to meet "global" standards of compensation, is a workforce populated by folks who can deconstruct NAFTA and read power relations into everything they see. As Paul Lauter puts it:

NAFTA envisages a decline in living standards for many—if not most—American workers, which is surely the only way Americans will be able to staunch the outflow of jobs to lower-paying and lower-cost Mexican plants. The problem with education, from this perspective, especially college and university education, and most particularly "liberal arts" education, is that it raises expectations far too high. . . . An "overeducated" work force is, to this kind of thinking, as "destabilizing" to the United States as it once was to the state of Kerala in India. (81)

I'm not saying that all nonprogressive educators and their kin consciously try to keep people docile and confused the better to control them (I stop short of fully elaborated marxist theses here), but I am saying that the resistance to theory involves more than the resistance to reading; it is not only a resistance to the production of new knowledge in the humanities, but often a resistance to any project that will enable students to sift through (and possibly create) new knowledge on their own.

This is why the right is so confused about pedagogy, and so uncertain as to whether to pillory or defend college students: when it comes to dealing with students who don't want Linda Chavez or Jeane Kirkpatrick as their commencement speaker, the right has no problem holding forth on how today's students should be challenged from "different" perspectives. But when students show up for class unable to contribute anything to discussion other than what Rush Limbaugh has told them to say, suddenly the right discovers a reason to respect students' integrity. Witness for instance the incredible passage in Lynne Cheney's *Telling the Truth* in which she salutes the students who resist the teachers who challenge them—those "undergraduates of independent mind," "particularly outside the Ivy League," who gallantly refuse "to move beyond what common sense and their own experience tell them" (16).[2] I cannot recall a "defense" of higher education more opposed to education. And though we are now past the dark days when the Secretary of Defense was married to the Secretary of the Defense of Ignorance, that doesn't mean we can relax now. Mr. Limbaugh is at the moment the most influential public intellectual in the country, surpassing even the ubiquitous Camille

Paglia, and any academic who hopes to teach students to think critically will necessarily have to swim upstream against a culture that produces approximately fifty thousand dittoheads for every sympathetic reader of Joan Scott.

There are other reasons to be a sympathetic reader of Joan Scott rather than a dittohead, aside from the fact that she sees the stakes clearly. Her critique of identity politics is one of the most nuanced and intelligent around; although I have considerable sympathy with similar left analyses of "identity," including Richard Ohmann's and Todd Gitlin's, I find Scott's especially valuable for its attention to the social context that fosters identity politics. As Scott puts it:

> a pluralism or multiculturalism that fails to recognize that difference is a relationship of power achieved through a process of signification encourages separatism. Indeed it provides the conceptual basis for an essentialism that denies the historicity of processes of differentiation.

Moreover, as if this point weren't already worlds beyond the polemics of people who would simply oppose "difference" to "commonality," Scott extends her inquiry to the hidden logic of individualism lying within the politics of identity, whereby an untheorized, unproduced, always-already-accessible thing called "experience" becomes the ground for knowledge, and "individuals then generalize their perceptions and claim to speak for a whole group." This phenomenon is most newsworthy (that is, most visible to powerful white men) when it happens among minority groups and women, of course, but it's by no means confined to them; on the contrary, spokesmen for aggrieved white men obey precisely the same logic of individualist representation—though they're not normally accused of playing identity politics when they do. Suffice it to say, however, that Scott's brief but sophisticated account of the common pitfalls of individualism and group politics makes David Bromwich's *Politics By Other Means,* by contrast, look like an undergraduate exercise in defending "the individual" against "society."

Last but not least, against the right's relentless demonization of Women's Studies and African-American Studies, Scott calls us to remember that these programs don't exist exclusively because of gender and race exclusions from

the distant past of academe; on the contrary, to this day, disciplines dominated by "traditionalists" continue to have all kinds of difficulties seeing the lives of women and minorities as central to their enterprise. "History departments," writes Scott,

> regularly refuse to consider for positions in general American history, for example, scholars who write on women or African-Americans (or homosexuals or other particular groups), arguing that they are not generalists, unlike those who are no less specialists but have written about national elections or politicians' lives—subjects that are taken to stand for what the whole discipline is about.

Some time ago I got wind of a history department whose search committee apparently could not consider hiring a woman whose work was on the history of abortion, without requesting all kinds of supplementary materials that would (perhaps) convince the search committee that her work was indeed "history," and that it was "important." Among the conductors of the search was a senior male scholar whose work was in the history of sixteenth-century dredging—not even the history of sixteenth-century *filling things up,* mind you, but the history of dredging. Though this may be an outlandish example, it testifies nonetheless to the fact that many departments of history, particularly at less prestigious schools, continue—even at the end of the twentieth century A.D.—to operate on the belief that "feminism" and "scholarship" are mutually exclusive. What's more, some commentators have gone so far as to suggest that departments of history may not be unique in this regard.

Having put all that on the table, I'll move at last to the three points where I disagree with Joan Scott's work. As I hoped to signal in my title, one point has to do with truth, another with justice, and another with the American way. I suppose it would be best to take these in their traditional order.

Truth: Scott's position on truth leaves matters murky—not because it is unclear, but because it is not sufficiently distinguished from her opponents' defenses of what they also call "truth." "Truth can be defined," she writes, "as an ever-receding horizon—not a fixed quality that can ever be finally known—that is approached through a communal enterprise of hard work,

conflict and argument." This is hardly disputable on its face. But it is on questions about "truth" and "relativism" and "objectivity" that intellectual and political conservatives have won so much support among nonacademics, painting poststructuralism as sheer nihilism and postmodernism as anathema to truth-seeking. Indeed, in 1993 John Silber defended "truth" in almost precisely Scott's terms, claiming that under his leadership, Boston University has "resisted relativism as an official dogma, believing that there is such a thing as truth, and if you can't achieve it, at least you can approach it" (Silber, "President's Report" 30). For an educational fascist like Silber, of course, there is no contradiction between espousing such a love for truth and going on to trumpet Boston University's "resistance" to practically every form of intellectual inquiry that postdates the fall of Hitler—not merely critical legal studies, "radical feminism," structuralism, and deconstruction, but even the critical theory of the Frankfurt School (which, since it had its origins in critiques of totalitarianism, would for obvious reasons be unpalatable to the Silber regime).[3] One notes, too, that Lynne Cheney feels no compunction about stringing together a pack of lies and misrepresentations under the title, *Telling the Truth.* Just as Midge Decter and Elliot Abrams once credited themselves with furthering the spread of "democracy" in Central America, so too do their conservative counterparts in academe lay claim to "the truth"; and in a world where "democracy" can be used to mean "death squads," so can "truth" be defined as "that which prevails when questioning and dissent are prohibited."

The point needs to be made, much more forcefully than it has been made to date, that "contingent" and "paradigm-specific" truths are indeed all that human truths (including this one) can hope to be. Defenses of "immutable" and "objective" truths may be fine when they come from the mind of God, but even so devout and downright ontotheological a believer as Saint Thomas Aquinas has held that humans don't have direct access to "truth" in that sense. In Article Seven of Question 16 of the *Summa Theologica,* Aquinas writes that "created truth"—that is, truth devised by humans—cannot be eternal, for "the truth of enunciations is nothing other than the truth of the intellect," and "if no intellect were eternal, no truth would be eternal." Thus "because only the divine intellect is eternal, in it alone truth has eternity"

(Aquinas 179). As a dues-paying postmodern antifoundationalist, I would normally find it easier to make this kind of point by showing that Thomas Kuhn does not discard the concept of truth in the course of developing his antitelelogical history of science, and then by showing that Kuhnian historicism and sociology allow us to see how careless thinkers characteristically equate "objectivity" with mere conformity to their currently accepted professional standards.[4] But Aquinas makes the case more dramatically, I think. The case is this: human truths always contain the possibility of error, of being revised or supplanted by *other* human truths, whereupon humans will enter into debates about what constitutes truth and untruth. These debates will involve competing standards for conceiving truth and untruth, but each participant in the debate *will* indeed have such standards. So when you come across a postmodernist talking blithely about "positionality" instead of "truth," remember that no positionality is worthy of the name if it does not have communicable standards for what is and is not true; and when you come across someone talking of "timeless" or "universal" truths, ask whether in fact he or she has better access to the divine intellect than Aquinas presumed possible.

Justice: As she turns to address the vast cultural and demographic changes in American university populations since World War II, Scott writes that "the expansion of the university has not so much altered admission standards as added more considerations to them and made them more visible." True enough, but the "expansion" of American higher education in the 1960s has actually done much more than this; and, in fact, it has altered admission standards to most elite American schools—by raising them. Perhaps nothing is so fraudulent about the conservative attack as this: in railing at "racial preferences" in college admissions and hiring, the neocons habitually forget that everyone who graduated from an all-male, all-white school (as most major American universities were until the 1960s) was competing for admissions and honors—and jobs, and privileges—with an artificially weak applicant pool that included less than forty percent of the potential college population. Having benefited hugely from our nation's legacy of sexism and *apartheid* in higher education, these people (and their under-forty acolytes at the Heritage

51

Foundation) now show up to complain about the dilution of academic standards. That's bad enough as is. But what's worse is that the tradition of academic sexism and *apartheid*, like the academic-traditionalist intransigence that necessitates Women's Studies programs, lives on today in the largest "affirmative action" program in the country—namely, the system of legacies, thanks to which the children of these all-male, all-white alumni are now given preferential treatment in college admissions.

The American way: In Section I, "Paranoids, Fetishists, and Imposters," Scott evinces an optimism I envy and try to maintain whenever possible. But since it's been getting less and less possible, I'm going to demur this once. She writes:

> Serious intellectuals have only to read the self-assured, hopelessly ill-informed, and simply wrong descriptions of deconstruction, psychoanalysis, feminism, or any other serious theory by the likes of D'Souza, Richard Bernstein, David Lehman, Roger Kimball, Hilton Kramer, George Will—and even Camille Paglia—to understand the scam. They will recognize people for whom teaching has no real value, for whom literature is a pawn in a political argument but not a passionate commitment to the play of language and the pleasure of reading.

I hate to say it, but this isn't so: any number of serious intellectuals haven't understood the scam at all. Serious intellectuals—even those who are only serious intellectuals by virtue of their own self-description—have simply proven much less savvy than Scott suggests they should be. In fact, some of them have read (or claim to have read) the work of both the academic progressives and their attackers, and have concluded that the attackers have the better case.

Sometimes, this evinces nothing more than the sorry fact that even among those segments of American cultural life that are *not* defined by the anti-intellectualism Richard Hofstadter and Joan Scott describe, the criteria for qualifying as a "serious intellectual" in the United States are an embarrassment to the West's own best traditions. The *Partisan Review,* for instance, a once-respected journal that apparently still considers itself an important intellectual

forum, recently published this assessment of the culture wars: "Part of the problem with the debate over multiculturalism," wrote editor William Phillips, "is that it is not being conducted in good faith by the politically correct academics. . . . It must be emphasized that the politically correct teachers actually are denouncing the traditions and values of the West and of America as being the work of 'dead, white males,' and that they would substitute African and Asian traditions and values" (12). The objects of Phillips's criticism here were Gerald Graff and Stanley Aronowitz, in their roles as cofounders (with Gregory Jay and Paul Lauter, respectively) of Teachers for a Democratic Culture and the Union of Democratic Intellectuals, organizations well known for their commitment to disseminating Confucianism and Yoruba percussion instruments. No doubt we will soon read in *Partisan Review* of the nefarious plans of Stanley Fish and Catharine Stimpson to convert the curriculum to Australian and Antarctican traditions and values.

Lest Phillips seem too easy a target, let us turn to William Kerrigan, a distinguished Renaissance scholar and reader of difficult books who has been spurned by a profession of poseurs and impostors:

> While I was reading difficult books, the new cream-bowl theorists, content with handbook-deep knowledge, went into serious professionalism, jerry-building "programs" and "concentrations" onto the traditional structure of academic majors, setting up "institutes" to secure their unearned self-importance, arranging conferences and starting journals. (161)

Kerrigan describes an intellectual profession blind to the contradictions only he can discern: "Although the philosophical concept of essence was ritually attacked, academic prose began to sprout poisonous blossoms like 'narrativity' and 'intertextuality' " (160). Most of all, he decries the decline of scholarly standards: "People got tenure for writing about the imperialist fantasies of Marvel Comics or the gender rules in Harlequin Romances—ideas that might have made decent articles for *High Times* but, driven by theory, got seriously out of hand" (160).

I will leave it to others to decide whether Janice Radway's *Reading the Romance* is a *High Times* article on theory-steroids, or a significant contribution

to various intellectual traditions such as feminism, cultural studies, ethnography, reception theory, and the aesthetic theories of late Prague Structuralists like Jan Mukarovsky and Felix Vodicka (about whom Radway has also written—see Radway, "The Aesthetic"). For toward the end of his essay, Kerrigan himself demonstrates why it's so dangerous to pose as a serious intellectual in regard to subjects you know little about—like multiculturalism, for example. "Black and Hispanic students," he writes, "must be taught the language of the British and American intelligentsia, since integration will never succeed on any other terms" (166–67). Kerrigan goes on to note the risks he takes in saying so: "Such sentiments are not politically correct. In some universities I would be shouted down for giving voice to them" (167). Perhaps, but it may be that the people shouting him down would be friends, trying to keep him from embarrassing himself.

I first read Kerrigan's take on "integration" in early 1993, about a year ago, and I still haven't figured out what it means. I picture an all-white neighborhood whose residents say, "we won't let those black people onto our block until they stop saying *allotropy* when they mean *allegory*." I try to imagine a United States in which large numbers of *white* people actually speak the language of the British and American intelligentsia. Then I wonder *which* language of the British and American intelligentsia one would want black and Hispanic students to learn—for, after all, the thing that potentially torpedoes Kerrigan's plan for integration is the fact that some of the British and American intelligentsia are themselves black and Hispanic. I presume Kerrigan does not envision an America in which racial minorities grow up talking like Stuart Hall, Gloria Anzaldúa, Cornel West, or Hazel Carby—though it's an attractive prospect, and lots of leftist academics are doing what they can to bring it about.

Lest Kerrigan seem no more serious than Phillips, there is, finally, the exemplary case of John Searle, surely a serious intellectual by any standard, and one of the key figures to whom the right turns when it wants to give itself an aura of "diversity" and "legitimacy." Although Searle's criticisms of the postmodern humanities sometimes have a cogency and a *gravitas* that Kerrigan and Phillips notably lack, they are nonetheless vitiated by his ten-

dency to treat his opponents' arguments only in caricature—as when he defends the Western canon by noting, "it doesn't in any way discredit the works of, for example, Descartes or Shakespeare that they happen to have been white males, any more than it discredits the work of Newton and Darwin that they were both English" ("Is There a Crisis" 705). Since Searle continually remarks on the low intellectual level of his opponents, it seems only fair to point out that Searle purchases these remarks largely by depicting his critics as utter simpletons. Paraphrasing postmodernist thinkers' understanding of Kuhn, Searle writes, "the idea, roughly speaking, is that Kuhn is supposed to have shown that science does not give us an account of an independently existing reality. Rather, scientists are an irrational bunch who run from one paradigm to another, for reasons with no real connection to finding objective truths" (703). That's roughly speaking, all right, even from the positionality of an Aquinas. I have yet to see any substantial reading of *The Structure of Scientific Revolutions* for which Searle's can be said to be an accurate restatement.

What's most important about Searle, however, is how he casts his role as defender of what he calls the Western Rationalistic Tradition. At his worst, in order to defend metaphysical realism from the likes of Richard Rorty and Jacques Derrida, he relies simply on the argument from authority (which, last time I looked, was actually considered a logical fallacy in the Western Rationalistic Tradition). In a recent issue of *Daedalus*, he remarks that "attacks on the Western Rationalistic Tradition are peculiar in several respects," the first of which is that although the attacks are philosophical in nature, they have "little influence in American Philosophy departments." Specifically, "the philosophers who make an explicit point of rejecting the Western Rationalistic Tradition, such as Richard Rorty or Jacques Derrida, are much more influential in departments of literature than they are in philosophy departments" ("Rationality" 77). That the hostile American reception of Rorty and Derrida (and Dewey, and Heidegger, and Gadamer) might say more about the parochialism and stagnancy of philosophy departments than about Rorty and Derrida never occurs to Searle, who construes his own field of "analytic philosophy" as a noble enterprise run "by a solid and self-confident professorial establishment

committed to traditional intellectual values" (71). The second strange feature of the attacks, according to Searle, "is that it is very hard to find any clear, rigorous, and explicit arguments against the core elements of the Western Rationalistic Tradition." But this is a mystery easily solved, it appears. "Actually," Searle adds immediately, "this is not so puzzling when one reflects that what is under attack is the whole idea of 'clear, rigorous, and explicit arguments.' Rorty has attacked the correspondence theory of truth, and Derrida has claimed that meanings are undecidable, but neither in their works, nor in the works of other favorites of the postmodernist subculture, will you find much by way of rigorous arguments that you can really sharpen your wits on" (77). And as a result, one surmises, the wits of the folks on Searle's side of the aisle have become duller with each passing year.

Searle is not always as supercilious as this, but he does descend to such rhetorical gestures whenever he wants to contrast his own careful, rigorous reasoning to the arguments of those against whom he defends the Western Rationalistic Tradition. I'll cite just one more representative passage under this heading, since it returns us to the debate over "truth" I sketched out above:

> Those who want to use the universities, especially the humanities, for leftist political transformation correctly perceive the Western Rationalistic Tradition as an obstacle in their path. In spite of their variety, most of the challengers to the traditional conception of education correctly perceive that if they are forced to conduct academic life according to a set of rules determined by constraints of truth, objectivity, clarity, logic, and the brute existence of the real world, their task is made more difficult, perhaps impossible. (70)

No doubt. But then again, were academic life conducted by a set of rules determined by how closely philosophers were required to engage the arguments of their most rigorous intellectual adversaries, the publication of smug, sloppy stuff such as the passage cited above would also be made more difficult, perhaps impossible.

So, then, if you take Searle's depiction of us academic insurgents, and stack it up against Joan Scott's specimen essay of academic insurgency, I

think you'll find some virtue in my three closing propositions. One: even the most "serious" of the defenders of academic traditionalism, such as Searle, are failing to conduct their end of the debate by reasonable standards of argumentation and intellectual probity even when—or particularly when—they themselves invoke those standards. Two: what I just called "reasonable standards of argumentation and intellectual probity" are themselves extremely precarious—challenged most effectively, of late, by the willful flouting of those standards by self-designated intellectual "traditionalists" whose idea of scholarship is a string of citations to sources, all of which misrepresent contemporary academe in precisely the same way, or whose practice of criticism depends on egregious distortions of the positions (and sometimes the very written words) of their opponents. Third and last: the crisis of "political correctness" in the humanities is not simply or even primarily a crisis of how the university is represented to "the public," but a crisis within the American intelligentsia itself, over the role that academic intellectuals should play in fostering or refusing to foster critical thinking among our new student populations and our sundry nonacademic audiences. Whatever else may be said in response to "The Campaign Against Political Correctness," it still remains for Joan Wallach Scott's opponents to match the intellectual standard she has set for the discussion of these issues.

Notes

1. For Cheney, see *Telling the Truth*, discussed below in this essay; for Schlesinger, see his dissenting opinion to *One Nation, Many Peoples: A Declaration of Cultural Interdependence*, also known as the "Rainbow Curriculum." On the issue of student empowerment, Schlesinger is, as usual, more nuanced (and more honest) than Cheney. Asking whether public education should "seek to make our young boys and girls contributors to a common American culture" or "strengthen and perpetuate separate racial and ethnic subcultures," Schlesinger proposes that students be "encouraged to understand the American culture in which they are growing up and to prepare for an active role in shaping that culture" (46). In the penultimate paragraph of his dissent, however, he undercuts that "active role": "I am also doubtful about the note occasionally sounded in the report that 'students must be taught social criticism' and 'see themselves as active makers and changers of culture and society' and 'promote economic fairness and social justice' and 'bring about change

in their communities, the nation, and the world.' I very much hope that, as citizens, students will do all these things, but I do not think it is the function of the schools to teach students to become reformers any more than I ever thought it the function of the schools to teach the beauty of private enterprise and the sanctity of the status quo" (47). Well said. But if we put these arguments together, we wind up with an odd conclusion: Schlesinger recommends that students be active shapers of their culture only so long as they contribute to a *common* culture and are not encouraged to become "reformers" (Schlesinger's word) who "see themselves as active makers and changers of culture and society" (one of the phrases to which Schlesinger objects). This sounds very much like a prescription for the maintenance of the cultural status quo, Schlesinger's demurrals notwithstanding. I see no way to teach students critical thinking without also—indeed, simultaneously—giving them the tools of social criticism by which they might become active makers and changers of culture and society.

2. There's more to Cheney's argument than this. After all, notes Cheney, there are some bad liberal students, too: "it is doubtless more than coincidence that some of the most notorious attempts to suppress thought and expression involve students trying to enforce the orthodoxies that have become the staples of politicized classrooms" (16). With her customary fidelity to high standards of scholarship, Cheney footnotes this sentence by referring to the so-called "Thernstrom case" at Harvard, as reported by Stephan Thernstrom in *Academic Questions* (the NAS organ), John Taylor in *New York* magazine, and Dinesh D'Souza in *Illiberal Education*. Leaving aside Cheney's reliance on the usual daisy chain of right-wing disinformation, surely it is remarkable that anyone would believe or state that African-American students could not contest Thernstrom's claim that the disintegration of the black family is the cause of black poverty unless they had come out of "politicized classrooms."

3. For the full listing of theories and subjects proscribed by Silber, see Dembner ("Silber's Words" 27, 30 and "Silber Says" 1, 10). In his November 19 response to faculty who demanded a clarification of his April 15 remarks, Silber said, "Marxism, structuralism, feminism, etc., do not, in and of themselves, threaten academic freedom, but each of these views is highly susceptible to being formulated as dogma, impervious to any arguments or evidence not already in conformance with the basic tenets of the dogma." Dembner notes that "Marxism was not included in Silber's earlier remarks as an area that had been 'resisted.' Those mentioned in the April 15 report to trustees were critical legal studies, revisionist history, Afrocentrism, radical feminism, multiculturalism, the Frankfurt School of Critical Theory, structuralism and deconstruction, dance therapy, gay and lesbian liberation and animal liberation." What Silber had said about dance therapy—"we have refused to take on dance therapy because we don't understand the theory of it" ("President's Report" 30)—he could doubtless have said about any of the above.

4. For an illuminating exchange on how "objectivity" gets confused with Weberian "conformity to professional standards," see the exchange between Gerald Graff and Jeffrey Herf in Bérubé and Nelson, in the section entitled "Money, Merit, and Democracy at the University: An Exchange."

5

The Great PC Scare

Tyrannies of the Left,

Rhetoric of the Right

Jim Neilson

Media Representations of PC

"Watch what you say," warned the cover of the December 24, 1990 *Newsweek,* announcing the arrival of the THOUGHT POLICE. Having spent the previous six years as a university instructor, and having just that fall returned to graduate school, I found *Newsweek's* declaration surprising. Somehow I had been oblivious to the onset of totalitarianism in American universities. Try as I might, though, I could not thereafter ignore the threat posed by PC. For, as documented by the mass media in the winter of 1990 and the spring and summer of 1991, PC threatened American democracy and challenged the very basis of Western civilization. My intent here is not to mock the silliness of the great PC scare (notwithstanding the appropriateness of such mockery), but to examine why the PC debate took the shape it did, why it was received so readily by the mass media, and what its effects have been and continue to be upon public discourse.

Perhaps the most striking feature of media representations of PC was its consistent identification with fascism. For *Newsweek,* PC was "a totalitarian philosophy" that "one defie[d] . . . at one's peril" (Adler 51, 50). Defining PC, John Taylor, in *New York,* cited Hannah Arendt's *The Origins of Totalitarianism* and approvingly quoted Camille Paglia: " 'It's fascism of the left. . . . These people behave like the Hitler Youth' " (35). In the *New Republic,* Eugene D. Genovese spoke of academic "terrorists" and "storm troopers" who committed "atrocities." An editorial in the *Chicago Tribune* even accused the professoriate of "crime against humanity" (qtd. in Bérubé, "Public Image" 31).[1] Not surprisingly, this hyperbole was most prominent in the work of conservative colum-

nists. George Will, for example, fantasized about an "academic constabulary" patrolling "campuses, pouncing on speech, films, teaching material, even parties that deviate from approved ideology" ("Curdled"). While it might be argued that the rantings of editorialists such as Will are wholly different from the reporting of reputable journalists, I would suggest that (1) journalistic accounts often were similarly exaggerated, as in the *Newsweek* cover story; (2) there was little opposition to this exaggeration, even liberal editorialists accepting the existence of and threat posed by PC, thereby giving a journalistic imprimatur to the fantasies of Will, *et al.*; and (3) never in the mass media was there a framework that offered an alternative view of the politicizing of the academy; invariably, discussion of the university was filtered through the frame of political correctness. Such was the normalization of PC and the equation of it with fascism that George Bush could warn of "political extremists [who] roam the land" and receive no criticism; he was merely echoing what had already become the consensus view, *Newsweek* having six months earlier alerted the nation to "the march of PC across American campuses" (Adler 49).

I do not mean to suggest that the mass media universally defined PC as a few goosesteps shy of Nazism. Even the most hyperbolic journalistic representations of PC were qualified and at least somewhat contextualized. Although William A. Henry III, in *Time*, spoke of "a new intolerance" and described the university as an "upside down world," he admitted that "this new thinking is not found everywhere" and that "most students at most colleges continue to take courses bearing at least some resemblance to what their predecessors studied" (66). Likewise, *Newsweek* asserted that "if women, gays and racial minorities are seeking special protections, it is because they have been the objects of special attacks" (Adler 49) and that the opponents of PC are "often the most senior and influential people on their faculties" (Adler 50). Such details, however, did little to mitigate the main thrust of these articles or to counter the equation of PC with totalitarianism.[2]

Predictably, anti-PC rhetoric also was rife with red-baiting, as demonstrated by Taylor's article in *New York*, which asked, "Do I Say 'Indian' Instead of 'Native American'? 'Pet' Instead of 'Animal Companion'?" over a photograph

of Red Guards parading their dunces and Hitler Youth burning books (33). Taylor quoted history professor Alan Kors: "In certain respects, the University of Pennsylvania has become like the University of Peking" (35). Similarly, Charles Krauthammer saw university-sponsored sessions in racial sensitivity as a "middle-class take on Chinese reeducation camp[s]" ("Annals"). And *Newsweek* concluded its discussion of PC by suggesting that:

> some who recognize the tyranny of PC . . . see it only as a transitional phase, which will no longer be necessary once the virtues of tolerance are internalized. Does that sound familiar? It's the dictatorship of the proletariat, to be followed by the withering away of the state. (Adler 55)

Thus, according to *Newsweek*, even "some" academic leftists (who in familiar, red-baiting fashion remained unspecified and unnumbered) admitted the tyranny of PC. Their anonymity, presumably, was a necessary protection against midnight raids by the thought police.

Another convention of media discussions of PC was the assertion that PC represented a new McCarthyism.[3] For Harvard University history professor Stephan Thernstrom, cited by Taylor, being called a racist was "like being called a Commie in the fifties. . . . This is a new McCarthyism" (34–35).[4] Likewise, Robert D. McFadden, in the *New York Times*, spoke of "a new kind of intolerance: a McCarthyism of the left" (33). *Newsweek* asked, "Is this the New Enlightenment—or the New McCarthyism?" And in the *New Republic*, Genovese asserted that "our conservative colleagues are today facing a new McCarthyism in some ways more effective and vicious than the old" (30). (Considering the extent to which the anti-PC forces received corporate backing, perhaps this rhetoric should more closely have approximated the language of advertising and PC been identified as a new *and improved* McCarthyism.)

Since McCarthyism is defined by its anticommunism, the yoking of it with a movement often depicted as communist was a remarkable feat, one that removed McCarthyism from its historical context and emptied it of its political content. What is even more remarkable is that PC, unlike McCarthyism, had virtually no state support and had been denounced by the President, the Secretary of Education, the Chairwoman of the National Endow-

ment for the Humanities, and many members of Congress. This McCarthyism had spawned no Un-American Activities Committee, no loyalty oaths, no firing of professors, no blacklists. Even the much derided university speech codes resulted in the expulsion of just one student and the suspension of a handful of others (Dodge A35). According to a survey of college administrators sponsored by the American Council on Education, only one in ten schools had had controversies about campus speakers in 1990, and "three per cent [had had controversies] over textbooks or information presented in the class-room" ("Few Colleges" A23).[5] In effect, a debate in the humanities—which led to heckling, to the establishment of racially and sexually sensitive speech codes, and to the creation of more representative curriculums—was seen as an Orwellian nightmare. In distorting fact and positing a large-scale movement that threatened democracy, these allegations of a new McCarthyism followed many of the same tactics and embraced many of the same beliefs as the old McCarthyism. Such misrepresentations would deserve little more than contemptuous laughter if they had not distorted the suffering inflicted by McCarthyism and if they had not been reinforced so consistently by the mainstream media.

But the most preposterous misrepresentation perpetuated by the media was that the left dominates the universities. A 1984 Carnegie Foundation for the Advancement of Teachers survey found not a leftist bias in the academy, but a wide distribution of political orientations among college faculty: 5.8 percent identified themselves as left, 33.8 percent liberal, 26.6 percent middle-of-the-road, 29.6 percent moderately conservative, and 4.2 percent strongly conservative (cited in Balch and London 43).[6] Nonetheless, conservatives used these results to support their belief in the left's domination of the university. Former Education Secretary William Bennett, for example, used the Carnegie study to demonstrate a liberal bias in departments of philosophy, sociology, and history:

> A 1984 Carnegie Foundation survey of the professoriate found that, among philosophy faculty at four year institutions, 21.7 percent designated themselves as "left," *none* as "strongly conservative"; for the sociologists, the percentages

were 37 percent versus 0.9 percent; for historians, 12.9 percent versus 3 percent. (*Our Children* 143)

Likewise, Michael Novak cited the Carnegie study to demonstrate the leftist domination of the liberal arts:

> A recent Carnegie Foundation poll . . . indicates that only 31% of the faculty in liberal arts colleges describe themselves as "middle of the road" or "conservative." A whopping 69% describe themselves as "moderately liberal" or "liberal."

What is missing from these arguments and from media discussions of PC is recognition of the right's domination of other academic disciplines, arguably the richest and most powerful branches in the academy—business and the applied sciences. The mass media regularly downplayed evidence that would have complicated if not refuted the notion that university campuses were dominated by a politically correct left, endorsed accounts that were grossly distorted, identified extreme accounts as representative, and did so in a rhetoric given over to hyperbole and paranoia.

The Shaping of PC

But the central question remains: why was PC depicted as leftist tyranny, despite much evidence to the contrary, and with virtually no recognition of alternative ways by which the conflict in the academy might have been framed? Partly, the persistence of the PC frame was due to institutional biases and structural constraints within the mass media. Since they need a substantial audience to maintain advertising revenue, the mass media must factor profitability into editorial decisions. Thus, although moderated by concepts of decorum and journalistic responsibility, the mass media lean toward the sensational. After all, a cover warning of the thought police is more likely to sell than one announcing that curriculums in the humanities have been broadened to express a greater cultural diversity due to new understandings of how inseparable are traditional academic classifications and conceptions of value from structures of power. In attempting to reach a large audience, the mass media must also eschew complexity and present a simple model of a complicated debate, reducing a variety of theoretical and political positions

to two sides, the politically correct and its opposition. A more rigorous discussion of PC would require the media to drop this Manichaeanism and to recognize how contemporary philosophy and theory have problematized numerous cultural presuppositions. But the media have ignored these matters. Not until 1988 and the Paul de Man controversy, for example, did deconstruction receive significant media attention. This aversion to theory, argues Mitchell Stephens in the *Columbia Journalism Review*, lies "in the grand tradition [of] . . . American journalism . . . of mocking intellectual pretensions . . . [and having] impatience with thoughts that cannot be summed up in a newspaper-length paragraph" (42). Such indifference and hostility toward theory are not merely a product of the media's discomfort with cant. This anti-intellectualism results from the media's commercial interests, which require reduction and simplification, hence distortion.

However, an ignorance of theory, while explaining the media's reduction of complexity to the black and white of PC, does not explain why PC was viewed as leftist totalitarianism. An understanding of the persistence of this misrepresentation requires acknowledgment of the media's reliance upon government and business sources and upon "experts" funded and approved by these sources.[7] For it is this use of experts that, above all else, shaped media representations of political correctness. Because news organizations seek to reduce expense and thus maximize profit, they often rely on information provided by government and corporate sources. In recent years this reliance upon expert sources has increased. According to Lawrence C. Soley, "financial cutbacks in newsrooms following takeovers . . . [have] made the network news even more dependent on 'experts' for explaining breaking news events" (31). In addition to saving expenses, "expert" sources are used because their elite status and proximity to power make them inherently credible. Reliance upon a limited circle of "experts" has predictable results: conventional wisdom is normalized, while alternative perspectives are seen as irrelevant, if not irrational.[8] When these alternative viewpoints are also difficult and unfamiliar, as was the case with much of the theory undergirding recent attempts to modify university policies and practices, while the opposition's arguments endorse familiar and unquestioned beliefs in individual liberty

and freedom of speech and are conveyed by sources that are seen as essentially credible, it is no wonder that the media's ostensibly objective depictions of PC seemed to mirror the rhetoric of the right. To understand their reliance upon "experts," one should also recognize that mass media outlets are owned by a wealthy, corporate elite. In 1990, according to Ben Bagdikian, "despite more than 25,000 outlets in the United States, twenty-three corporations control[led] most of the business in daily newspapers, magazines, television, books, and motion pictures" (4). And the trend is toward an even narrower range of ownership. Investment banker Christopher Shaw suggests that "by the year 2000 all United States media may be in the hands of six conglomerates" (qtd. in Bagdikian 5). Media dependence upon experts funded and approved by government and corporate sources, therefore, is a predictable result of the institutional sympathies between powerful elites.

Nonetheless, it is odd—after a decade in which the right dominated American politics and implemented much of its agenda—that public debate of PC was so frequently concerned with 1960s radicals. For *Newsweek,* "campus radicals who grew up in the 60s . . . are now achieving positions of academic power" (Adler 48), while for Taylor, in *New York,* "though much of the country subsequently rejected the political vision of the sixties, it has triumphed at the universities" (36). In *Time* George Will fulminated about "tenured radicals, often 1960s retreads" ("Curdled"), and William A. Henry III suggested that the "generation shaped by the struggles of the 60s . . . vowed back then to transform campuses into engines of ongoing social change, now they are in a position to impose their will" (69).

Such sixties bashing, though common to the right generally, has been a hallmark of neoconservatives specifically. More than the *bête noir* of neocons, the New Left was their *raison d'être.* It caused neocons to repudiate their former radicalism and to endorse an ideology of moderation. Nathan Glazer documented how the New Left moved many, including himself, to the right: "the student revolt . . . served to deepen the estrangement from radicalism of others like myself who saw it as a threat to the very existence of the university and to the values of which the university, with all its faults, was

a unique and precious embodiment" (76). Neocons were shaken by the excesses of the New Left, who seemed insufficiently appreciative of the freedoms allowed in the U.S., particularly on college campuses. Wrote Glazer, "to the degree that radicalism in the latter part of the 60's wished to destroy the university or even refused to acknowledge its right to distance itself from the world . . . no matter how great the horrors of the world outside, to that degree were we further estranged from the radicalism with which we had begun" (78). Likewise, Irving Kristol declared, "if there is any one thing that neoconservatives are unanimous about, it is their dislike of the 'counterculture' " (qtd. in Steinfels 52). The prominence of sixties radicals in the PC debate comes from this neocon antipathy for the New Left.

Neocons saw a threat to Western civilization in the campus turmoil of the sixties, for the university was the embodiment of the Western tradition of tolerance, democracy, free inquiry, etc. To attack the university was to threaten these vital first principles. Therefore, for Norman Podhoretz it became "more important to insist . . . on the freedom of large areas of human experience from the power of politics, whether benevolent or malign, than to acquiesce in the surly tyranny of the activist temper" (31). And Glazer warned that "it would be all too easy to arrange matters so that [the freedom to pursue research and teaching] should come to an end, as it did for a time in Nazi Germany, Soviet Russia, and elsewhere" (77).

This sense that campus radicalism might bring forth a new totalitarianism, in retrospect, may seem preposterous; nonetheless, it was a defining characteristic of neoconservatism in the late sixties and early seventies. The reasons for this belief are many, but two in particular stand out. First, a good number of neocons at one time had been leftists. By the late sixties, however, many had long since become anticommunists. Their personal experience and disillusionment gave neocons, or so they assumed, a special insight into the nature of leftist politics, and persuaded them that campus radicalism could lead to totalitarianism. Second, neocons linked the New Left with totalitarianism, strangely enough, because of the Holocaust. As a group of intellectuals coming of age in the postwar period, many of whom were Jewish, neocons were

concerned about the potential consequences of ungoverned mass movements like the campus protests and urban riots of the sixties, hearing in these an incipient fascism.[9]

It is no wonder, then, that in *New York* Taylor cites Hannah Arendt's *The Origins of Totalitarianism,* since, as Isidore Silver has suggested, Arendt's argument is central to neoconservatism. Silver succinctly restated this argument: "The great failure of modern times was the inability of the ruling elites in France, Germany and the Slavic countries to retain their own legitimacy in the face of a wave of social and political convulsion" (qtd. in Steinfels 278). For neocons it was liberalism specifically that failed in the sixties—its policies caused the ruling elite to lose legitimacy, which created a climate of social and political unrest. Neocon repudiations of university officials for their capitulation to the demands of campus radicals, both in the sixties and today, stem from the perception that, in giving in to student demands, these officials fail in their duty to maintain the integrity of elite ideals. By sympathizing with student radicals, professors, and administrators who should have known better weakened those structures of belief and authority needed to support the democratic system, thereby furthering mob rule and bringing us closer to totalitarianism. Though written in the 1950s to denounce elite sympathy with the mob in Nazi Germany, the following passage from Arendt's *The Origins of Totalitarianism* could easily have been written by Irving Kristol to deride liberal sympathy with campus radicalism or George Will to criticize trendy academics' support of multiculturalism:

> There is no doubt that the elite was pleased whenever the underworld frightened respectable society into accepting it on an equal footing. The members of the elite did not object at all to paying a price, the destruction of civilization, for the fun of seeing how those who had been excluded unjustly in the past forced their way into it. (332)

Neocons, then, reacted strongly against the New Left because they saw it as a threat to the traditions of a liberal education, what the *New Republic* described as "the pursuit of inquiry, with no end in sight, and with no justification except its own curiosity" ("Derisory" 5). An attack on the univer-

sity was an attack against democracy itself, or, in Glazer's words, on the democratic values of which the university was a unique and precious embodiment. Considering this history, we can begin to understand the prevalence of the paranoia and nearly apocalyptic fear common to neocon anti-PC rhetoric. For example, the *New Criterion* asked, "Are you apprehensive about what the politics of 'multiculturalism' is going to mean to the future of our civilization?" (qtd. in Houston Baker 3–4); Bennett suggested that "the West is under attack" (198); Kimball spoke of a "war against Western culture" (qtd. in Brooks 5); and Bloom asserted "we tread near the abyss" (qtd. in Brooks 5). Assuming such anxiety was neither a cynical ploy to gain political advantage nor the product of racism, we can identify its genesis in neocon animosity toward sixties radicalism and the fear that such mass movements might lead to totalitarianism.

A detailing of recent sixties bashing reveals how consistently this theme has been invoked by neocons. In 1985 Midge Decter wrote that "beginning in the mid-1960's . . . the American university became a veritable hotbed of reckless, mindless anti-Americanism" (A31); in 1986 Jeffrey Hart wrote that on campus "former Sixties radicals are calling the shots"; and Stephen H. Balch and Herbert I. London argued that "given . . . the intellectual proclivities and gentrified tastes of many 60's radicals, the academy provided a safe, even pleasant, haven" (41). In 1987 Allan Bloom argued that "in the mid-sixties, the natives, in the guise of students, attacked" (324); and in 1988 William Bennett described some of the recent curriculum changes as "perfectly preserved fossil[s] of 1960s-style political action" (205). Perhaps the most ridiculous assertion along these lines (admittedly, there are many to choose from) belongs to John Silber. Like Archbishop James Usher, who pinpointed earth's creation at 9 a.m., October 23, 4004 BC, Silber was able to find that "on December 2, 1964 [with the seizure of a campus building at Berkeley], higher education in the United States had . . . reached the zenith of its public esteem and entered a downward course" (93). Finally, in *Tenured Radicals*, Roger Kimball proclaimed that "the men and women who are paid to introduce students to the great works and ideas of our civilization have by and large remained true to the emancipationist ideology of the sixties" (xiv).[10] Since

the political orientations of university faculty, based on self-characterizations, are ideologically diverse, the notion that sixties radicals run rampant on most campuses seems unlikely. Why then did the media generally accept the proposition that the academy was dominated by tenured radicals? The campus radicals myth gained potency and was adopted by the mass media for the same reason that so much of the PC debate mirrored neocon rhetoric— because of a well-funded attack on leftist influence in and domination of the university.

This strategy can be traced to a 1984 memo written for the Smith-Richardson Foundation in which Roderic R. Richardson argued that, to facilitate its educational agenda, the right needed to aim for the rhetorical high ground (a goal achieved in the subsequent PC debate, where the left were totalitarians, the right defenders of liberty).[11] Midge Decter, also a member of the Smith-Richardson Foundation, reaffirmed this "high-ground" strategy in a *New York Times* op-ed piece. A year later, Balch and London's article, "The Tenured Left," appeared in Decter's *Commentary*. This theme subsequently was adopted by Hart in *National Review*. The success of the arguments first laid out in these pieces is apparent in how closely they prefigure mass media representations of PC. Five years before it was trumpeted on the cover of the *New Republic,* Balch and London identified "the chilling effect" of leftist discourse; similarly, years before it was discovered by *Newsweek,* Hart wrote of "the academic thought police." Hart also asserted that "the American academy has become a totalitarian institution," much as *Newsweek* would define PC as "a totalitarian philosophy." And just as, in 1991, Nat Hentoff accused Brown University President Gregorian Vartan of "classic Orwellian speech" (qtd. in Henry 67) and George Bush asserted that the left demanded correct behavior "in their own Orwellian way," so Hart concluded his essay with "George Orwell, call your office. The animals are running the farm again."

I do not mean to suggest an elaborate conspiracy plotted by a cabal of neocons from within their secret chambers. The PC debate was shaped without the machinations of the Trilateral Commission and the Freemasons, and as far as I know required no second gunman. Instead, this debate was shaped by a confluence of factors: the media's institutional biases, the elite status

and class affinity of its owners, editors, and reporters, the marginalization of oppositional discourse, and the right's substantial financial resources and corresponding political influence.

Balch and London, for instance, who, in *Commentary,* published one of the first anti-PC articles, became, respectively, chair of the board and president of the National Association of Scholars, with its own journal and a yearly budget, supplied by right-wing foundations, of a quarter of a million dollars. Bloom's *The Closing of the American Mind* was partly funded by the Earhart and Olin foundations, and Bloom received 3.6 million dollars from the Olin Foundation to run the University of Chicago's John M. Olin Center for Inquiry into the Theory and Practice of Democracy (Wiener 12). Kimball, whose *Tenured Radicals* was published originally in the *New Criterion* (for which he served as managing editor), received generous support from the Olin Foundation as well as the Institute for Educational Affairs, which was founded by Irving Kristol and former Treasury Secretary William Simon, and supported by corporations like Coors, Bechtel, and General Electric. In 1989 alone, the Smith-Richardson Foundation spent nearly five million dollars and the Olin Foundation nearly fifteen million dollars supporting scholarship in universities and conservative think tanks.

The Institute for Educational Affairs—now known as the Madison Center for Educational Affairs—exemplifies the right's rhetorical and political strategy. Formed in 1979, the Madison Center has helped fund right-wing student newspapers. In fact, one key component of the PC debate—the belief that conservatives are an embattled minority on campus—can be traced to periodicals like the *Dartmouth Review,* which has consistently portrayed itself as a lonely conservative voice in a landscape of intolerant liberals, a view of the right largely adopted by the media in its discussion of PC, where well-financed right-wing attempts to shape academic discourse, such as the National Association of Scholars, have been depicted as modest attempts to thwart PC tyranny. By omitting or downplaying its ample resources, the media naturalized the right's opposition to PC, portraying it as a populist uprising against leftist totalitarianism.

For an embattled minority, the anti-PC forces have notable political and

financial clout. As of 1989, the Madison Center's "Collegiate Network" of newspapers comprised sixty-four publications receiving collectively over three hundred thousand dollars, were provided with editorial cartoons and columns, given seminars on newspaper production, and offered a toll-free advice hot line (Gordon 16). Needless to say, these newspapers received abundant corporate advertising. Also, promising writers from these newspapers have received entry-level positions and internships at a variety of media outlets. In 1990 the Madison Center supported two internships at the NAS's journal *Academic Questions* and two at the *New Republic,* as well as placing summer interns at NBC News, the National Endowment for the Humanities, the Department of Commerce, the Office of the Vice President, the conservative Catholic magazine *Crisis,* the Heritage Foundation's *Policy Review,* and the Moonie-owned *Insight* (Henson and Philpott 12). Another group, the National Journalism Center, according to Benjamin Hart, places "dozens of . . . graduates every year in important positions in the news media across the country" (qtd. in Henson and Philpott 12).

The most prominent recipient of this support has been Dinesh D'Souza. In 1990, D'Souza achieved a level of media attention more common to athletes and Hollywood celebrities than the author of an anecdotal discussion of American universities, *Illiberal Education.* The coverage given D'Souza, though, was no fluke. A founding member of the *Dartmouth Review,* D'Souza went on to edit *Prospect,* Princeton's conservative alumni magazine; wrote a biography of Jerry Falwell *(Falwell, before the Millennium);* served as managing editor for the Heritage Foundation's *Policy Review;* and became a domestic policy analyst in the Reagan administration. To help write *Illiberal Education,* D'Souza received $150,000 from the Olin Foundation—$100,000 in the form of a research fellowship at the American Enterprise Institute, $30,000 filtered through the Institute for Educational Affairs, and $20,000 for book promotion through the Madison Center. With these credentials, with such substantial corporate and government backing, D'Souza predictably was recognized as a reliable source and was granted expert status by the media. Within 1991 alone, D'Souza published not just in conservative periodicals—the *Wall Street Journal, Forbes,* and *National Review*—but in the *Washington Post,* the *Christian*

Science Monitor, the *New Republic,* the *American Scholar*, and *The Chronicle of Higher Education*. In addition, the *Atlantic* published a twenty-eight page, a twelve thousand-word abridgement of *Illiberal Education*. As Michael Bérubé argued, in *The Village Voice*, "that the *Atlantic* would have published D'Souza, and at such length, is an important sign of the extent to which public discussion of American academia is now conducted by the most callow and opportunistic elements of the right" ("Public Image" 37).[12]

The shift Bérubé identified as specific to the public discussion of the academy occurred generally in American public debate in the 1980s. As I've discussed, this change can be attributed to the rightward turn of mainstream politics and the media's tendency to reflect the interests and beliefs of those in power.[13] I would add, though, that the left generally has been underrepresented in public debate. Because of the corporate interests of large media firms, there has always been a sympathy between the mainstream media and the right, and an exclusion of, if not an active hostility toward, the anticapitalist left. The right's prominence in public discourse (and the left's marginalization), therefore, was not created but exacerbated by the rightward trend of mainstream politics in the 1980s. In parroting so much of the right's rhetoric, then, the mass media merely followed its tendency to reflect the dominant ideology of the political and intellectual elite. Nonetheless, there was an active right-wing attempt to shape public discourse. This notion, that a crowd of neocons who share similar political beliefs, who read, write, and edit a group of like-minded journals, who are sponsored by a relatively small number of foundations, who held various positions in and contributed to the policies of the Reagan and Bush administrations, and who maintain personal and professional ties to the mass media, influenced the political debate in the media generally and helped shape the PC debate specifically should not be considered radical or improbable.

Unable seemingly to distinguish between conspiracy and confluence of interest, though, many object to this argument. Such misreading is understandable from conservatives, who seek to paint themselves as a set-upon minority, and from liberals, who, because their ideology rests upon belief in a free press and a free marketplace of ideas, are reluctant to acknowledge that

public debate in a capitalist system is inherently circumscribed. What is less understandable is the tendency of some on the left to deny or downplay the right's influence upon the media. I suspect this reluctance stems from that strain of poststructuralism which seeks, in the words of Jean-François Lyotard, to wage war against totality. Consequently, to acknowledge the influence of the right's financial and political clout is to endorse a standard marxist class analysis. And for many on the poststructuralist left, a marxist analysis, because it posits a hierarchical, essentialist, totalizing scheme, perpetuates rather than challenges the post-Enlightenment paradigm underlying all power relations. Whatever the reason, without recognition of a loosely organized right-wing attempt to influence the media, it becomes difficult to explain why the mass media seemed incapable of seeing beyond the PC frame and so often seemed to adopt right-wing rhetoric. A marxist analysis, on the other hand, helps show how mass media representations of PC were shaped both by the neocon campaign to influence public discourse and by the media's institutional reliance upon, sympathy for, and bias toward the wealthy and the powerful.

The Function of PC

Probably the most vilified aspects of PC were university speech codes; these were attacked in virtually every mainstream anti-PC essay. Henry began his article in *Time* by having his readers "imagine places where it is considered racist to speak of the rights of the individual when they conflict with the community's prevailing opinion. . . . Imagine institutions that insist they absolutely defend free speech but punish the airing of distasteful views by labeling them unacceptable 'behavior' " (66); Taylor in *New York* spoke of an attempt "to restrict speech and control the behavior of a new generation of students" (40); and *Newsweek* argued that "PC represents the subordination of the right to free speech to the guarantee of equal protection under the law" (Adler 52). More than anything else, it was this assault on free speech and the liberal university's tradition of free inquiry that persuaded both the media and scholars like C. Vann Woodward and Eugene D. Genovese of the threat posed by political correctness. Of course, the American university historically has limited minority views and excluded and suppressed leftist

discourse.[14] And research programs in universities remain bound to, and often are defined by, the interests of liberal capitalism. But even ignoring these limits on academic speech, we can see in the PC scare itself the bounds of generally acceptable academic discourse. For the PC scare functioned primarily to constrain leftist expression in the academy.

While denouncing PC for threatening the university as a place "dedicated to the life of the mind as a radically undetermined adventure" ("Derisory" 6), the critics of PC often revealed the limits of this life of the mind. Writing in *Time,* Henry suggested that "for most of American history, the educational system has reflected and reinforced bedrock beliefs of the larger society." Unfortunately, according to Henry, "now a troubling number of teachers at all levels regard the bulk of American history and heritage as racist, sexist and classist and believe their purpose is to bring about social change" (66). Likewise, Michael Novak, in *Forbes,* asked, "is it healthy for democracy when its cultural leaders have a view of reality far out of accord with that of leaders of its economic and political systems?" Rather than challenging conventional beliefs and aiming for social change, then, the university's goal, according to these critics, is to reinforce "bedrock beliefs of the larger society" and to promote a view of reality that accords with that of its economic and political leaders. Despite the frequent denunciations of universities' restrictions on speech, therefore, many of those who attacked PC did not endorse an un-restricted, nonideological pursuit of truth (as if this were possible). Instead, they believed that academic study and discourse should take place within a range of opinion reflecting the dominant ideology. Radical discourse is allow-able only if it remains marginal. Thus Henry criticized political correctness because "at times it amounts to a mirror-image reversal of basic assumptions held by the nation's majority" (66). Likewise, William Simon argued for the need to support scholars "who understand the nexus between economic freedom and political freedom, the link between capitalism and democracy" ("To Reopen"). Lewis Lundberg, former chair of the Bank of America, defined this understanding of the function of the university: "the corporation today is the major beneficiary of the product that the college or university manufac-tures—the trained mind" (qtd. in D. Smith 152). For Henry, Novak, Simon,

and others the problem with the university—with PC—was not that it re-
stricted free speech, but that it threatened to disrupt this "training," that it
allowed, however muted and ineffectual, anticapitalist discourse. According
to these critics, school should serve as, in Louis Althusser's terms, an ideologi-
cal state apparatus that "teaches . . . in forms which ensure *subjection to the
ruling ideology*" (133). As recent discussion of the need to reform education to
meet the demands of a high-tech, global economy demonstrates, the university
functions to train students to efficiently perpetuate a system of national
privilege and class exploitation.

This notion that universities should serve to maintain status quo bourgeois
liberalism is a consistent feature of neoconservative ideology. Although they
repudiated its policies for contributing to the social turmoil of the sixties,
which in turn created a crisis of authority and threatened liberal democracy,
many neocons have begrudgingly accepted the inevitability of state capitalism.
According to Kristol, "It is idle . . . to talk about returning to a 'free enterprise'
system in which government will play the modest role it used to." In fact,
"had [Ronald Reagan] become a two-term President, he (and we) would have
found," Kristol accurately predicted in the 1970s "that, after the ideological
smoke had cleared, not all that much had changed" (30). Whereas the extreme
right has sought to dismantle state capitalism, neocons have attempted to
function as a moderating influence upon the college educated middle class,[15]
the state-sponsored elite Kristol labelled "the New Class."[16]

Since they could not hope to overturn state capitalism, neocons should
instead, Kristol argued, "shape or reshape the climate of public opinion, a
climate that is created by our scholars, our teachers, our intellectuals, our
publicists: in short, by the New Class" (145). As its broad adoption by the
mass media and its embrace by conservative and liberal politicians, pundits,
and academics reveals, the great PC scare was a particularly successful shaping
of the climate of public opinion. In *The Neoconservatives,* Peter Steinfels
explains the purpose behind such manipulation: members of the New Class
"must wield their authority with a good conscience, free of the sentimentality
or guilt that would inhibit decisive and painful measures. They must feel
secure in the power and prerogatives they enjoy" (67). Much of the criticism

of PC can be read, therefore, as an attempt to vitiate the discussion of race, class, and gender inequity (what some on the right have derisively labelled "victimology") in order to enhance the New Class's confidence in liberal capitalism.

The great PC scare did not, however, function primarily to overcome the debilitating guilt felt by bourgeois liberals for their legacy of oppression and injustice. It is not likely that the culture industry responded so readily merely to assuage liberal guilt. Nor does the spectre of totalitarianism explain the cultural acceptance and distribution of the PC myth. This myth was endorsed by the mainstream culture because it was useful in countering a potential adversarial culture and helpful in both promoting national allegiance and discipline and encouraging establishment consensus. As Kristol acknowledged, "imperial powers need social equilibrium at home if they are to act effectively in the world" (qtd. in Steinfels 69).

Ultimately, then, the great PC scare functioned to ward off whatever remote threat PC posed to the interests of capital. This fear could be found in the red-baiting common to discussions of PC, and occasionally was expressed overtly in the major media—for example, Newsweek asserted that "PC . . . attempt[s] to redistribute power from the privileged class . . . to the oppressed masses" (Adler 53). Likewise, Novak declared that "in PC, capitalism is a particular object of loathing" (132). Sometimes this threat was identified specifically as marxist, especially in the rhetoric of the right. For example, Balch and London argued that although "Marxist professors do not dominate opinion in their disciplines, it would be a mistake to underestimate their influence or the influence of Marxist studies" (45); and, in a 1993 issue of Partisan Review, devoted to political correctness, Ronald Radosh wrote that "for many members of the former Marxist left, the death of Communism has been replaced equally fervidly with advocacy of the new PC" (680), and Robert Brustein suggested that "PC has crypto-Maoist roots, and, in extreme form, is dedicated to a program not unlike that of the unlamented cultural revolution by the People's Republic of China" (527). But the threat posed by the academic left was stated most clearly years before the PC scare by William Simon, who in 1978 called for "a massive and unprecedented mobilization

of the moral, intellectual and financial resources which reside in those . . . who are concerned that our traditional free enterprise system . . . is in dire and perhaps ultimate peril" (*Time* 229).[17] Or, as he wrote a decade later in the *Wall Street Journal*, "I doubt even Lenin himself dared to dream that American business would donate the funds to finance the destruction of freedom at home." In organizing opposition to this allegedly anticapitalist movement, Simon identified "three fronts on which to act aggressively if we are to create a sophisticated counter-force to the rising despotism" (233): foundations, the media, and the universities.[18]

Fearing that "the leaders of the American free enterprise system are financing the destruction of their own system and ultimately of our free society" (qtd. in Modic), Simon called for businessmen to end "the mindless subsidizing of colleges and universities whose departments of economics, government, politics and history are hostile to capitalism" (231). To this end, after leaving the post of Secretary of the Treasury, Simon became president of the Olin Foundation and cofounded the Madison Center for Educational Affairs, both of which featured prominently in shaping and promoting the great PC scare. It is useful to remember that, according to Simon, the purpose of the Olin Foundation "is to support those individuals and institutions who are working to strengthen the free enterprise system" (233).

Any reasonable view of the contemporary university, of course, would recognize what an insignificant threat PC poses to the free enterprise system, with its massive resources and control over the distribution of information. Yet capitalism historically has attacked, scapegoated, or otherwise rendered inoperable all oppositional movements, regardless of how weak or improbable. PC has been viewed as a potential (if distant) threat to capitalist hegemony because it has recognized the harm caused by Western culture's racism and sexism, and consequently has hinted at America's continuing lack of social justice and its urgent need for an egalitarian politics. The great PC scare, therefore, was an attempt to disable such radicalism by fear (i.e., by equating PC with totalitarianism), by implied threat, and by delegitimation through ridicule.

What then has been the result of the right's anti-PC campaign (other than

to inspire leftist academics to write long-winded and excessively documented essays)? First, the anti-PC rhetoric has helped the right sell itself as moderate and objective. In January 1993, while watching TV I heard Pat Robertson, alleging the bias inherent in network news and promoting the objectivity of the Christian Broadcasting Network, argue that CBN's news was truer because it was "not filtered for political correctness." And in television commercials William F. Buckley says he created *National Review* to offer an alternative to "the single-voiced commentary now known as 'politically correct'."

A more interesting—and more harmful—result of the great PC scare has been the widespread adoption of PC as a pejorative term for leftist activism. In a *New York Times* article discussing efforts to boycott Colorado for its passage of the antigay Proposition 2, Michael Specter called Liza Minnelli's decision to cancel a concert performance, "a decision that some [in Aspen] called a valiant act of conscience and that others called mindless pandering to the politically correct" (A9). And in an article in *Newsweek* discussing Senator Bob Packwood's sexual harassment of women, Patricia King and Bob Cohn wrote, Packwood's "supporters say that in the politically correct atmosphere of Portland politics, it has become nearly impossible to defend him."[19] Despite the care with which they disassociate themselves from these claims, Specter, King, and Cohn grant these claims credibility by presenting them as plausible explanations. What these passages demonstrate is the fatuousness of journalistic notions of balance, for the balance demonstrated here is between boycotting Colorado and seeing this boycott as politically correct, between asking that Packwood be removed from office for his admitted history of sexual harassment and seeing such discussion as politically correct. The choice, then, is either to take action based on moral principle or to view these moral positions as mindless, herdlike posturing. A balanced report might have suggested that the supporters of Proposition 2 are determined to impose their religiously correct views upon the population of Colorado and that the Packwood supporters are determined to impose their patriarchally correct views upon the population of Oregon. The problem with implementing this kind of balance, of course, is that there is no term for the right comparable to PC. The very act of labelling the right "homophobic" or "sexist" is to be

PC. Therefore, an important consequence of the PC scare is to naturalize social injustice and to problematize any argument that recognizes the political and economic exploitation of the powerless by the powerful.

The effect of the great PC scare, then, has been to institutionalize a term that discredits even modest leftist concerns, presenting the left with one more obstacle, and moving the political "center" to the right, thus further cementing the right's political and cultural hegemony. Take, for instance, Bruce Bawer's review in the *Washington Post* of Richard Powers's *Operation Wandering Soul*. Powers's novel is an indictment both of the harmful effects of consumer culture, particularly upon a group of children at a charity hospital in contemporary Los Angeles, and of the lethal consequences of U.S. imperialism in Southeast Asia. For Bawer, though: "Powers divides people too neatly into good and bad, and does so along crude, politically correct lines, aligning himself throughout with . . . the received ideas of today's academic establishment."[20] Thus a novel which looks unflinchingly at the brutal results of capitalism[21] is defined as the mindless repetition of academic cant. An important use of PC, then, is to invalidate left-of-center social criticism.

A more substantial consequence of the PC scare is the delegitimizing not just of social criticism, but of social policy. A case in point is the treatment of Bill Clinton's one-time nominee for Assistant Attorney General for Civil Rights, Lani Guinier. Although not accused specifically of being politically correct, Guinier nonetheless was attacked via a similar strategy. Just as in the PC scare political correctness was identified and defined by conservative publications and pundits, so Guinier's unfamiliar ideas were first defined by Clint Bolick in the *Wall Street Journal*. And just as the PC scare was built by the uncritical repetition of initial misrepresentations, so subsequent media discussions of Guinier harked back to Bolick's essay. Bolick's thesis (that Guinier was a "quota queen") gained such currency that it took on the weight of fact. Guinier was so effectively redefined that evidence which countered this dominant perception was viewed with skepticism. Thus Ray Kerrison warned, in the *New York Post,* that "Lani Guinier may appear to be learned, but at heart she is a crackpot" (qtd. in P. Williams 27).

This attack on Guinier would have been more difficult had the grounds

needed to believe such falsehoods not been prepared by the PC scare. The distortions of her views were that much more believable because Guinier was a female African-American academic. (And we know how irresponsibly radical they can be when demanding their rights.)[22] We can map out the kind of equation that supported such assumptions: female African-American academic=PC, PC=radical, radical=crackpot, hence—"loony Lani." Since PC was a unified movement that dominated universities, and since someone like Leonard Jeffries was viewed as representative of PC, Guinier's well-considered views on civil rights could be seen as "right out of Leonard Jeffries melanin-and-ice people school of thought" (Kerrison qtd. in P. Williams 27). The upshot of all this, of course, was that Guinier, who promoted an understanding of civil rights that might have encouraged slightly more egalitarian policies, was removed from consideration for Assistant Attorney General for Civil Rights without a hearing and with no chance to defend her views.

Unlike Guinier, Sheldon Hackney, appointed by Bill Clinton to head the National Endowment for the Humanities, was both granted a hearing before and ultimately confirmed by the Senate. Considering that Hackney was President of the notorious University of Pennsylvania (the school Alan Kors had compared to the University of Peking) and was the target of repeated criticism by conservative and some liberal pundits, one might have expected his nomination to have met the same fate as Guinier's. Two incidents in particular were seen as grounds for thwarting Hackney's nomination—the case of Eden Jacobowitz, a Penn freshman who had yelled "shut up you water buffalo" at a group of African-American coeds, and who subsequently had been charged with violating the university's speech code, and the case of several African-American students who had stolen fourteen thousand copies of Penn's free student newspaper to protest an allegedly racist columnist. Because the university disciplined Jacobowitz but did not discipline those who had confiscated the newspapers, Hackney was criticized for capitulating to the terrors of PC. Conservative columnists attempted to discredit Hackney through a familiar strategy: through red-baiting, through the omission of complicating facts and background information, and through the use of a narrative frame that had become conventionalized in the great PC scare.

Red-baiting. Turning his attention to "that swamp of political correctness that is the American academy," Charles Krauthammer in the *Washington Post* found "campus fascism" and saw similarities between the theft of Penn's student newspaper and book burning ("Spineless"). Also in the *Washington Post,* George Will employed his customary moderate and reasoned prose, decrying "the university's thought and speech enforcers" and their use of "the punishment preferred by totalitarian regimes and American campus liberals—reeducation in the form of 'sensitivity' training." For Will, the newspaper theft demonstrated "brownshirt tactics" ("At Penn"). Likewise, in *Newsweek* Will spoke of "Brownshirt behavior," of "Penn's thought police," of "thought vigilantes on the prowl," and of "inquisitors sniffing for punishable utterances" ("Compassion"). Paul Greenberg, in a column syndicated by the *Los Angeles Times,* longed for the day "when civilization returns," and suggested that "students at Penn needn't read '1984'—they live it." And the *Wall Street Journal* fretted over "cadres of the politically correct" ("Mr. Hackney"), seeing in Hackney's appointment evidence that "we may not have reached the turning point in the battle to restore democracy to campuses" ("Hackney"). By uncritically rehashing the same old anti-PC argument and by repeating stock phrases and familiar anticommunist epithets, the right has been consistently guilty of its own politically correct speech.[23]

Omissions. Although it may be true, as was repeatedly asserted in newspaper accounts, that when yelling out his dorm window Jacobowitz had in mind the Hebrew word *behayana,* meaning both "water oxen" and "foolish person," what the media failed to mention was that Jacobowitz's remarks were made at the same time several other students were yelling racial slurs. However subsequently mishandled by Penn administrators, the Jacobowitz incident should be recognized as part of the larger problem of campus racism. By omitting this information, Krauthammer, Will, Greenberg, *et al.* made the university's behavior seem like mindless conformism to politically correct thought; they transformed an incident that demonstrated the persistent problem of racism on university campuses into one that demonstrated the tyranny of PC. The hurling of racial epithets at a group of African-American undergraduate women was reduced to, in the words of the *Wall Street Journal,* the

"prosecut[ion] [of] a freshman for shouting 'water buffalo' at some raucous black women" ("Other").

The newspaper theft likewise seems to have been selectively reported. Accounts of this incident suggest that African-American students were upset at the allegedly racist remarks made by a student columnist. Yet these remarks, despite serving as the ostensible cause of the theft, were never repeated by the major media. With such information omitted, the action taken by African-American students was made to appear just one more abuse prompted by excessive racial sensitivity and encouraged by PC.

Narrative. Using the rhetoric of red-baiting and omitting explanatory background information, conservative columnists were thus able to reconstruct the incidents at Penn to fit into a preexisting narrative: a white male makes innocent remarks or takes part in innocuous behavior that is misconstrued as racist and is subsequently punished, while African-Americans (or women, or homosexuals, or other ethnic minorities) take part in some form of outrageous behavior (storm a professor's office, interrupt a classroom lecture, etc.) and receive no punishment whatsoever—thanks to cowed administrators unwilling to challenge the dominance of political correctness. (In response to the newspaper theft, according to Krauthammer, Hackney issued a "craven statement," and his behavior, according to Will, was "clearly craven.") Because this narrative had been conventionalized by its frequent use in the PC scare, it was not seen as an ideologically charged interpretation of events but as factual representation. To repudiate Hackney, conservative columnists had merely to use a familiar rhetoric and to plug into a preexisting narrative frame. This, of course, is an essential component of ideology—the replacement of argument and fact with a narrative that becomes increasingly conventionalized and naturalized through repetition and therefore becomes increasingly more difficult to refute.

Yet Hackney was confirmed. While there are several reasons for Hackney's success and Guinier's failure (Hackney was more of an establishment figure;[24] Guinier's gender and race contributed to her being perceived as an extremist; the Clinton administration had learned from its mistakes in the Guinier nomination), perhaps the most convincing explanation is that Hackney admit-

ted the error of his ways. In a familiar liberal response to accusations of sympathizing with the left, Hackney acknowledged he had made mistakes, repudiated the politically correct beliefs attributed to him, and asserted his political neutrality.[25] In his testimony before the Senate, Hackney asserted that political correctness—which he described as "overly solicitous of minority groups and fashionable and trendy concerns"—"would be a serious problem if it were to capture a campus" (Clymer). Hackney also said he was troubled by scholarly fields like deconstruction and poststructuralism—what he labelled "the intellectual form of political correctness"—because these maintain "that every statement is a political statement so that there can be no objective tests for truth" (Burd, "Hackney Clears"). And Hackney suggested that he saw the NEH, which had previously been run by ideologues like William Bennett and Lynne Cheney, as nonideological. "The NEH," he said, "should not have a social agenda" and "ought not to be engaged in partisan or ideological affairs" ("Hackney Clears").

Because of statements such as these, attacking political correctness and affirming the impartiality of the NEH, Hackney was confirmed. He even received praise from conservatives such as Senator Orrin Hatch, for whom "Hackney made a pretty good case that he is against political correctness" (Toner), and Stephen Balch, who called the hearing "a red-letter day in the recent history of the humanities" and thought Hackney's "censure [of] scholarly theories . . . [like] deconstruction and post-structuralism . . . immensely significant" (Burd, "Hackney Attacked"). Because of Hackney's statements at the hearing, the National Association of Scholars decided not to oppose his nomination. Criticized for requiring conformity to the strictures of political correctness and for not tolerating dissenting views, Hackney was confirmed by the Senate only after being reeducated through a public chastising and a public renunciation of PC. There is a surreal quality to all of this: a political appointee who, in order to be confirmed by a political body, testifies that as head of a government agency he will be nonpolitical, who repudiates his political beliefs, and who, in order to head an agency that provides money to humanities scholars (many of whom have been influenced by theories that

assert the political nature of all discourse), criticizes theories that assert the political nature of all discourse.

Hackney's nomination was controversial because he had been associated with political correctness and its modest attempts to promote social justice. Guinier's nomination generated such outrage because she promoted a view of civil rights law that aimed at producing a more egalitarian democracy. This controversy and outrage should come as no surprise since, for someone like William Simon, "egalitarianism and despotism are linked. Historically, they always have been. Hitler and Stalin and Mao all offered their people an egalitarian society, disclosing only when it was too late that some would always be 'more equal than others' " (*A Time* 198). The persistent and over-wrought attack on leftist discourse in the academy, as embodied in the PC scare, then, was meant to circumscribe leftist criticism of the continuing social inequities in the United States, particularly that criticism which placed the blame for such inequities on capitalism itself. It was a preemptive strike meant to discipline the academic community for allowing too prominent a discussion of America's lack of social justice and its need for a radical egalitarianism.

I began this essay by suggesting how inexplicable the great PC scare seemed when I was confronted by *Newsweek's* thought police cover story. Although as "political correctness" it may have taken a novel form, this scare, I now realize, was an all too predictable response; such consistent misrepresentations and hyperbole are the minimum obstacles used against social criticism that threatens the interests of capital.

Notes

1. Not only has PC been associated with Nazism, but the Nazis themselves have been seen as PC. In a review of "Degenerate Art," a documentary about Nazi art, the *New York Times* discussed "the politically correct pastoral works and monumental statues celebrated by the culture bosses of the Third Reich" (Kimmelman).

2. In fact, it could be argued that by acknowledging the limits of and constraints faced by PC, the mass media presented a more nuanced and responsible picture of higher education, making their call to arms over the imminent threat of PC that much more convincing.

3. PC has also been labelled the "new intolerance," "new fundamentalism," and "new puritanism."

4. There is always the possibility that "McCarthyism" is not meant disparagingly. After all, for Allan Bloom, "the McCarthy period was the last time the university had any sense of community. . . . In major universities [McCarthyism] had no effect whatsoever on curriculum or appointments. The range of thought and speech that took place within them was unaffected. Academic freedom had for that last moment more than an abstract meaning, a content with respect to research and publication about which there was general agreement. . . . Today there are many more things unthinkable and unspeakable in the universities than there were then. . . . In the fifties campuses were calm. . . . Professors were not fired, and they taught what they pleased in their classrooms" (*Closing* 324).

5. Conservatives have taken issue with the American Council on Education survey. Stephen H. Balch suggests that "this is the higher education establishment responding to a year of bad publicity and trying to put the best face on it" (qtd. in Cooper A5). Without specifically addressing this survey and using only anecdotal evidence, George Will asserted that "the new tenet of political correctness is that political correctness does not exist" ("Catechism" C7).

6. Richard F. Hamilton and Lowell L. Hargens, sociologists at Ohio State, report that compared to similar surveys conducted in 1969 and 1975, the academic community has become not more liberal but more conservative (liberal: 1969—40.6, 1975—35.6, 1984—33.8; moderate conservative: 1969—24.9, 1975—27.6, 1984—29.6). While it is true that the proportion of professors identifying themselves as left increased from 4.8 to 5.7 percent between 1969 and 1984, the proportion identifying themselves as strongly conservative increased from 2.6 to 4.2 percent during this same period. According to Hamilton and Hargens, the change "clearly was toward greater conservatism. The direction of change within the academic world, in short, was the same as that found within the general population" (qtd. in " 'In' Box").

7. For my understanding of the function of the mass media I am indebted to Edward Herman and Noam Chomsky's *Manufacturing Consent*.

8. According to Gaye Tuchman, "Newsmen will not print as 'fact' statements which contradict common sense." But of course the "notions the newsman takes for granted are actually a picture of his view of social and political reality" (674–75). Similarly, Hodding Carter asserts that because of "the closed circle in the nation's capital, intelligence for pundit and politician alike is defined by the ability to echo conventional wisdom in well-turned phrases that neither disturb or illuminate. . . . To be considered unconventional, eccentric, or 'extreme' is more to be feared in these circles than to be proved wrong" (qtd. in Soley 144).

9. Despite their persistent assertions that a nascent totalitarianism existed in the radical

politics of the sixties, neocons, sensitive to the singular horror of the Holocaust, objected when the New Left, employing similar rhetoric, equated U.S. social and foreign policy with Nazism. As Glazer suggested, "it was impossible for many of us to accept the easy and frequent equation of the United States with Nazi Germany, of Johnson and Hitler" (76)

Ironically, the anti-PC debate often resorted to rhetoric as excessive as that used years earlier by the New Left. Walter Goodman's criticism of the New Left in *Commentary* in 1970 could equally have been made to criticize the anti-PC arguments of people like Will and D'Souza:

> It is a stimulating conceit to think of oneself as holding the thin line against oppression—"Can we stop 1984." . . . The favored tactic . . . is to lump events together for maximum impact, leaving to others the work of sorting them out, of going over each change to determine whether indeed there is a pattern of concerted repression here that warrants comparison with Germany in the 1930's. (25)

That a decade-long war in Southeast Asia in pursuit of American commercial interests, an active government campaign to thwart dissent, and a continuing history of racial oppression and class division might suggest totalitarianism was inconceivable to neocons. On the other hand, the movement to establish racially and sexually sensitive speech codes on university campuses, to broaden curriculums to include the previously marginalized, and to acknowledge the consequences of Western patriarchy and ethnocentrism, according to some neocons, smacked of totalitarianism.

10. Although in anti-PC rhetoric the sixties are seen as directly responsible for the decline in American education, the right may identify any period of leftist ascendancy and an accompanying movement toward progressive education as harmful. As Diane Ravitch explains, "we can't blame the fall of standards in American education on political correctness; depending on your perspective, you can trace the decline of standards to the 1930s or the 1960s" (685).

11. For much of the following I am indebted to Sara Diamond's important research in the February 1991 *Z Magazine* and the Fall 1991 *Covert Action Information Bulletin*.

12. Perhaps an even more striking example of the rightward movement of public debate is the *New York Review of Books*. In 1970 Martin Mayer, writing in *Commentary*, suggested that the *Review* was the voice of the "totalitarian left" and would produce "the next Stalin and his speech-writers" (qtd. in Steinfels 76). By 1991, however, the *Review* was sympathetic to neocons and prominent in the anti-PC debate, featuring a much-quoted anti-PC essay by C. Vann Woodward.

13. Peter Steinfels explains this process: "The political mood may . . . promote changes in intellectual life, and these flow back to consolidate the new politics. The McCarthy era, for example, saw a nearly complete change in the scholars reviewing China studies for

the *New York Times* and the New York *Herald Tribune*. At these two papers, the group who had done over 80 percent of the reviewing in this field between 1945 and 1950 reviewed not a single book after 1952" (6–7).

14. See Robby Cohen, *When the Old Left Was Young*, and Ellen W. Schrecker, *No Ivory Tower*.

15. It is this moderate and centrist positioning that has helped neocons achieve such disproportionate influence among journalists. As Peter Steinfels argues, "at *Time* and *Newsweek*, neoconservatism often appears as the comfortable middle ground between these magazines' traditional conservatism and their liberal flirtation of the late sixties" (8).

16. According to Kristol, "this 'new class' is not easily defined but may be vaguely described. It consists of a goodly proportion of those college-educated people whose skill and vocations proliferate in a 'post-industrial society'. . . . We are talking about scientists, teachers and educational administrators, journalists and others in the communication industries, psychologists, social workers, those lawyers and doctors who make their careers in the expanding public sector, city planners, the staffs of the larger foundations, the upper levels of the government bureaucracy, and so on" (27)—i.e., the professional-managerial class.

17. Similarly, in 1972 Judge Lewis Powell wrote to the U.S. Chamber of Commerce urging business "to buy the top academic reputations in the country to add credibility to corporate studies and give business a stronger voice on campuses" (qtd. in Herman 23).

18. Simon succeeded in creating right-wing foundations to oppose what, in 1978, he had seen as the dominance of liberal and left-wing foundations. (For Simon, the Ford Foundation was disturbingly left of center.) According to Lawrence Soley, "the annual budget of any one of the big conservative think tanks exceeds the combined budgets of all left-of-center think tanks" (55). The PC scare demonstrated the effectiveness of this "counter-force" upon the media.

19. This sentiment was echoed by Senator Robert Cohen, who, in a floor debate over the Senate's treatment of Packwood, warned his colleagues "to be very careful that we have not moved into a world of political correctness" (C-SPAN 2, 2 Nov. 1993).

20. Considering that he writes for neocon publications like the *New Criterion*, *Commentary*, and the *American Spectator*, Bawer's criticism of today's academic establishment and Powers's politically correct politics is all too predictable.

21. For instance, Powers tells us that Bangkok "had grown into a skylined, sprawling, runaway, AIDS-infested needle nest. It had become a child-peddling shambles. Some hundred thousand juvenile whores of both sexes made a living in the place, the murder capital of the exotic East, the Golden Triangle's peddler, catamite to the slickest of tourist classes, gutted by CarniCruze junkets and semiconductor sweat shops, glistening in fat postcolonialism, clear-cutting its irreplaceable upcountry forest to support its habit" (309).

22. In response to the Guinier nomination and subsequent brouhaha, the *London Mail* wrote, "One doesn't want to make a ludicrous comparison, but it seems fair to say that America today, vis-à-vis feminist thought, is at the point Germany reached before the Nazis took over. The Nazis talked about *gleichschaltung,* the need to co-ordinate mainstream thinking with Nazi ideology. Militant feminists are doing that in America with their political correctness" (qtd. in P. Williams 27). One is grateful the *London Mail* did not want to make a ludicrous comparison.

23. Similarly, in 1993, Supreme Court Chief Justice William Rehnquist declared, "one senses that for [some universities] there is an orthodoxy or sort of party line from which one departs at one's peril" (qtd. in "Ways & Means"), while two years earlier *Newsweek* had warned of "a totalitarian philosophy" that "one defie[d] . . . at one's peril." And just as Balch and London, in 1986, and the *New Republic,* in 1991, warned of a "chilling effect," so in response to the Hackney nomination did former Reagan adviser Gary Bauer identify "a chilling atmosphere on a lot of university campuses" (Toner), and George Will proclaim "a chilling effect on speech" ("At Penn"). Perhaps the frequent use of this icy conceit stems from the right's nostalgia for the Cold War.

24. His friends include Art Buchwald, C. Vann Woodward, and Mike Wallace, the latter of whom even wrote a letter in defense of Hackney to the *Wall Street Journal.*

25. Another matter of controversy concerning Hackney was his opposition to ROTC at Penn due to the military's antigay policy. According to a supporter, Hackney also denied this position; he told the White House he had been an ROTC product at Vanderbilt, had served in the Navy, and had "not fought to ban ROTC on campus because he values it" (qtd. in Trescott).

6

"Political Correctness"

A Class Issue

Tom Lewis

George Bush made clear the class nature of the ongoing assault on "political correctness" when, in May 1991, he red-baited PCers and multiculturalists as "political extremists [who] roam the land, abusing the privilege of free speech, setting citizens against one another on the basis of their class or race." Bush generally aimed, of course, to tattoo "Stalinist" across the foreheads of all those who actively oppose racism and sexism. Yet his specific attempt to brand PCers with the hot iron of class struggle strikes an artificial chord. It is no secret within the universities that, as the primary entry point of cultural analysis or as a serious focal point of curricular reform, "class" has largely been abandoned by an academic left that for the most part describes itself as "post-marxist." In this light Bush's statement should be viewed as no more and no less than an expression of his own commitment to waging class war around the issue of "PC."

The specter of PC cadres controlling universities, cracking down on the free expression of ideas, and otherwise carrying the nation to the threshold of social revolution is and always has been a bogey invented by right-wing ideologues and media pundits. But whether one accepts or not that "tenured radicals" from the 1960s stand on the verge of "achieving in the classroom, faculty meeting and by administrative decree what [they were] unable to accomplish on the barricades" (Kimball, *Tenured* xv), both the right and the left concur in that marxism has contributed little of *specific* weight to "political correctness."

Dinesh D'Souza, for example, leaves "class" out of the subtitle of his *Illiberal Education*: "The Politics of Race and Sex on Campus." Paul Berman, writing in *Debating P.C.* of the curricular "melange" he calls "race/class/gender-ism,"

acknowledges that for most PCers "the word 'class' is invoked only for the purpose of conjuring a slight aura of Marxism" ("Introduction" 14). And Roger Kimball, in *Tenured Radicals,* endorses Frederick Crews's view that PC is best described as "Left Eclecticism," a term defined by Kimball as "any of a wide variety of antiestablishment modes of thought from structuralism and poststructuralism, deconstruction, and Lacanian analysis to feminist, homosexual, black, and other patently political forms of criticism" (32). Thus Kimball agrees with Crews that "Left Eclecticism is not identical with Marxism" (*Tenured* 32) and that marxism contributes mainly an "ethos" to PC (Crews, *Skeptical* 138).

The purpose of this essay is not to argue against the assessment that "marxism" or "class" lends only an "aura" or an "ethos" to PC; regrettably, because of "post-marxism," this assessment is true enough. But neither is it the purpose of this essay to lament PC's sharp focus on issues of race and gender, as if such a focus could only be at the expense of class issues. Rather, I would suggest that the abstract quality of "class" within PC results from and in turn reinforces the retreat into reformism that has characterized the academic left since the mid-1970s. PCers' responses to anti-PCers are therefore usually framed from within the discourse of "popular" or "radical" democracy, a discourse that is not adequate to the task of combating the class offensive at the heart of anti-PC.

In this essay I shall first indicate the role that anti-PC has played as part of class struggle in the United States over the past decade. I shall go on to consider how anti-PC disguises its class offensive by portraying itself as a defense of democratic freedoms and, much more importantly, how a number of defenders of PC accept the exact terms of debate—"people vs. power bloc"—on offer from the anti-PCers. Finally, I shall suggest a way in which the left's response to anti-PC can be strengthened so as to present an energetic defense of "politically correct" literary studies.

Profits vs. PC

One of the most persuasive ways to argue that it made very little difference who won the 1976 and 1980 presidential elections—or, for that matter, who

subsequently won the 1984, 1988, and 1992 presidential elections—is to start by recalling that it was Jimmy Carter who launched the first attacks against the gains that women and minorities won in the late 1960s and early seventies. After taking office Carter endorsed the 1976 Hyde Amendment, a piece of legislation that to this day bans federal funding for poor women's abortions. Carter remarked at the time that "there are many things in life that are not fair, that wealthy people can afford and poor people can't. But I don't believe the federal government should take action to try to make these opportunities exactly equal, particularly when there is a moral factor involved" (Tribe 154). Carter's Justice Department went on to file a brief against affirmative action in the 1978 Bakke "reverse discrimination" case. And, in the last year of his term, Carter made "massive cuts in funds for the poor, blacks, and the cities" (Ferguson and Rogers 111).

I raise the issue of Carter's record on race and gender because no one should harbor the illusion that the majority of Americans would have been any less exploited and oppressed in the 1980s under Democratic administrations than under Republican ones. For example, the massive transfer of wealth from the poor to the rich carried out during the Reagan years started under Carter. The 1978 Tax Reform Bill lowered the top capital gains rate for businesses from forty-eight to twenty-eight percent, and substantially increased the already regressive social security tax (Ferguson and Rogers 109). It was a plan drawn up by the Carter Administration, moreover, that Reagan used in 1981 when he smashed the Professional Air Traffic Controllers Union. Indeed, although capitalists had at their disposal over a thousand union-busting consultant firms throughout the U.S. in 1979, Carter consistently ignored the interests of working people, helping to inaugurate instead a gruesome new era of collective bargaining with the Chrysler bailout (S. Smith 11). And it should never be forgotten that Carter "began the military buildup completed by Reagan . . . when he made a trade off between military and social spending, authorising a whopping 5 percent annual increase in military spending coupled with massive cuts in poverty programmes" (S. Smith 10).

One complex reality set the limits of and gave direction to Carter's domestic policy: the fall in the rate of profit dating from the mid-1960s. The U.S.

accounted for more than fifty percent of world industrial output in the immediate post-World War II period; by 1980 its share had fallen to twenty-one percent. Largely financed by military production, the American postwar boom ended with the U.S. economy disadvantageously placed with respect to the economies of Japan and Germany, which had seen much greater percentages of their GDPs invested in plants and equipment. To overcome the profitability crisis, Carter—as Reagan and Bush would continue to do after him—pursued policies designed to reduce costs, lower wages, and slash public spending as ways of reversing the relative decline of the U.S. economy (Shawki).

Profitablity, of course, was restored in the 1980s through "the trappings of the Carter-Reagan-Bush military buildup: the creation of massive government and corporate debt; the transfer of resources from labor to capital; the looting of public spending on education, infrastructure and welfare" (*Socialist Worker* Jan. 1992:3). There was indeed an economic recovery in the 1980s—a recovery for the U.S. ruling class, achieved at the expense of the majority of working Americans. The top one percent of the population saw their incomes jump ninety-five percent, while the "bottom" ninety percent saw only a one percent increase. Corporations shouldered thirty-nine percent of the tax burden in the 1950s, but only seventeen percent by the late 1980s (Bartlett and Steele 47). Real wages in the U.S. returned to 1950s levels—down nineteen percent from 1973, and lower than those in many advanced capitalist countries today. And the comprehensive unemployment rate in April 1992 stood at just over thirteen percent (*Wall Street Journal* 6 Apr. 1992:2).

Thus Carter, Reagan, and Bush successfully carried out a vicious ruling class offensive that continues to this day. But what does the crisis of profitability have to do with the PC debate? To many in the autumn of 1990 it seemed that the controversy over PC exploded on the scene from out of nowhere: this is an important perception to which I shall return. As Berman points out, however, elements of the anti-PC campaign "surfaced in the national political discussion as early as 1984, when William Bennett, at that time the chairman of the National Endowment for the Humanities, criticized the universities in a pamphlet called *To Reclaim a Legacy* " (Berman 4). Bennett's

philippic was then followed by Allan Bloom's *The Closing of the American Mind* (1987), Lynne Cheney's *Humanities in America* (1988), Cheney's *Fifty Hours: A Core Curriculum for College Students* (1989), and a number of other, less famous attacks on PC.

Berman also suggests that the controversy was brewing in informal academic discussions of the legacy of sixties radicalism well before 1984. These discussions involved the general perspectives on Western society put forward by " '68 Philosophy," a term that Berman borrows from Luc Ferry and Alain Renault to refer principally to the writings of Derrida, Foucault, Lacan, Bourdieu, and Lévi-Strauss (7). They also involved the specific initiatives, such as affirmative action and curricular reform, undertaken within educational institutions in order to consolidate and extend the gains won by women and minorities during the great social upheavals of the sixties. For these reasons it is necessary to regard the current PC debate as "a continuation of an argument that is more than a decade old" (5).

But in the fall of 1990, the argument began furnishing grist for sensational headlines and cover stories in such widely read, nonacademic publications as *The New York Times, Newsweek, The Atlantic, New York, The New Republic,* and *The Village Voice.* Two considerations explain this timing.

First, our leaders judged that it was necessary to begin an ideological offensive against the growing awareness among the general public that the eighties had represented a sharkfest for the ruling class at the expense of women, Blacks, and the majority of working Americans. Although newspapers had touted a closing pay gap between the sexes in the mid-eighties, for example,

> women working full-time made only 64 cents to a man's dollar [in 1986], actually slightly *worse* than the year before—and exactly the same gap that working women had faced in 1955. . . .
>
> The pay gap had only "improved" for women by less than five percentage points since 1979. And as much as half of that improvement was due to men's falling wages, not women's improving earnings. Take out men's declining pay as a factor and the gap had closed only three percentage points. (Faludi 364)

94

By 1988, college-educated women could again flaunt the famous fifty-nine-cent buttons, as could black women generally, whose income had stagnated for a decade. The pay gap for Latinas and older women plummeted to even below fifty-nine cents, in part because "the mass layoffs of the '80s actually took a greater toll on female service workers than male manufacturing workers, . . . [and] women in service jobs who were reemployed had to settle for pay reductions of 16 percent, nearly double the reductions borne by their male counterparts" (Faludi 368–369).

Conditions for U.S. blacks had also worsened severely. From 1969 to 1989, the ratio of black male workers' income to that of whites "improved by only $22"—from $694 to $716 per every $1,000 for whites—"and of that only a rise of a single dollar came during the second decade," that is, precisely between 1979 and 1989 (Hacker 101). The median black family income fell to 56 percent of a white family's by 1990, down from 63 percent in 1975 (*The Economist* 3 Mar. 1990:17). White enrollment levels in institutions of higher learning increased from 32.4 to 38.1 percent between 1975 and 1988; but, during those same self-styled "affirmative-action years," the percentage of black high school graduates enrolled in higher education actually decreased from 32 to 28.1 percent (Selfa and Maass 12). Not surprisingly, a 1990 survey of racial attitudes in the U.S. conducted by the University of Chicago's National Opinion Research Center found continued widespread prejudice among non-blacks: 53% percent said African-Americans are less intelligent; 56 percent said African-Americans are more prone to violence; 62 percent believed African-Americans to be lazier; and 78 percent agreed that African-Americans "prefer to live off welfare" (*Washington Post* 9 Jan. 1991:2).

The main context in which the PC debate leaps off the campuses and onto the front pages, therefore, is one of more than a decade of ruling class attacks on the living standards of working Americans, attacks in which women and minorities suffered the most. By 1990 it was no longer possible to deny the truth about this one-sided class warfare, especially in light of documentation of the organized backlash against the economic and political gains women and minorities had won in the 1960s and early 1970s. What better way, then, to deflect the broad-based anger now welling up against the wealthy and

powerful than by attempting to divert it onto those very groups in society who *allegedly* had enjoyed "special treatment" and "advantages" in hiring and education during this period? What better way to prepare the ideological climate in which to carry out further attacks on wages and social programs than to promote racism and sexism to the point where the victims—rather than targeting CEOs, financiers, and politicians—would fight among themselves over which separate sector(s) of the exploited and oppressed to blame?

There is a second, more limited context that also helps to explain the full unleashing of the anti-PC campaign in the fall of 1990. Corporate barons, political leaders of both parties, and the media elite began in earnest their preparations for war in the Persian Gulf. Because of its deep hostility to the sixties, anti-PC was quickly enlisted by apologists for the war in campaigns to portray anti-war activists as dogmatic personalities still suffering the effects of the "Vietnam Syndrome." The world was different now, so brayed the warmongers, and the U.S. had to fulfill its destiny as the world's cop. Checking the growth of any sort of anti-imperialist struggle—potentially one like the student movement against the Vietnam war in the '60s—became a top priority. Alongside the lies, censorship, hypocrisy, and fake television footage, what better way to ensure that the Pentagon was left alone to kill more than 150,000 Iraqis than by discrediting the "tenured radicals" who were the most likely candidates to put forward anti-imperialist arguments on campuses as part of an effort to build a mass movement against the Gulf War?

Bush's war was about defending the capital flows to the U.S. generated by Middle Eastern oil profits, and his quick "victory" inspired a new confidence in the ruling class. Even if U.S. imperialism was in decline economically, the U.S. remained the world's chief military power. Thus,

> no sooner had the war ended overseas than Bush resumed the war at home. Having made great strides towards eliminating the Vietnam Syndrome, he set his sights on finishing off the other reminders of the 1960s social movements, escalating attacks on blacks, women, and lesbians and gays under way since the late 1970s. . . . The new enemy, he told students, was "political correctness." (S. Smith 31)

For Bush, attacking PC was like standing up for Kuwait by attacking Iraq. Urging Americans to "defend others' rights," he lamented that "neighbors who disagree no longer settle matters over a cup a coffee" and contrasted administrative "inquisition" and professorial "bullying" to the needs of "men and women [who] must feel free to speak their hearts and minds" on campuses (Bush 227, 228).

People vs. Power Bloc

Dinesh D'Souza provides anti-PC with its central rhetorical figure when he coins the expression "the victim's revolution" (D'Souza 1991). With this expression D'Souza "explains" racism and sexism on campus as the result of a backlash on the part of white and usually male students against the "special preference" enjoyed by minority students. The usefulness of the expression for D'Souza—and its obvious scandal for progressives—is that it projects women, blacks, Latinos, and other minorities as the ultimate source or cause of their own oppression.

According to D'Souza, however, the immediate causal agents provoking the backlash remain university administrators and professors. They are the ones who exercise an insidious control over students by shaping "the rules that govern [students'] academic and social lives in the university" (19). They are the ones who violate "the democratic principle of equal opportunity for individuals" and promote an "underlying concept of group justice [that] is hostile both to individual equality and excellence" (55). It is their allegiance to affirmative action that lies "at the root of the problem" of racism (129–130). Far from enabling minorities, their criticism of existing academic standards actually proves punishing, since minority students "seem better off when they are encouraged to improve their performance than when they are induced to believe that measures of performance are rigged against them" (188).

Indeed, a "primal scene" of the bureaucratic suppression of individual students' rights lends D'Souza's arguments their apparent coherence. White students do not want to be racist, and male students do not want to be sexist: nevertheless, they are forced into becoming racists and sexists by

administrators and professors whose affirmative action policies refuse to recognize individual equality, individual freedom of expression, and individual merit. D'Souza even reckons that racism and sexism would disappear, if only everyone would realize that affirmative action harms not only individual white males, but also those whom it is designed to serve. *Qua* individuals, minority students are to be seen as just as oppressed as white males (!), since university bureaucracies "typically consider minorities as members of a group, important only insofar as their collective numbers satisfy the formulas of diversity" (230). All of it together adds up to what D'Souza denounces as the "tyranny of the minority."

This rhetorical vision of a disenfranchised collectivity of individual students oppressed by a powerful bloc of lefty bureaucrats also informs Roger Kimball's diagnosis of the "ills" of contemporary higher education:

> Efforts to dismantle the traditional curriculum and institutionalize radical feminism, to ban politically unacceptable speech and propagate the tenets of deconstruction and similar exercises in cynical obscurantism: Directives encouraging these and other radical developments now typically issue from the dean's office or Faculty Senate, not from students marching in the streets. (*Tenured* 167)

Under the leadership of "tenured radicals," Kimball claims, "the university, traditionally a bastion of free speech and a place where controversial ideas may freely circulate, has begun to encroach even on these ideals in the name of a certain vision of political rectitude" (68). Professors and academic deans exude "an extraordinary odor of superior self-righteousness" as they "violate the right to free speech guaranteed by the First Amendment" (68–69). They issue "demands for ideological conformity" and enforce them through "antiharassment rules that provide severe penalties for speech or action deemed offensive to any of a wide range of officially designated victims" (xv–xvi).

Now, it is important to observe that, within this nightmarish script of American academia, Kimball and D'Souza dish out to marxist professors criticism and responsibility of a different register from that which they visit upon feminist and African-American scholars. Of all the prominent anti-

PCers, Kimball expends the most energy bashing marxists. Evaluating Terry Eagleton's work in the aftermath of the collapse of the Stalinist regimes in the Soviet Union and Eastern Europe, for example, Kimball crows that "a lot of good it does to subscribe to a materialist philosophy if it is consistently so glaringly wrong about the material world" ("Contradictions" 17). Eagleton, in fact, "knows that, put baldly, the doctrine of economic determinism is patently absurd," so he must employ "various gambits to soften or conceal the absurdity, without ever really denying the basic model of economic determinism" (20). Thus the key to understanding Eagleton is that he occupies "the uncomfortable position of being a literary critic who doesn't care much for literature except insofar as it is an instrument for social change" (21).

Kimball levels many of the same criticisms against Fredric Jameson. Jameson, like Eagleton, is a marxist "whose possession of 'the truth' is impervious to experience" ("Jameson's Laments" 15). In Jameson's case, however, this is because his nostalgic, "romantic utopianism" (14) contributes to an overall posture of "gnostic contempt for everyday experience and faith in a secular apocalypse" (15). Indeed, Kimball refuses to take Jameson seriously at all, since Jameson himself seems incapable of mounting an effective challenge to bourgeois society:

> What is the alternative? Professor Jameson is too busy boning up on cyberpunk, MTV, and performance art to formulate a compelling response. In the end, *Postmodernism* may be said to represent Professor Jameson's substitution of capitulation for an analysis of culture: he is fond of postmodern architecture and music, he confides, and "Food and fashion have also greatly improved, as has the life world generally." Perhaps it is just that life in Durham, North Carolina, as the William A. Lane Professor of Comparative Literature is not so bad. In any event, one suspects that Professor Jameson's seemingly insatiable appetite for intellectual novelty has finally given him a bad case of conceptual indigestion. What we are presented with in his new books is the spectacle of an intellectual whose longstanding commitment to gnostic pieties and fashionable politicized aestheticism has at last led him to abandon seriousness altogether. (16)

In short, Kimball has precious little to present as a case against Jameson's marxism or anybody else's. He relies without argument upon the *doxa* of the prevailing "post-marxist" winds in order to dismiss marxism as irrelevant to explaining contemporary capitalism. He sinks to *ad hominem* argument in order to bait academic marxists as hypocrites addicted to the privileges capitalism affords them.

This is not the place, of course, to embark upon a full-fledged discussion of how Kimball does manage to exploit a genuine weakness of academic marxism: namely, its lack of clarity concerning the nature of the Cuban revolution and, in particular, the Chinese "cultural revolution." Suffice it to say that Cuba and China are not "socialist" countries any more than Stalinist Russia and its East European satellites were "socialist" countries. Kimball can play the "Death of Marxism" card so effortlessly against Jameson—and, in a different essay, against Neil Larsen and Barbara Foley ("Periphery")—only because very few marxist theorists have contested the identification of these countries with socialism. (See Harman, "Storm" and "State," Gonzalez, and Callinicos for recent expositions of the alternative, "state capitalist" analysis of these countries.)

The point that concerns us here is rather the extraordinary way in which Kimball and D'Souza let marxists off the hook when it comes to apportioning blame for PC. Irrelevant and hypocritical in their own right, marxists sometimes act as the allies of PC. But the real PC villains remain the "race and gender" educators:

> It is certainly the case that individual professors in university English or history departments will incline to their own interpretations, or espouse a set of interpretations that could plausibly be termed "ideological." An English professor may identify with the New Criticism; a philosopher may think of himself as an historicist; a sociologist may apply functionalist analysis. More conventionally ideological styles, such as libertarianism or Marxism, may provide a frame of reference for particular scholars in various fields. In no other area, however, is there a shared orthodoxy for the entire department, indeed for the *entire field*. In fact, there is typically a wide range of positions within departments,

and universities usually go out of their way to assure that these differences are reflected in the curriculum. But this is not the case in Women's Studies and Afro-American Studies. (D'Souza, *Illiberal* 210)

D'Souza clearly indicts—not marxists—but feminist and black scholars as the power bloc imposing "a tyranny of the minority, or more precisely, tyranny in the name of minority victims" (214). When these scholars validate the experiences and concerns of women and minorities, they "in reality promote principles of inequality" (215). Racist and sexist backlash becomes inevitable because "the monolithic ideological focus of the so-called 'studies' programs seems to have produced a relentless, even fanatical, conformity of thought" (214). Once again, the victims have become the source of their own oppression.

It should come as no surprise, therefore, that opponents of such outrageous views as those of D'Souza and Kimball most often respond by tackling the anti-PC argument on its own terrain. That is, they generally pursue strategies of seeking to reverse and to refashion the central opposition between the "people" and the "power bloc" through which anti-PCers disguise their anti-democratic goals. Catharine R. Stimpson's famous 1990 MLA Presidential Address offers a paradigmatic illustration of the attempt to answer anti-PC from within the discursive framework of "radical democracy."

Stimpson's sympathies lie openly with those who believe that "multiculturalism promises to bring dignity to the dispossessed and self-empowerment to the disempowered, to recuperate the texts and traditions of ignored groups, to broaden cultural history" (45). She argues that the pressures exerted by global economic and communications systems toward creating a common culture are and must be accompanied by efforts toward "creating a counterforce, a variety of particular identities" (49), among which appear "age, class, ethnicity, institution, gender, nation, tribe, race, rank, religion, sexuality" (43). One edifying possibility afforded by the debate itself over multiculturalism is the ability to "create the moral equivalent of cultural border skirmishes" (54). What must be avoided in such skirmishes, however, is "romanticizing one thing while demonizing another . . . a bad performance of an old two-step of language: the binary opposition" (57). Thus Stimpson suggests in effect that

literary scholarship should stage discursive encounters between the "people's" drive toward serial diversity and the "power bloc's" drive toward cultural homogeneity, all the while refusing to draw clear boundary lines between the sets of groups and interests that compose the two processes.

Now, it is crucial to highlight the tension displayed in Stimpson's argument between an understanding of multiculturalism as embodying legitimate demands by oppressed groups for greater power in society, on the one hand, and a hesitation to view their oppression as the result of a *real opposition* between oppressed groups and their oppressors, on the other. This tension actually stops Stimpson from endorsing PC in the same enthusiastic way in which she has endorsed multiculturalism:

> In 1990, these rhetorical oppositions [such as "representation of various groups" versus "merit"] linked up into a single two-footed trope, the conflict between being "politically correct" and being "politically incorrect." . . . The brief against P.C.ers is that they insist on a single attitude toward diversity, a monolithic celebration of differences. The tone of the brief varies from the wry, ironic bemusement of the cartoon character Politically Correct Person to vitriolic accusations that our campuses are the equivalent of totalitarian reeducation camps.
>
> I welcome the refreshments of satire and suspect the excesses of rage. So situated, I predict that the P.C. phenomenon, now hyped up, will eventually dry up. Our many differences will persist. (58–59)

Stimpson at best ducks and at worst dismisses the issue of PC in this passage. This is possible only on the basis of her failing to see the attack on PC within the context of the right-wing's wider agenda. Unbelievably, in the midst of a sustained ruling class attempt to destroy the hard-won gains of women and minorities, all Stimpson can finally express is her hope that future historians will say of the MLA that, "we had the freedom, with generosity, and courage to see the differences among texts and among ourselves. We erased the damaging differences. We typed out the differences that promised to renew us. We refused to destroy one another. For this, and for other reasons, we had our astonishing achievements" (60).

Failure to understand that "the attacks on women and minorities are part of an overall class offensive which aims to bolster a society run by and for a tiny minority" (Selfa and Maass 21), moreover, not only blocks the ability to defend PC but ends up weakening the defense of multiculturalism as well. Here the acid test remains Afrocentrism. Radical writers as different in other ways as Todd Gitlin, Cornel West, and Barbara Ehrenreich adopt a moral approach to the issue of Afrocentrism rather than a class approach. By this I mean that, while appropriately indicating the real limitations of identity politics, they manage nonetheless to equate the separatism or nationalism of historically oppressed groups with that of their oppressors.

Gitlin bemoans, for example, the "kind of parochialism in which one is justified in having every interest in difference and no interest in commonality," a parochialism, he claims, that results from "American-style tribalism" (Gitlin 188, 190). West argues that, "in so many slices of the black community, with the escalation of the discourse of whiteness and blackness, racism escalates, both in terms of the life of the mind as well as in practices. . . . Black nationalism politics [sic] is something that has to be called for what it is" ("Diverse" 329–30). And Ehrenreich explains that "when I say multiculturalism, I do not mean African-American students studying only African-American subjects; I mean African Americans studying Shakespeare (perhaps taught by African-American professors). I mean Caucasian students studying African-American history, Asian-American history, and so on" (Ehrenreich 334–35). Hence, for Ehrenreich, multiculturalism concerns the "attempt to find, in the rich diversity of the human world, some point of moral unity that brings us all together" (338).

But no such point of *moral* unity exists in the present historical context. It simply is not the case that black nationalists choosing to organize themselves separately can be construed as the moral equivalent of white supremacists choosing to organize themselves separately. The entire history of black oppression justifies the unconditional right to self-determination for African-Americans. If a separatist path is chosen, then it must be seen as a response to white oppression: emphatically, it is *not* a form of "black racism." Indeed, to posit, as these writers do, the equivalence of Afrocentrism and white suprem-

acy in moral terms is already to embark on the fatal slide toward accepting as valid the right-wing charge that affirmative action itself represents a form of "reverse discrimination." That is why multiculturalists must hold firmly to the view that there exists no such thing as "reverse discrimination," or, more to the point, "reverse racism."

For "racism" requires the *power* to oppress—a power that blacks, Latinos, and other minorities do not possess in this society. A class perspective on Afrocentrism and similar cultural movements, therefore, involves unconditional support for them against their detractors. Arguments still must take place with nationalists concerning the greater promise and success of united struggles against exploitation and oppression. Nevertheless, by supporting nationalisms of the oppressed unconditionally, it is possible to win individuals to united struggle by breaking the identifications that members of oppressing groups have with their dominant culture, and by earning the trust of members of oppressed groups. In backing away from a confident assertion of "class" rather than "morality" as the needed point of unity in the struggle against oppression, therefore, the critique of identity politics offered by Gitlin, West, and Ehrenreich loses what purchase it otherwise might enjoy, and they leave themselves with only the most abstract moralism as a weapon in the fight for the liberation of women and minorities.

Theory and Practice

From the point of view of literary theory, the obvious stake in the PC debate remains the ability to define the field of literary studies. John Searle remarks that:

> many professors of literature no longer care about literature in the ways that seemed satisfactory to earlier generations. It seems pointless to many of them to teach literature as it was understood by such very different critics as Edmund Wilson, John Crowe Ransom, or I.A. Richards; so they teach it as a means of achieving left-wing political goals or as an occasion for exercises in deconstruction, etc. The absence of an accepted educational mission in many literary studies has created a vacuum waiting to be filled. Perhaps the original mistake

was in supposing that there is a well-defined academic discipline of "literary criticism"—as opposed to literary scholarship—capable of accommodating Ph.D. programs, research projects, and careers for the ambitious. When such a discipline fails to be "scientific" or rigorous, or even well defined, the field is left wide open for various fashions, such as deconstruction, or for the current political enthusiasms. (Searle, "Storm" 105–06)

Searle is right, of course, to recognize that a power vacuum exists within literary studies. Yet he is wrong to lay the blame for this at the doorstep of a wobbly distinction between "literary criticism" and "literary scholarship."

While some differences may exist between literary criticism and literary scholarship—one need not have a Ph.D., for example, in order to hold down a job as a literary critic—none of them is finally important when it comes to defining an educational mission for literary studies. It is difficult to imagine what Searle has in mind when alluding to these differences, since even the driest, most "scholarly," and most "scientific" catalog of literary genres enacts assumptions about the social and psychological functions of such forms and inevitably spills over at some point into interpretation and even conjecture. Searle implies that, if literary studies were more rigorous, then there would be neither the need nor the opportunity for political investments in the academic discipline of the kind represented by PC and multiculturalism. Yet this is surely to ignore that the objects of literary study—that is, literary texts—are constituted as no more and no less than specific significations of social relations: relations of individuals to other individuals, of individuals to groups, of groups to other groups, of humans to their institutions (including language), and of humans to nature.

Unlike, say, a purely syntactical study of a literary artifact, therefore, the "literary" study of literary texts is unavoidably political and ideological because of the nature of the object studied. This is not the place to rehearse the widely accepted *knowledges* produced by literary "scholarship" in this regard: in particular, the secularization of the aesthetic in the form of the fictional and its supplanting of religious representation as the primary means through which individuals acquire explanatory images for their subjective experiences

in the modern world. One need only recall here that literature and literary study constitutively concern such things as social relations and individual identities in ways that gases and plasma physics do not. Given this reality, it is both necessary and easy to affirm the desirability of "politically correct" and multicultural literary studies on the grounds of full equality and liberation for the exploited and oppressed.

From the point of view of social and cultural theory generally, what remains at stake in the responses PCers make to anti-PCers is the ability to devise the best strategies for defending and extending the gains that women and minorities won in the 1960s and early seventies. The "post-marxist" left no longer looks to revolutionary socialism as the context within which to wage a successful struggle for the liberation of women, blacks, or gays and lesbians. For the members of that left, the working class has failed to deliver profound social change and must now be abandoned in the search for "new subjects." Little does it seem to matter to them that the working class comprises at least seventy percent of society—including nurses, teachers, and secretaries, lesbians and gays, as well as the vast majority of blacks, Latinos, and Asians—who are compelled to work for a living and who have little or no control over what they make or do and the conditions under which they work.

Indeed, "post-marxist" academics claim that there is no privileged relation between the working class and the fight for full democratic rights and free-doms. Politics and ideology are now said to float freely above economics, and socialism must and can be constructed independently of class. The tactics and goals required by such a "declassed" socialism are those of a "plurality of democratic struggles" aimed at the achievement of "universal" human rights. Cross-class alliances and identity politics thus become the preferred models for organizing. And, not surprisingly, intellectual elites become the leadership of the social movements, insofar as intellectuals are judged to be the most susceptible to the kind of universalist and rationalist discourse that distinguishes the "new true socialism" from a "class-struggle socialism" still tied to narrow, even "sinister," interests of a material variety (see Wood 3–6).

Because of Bill Clinton's abysmal record on women, blacks, and gays and

lesbians; given his clear commitment to shifting the "New Democratic Party" sharply to the right; and because further austerity represents the only way out of the current economic crisis that is acceptable to the big business interests served by Clinton no less than Bush—it is quite likely that the anti-PC campaign will continue, albeit in a subtler, neoliberal form. Clinton says he is pro-choice, but he favors parental consent laws. Arkansas has *no* provision for state funding for the abortions of poor women and teens. Clinton supposedly supported lifting the ban on gays and lesbians in the military, but Arkansas "is one of several states which still has an anti-sodomy law. . . , requires contact tracing for people with the HIV virus, and allows doctors to test patients without their consent" (D'Amato and Selfa 7). Only two states, moreover, lack a civil rights bill banning discrimination in hiring or housing: Alabama and Arkansas. The rate of black unemployment in Arkansas during 1992 hit "17.2 percent, the highest of the five Deep South states" (D'Amato and Selfa 6).

Clinton may well become responsible for the enactment of some limited reforms that cost nothing, such as a Family Leave Act or congressional legislation of *Roe v. Wade*, but he will tread lightly where corporate profits and deficit fears are concerned, and so he will fail to address in an adequate manner the underlying structural problems of the economy that have given rise to the anti-PC offensive in the first place. Indeed, Clinton's call for sacrifices and preparations to impose austerity on working people go hand-in-hand with his slurs against the "bean counters" who wanted to see more women named to his cabinet.

The question thus arises whether the fight back should be organized on the basis of an explicitly class politics. Clinton's nomination of Zoe Baird in response to pressure from feminist groups provides a clear focus for an answer: Baird is a reactionary on worker's rights, the environment, and health care reform. Examples abound that equally discredit cross-class alliances and identity politics as strategies in for the nineties, including the willingness of middle-class feminists to sell out the abortion rights of poor and teenage women, and the pathetic performance of black middle-class politicians during and after the L.A. rebellion. Only a conscious class politics has any real chance

of success in the fight to defend women and minorities against the ruling class's ongoing offensive. But who in the universities holds the view anymore that class struggle is the central dynamic of social change?[1]

Note

1. This essay was originally completed in early 1993 and thus records only a brief surmise of Clinton's record. However, that surmise has proven to be all too true in the interim, given Clinton's backtracking on the Haitian refugees, gays in the military, Lani Guinier, and the prospect for grotesquely unfair tax increases and budget cuts in social programs, and serves to reinforce the conclusions I reach here.

7

What Was "Political Correctness"?

Race, the Right, and Managerial

Democracy in the Humanities

Christopher Newfield

If people get the enemies they deserve, it doesn't seem fair that pluralistic liberal humanists last year found themselves denounced as the threat to liberty known as political correctness (PC). Did we deserve this? Overall, we have been so cooperative. Having internalized a common American dislike for political conflict, humanists who teach many sides of various debates suddenly found themselves cast as coercive ideologues. Having only rarely drawn public policy implications from their fields, humanists suffered the charge that they replace education with indoctrination. In part due to disbelief, their rebuttals were reluctant and mild, largely invoking mainstream values (academic freedom, dialogue, diversity, tolerance) and tracing their opponents' arguments to the kind of moral failure that the latter had first attributed to them.[1] Some simply waited for the alarms to stop, for they seemed like the false alarms of the sort of people who might mistake AIDS education for the rejection of the family.

After more than a year of broadcasting emergencies, the national press lost interest, and we might be tempted to breathe a sigh of relief and get back to work. The conflicts the debate has expressed, however, are nowhere close to being settled, particularly on the point of whether conflict is good. The value of conflict was a major stake in the debate from beginning to end, particularly when it involved social antagonisms that could not be resolved through acts of imaginative sympathy. For example, Robert King, the acting dean of the College of Liberal Arts at the University of Texas at Austin, claimed that (at least Freshman) English courses should teach "writing and self-expression" rather than "politics and ideology" for no stated reason except

that politics and ideology are bound up with "division and separatism and hatred" ("Community").[2] This kind of attack challenges the validity of teaching conflict in the period when it has been most fruitful in bringing suppressed or ignored cultures into a long overdue dialogue with the traditional academic mainstream. Much of U.S. journalism concurred that a politicized humanities threatened a fragile national fabric with civil unrest.

This attack on conflict in the humanities continues to affect us. It continues to drive a wedge between "political" and "scholarly" forms of humanities research at a time when their convergence promises the revitalization of literary and cultural study as a functioning member of public discourse. And it officially rejects those forms of "political" research which threaten to go beyond affirming fundamental civil rights to engage in systemic analysis of the ties between power and knowledge. Hence, fields like Chicano Studies and "queer theory" become increasingly unsafe when they move from offering one more piece of the cultural mosaic to criticizing that mosaic's basic design.

Conservative challenges to the presence of politics and racial difference in humanities research have not been met with a defense of political critique so much as with the rejection of the politicized form the challenge has taken. The moderate response to PC bashing has not normalized politics but has generally mirrored the right's axiom that the free exchange of ideas has been besieged by the repressive effects of political agendas.[3] This of course perpetuates the myth that politics, especially in the form of equitable debate in humanistic research, blocks rather than enables nontechnological knowledge. The mutual evasion of politics has the immediate practical effect of misdescribing the PC crisis as the result of the right's irresponsible politics. More importantly, it obscures the larger identity crisis in the humanities to which the right responds.

To blame confusion or institutional weakness in the humanities entirely on the right is inaccurate and finally self-destructive. It amounts to a form of projection that disavows the center's and even the left's ambivalence about the role of social issues in the ongoing development of the humanistic disciplines. Blaming a vocal right allows humanities scholars to ignore our reluc-

tance to abandon those forms of security on which we have lately thrived, even when PC-bashing has shown this security to be frail.

The PC debates were not only political fights but were fights about the types of politics that cultural intellectuals should be allowed to present to society. The two contexts of the PC debates that I wish to stress, then, are major forms of control of the humanities' access to the outside world. The right's "bad behavior" was an effect of a perceived crisis of control rather than its cause.

The first of these contexts is a remarkably stable type of university governance. The general format might be labeled managerial democracy: major decisions affecting one level of the institution are made by levels above it, but usually with at least formal rights of consultation and participation. The functioning of the system is thought to depend equally on the consent of the governed and the authority of management. Thus department chairs decide the teaching schedules of individual faculty and deans determine the graduate funding of individual departments, but this authority, though hierarchical, incorporates much discussion and informal rights of appeal. University governance, as in my own very routinized University of California system, often seems the best of both worlds: it combines an efficient command structure with a great deal of reciprocity. Administrative democracy appears to be impartial and uniform on the one hand, and inclusive and open on the other. It suggests the best virtues of moderation; the clash of vibrant, creative energies on the student and faculty level can be organized and reconciled by the comprehensive and balanced overview provided by the leadership above. It is something like this vision of creative balance that former University of California president Clark Kerr memorialized thirty years ago in his influential version of postwar university management philosophy:

> To make the multiversity work really effectively, the moderates need to be in control of each power center and there needs to be an attitude of tolerance between and among the power centers, with few territorial ambitions. When the extremists get in control of the students, the faculty, or the trustees with

class warfare concepts, then the "delicate balance of interests" becomes an actual war. (36)

Kerr envisions a synthesis of tolerance and supervision that encourages the free migration of ideas and careers while eliminating the "extremists" who wish to disrupt this controlled mobility. Under this kind of liberal management, democratic exchange has a great deal of leeway within the limits of good order.

Administrative democracy has achieved remarkable stability and continuity in university life in the postwar period, when well-established universities enjoyed a financial security exceeding that of most of American industry. It is surprising that Dinesh D'Souza could get airtime by proclaiming a "campus revolution," since revolution is the last form in which the university's intellectual changes arrive. University administrations are generally in the hands of Kerr's moderates, with the best-known exceptions being conservatives. In a decade when corporate funding for conservative think tanks exploded, no one sent money to fund new research units in postcapitalist economics. University administrators are not elected by students or faculty. Unequal pay still rewards the equal work of professors of electrical engineering and American history. People of color remain a small and sometimes shrinking minority, and universities almost never explain their presence as an openly political choice.[4] Financial incentives are vastly more influential in creating university policy than any group's programmatic desires. Likening the funding behind a university's government contracts or corporate partnerships to any potentially "subversive" humanities projects is like comparing a TV station to a filing cabinet. The ten million dollars spent at my campus last year through the Department of Defense equals the amount budgeted this year by the four national humanities agencies for all national humanities research fellowships (see Townsend, Greenberg, and *Educational*). The John M. Olin Foundation alone spent twice that sum in 1990 entirely on "helping different people from respectable strands of modern conservatism."[5] Such radically asymmetrical commitments are built into the structure of our institutions and even our national identity. D'Souza and others fail completely in their attempt to find revolutionary opposition to them.

The humanities had a secure place in this broad and peaceful postwar consensus. Dominick La Capra once remarked that the research university is structured like a nuclear family: the scientists are the dads, and they go out and make the money, and the humanists are the moms, and they stay home and take care of the kids. During the 1980s, staying home paid off. Humanists might have been junior partners in university governance, but we prospered along with our scientist husbands. Humanities departments began hiring again after a fifteen-year stagnation, positions for newly validated specialties expanded with the canon, and traditionally unacceptable or "minority" fields such as lesbian and gay studies, feminist studies, popular culture, and African-American literature seemed on the threshold of qualified prosperity. Perhaps as a result of these trickled-down and yet hard-won gains, in ten years of graduate and faculty employment at three very different research universities, I have yet to hear any sustained faculty critique of the structural features that silently determine the university's mission and products day by day. I long ago concluded that humanists were largely content with the political structures of their institutions, provided they were fiscally sound. Feelings of deprivation or neglect would be addressed through individual success, rivalry with kindred humanist groups, program development, and local struggles with specific administrators. In the foreseeable future, there would be no general questioning of funding ratios with science and other fields or calls for *glasnost* in existing forms of managerial authority.

The first context for the PC wars, then, is the humanities' general contentment with the university's managerial democracy. The second is an identity crisis at the humanities' *literary* end. During the 1980s, traditional definitions of literary study as general enlightenment yielded more than in previous decades to those defining literary study as part of a spectrum of human sciences. Literary study, particularly at larger universities, has been shifting from literary history to cultural problems, from a field defined by its object of study (the expanded literary canon) to one defined by its questions and methods.[6] But developments in the 1980s accelerated this move away from the traditional mission without offering an accompanying clarity about a general mission to replace it. Giving the humanities a new research identity,

as diverse as that would inevitably be, required an analysis of the relation between the humanities and contemporary American society that the 1980s academy did not provide. The analyses that did exist were sporadic and often recriminatory. Thus the humanities still has currency with the public through its roles as cultural curator and teacher of skills, but it lacks similar status as a field of research. PC bashing simply exploited an identity crisis that was already well along.

These two contexts for 1991's PC debates have politics in common—the politics of university governance and of the public role of critical cultural studies. The common politics is that of managerial democracy inside and outside the U.S. university, which addresses social conflicts through procedural reconciliations. With notable but rare exceptions, literary studies had not openly challenged this type of administration or its effects on its own research until the insurgence of precisely those fields—gender studies, race studies, queer theory, and others—that the right has fingered as "political."

Rejecting Politics: The 1980s Right

Last year's attacks on the academic humanities built on a tradition refurbished in the Reagan eighties, when admonishments from policy makers and education officials became part of scholars' discussions of their field. Initially, these demanded a limited compliance that could not be mistaken for a threat to civil liberties. The early requests were restricted to rehabilitating teaching functions in the humanities while posing little danger to variegated research. Thus William Bennett's relatively modest proposal, *To Reclaim a Legacy*, asks that the humanities "accept its vital role as conveyor of the accumulated wisdom of our civilization." Lynne Cheney's 1988 National Endowment for the Humanities report on the humanities in America, while sometimes criticized for its attack on academic specialization, mostly focuses on the need for improved public access to this accumulated wisdom. These documents seemed compatible with the continued expansion of humanities funding and even with their "democratic" dissemination.

Other works of that decade offered more confining descriptions of what humanities tradition should look like. I am thinking particularly of Allan

Bloom's *The Closing of the American Mind* (1987) and Roger Kimball's *Tenured Radicals* (published in 1990 but based on primal scenes occurring between 1986 and 1988). These books discuss an abundance of deficiencies in the modern university's treatment of the humanities: the loss of canonical texts, trendy methodologies, the fragmentation of the knowledge base, and the teaching of material for reasons other than abstract quality or tradition. Rather than being exposed to the values and ideas that make Western civilization a global triumph and that undergird our prosperity and morality as a nation, students today are likely to be taught that no values are better than any others, and that they can believe what they please. They are exposed to "nihilism, American style," to name a section of Bloom's book, or to "relativism," to cite Kimball's definition of the "New Sophistry," or to Theory, and so on. These trends expressed themselves in the increasing internationalization of English departments under the auspices of studies of post- or neocolonial culture. They appeared in public debates about the literary canon and about the immorality of deconstruction as allegedly revealed by Paul de Man's wartime journalism.

But this large host of concerns usually boiled down to a complaint about the presence of "politics." In each case the problem was the infection of the nation's representative culture by current controversies and the interests of discontented groups.

The 1980s jeremiads, though often intricate, reiterate a desire to preserve art from politics that was most systematically articulated by Matthew Arnold's nineteenth-century plan to govern the conflicts of national life with the best ideas from the past. Kimball, for example, invokes an Arnold who "looked to criticism to provide a bulwark *against* ideology, against interpretations that are subordinated to essentially political interests" (*Tenured* 74). Like Bloom, Bennett, and others, Kimball demands that the modern academy regard criticism in the same way: as a realm of "truth and virtue" that remains unaffected by partiality and conflict.[7] When these authors contemplate contemporary U.S. society, they sound much as Arnold did when he gazed on the spectacle of the French Revolution. In France, Arnold saw "a whole nation . . . penetrated with an enthusiasm for pure reason," but the wonderful "force, truth,

and universality of [its] ideas" was destroyed by one thing: "the mania for giving [them] an immediate political and practical application" ("Function" 264–65).

Thus, in the Arnoldian tradition, politics corrupts reason while criticism preserves reason's liberatory powers. It represents right, where "right is something moral, and implies inward recognition, free assent of the will" (266). Society is a mess, coercive and chaotic. Politics is an enslaving anarchy without orders from above.[8] Criticism, "the best that has been thought and known in the world," provides those higher orders. It manifests itself as a rejection of political application in favor of "disinterestedness." The purest containment of politics is found in the formal union of great poetry, and it is for this reason, in the words of I.A. Richards, that poetry is "capable of saving us; it is a perfectly possible means of overcoming chaos" (qtd. in Eagleton, *Theory* 45). Freedom depends utterly on the absence of all politics not subordinated to the law of criticism. Disinterestedness means a willing submission to a Kantian universal. The 1980s attacks on what would later be called PC follow Arnold's polarization of society and thought, a polarization that virtually invented "the humanities."

But in looking at the 1980s books again, I am struck by how unsuccessful they are at translating their Arnoldian view of culture into a present crisis. They pointed out the footprints of politics in the garden of the humanities and called for backup, but none arrived.

Why wasn't there more *public* response?[9] This absence can be explained in part by the manifest fact that upheaval was far more dramatic outside the university than in, and that most law-and-order energies were focused there. On top of this, the attacks were anecdotal, transparently idiosyncratic, and too sweepingly rejectionist to convene more than a self-elected rump parliament of bypassed public guardians. And much of their fire was drawn off by the de Man controversy.

Furthermore, liberal educators had two good lines of defense. They pointed out that knowledge in general, and the right's accusations in particular, are always political in a broad sense. They also noted that it is normal for

humanistic knowledge to grow and change in the way that distinguishes any living set of disciplines, not to mention any democratic institution. On the first point, liberals could reiterate the long-standing pragmatist argument that knowledge is always inflected by the historical conditions and interests through which it is pursued. The right could respond only by tilting at an imaginary reductionism that purportedly claims that knowledge reflects exactly the interests of the knower, and by searching with little success for a crudely deterministic relativism.[10] On the second, the right was unwilling or unable to elaborate the kind of methodological and conceptual changes that a truly disinterested humanities *would* allow. It was unable to take the crucial step of developing its own persuasive and stable criteria for distinguishing "political" from "disinterested" knowledge. It could not explain why, for example, it is "political" to teach the theme of colonialism in Shakespeare's *The Tempest* but "disinterested" to discuss *Richard III*'s "long survey of England's troubles in the fifteenth century."[11]

Thus the right's fragile denunciations of all newish ideas suggested simply a creationist rejection of conceptual evolution. Barbara Herrnstein Smith, in her 1988 MLA Presidential address, could plausibly reduce much of the right's unhappiness to a fear that "contemporary humanities education may be making students *less* complacent, *less* conformist, *less* transcendentally inspired and consoled, and, therefore, more critical of orthodox assumptions, conventional accounts, and established authorities and arrangements" (287). To make matters worse, the liberal enemy did not bear out the right's charge that they produce ideologically predetermined results, for, as Smith does in her address, they call for the kind of pluralist individualism in research that official U.S. culture expects of all its citizens. By comparison to the centrist model of how change and progress emerge from open yet highly disciplined research strategies going forward only under the continual guidance of broadly accepted professional standards, the conservative ideal of a transcendental disinterestedness was superfluous. Even its money wasn't buying many new members. The 1980s right had all the earmarks of an outraged but doomed rear guard. Nonacademics were deeply unimpressed.

The Race Menace

Why, in 1990, did the media start to care about all this? Because the right suddenly discovered its clear and present danger. In the 1980s they had offered a custodial project of conserving the traditional canon and values free of "political" challenges to their authority. In the 1990s this has become a cultural militarization proceeding along the lines of the war on drugs.

The new danger was described as a threat to freedom of thought and speech. The media had largely ignored the conservative 1980s canon police and related attempts to suppress controversial ideas as political. When told that this censorship menace had appeared on the center-left, it expressed a patriotic ire. *Newsweek* ended 1990 with a cover story on the left-wing "thought police." This article's data, written up by Jerry Adler, suggests that the staff could find very little in the way of empirical referents for the PC movement; they cobbled the story together from a series of disparate campus incidents in which a racial or sexual minority rebels against a routine slight coming from someone or some group for whom such back talk is "nontraditional." What to these students were often acts of disputation, remedy, reform, or clarified dialogue are described by Adler as insidiously totalitarian and part of a widespread popular front falling just short of conspiracy.

How did these incidents of redress or protest get translated as attacks on freedom? Adler uses a prefab anticommunism. "There are in fact some who recognize the tyranny of PC, but see it only as a transitional phase, which will no longer be necessary once the virtues of tolerance are internalized. Does that sound familiar? It's the dictatorship of the proletariat, to be followed by the withering away of the state. These should be interesting years" (54). It was Adler himself who sounded familiar. Even if his targets had comprised reborn Leninists (strangely preaching tolerance and an end to hate speech), we might still marvel at the perfect malleability of anticommunist rhetoric as it moves to fit the projected source of almost any breach of consensus. That his targets were mostly students preoccupied with antidefamation and civil rights issues—who were often simply opposing the more everyday barriers to the "common citizenship" their detractors desire, and who usually oppose these barriers with the help of already existing legislation—makes it still more

remarkable that language used during the Cold War against an apparently expansionist nuclear superpower could be immediately redeployed against twenty-year-old members of traditionally powerless American social groups whose grievances the author admits as valid.

When did these dangers become equivalent? When the incidents involved people of color who convinced the authorities to side with them. Communistic and racialized others share a power to reveal the permanent vulnerability of established American authority.

Newsweek was not alone in comparing multiculturalism to communist militarism. The Washington columnist Charles Krauthammer described race consciousness in the same way. He first identified a renewed "Socialist" threat to American peace in similarities between certain political trends in foreign countries and American universities. These menacing foreign trends are environmentalism and peace, which are bad enough in themselves, but made worse through their international solidarity with a domestic mutation, deconstruction. Deconstruction is not just a decadent nihilism that the public has prudently ignored, but a trojan horse for an "intellectually bankrupt 'civil-rights community.' " This civil-rights community, for Krauthammer, "poses a threat that no outside agent in this post-Soviet world can match"—"the setting of one ethnic group against another, the fracturing not just of American society but of the American idea" (B5). PC is a new form of communism because it allows for ethnic differences that are *not* subsumed into a common culture.[12]

Further confirmation that the right fears racial difference rather than censorship came from the syndicated columnist George Will, who demanded that America treat the politicized humanities as a covert operation. We must attend, he wrote in *Newsweek*, to:

the many small skirmishes that rarely rise to public attention but cumulatively condition the nation's cultural, and then, political, life. In this low-visibility, high-intensity war, Lynne Cheney is secretary of domestic defense. The foreign adversaries her husband, Dick, must keep at bay are less dangerous, in the long run, than the domestic forces with which she must deal. Those forces

are fighting against the conservation of the common culture that is the nation's social cement. ("Literary" 72)

Will stops short of calling on the NEH to give fellowships for organizing "common culture" citizens councils, but he does sound the alarm about "domestic forces," which declares a new civil war at the very moment when American sovereignty seemed most triumphant. Our only defense against this fragmentation, he suggests, has been the unifying supervision of a common culture that is now being challenged by the excessive self-assertion of minority groups.

Much of the early PC-bashing was like Will's in slant if not in pitch—an Arnoldian vision of anarchy without firm rule from above. As Arnold used to say, "force till right is ready." Ideally, a different Cheney would supervise each half of this marriage of light and power. The danger they forestall is that, as Evelyn Waugh says in Kimball's concluding citation, " 'once the prisons of the mind have been opened, the orgy is on' " (Tenured 207). For a post-Cold War U.S., the opened mind would produce not just a political orgy but a race orgy, the recipe for social collapse.[13]

These three journalists amplify a connection between anarchy and the presence of racial difference that temporarily culminated in the closely concurrent publications of Dinesh D'Souza's Illiberal Education and Arthur Schlesinger's The Disuniting of America. While politics threatened truth, virtue, and freedom in the 1980s, both authors saw racial difference threatening national security in the nineties. D'Souza's book picks up the 1980s issues of censorship and "politicizing scholarship," but grounds these and other phenomena in the "minority victims' revolution on campus" (185, 175). Readers should not think that this book is a brutal and silly mass of anecdotes simply because of the stuffy incompetence of D'Souza's paraphrasing of ideas or the boyish stupidity of his claim that no one feels impaired by "the effects of Western colonialism in the Third World, as well as race and gender discrimination in America" except to win unmerited career advantages (13). The book's structure is in fact quite precise: from the West Coast to the Midwest to the Northeast and even into the South, the invasion of coercive left-wing politics

shows up best in the "racial incidents" that advance the "victim's revolution" of those who seek remedies for their (wrongly) perceived subjugation by America.

For D'Souza, almost everything new in the academic humanities in the last ten years points to race revolt—except, perhaps, a funding base that lags further and further behind that of military and scientific research.[14] "The real problem," he says, "is not reader-response theory or deconstructionism *per se*; rather it is the extent to which they serve the ends of a political movement that has propelled them to the forefront of the victim's revolution on campus" (182).[15] D'Souza's hodgepodge assimilation of disparate disciplines, groups, and intellectual traditions makes sense only as moments in an overriding effort to identify civil rights with civil war. More precisely, it links revolution to any notion of civil rights based on a consciousness of racial subordination and difference. Like the other journalists, D'Souza sees racial difference as a problem because it endangers common culture or what he calls the "neutral framework," the "uniform standard," or "the shared community which transcends . . . narrower interests" (186, 50, 55).[16]

The example of D'Souza and the other journalists suggests that the success of the 1990s attacks on PC links a traditional anticommunist sense of a nation in peril to a galvanizing race anxiety. As such, it activates a genteel white nationalism in which the red menace is directly replaced by the rainbow menace.[17]

Race and Political Order

This ready slide from the red to the race menace needs further explanation. This is particularly true in light of the fact that U.S. conservatives are often as devoted to the multiracial melting pot as are liberals, and regard racial or at least "ethnic" difference as proof of America's powers of cultural synthesis, its rich pluralism, and its centrality to global civilization. So why is some multiracialism dangerous and not others, and why now, when changes in racial power remain so gradual, not to say downright slow, uncertain, and in reverse?[18] Why does a rights-based campus multiculturalism no longer seem to conservatives like a showcase of healthy American diversity?

In addressing this question, one cannot simply invoke these conservatives' racism. Precisely because of its racist histories, the U.S. is as fecund as any society in proliferating variations of racialized thinking. Using the term *racism* can too easily grant it an explanatory power when its own existence and workings themselves need explanation.[19] Further, as an explanation, *racism* lumps together a wide range of behaviors that run from slaughter and lynching to "color-blind" institutional discrimination. Racism, with its historical connection to segregationism, favors the former side of this spectrum, and tends to obscure the fact that the racialist thinking of elite, educated, usually Euro-American professionals is, at least rhetorically, antisegregationist. D'Souza, for example, does not lament what he oddly calls "the recolorization of America," but only "minority demands for self-segregation" (48). Bloom also complains, not about the presence of students of color, but about their "doing it by themselves" (*Closing* 93). The right is not calling for segregationism but for the opposite, a well-governed integration, and their racial anxieties cannot be reduced to racism in its conventional sense.

Integrationism, according to Gary Peller's recent description, "identifies racial oppression in the social structure of prejudice and stereotype based on skin color, and equates progress with transcending a racial consciousness about the world." It blends with the Arnoldian or neoplatonic idealism of conservative humanists in their concern with transcending difference. Conservatives are not at all extremist in sharing a post-1960s mainstream Euro-American consensus that color blindness underwrites ideally neutral, uniform judicial procedures. "Liberals and conservatives are broadly distinguished by how far they believe the realms of bias or neutrality extend. But their understanding of racial justice is the same: achieving justice means universalizing institutional practices in order to efface the distortions of irrational factors like race, ultimately making social life neutral to racial identity" ("Integration" 55, 56, 57).[20] Integrationism regards racial assimilation as a prerequisite to the "common culture" that forms Will's "social cement."

It might seem at first that linking 1990s PC-bashing conservatives to racial integrationism makes them acceptably moderate, but this is not the case. During the 1980s the right promoted integrationist "common culturalism,"

but only while simultaneously separating integrationism from any tendency toward egalitarian pluralism. Michael Omi and Howard Winant have nicely described this double movement: "In the aftermath of the 1960s, any effective challenge to the egalitarian ideals framed by the minority movements could no longer rely on the racism of the past. Racial equality had to be acknowledged as a desirable goal. But the *meaning* of equality, and the proper means for achieving it, remained matters of considerable debate" (113). The right, of course, argued that equality means equality of opportunity, which it further defined as the chance to apply and compete regardless of the material disadvantages and systematic disparities that influenced the outcome. Were equality of opportunity to have suddenly produced cross-racial equality of outcome, the right would likely have denounced it, having insistently stigmatized equality of outcome as sufficient proof of state tyranny. This was so much the case that liberal demands for equal outcomes across race (and to a lesser extent, gender) have all but vanished from public view, and even the fallback defenses of equality of opportunity were softpedalled by their few Euro-American defenders. For more than a decade, equal opportunity employment practices were attacked as "quotas" and "special preferences" that penalized white citizens for racial crimes they did not commit. At the same time, conservatives portrayed every kind of social equality as a danger to economic efficiency, freedom, and meritocracy. In this environment, integration formed an alliance with inequality. Integrationism favored top-down social discipline at least as much as it promoted racial equality.

This inequality, when linked to the idea of a common racial culture, extends to the public realm those inequalities of administrative order in which most Americans spend their working lives. Integrationism partially replaces exclusion from membership as a mechanism of producing cultural unity, but exclusion from *power* remained the common effect.[21]

Supreme Court Justice Byron White's 1989 decision in *Wards Cove Packing v. Atonia* offers a convenient illustration of *anti*egalitarian integrationism. Alaskan cannery workers had brought a discrimination suit against company management on grounds that Asian and native Alaskan employees were far more likely to be found in unskilled line jobs than in better-paid, managerial

positions, where white employees predominated. The cannery workers' suit did not allege deliberate discrimination but only discriminatory effects. Their suit in effect confronted integrationist racism by claiming that ostensibly neutral and inclusive procedures can have racist outcomes. Justice White, writing the majority opinion favoring the company's policy, first acknowledges that the Court has interpreted Title VII of the Civil Rights Act of 1964 to prohibit not only discriminatory intentions but ostensibly unintended yet discriminatory outcomes:

> *Griggs* v. *Duck Power Co.*, 401 US 424, 431 (1971), construed Title VII to proscribe "not only overt discrimination but also practices that are fair in form but discriminatory in practice." Under this basis for liability, which is known as the "disparate impact" theory and which is involved in this case, a facially neutral employment practice may be deemed violative of Title VII without evidence of the employer's subjective intent to discriminate that is required in a "disparate treatment" case. (*Ward's Cove* 642, 645–46)

The concept of disparate impact traces racist effects to institutional structure rather than to individual bigotry. It does not limit itself to anomalies of racial prejudice but challenges the normal operation of a system in which administrative power has the appearance of neutrality. It refuses to focus only on individual bias, on the intrusion of personal politics into an impartial system of business practices, for it supposes that such racial politics can be part of the "impartial" system itself.

White's opinion repudiates direct racial discrimination or segregation, and cannot be considered racist in that sense. The "employer's selection mechanism," he says, may not use "barriers or practices deterring qualified nonwhites from applying for noncannery positions," and it may not result in a "percentage of selected applicants who are nonwhite [that is] significantly less than the percentage of qualified applicants who are nonwhite" (653). But White's opinion does allow discriminatory effects that issue from a "reasonable" business practice. Business may rush in where barriers fear to tread.

White's ruling defends rational and systemic as opposed to prejudiced discrimination in two major ways. It shifts the burden of proof of disparate impact from the mangers of the practice to those who challenge it (659).[22]

More fundamentally, it affirms the priority of the needs of business to those of employees or the general citizenry. In earlier cases, like *Griggs*, the Court had ruled that the employees' complaint would prevail over a management preference unless management could show business *necessity*; employees were granted parity with their bosses in all but extreme circumstances. White rejects this precedent by declaring that the company need not demonstrate business necessity but only a reasonable preference.[23] Furthermore, though the employer must be willing to try to justify the preference, it need not actually succeed in persuading the affected persons or the courts.[24] White augments managerial power by allowing it to make laws out of its preferences rather than out of "necessity," and by allowing it to govern without the consent of the governed.

White makes this consolidation explicit. Though unskilled cannery workers are free to make their own governance suggestions, such as affirmative action hiring,

> any alternative practices which [the cannery workers] offer in this respect must be equally effective as [management's] chosen hiring procedures in achieving petitioners' legitimate employment goals. Moreover, "factors such as the cost or other burdens of proposed alternative selection devices are relevant in determining whether they would be equally as effective as the challenged practice in serving the employer's legitimate business goals. Courts are generally less competent than employers to restructure business practices."
> (661)

White is protecting the right of management's "chosen practices" to prevail in whatever ostensibly democratic consultation they have established with the employees. Varying a phrase three times in a display of its ascendancy in his mind, White declares "legitimate business goals" to be a principle to which the public judiciary must conform. Management also trumps the laws of economic efficiency through the priority of unspecified "other burdens." All parties, White supposes, must submit their various claims to the laws of business as interpreted by those in management positions.

Racial difference intruded itself in the cannery suit as an obstacle to the

free circulation of administrative prerogatives. The cannery employees made a claim about their own preferences as to the social and economic effects of company policy, and presumed their autonomous agency. They took some sovereignty from management and spread it around. The danger, for Justice White, lies not so much in damaging white supremacy as in damaging what white supremacy symbolizes to white elites: management's exclusive power to decide about race and virtually everything else. Since managerial authority must enforce a great deal of cultural sameness, management will stay "white" as long as it stays management. The principles of management allow Justice White to maintain racial divisions without making a racial case. Managers don't discriminate, but all good management does. White's opinion can reject racial discrimination even as it justifies the racialized hierarchies of managerial order.

Racial outcomes cannot be judged by whether a person of color is excluded or included from a system unless the system's structure of governance has been analyzed. In discussing the integrationist defense of managerial authority, I do not mean to suggest that U.S. racisms are reducible to antidemocratic tendencies or that racism is a secondary characteristic of managerial elitism. U.S. institutions seem so frequently to be inhibited by a primal white "fear of a black planet" that forgetting that race is "a preeminently *social* phenomenon" is often a functional shortcut to accurate pictures of everyday interactions.[25] But as a phenomenon inextricably though variably related to a multitude of other social factors, racism must be learned and relearned, and for this it needs schoolrooms; in the 1980s one of these schoolrooms was the hierarchical, managerial integrationism that Reagan culture heralded as the "Freedom Road" of "minority opportunity." It is impossible to understand racism in the U.S. without understanding the abounding American faith in higher management; these intersect in the PC debates.

As it appears in the vast canon of literature on corporate power, the managerial tradition that rears its head in *Ward's Cove Packing* rests on at least two symbiotic features. First, it tolerates and even encourages difference. Kerr coined the term *multiversity* to express and endorse institutionalized diversity, and White conceives the normative corporation to be multiracial,

although he does not use the term. This tradition gains momentum as the 1980s renewed America's commitment to business culture while simultaneously proliferating schemes for liberalized, decentralized management like William Ouchi's "M-Form" strategy for "multidivisional" operations. Hewlett-Packard calls this ostensible democratization "MBWA (Management By Walking Around)" (Naisbitt and Aburdene 48). This kind of management rejects essentialist notions of power flowing from a sovereign, and would be best termed *post*modern management had Michel Foucault not traced ideas of power as an economy all the way back to the sixteenth century, and had political economists like David Harvey not demonstrated how "flexibility is not a new concept" ("Flexibility" 73). The flexible manager is the benevolent parent who, in one account, insures that his or her company is a "nourishing environment for personal growth" (Naisbitt and Aburdene 52). The corporation becomes a family of units, each of which is celebrated for its autonomous and unique contribution. The 1990s synthesis has been most triumphantly described in the title of Tom Peters's most recent book, *Liberation Management*.

But then, decentralized and "flexible" management retains final sovereignty over all divisions. Thus Kerr's multiversity relies on "moderates" being in control. Good management depends on the dispersion of a general economy of governance, on Kerr's "delicate balance of interests." The individual corporate sovereign has been replaced by the circulation of general rules and influences that, while encouraging diversity, maintains unity nonetheless. To repeat, flexible management systematizes sovereignty as an *economy* of power.[26] Since, again in Kerr's terms, moderates are "in control of each power center," each separate unit can be trusted to resemble the others enough to insure governing power through a common culture. As Ouchi notes, "each division in an M-form company is not truly autonomous" and thus does not challenge a dispersed but finally universal command (23).[27] Differences are encouraged so long as basic rules and values circulate through the corporation's every subculture without impediment. Diversity does not subvert this general economy. In fact, the background uniformities of the general economy depend on a recognition of diversity in order to function, for they must encourage a sense of inclusion, individuality, and participation.

This second aspect of flexible management guarantees that top-down authority, while it does not appear in the old form of sovereignty, survives, coexists, and works through the dispersal of power into a multidirectional field. As Harvey notes, "flexibility has little or nothing to do with decentralizing either political or economic power and everything to do with maintaining highly centralized control *through decentralizing tactics*" ("Flexibility" 73). Flexible management sponsors differentiation as a means to a more inclusive, delicate policing, and most advocates of renewed corporate management are open about this. "You have to sit back and trust your people," Lee Iacocca observes, "once you've laid down the rules" (79). The successful operation, note Tom Peters and Robert Waterman, achieves "the coexistence of firm central direction and maximum individual autonomy." It masters "simultaneous loose-tight properties." It knows how to be sure that "soft is hard" (318, 319).

An administrative democracy like ours prizes "soft" universals as the basis of an economy of order. What is soft and universal at the same time? According to Peters and Waterman, "culture is the 'softest' stuff around" (319), and it offers universals that provide Will's "social cement." U.S. cultural systems are clearly too complex to be equated with business firms, but the vast majority of their inhabitants are habituated to a businesslike union of diversity in commonality. The right's furious rejection of attacks on European culture's claims to universality does not denote a nostalgia for an imperial dominance so much as a defense of a very functional form of flexible control.

Racial difference has a long American history of underwriting the paradoxical conjunction of democratic and hierarchical power. Barbara Fields has argued that as early as the seventeenth century, "racial ideology supplied the means of explaining slavery to people whose terrain was a republic founded on radical doctrines of liberty and natural rights. . . . Race explained why some people could rightly be denied what others took for granted: namely, liberty." (114). After the end of American slavery, racial difference was adapted to a variety of social orders where it performed the same general function of justifying the presence of subordination in a system officially dedicated to equal freedoms. At present, when racial difference does not officially mean

racial inequality, the threat of unmanaged difference can justify managerial hierarchy in a system officially dedicated to democracy; it makes top-down management seem a unifying, rationalizing source of equity, fairness, and mutual understanding, one which does not contradict and in fact enhances democracy's dispersal of power.

In *Ward's Cove Packing* and much of the recent PC troubles, unmanaged racial difference is singled out as the kind of diversity that rejects managerial governance. Racial difference arguably poses the single most visible threat to these flexible resolutions. Race connotes autonomous principles that cannot be subsumed by centralized rules, a "democratic imaginary" from the management point of view (regardless of the sort of democracy a racialized group might or might not practice). Much of the tremendous racial anxiety now being felt among conservative integrationists is the old Arnoldian wine in an American bottle: the belief that racial difference would mean the lawlessness of an equality with what is different.

The right is no longer resisting the presence of people of color *per se*, but has fought it bitterly when it represents a democratization of power relations. The right repudiates segregation precisely to the extent that segregation has a separatist flip side which pushes unmanaged democracy into an "anarchic" politics of difference. Integration justifies and sustains inequalities that no longer flow from crude discrimination but from ostensibly neutral market mechanisms for allocating resources. Conservatives now approve of civil rights where this means the right of any individual to face open competition according to general rules of performance.[28] They do not approve of civil rights when that means a redistribution of economic power of the kind increasingly demanded by Malcolm X and Martin Luther King, Jr. in their final years. They support a Rainbow Coalition when it means "Weed and Seed" for poor children but not when it challenges the management of community governance.

Flexible Authoritarianism and the Humanities

I've been suggesting that the crisis of race among conservative integrationists has been inseparable from the crisis of hierarchical power within mass democ-

racy. Where do the conservative humanities fit into this? Flexible management, schematically, operates through a double gesture in which hierarchical central- ization coexists with egalitarian dispersal; the conservative humanities does not admit assisting either of these, but describes itself as inhabiting a realm of freedom in which management is not required. This claim is far less plausible than it first appears.

As I've already noted, the conservative attack on PC relies on a fixed opposition between the coercions of politics and the freedoms of disinterested thought. Where this distinction is in place, literature, art, and their related commentary are seen not to need to impose laws of authority in the manner of a Supreme Court justice. Politics imposes a law external to the individual while art allows the individual to give a law to him or herself. While history and "public opinion" encourage the individual to "surrender to whatever is most powerful," criticism in the Arnoldian sense provides a liberating "quest for knowledge and certitude" (Bloom, *Closing* 41). D'Souza, for example, traces his alternative to "illiberal education" to John Henry Newman's *The Idea of a University* (1852), which for him envisions " 'that true enlargement of mind which is the power of viewing many things at once as one whole, of referring them severally to their true place in the universal system' " (23). Individual knowledge is accompanied by interpersonal harmony. Bloom sees true education as reflecting the fact that "men may live more truly and fully in reading Plato and Shakespeare than at any other time, because then they are participating in essential being and are forgetting their accidental lives." Because truth reveals the "Oneness" of "essential being," "those who seek the truth" become "absolutely one soul as they [look] at the problem" (*Closing* 380, 381). This view crosses narrowly defined political boundaries to influence the more liberal dreams of educators like Woodrow Wilson, who saw the ideal university as a place that was "used to the rough ways of democracy; and yet a place removed—calm Science seated there, recluse, ascetic, like a nun" (qtd. in Kennan 4). While political democracy may require supervision, thought does not. Scholars who rise above politics into calm science achieve a collective harmony, but only through mutual consent rather than external rule.

But the humanities as a search for ordered freedom has a couple of liabilities. It has tended to found its unity on exclusion, and there is little dispute at least about the basic facts of its history of celebrating universal reason even as it divides the cultural globe along lines of gender, race, nation, sexuality, and so on. And it does not rise above the centralizing, hierarchical aspect of management but retains and idealizes it. The conservative humanities might manage to pluralize itself by broadening its universals or reexamining previously rejected candidates for inclusion, but this would not prevent it from sustaining the comforts of authoritarian governance.

What would make the conservative humanities deserve the label "authoritarian"? One traditional criterion is the presence of arbitrary power, and Roger Kimball finds this possibility plausible enough to address. It comes up as he is trying to explain his objection to the liberal view that "the humanities are better conceived as fields of exploration and critique rather than materials for transmission." Stating his preference for "transmission" over "exploration," Kimball sees the resistance to receiving transmissions as a sign of "a deep suspicion of authority." He then argues that while some authority is worthy of suspicion, the authority characterized by humanistic tradition is not. The bad kind of authority wields that "*arbitrary* power whose aim is domination." The good kind is based on a "*legitimate* power whose aim is unity," and this authority typifies what cultural history has found worthy of transmission. Legitimate power rests on a vision of unity while arbitrary power seeks only control (*Tenured* 74).

But refuting the presence of arbitrary power is irrelevant in an epoch when the most successful forms of power, particularly in cultural circles, dominate through the opposite of arbitrariness; systematization, coordination, integration—in a word, unity. Kimball unwittingly confesses this feature of unity in defining it, following Arnold, as the "willing 'deference to a standard higher than one's own.' " The difference between unity and domination, for Kimball, boils down to the difference between "willing" and "unwilling" deference. Deference is present even in willing consent, and whatever free will is involved arises only as the freedom of an inferiority to a "higher standard." Consent is meaningfully distinct from submission when it refers to an agreement

between equals, but it is precisely this equality that Kimball's unity denies. Under "unity" and tyranny alike, the subject is obliged to consent to the views of "great wise men in other places and times who can reveal the truth about life" (*Closing* 34). Kimball succeeds only in showing that unity is a form of domination, "legitimate" though that may be.

By dropping the misleading issue of "arbitrary" power, the authoritarian strain in the contemporary humanities can be better described as the tacit assertion of an inherently hierarchical system in which the interpreter can best act on the basis of his or her secondariness, belatedness, or inferiority to a preestablished governing standard in relation to which freedom must be regarded as consent rather than control.

Prospective democracy is not a novel irritant for the humanistic right. It has never been libertarian, and has never favored entrepreneurial textual interpretation, iconoclasm, new conceptual products, self-determined promotions, or relocating intellectual production in new cultural settings. To the contrary, conservative humanists from Arnold on have emphasized law and order. At times they sound as though submission is not the means to the end of unity but an end in itself. To take one recent example, Victor Brombert, president of the Modern Languages Association in 1989, observes that:

> the critic who lacks humility before a work of art and refuses to accept the role of attentive mediator and interpreter is likely to assume as well a doctrinaire stance and a presumptuous critical absolutism. When criticism no longer has its roots in the love and awe of greatness, there is always the risk that the roles of artist and critic will be mixed up or reversed, so that the great text becomes a mere pretext for the critic's display of intellectual prowess or, what is perhaps even worse, for the imposition of the tyranny of abstractions. (395)

These connections would be Orwellian were they not so venerable. Humility is freedom and intellectual independence is tyranny. Mediation is liberty and criticism is presumption. For Brombert, critical understanding and freedom of thought hinge on a deference which is willed yet mandatory. The position that casts deference as risk and dialogue (394), and that describes a "display of intellectual prowess" as authoritarian, might itself be called authoritarian

for declaring subversive all ideas not cleared in advance by their connection to established "greatness."

Some readers may prefer to read the conservative humanities as talking about the kind of respect for intellectual labors that have preceded our own, a respect that requires widely believable reasons for rejecting their findings. But this sort of critical respect requires precisely the equal footing that the right attacks. In a piece first written in 1967 and reprinted in 1990, Bloom laments precisely such a "democratization of the university":

> The most obvious, the most comprehensive, the truest explanation of what is going on in our universities today is the triumph of a radical egalitarian view of democracy over the last remnants of the liberal university. This kind of egalitarianism insists that the goal of a democratic society is not equality of opportunity but factual equality; . . . it will brook no vestige of differentiation in qualities of men and women. It would more willingly accept a totalitarian regime than a free one in which the advantages of money, position, education, and even talent are unevenly distributed . . . the universities have become the battleground of a struggle between liberal democracy and radical, or, one might say, totalitarian, egalitarianism. (*Giants* 367)

Bloom never considers the possibility that the "factual equality" of a research community is a prerequisite to free discourse. He instead describes equality as the loss of individual consciousness in a totalitarian herd. Bloom of course likes loss of distinct individuality in "absolutely one soul," but not a loss of self into equality. Oneness is freedom, but equality is totalitarian, because freedom entails a higher authority.

This specter of equality, leftover from the sixties, may help explain the otherwise bizarre right-wing axiom of the nineties that civil liberties and multiculturalism are Stalinist attacks on freedom. And it exposes the politics of this equation: an unqualified hostility to the idea of a democracy that rests on some kind of egalitarianism rather than on the rule of great ideas, canonical texts, and their authorized agents in the field. Egalitarian democracy means civil war or, as a first step, undergraduates who feel no awe before the slave democracy of the Greeks.

The academic right's concern for submission also targets the democratized classroom. One example, citing some evidence of Lynne Cheney's, claims that "a salient symptom of the illness of our institutions of 'higher learning' is the proliferation of junk courses. . . . The University of Delaware has a course in death-related issues in which a computer simulation of the student's own death 'puts you in touch with your own feelings.' A course on 'Tarot-Card Reading, Dowsing, Divining and Tea-Leaf Reading' at Boston University is described by a student as 'one of those classic courses where you learn something about yourself' " (Sirkin and Sirkin 9). The authors dismiss these courses not because of their particular content or methodology but because they presume the importance of the lives of their students. The predetermined truth the right wishes to associate with political correctness is in these examples a routine component of its own definition of legitimate classroom topics, since they seek to exclude the supplements or challenges to the truth that arise from students' active participation.

This rejection of democratic knowledge has also controlled much of the recent debate about Afrocentric curricula in public education. One tactic of critics of Afrocentricity might have been simply to accept the need to change the presently low visibility of the non-European civilizations taught in humanities courses and go on from there to help sort likely facts and hypotheses from dubious wishfulness, with the background understanding that cultural knowledges are not all readily translatable into established concepts. But this difficult collaborative project has not gotten off the ground. Many observers have categorically dismissed Afrocentricity by describing it as a response to the masses—as what Lynne Cheney calls teaching " 'what people think is important for [students'] self-esteem' " (qtd. in Kantrowitz 46). The longtime-liberal Arthur Schlesinger claims that a New York State curricular report, authored by an advocate of Afrocentricity, has an interest in history "not as an intellectual discipline but rather as social and psychological therapy whose primary function is to raise the self-esteem of children from minority groups" (35).[29] The issue for Schlesinger seems not the particular errors of fact or interpretation, but the idea that a community might have made their own decisions about how knowledge is to be structured and used. Reducing

Afrocentricity to therapy preempts serious analysis of particular historical accounts in the new textbooks, and replaces it with the *a priori* discrediting of the ideas of scholars mindful of a community's cultural independence. This is obviously not to say that xenophobic Afrocentrisms should be adopted, although most moments of Afrocentric mythologization are entirely in parallel with the Euro-American tradition of whitewashing U.S. history for its own children. It does indicate, however, Cheney's and Schlesinger's assumption that accurate scholarship, in the absence of specific empirical indicators, has been undermined through contact with the needs and interests of a community, with their desire for autonomy and recognition, with their desire to separate their histories from the rule of Europe.

Without demonstrating substantive problems, the right rejects the category of "democratic knowledge" as a contradiction in terms. This idea goes beyond the uncontroversial claim that standards and beliefs are constitutive of teaching and research, and must be administered by credentialed and experienced personnel, and that most standards, structures, traditions, and values always remain in place. It extends to denying some democratic truisms: that genuine knowledge emerges from the experience of subordinate or unauthorized voices, from questioning authority, or from the reciprocal interaction of untrained students and trained but receptive instructors. It denies that standards, though never absent, should be directly and indirectly, knowingly and unwittingly subject to the continual pressure of the desires and interests of those whom Thomas Jefferson called the "living generation," of those who, within ongoing procedures of scholarly persuasion and proof, may take it upon themselves to discuss whether *The Tempest* is "about" imperialism, or debate the racial origins of ancient Greek civilization, or analyze the assumptions that allow so many white educators to dismiss out of hand any version of Afrocentric investigation. It rejects the egalitarian notion that, in a multiracial society, Euro-American interests and traditions would not be the sole judges of the relations between theirs and other American cultures—that cultural law would be decided with the help of the governed and not by "tradition" or the "secretary of domestic defense." It rejects democracy without higher management.

It should now make more sense that part of our intellectual culture could so readily replace the communist revolution with the "victim's revolution." The red menace of the 1950s referred as much to domestic insurrections of the lowly as to the danger of foreign conquest; racial segregation was compatible with containment strategies justified by the presence of the Soviet Union. The rainbow menace reflects a similar fear of decisions about knowledge and power coming from below. D'Souza openly avows this threat by warning his readers that debates over literary theory and affirmative action challenge existing modes of governance. The minority revolutionaries seek "a fundamental restructuring of American society. It involves basic changes in the way economic rewards are distributed, in the way cultural and political power are exercised, and also in privately held and publicly expressed opinions" (*Illiberal* 13). Presuming the American tradition to be hierarchical, D'Souza entitles his attack on affirmative action "More Equal Than Others" and calls his exposé of victim-loving theorists "The Last Shall Be First." His complaint about teaching *I, Rigoberta Menchú* in one of Stanford's eight "Culture, Ideas, and Values" classes is that Menchú regards history as leading toward "the final emancipation of the proletariat" (72). The ideal of a common culture prohibits this kind of secession from the top-down management on which social order is thought by the right to depend. Here racial autonomy implies the secession at other times attributed to class war.[30]

This sort of humanistic thinking is controlled by its authoritarian imaginary. It must be remembered, however, that in a nation formally consecrated to democratic ideals, authoritarian power cannot violate democratic procedures. Though power may be top-down, it must also be decentered; this is the paradoxical yet profoundly functional combination of conflicting modes that can be termed, among other names, liberal authoritarianism or managerial democracy.

From the right's perspective, the PC position threatened to disrupt this coordination of opposites. It marked the withdrawal of voluntary deference. PC activated the most important weakness of decentered forms of authority: amidst all the dispersal, mobility, and regulated autonomy of flexible management, unifying control might become too diffuse. Management's democratic

elements might absorb enough participatory inclusion and differential input to change into something more self-directed. The conservative humanities puts the sovereignty back in flexibility by reemphasizing the masters that do not command but only invite our love of their superiority. Rejecting simple despotism, the right works to maintain the double-edged power of managerial supervision. Its job is to make this top-down flexibility appear more beautiful than democracy.

After PC

The PC debates did not simply reaffirm managerial feelings in general, but supported managerial resolutions of specific subjects of debate. This has been a more successful strategy than would have been, say, simply reaffirming fundamentalist "Judeo-Christian" values. In the four years since PC entered common usage, educational quality has been largely decoupled from educational funding; humanities research has been continually criticized as an intellectually pointless betrayal of undergraduate teaching; and the humanities have been stripped of their 1980s social function as the repository of national heritage. In each case, the conclusion is that humanists cannot be trusted to manage themselves, but need supervision from those with better standards of fiscal prudence and more mainstream values. The PC debates have stabilized the culture of management in those modes in which the humanities have the greatest need for autonomy—defining valid research, designing undergraduate instruction, and allocating resources. I should repeat that this culture does not work through intervention and direct control, and the absence of crude attempts by watchdog groups or administrators to decide such things as undergraduate English major requirements should not be taken as tokens of independence. It is also true that many agencies, fields, departments, and individuals are doing just fine, but the general patterns of governance that I've discussed are as mildly and yet effectively determinant as before. They remain particularly effective in those emergent areas of teaching and research that are in most need of protection. Thus, for example, many literature departments are under significant pressure from their most prudent members

to roll back to their "core" functions of (expanded) canon coverage, the teaching of basic interpretative skills, the application of uniform standards of competitive quality, and so on. In particular contexts, these are all important activities, but we are in danger of faltering in our attempts to intensify the visibility of our recently expanded functions precisely because of our failure to free self-governance from such intellectual and financial pressures.[31]

This feels to me like a crucial interval of time, in which the old order of disciplines, with the humanities isolated from public power, has been carried over but without many of its traditional functions. Can we go beyond self-defense toward transforming our social effects?

There are many hopeful signs, of course, extending from recent changes at the National Endowment for the Humanities to the widespread goodwill of local administrators and the open-mindedness of undergraduates. In the current context, I'm looking for the academic humanities to consolidate its centrist consensus and then press on from there to develop a greatly enhanced cognitive and social presence.[32]

First, the humanities should stabilize its commitment to already established centrist values.

Debate should be trumpeted as one of the fantastic pleasures and virtues of cultural knowledge *and* as the necessary condition of knowledge's development. The work of Gerald Graff and others has been quite valuable on this score.

Diversity. This is another term that a wide cross section of humanists at least nominally affirms. It is also an effective form of self-defense; the PC debates have suggested that supervisory decentralization must expend tremendous resources in attempting to assimilate fundamental cultural differences. Diversity should become a more intense and pervasive priority, with expanded racial representation being accompanied by better recognition of profound ideological and experiential differences.

Democracy. Here's another concept with widespread appeal. Democracy is no panacea, and remains in need of ongoing redevelopment. But the humanities excels in critiques of the kind of double-edged mechanisms that restrict democracy in democracy's name. It is already in position to offer

better forms of democracy than those currently supported by economics, policy studies, corporate administration, and other mainstream practices. In any case, the practicalities of increased cost-cutting and legislative intervention will increasingly force us to defend ourselves with effective and attractive forms of self-management, and exchange knowledge with nonacademics in similar situations.

Second, debate, diversity, and democracy are in themselves insufficient without further reformulations of the managerial outlooks that condition the humanities. The progressive humanities would be much stronger were it also to embrace politics, disunity, and freedom.

Politics. In itself, *debate* can omit two crucial considerations: the effect of power relations on the knowledge being discussed and produced, and, more specifically, the difference between managerial and self-directed forms of group relations. Debate is of course the premier mode through which managerial systems distribute power, and this distribution depends on an (almost always false) presumption of the equality of the parties of the debate. *Politics,* to the contrary, brings into debate the consideration of how power affects particular acts of cultural interpretation and production. This does not require a focus on a writer's political views or the commitment of research and teaching to polemical positions or social passions. It means understanding our professional activities through the actual social relations in which we find ourselves rather than through the idealized communities of common cultures with which literary study is overendowed. Some of the strongest fields in the PC period were those that looked beyond unreal commonality at their links to their own institutions and communities. Such moves should be portrayed as the source of intellectual success rather than of professional compromise: if we can't systematically examine the conditions under which we and others produce cultural knowledge, we will never be able to improve our control of those conditions.

Disunity. Academic cultural work has frequently been a mode of "diversity management," whether it comes in the form of canon maintenance, the dismissal of popular culture and women writers, the view of "minority" cultures as marginal, or other, subtler ways. These views have generally

affirmed only those differences that appear compatible with a background commonality. The next step toward a more accurate and equitable understanding of American cultural relations is precisely what the center has thus far refused—the "disuniting of America" in the realm of cultural governance. Our national disuniting began with our inception, and it's not too soon to get over our regret about this. Disunity is in fact a strength, and rather than assimilating our distinctive national cultures to common norms, the humanities should develop models of the nation as constituted by ongoing negotiations between autonomous cultural groups.

Freedom. The humanities' notions of *democracy* generally go no farther than endorsing the conversational processes that comprise the modern organization, which combines diffusion with hierarchy. As even the corporate world decides that the "horizontal" is more profitable than the "vertical," the humanities should focus on the drastic enhancement of individual freedom within the dispersed yet restrictive institutional relations in which we inevitably live. The humanities faces the continual withering away of its public base unless it recovers the power to define progressive education as a source of emancipation in the specific sense, to repeat, of systems-embedded self-management. It is no accident that most of the healthiest PC fields rested at least as much on public interest as on administrative recognition, and thus kept their intellectual developments in touch with those who would use them to rewrite managerial authority for their own ends.

The active creation of political visions is crucial to the humanities as a form of knowledge *and* to its power to compete with technology and business in the shaping of post-Cold War U.S. society. Gore Vidal has remarked that the U.S. has elections instead of politics; in the humanities, instead of politics we have had managerial ideals. For this reason, only a few of us have been better than executives, managers, and scientists at freeing up U.S. cultural relations. Democracy and freedom are often evoked and seldom applied, their defeats as opaque as they are denied. For putting politics back in the place of governance, the PC debates have been well worth the trouble. Conservatives got the ball rolling; the rest is up to us.

Notes

1. Teachers for a Democratic Culture, a valuable advocacy group, characterized the right's ideological attacks as "harassment and misrepresentation," as "hypocrisy," "intolerance," and "mischievous misrepresentation" ("Statement").

2. "Community and Factionalism" was an advertisement funded by the American Income Life Insurance Company of Waco, Texas. King's latter phrase describes a kind of multiculturalism he opposes to the pluralistic, "tolerant" kind; the association of politics with division is not explicit but is pervasive.

3. An important exception has been Graff (see *Beyond the Culture Wars*). As I argue more generally below, this valuable public discourse is more effective against those portions of the right that *suppress* conflict than against those that *manage* conflict by encouraging selected varieties.

4. For example, Chancellor Chang-Lin Tien of the University of California, Berkeley, defends his campus's admissions procedures by citing the University of California Regents' Policy on Undergraduate Admissions: "Mindful of its mission as a public institution, . . . the University seeks to enroll, on each of its campuses, a student body that . . . encompasses the broad diversity of cultural, racial, geographic and socio-economic backgrounds characteristic of California." It is of course "political" to believe that a public university should reflect the demographics of taxpayers rather than, for example, the research needs of its military contractors. But for good practical reasons, Tien describes a university that mirrors existing society (and its legal mandates) rather than one that suggests "political" preferences for one vision of society over another ("A Diverse Student Body" B7).

5. James Piereson, president of the Olin Foundation, quoted in Henson (8). The four major humanities agencies to which I refer are the American Council of Learned Societies, the National Endowment for the Humanities, the Guggenheim Foundation, and the National Humanities Center.

6. Jonathan Culler contrasts "two general models" for recent humanities research: "reproducing culture and the social order" and the "production of knowledge" (33).

7. Arnold is absent from Bloom, but his role is played by the far more idealized rule of Neoplatonism.

8. See Arnold, *Culture and Anarchy* 113. Arnold is famously repelled at the idea of just anyone "doing as one likes": "For a long time, . . . the strong feudal habits of subordination and deference continued to tell upon the working class. The modern spirit has now almost entirely dissolved these habits, and the anarchical tendency of our worship of freedom in and for itself . . . is becoming very evident" (118–19).

9. Conservative institutional work was of course well under way, and included funding development, the formation of advocacy groups, and creating alliances between existing

media watchdogs and new academic monitors. For important descriptions of this institutional labor, see Diamond, "Managing," and Messer-Davidow.

10. Kimball is particularly preoccupied with political determinism; see his discussion of Stanley Fish's antifoundationalism (*Tenured* 154–65).

11. See Baker's introduction to *Richard III* (*Riverside* 709). Colonialism is also discussed in Hallett Smith's introduction to *The Tempest* in the same volume (1606–10). Kimball misstates these issues almost immediately. He admits that "No one would deny that literature is often about politics; but that is a far cry from maintaining . . . that the *essence of literature is politics*," describing a claim more sweeping than Fish and other influential critics have made (*Tenured* 41). Relatively recent developments in treatments of colonialism include greater criticism of colonial perspectives and a diminished trust in the great artist's ability to transcend these perspectives through art, but Kimball avoids these more complicated (and eminently defensible) changes.

12. Conservatives frequently attack women's studies programs in tandem with ethnic studies. Culturally conservative journalists, during 1990–92, seemed more wary of the danger to national unity posed by multicultural programs, but this does not imply reconciliation with women's studies in the least. For an interesting set of responses to the PC-bashing rejection of feminism, see *The Women's Review of Books* (February 1992).

13. Kimball's text founders when it stresses the presence of politics, relativism, nihilism, and so on, and finds its focus in an epilogue on multiculturalism. Those who wonder why scholars involved in studies of race, ethnicity, and nationalism are so disgusted by the right's self-described color-blindness might turn to this epilogue for illustrations, where in eight pages Kimball slides from rejecting politics (*Tenured* 193) to race-based attacks on the unifying powers of "common culture" (194–95) to tacit declarations of the "West's" superiority (198, 206–07).

14. D'Souza joins other journalists in tracking race revolution to the waning revolutionary appeal of world communism:

> One reason for this increasing radicalism is that, with the collapse of marxism and socialism around the world, activist energies previously channelled into the championship of the proletariat are now "coming home," so to speak, and investing in the domestic liberation agenda. A good metaphor of this is that Angela Davis, former vice presidential candidate of the U.S. Communist party, is now professor of the politics of reproduction at San Francisco State University. (*Illiberal* 214)

As D'Souza sees it, die-hard communists, having failed to dupe the workers of the world about production, now turn to reproduction, a topic on which women and minorities are especially vulnerable to manipulation.

15. More temperately, Schlesinger links ethnic studies programs to a preference for "group rights" over "individual rights" to "the decomposition of America" (78). This first

edition, cleaned up by the Norton reprint, materializes what many fear to be the right's vision of multiculturalism. Every eight pages, it inserts a two-page advertisement for Federal Express. Each ad features a happy, service-minded employee of a different race and national origin, each dressed in the Federal Express uniform. The ads convey a corporate alternative to a "disunited America" in which cultural differences have dwindled to a range of skin colors and stereotyped postures of solicitude, and all united by a common corporate citizenship. The book gives no place of publication, as if the publisher, "Whittle Communications L.P.," is fully globalized.

16. D'Souza's dislike for racial difference is particularly striking because he claims to revere differences of nearly every other kind. He complains—sincerely, in my view—that "most American students seem to display striking agreement on all the basic questions of life. Indeed, they appear to regard a true difference of opinion, based upon convictions that are firmly and intensely held, as dangerously dogmatic and an offense against the social etiquette of tolerance" (*Illiberal* 231).

17. This last phrase is Avery Gordon's, whom I would like to thank for continual discussions and invaluable insight about the issues this essay addresses.

18. Noting that in nearly all measures the social and educational resources of African-Americans have been getting worse, Henry Louis Gates, Jr. observes that "The implicitly racist rhetoric of [William] Bennett's civilizing mission has unfolded precisely as affirmative action programs on campus have become ineffective window-dressing operations, neces-sary 'evils' maintained to preserve the fiction of racial fairness and openness in the truly academic environment, but deprived of the power to enforce their stated principles" (21).

19. Barbara Jeanne Fields, discussing "race," rejects the widespread idea that the term "explains why people of African descent have been set apart for treatment different from that accorded to others." Race, she writes, "is just the name assigned to the phenomenon, which it no more explains than *judicial review* 'explains' why the United States Supreme Court can declare acts of Congress unconstitutional, or than *Civil War* 'explains' why Americans fought each other between 1861 and 1865" (100).

20. Peller's full-scale account of integrationist ideology appears in "Race Conscious-ness." For an interesting parallel account, see Thompson, esp. ch. 4.

21. David Palumbo-Liu's study of federal policy towards citizens of Asian descent samples this shift from "racial" segregationism to "cultural" commonality in which both attempt to preserve a hierarchical "social order." Palumbo-Liu represents the first type with the Chinese Exclusion Act of May 2, 1882: "in the opinion of the Government of the United States the coming of Chinese laborers to this country endangers the *good order* of *certain localities* within the territory." The second appears in Senator Alan Simpson's defense of the Immigration Reform and Control Act of 1983: "A substantial portion of [these new] immigrants do not integrate fully into society; they may well create in America

some of the social, political, and economic problems which exist in those countries from which they chose to depart. . . . [American] unity comes from a common language and a core public culture of shared values, beliefs, customs, which make us distinctly, 'Americans.' " Spanning a century of U.S. racial developments, the language of a common culture replaces that of exclusion, but with the same effect (4, 5).

22. This aspect of White's decision was reversed by the Civil Rights Act of 1991, but this legislation did not challenge the primacy of business needs.

23. In his dissenting opinion, Justice John Paul Stevens regards this change as the crux of the disastrous majority view: " 'The touchstone,' the Court said in Griggs, 'is business necessity.' . . . I am thus astonished to read that the 'touchstone of this inquiry is a reasoned review of the employer's justification for his use of the challenged practice.' This casual—almost summary—rejection of the statutory construction that developed in the wake of Griggs is most disturbing" (671).

24. Justice Stevens regrets that the "Court announces that our frequent statements that the employer shoulders the burden of proof respecting business necessity 'should have been understood to mean an employer's production—but not persuasion—burden' " (671).

25. The first phrase is Public Enemy's and also appears in Clarke. The second is from Omi and Winant (90).

26. This idea, though it appears to different effect in the work of Weber, Parsons, Adorno, and Marcuse, is in the U.S. humanities usually associated with Michel Foucault. Foucault frequently insists that power lacks authority, so that, in contrast to my emphasis here, a system is constitutively disciplinary without having an identifiable source or aim for its managerial directives. One implication of my argument here is that it would be wrong to read Foucault as claiming that "techniques of government" replace or eliminate "structures of sovereignty," for they actually refine and update them ("Governmentality" 101).

27. Ouchi rejects more centralized models not because they block the creative fulfill-ment that democratization brings (as the more New Age corporatists Naisbitt and Aburdene would have it), but because the U-form (unity-form) is grossly inefficient (18).

28. D'Souza, for example, favorably cites one observer of affirmative action at the University of California, Berkeley (John Bunzel) as saying that "what people at Berkeley didn't realize is that merit admissions is an *egalitarian* principle, because it means that no matter what your background, if you are among the best qualified students, Berkeley lets you in" (*Illiberal* 57).

29. Schlesinger is more sympathetic than this citation indicates, for the chapter which leads to this remark, "History the Weapon," acknowledges the racialized elitism of much traditional American history: "More than Irish or Italians or Jews, black Americans, after

generations of psychological and cultural evisceration, have every right to seek an affirmative definition of their past" (30). Schlesinger's understanding of the political nature of ongoing disputes within historical scholarship, and of the specificity of the African-American position there, makes his later reduction of Afrocentricity to therapy all the more remarkable a tribute to the fear among educated whites of self-directing knowledge communities.

30. This is only somewhat less true for the world order, where conflicts between rich and poor countries, in the waning of the East-West divide, have become increasingly color coordinated.

31. This problem is not limited to the humanities. The massively better funding available to scientific and technological fields comes with strings attached at both ends—the extramural funding agency and the home university. But the value of scientific research and the right of scientists to set their research agendas are solidly established.

32. For fuller discussions of the PC aftermath, see Newfield and Strickland.

II

The Trouble with Theory

8

The War Against Theory

Michael Sprinker

The following text is somewhat conjunctural. Since it was first drafted during the spring of 1991, much has changed both in the local academic situation that partly prompted it, and in the larger political culture about which it speaks. With the transition from Bush to Clinton, the antitheory right has moved out of the spotlight—mostly to cushy research positions in conservative foundations and think tanks. One does not have Lynne Cheney, William Bennett, and the rest to kick around any longer. At the same time, what is here called "left-wing antitheory" has become even more prominent, and arguably more antitheoretical. The ascendancy of neoliberalism is likely to drive this tendency onward in the near term. On the other hand, the resurgence of left politics in some parts of Western and Eastern Europe, not to mention the ANC's victory in South Africa, may give new impetus to theoretical work of the sort I outline at the end of this essay. In sum, the outcome of the theory wars is far from certain.

My topic is motivated by two recent events, one that is being played out in the broad arena of American intellectual life, the other in my own department of English at Stony Brook. As it happens, the former has been utilized to mobilize people in the latter, and it might be said that the local politics of Stony Brook are just symptomatic of a crisis that literary culture, primarily but not exclusively academic literary culture, is currently passing through. But characteristically, social processes are more complex than any local instance of them reveals, and such is certainly the case here. The theory/antitheory confrontation at Stony Brook is far more easily anatomized and explained

than is the larger field of battle in literary culture at large. For example, the attempt by the antitheory faction to draw sustenance from John Searle's by now infamous article in the *New York Review of Books*, "Storm Over the University," is doomed to failure, because Searle's piece argues for a much sterner conception of humanistic education than any to which my less enlightened colleagues aspire. Consider Searle's six proposals for general undergraduate education that bring his article to a close:

> First the student should have enough knowledge of his or her cultural tradition to know how it got to be the way it is. . . . However, you do not understand your own tradition if you do not see it in relation to others. Works from other cultural traditions need to be studied as well. . . . Second, you need to know enough of the natural sciences so that you are not a stranger in the world. . . . [Third], you need to have some knowledge of the subject matter that used to be called political economy. Fourth, you need to know at least one foreign language well enough so that you can read the best literature that that language has produced in the original, and so you can carry on a reasonable conversation and have dreams in that language. . . . Fifth, you need to know enough philosophy so that the methods of logical analysis are available to you to be used as a tool. . . . Finally, and perhaps most importantly, you need to acquire the skills of writing and speaking that make for candor, rigor, and clarity. (42)

One might quibble with details—for example, the professional philosopher's shilling for his own discipline in the fifth recommendation when what he aims at seems to be covered adequately in the sixth. The latter certainly would entail teaching logical reasoning without drawing any sharp distinction between logic and rhetoric. But on balance, can anyone, left or right, disagree strongly and in principle with the general premises Searle lays down? Granted, the real arguments in recent curricular debates, particularly those over multiculturalism that occasioned Searle's piece, are more specific and more serious than Searle's high church principles allow. Nonetheless, it ought to be clear that the ideals of multiculturalism could be well served within this general framework for undergraduate study—although of course they need not be.

In general, I think it wise for those of us on the cultural left to heed Searle's counsel in some measure, since it speaks to a broader audience in the university—one that includes scientists and their fans—than does the cultural right's philistine aestheticism, which tends to overlook the role of natural scientific training or political economy (never mind professional philosophy) in "the tradition" the right strives mightily to preserve. I am, in fact, to some degree on Searle's side, as will become apparent as I proceed. For Searle and I share a basic commitment to objectivity and a version of realist philosophy of science that is not only beyond the imagination of my department's antitheory forces, but utterly devastating to their enabling ideology of aesthetic humanism. My differences from Searle, beyond the more technical matter of what constitutes a consequent philosophical realism (to which Searle is, it needs to be said, a comparatively recent convert; his earlier, Austin-inspired work on speech acts will sustain no such ontology), are basically political. I shall return to them below.

How did the war against theory come to be fought? Who are its major antagonists? Which side should those of us on the left choose? To begin to answer these questions, I shall first try to sketch, very schematically to be sure, the "prehistory" of the current war (in the sense that Marx calls all that has occurred in human history prior to the transition to socialism "mankind's prehistory"). As the U.S.-led assault on Iraq demonstrated, the commencement of hostilities inevitably leads to the total (if sometimes temporary) effacement of all that led up to and inexorably produced the war itself.[1] Wars don't just happen; they have their causes and determinations, however complex. To understand the terrain of battle and the balance of forces, it is necessary to give a reasonably accurate account of how the conflict originated.

We might locate the distant origin of North American literary theory in 1957, with the appearance of Northrop Frye's *Anatomy of Criticism*.[2] However critically one may view that book today, it remained a powerful influence and an enabling presence in academic literary study at least through the mid-1970s, perhaps even beyond. Previous efforts to introduce systematic methods into the belletristic discourse of American criticism, books like the Chicago School's manifesto, *Critics and Criticism* (1952), or M.H. Abrams's *The Mirror*

and the Lamp (1953), had, at least on my reading of this history, generally failed to displace the gentlemanly humanism that dominated the discourse and pedagogical practice of American departments of literature well into the 1970s, when I was an undergraduate and a graduate student.[3]

Even the New Criticism, for all its formalist predilections, never shed the skin of its originators' late-Romantic aestheticism. When one reads the programmatic works of Ransom, Richards, Wimsatt, or Brooks, one cannot help being struck by the affinity they bear to the discourse of Weimar classicism, especially Schiller, and to a certain (however unsophisticated) reading of Kant's Third Critique.[4] Moreover, it is difficult not to catch the New Criticism's barely muffled appeal to norms of behavior and conduct that, as Richard Ohmann's still unsurpassed *English in America* definitively shows, would insulate literary study from the messy, worldly business of politics and ideological struggle.[5] Studying literature is valuable, the New Critics never tired of saying, precisely because it transcends or overcomes or allows us to stand outside of history, politics, the material world. Even a self-proclaimed cultural critic like Lionel Trilling shared this basic orientation, as did a more politically attractive figure like F.O. Matthiessen or an otherwise less readily characterizable one like Richard Blackmur.[6] What binds all the diverse writings of these men together is their common commitment to an idea of literature as a distinctive, and distinctively nonideological, human practice.[7] Into this discursive universe *Anatomy of Criticism* plunged, sharing many of its predispositions and, it should go without saying, its historical determinations. My own recollection is that even in the early 1970s, Frye's book was still being read as a license for humanistic literary criticism, its theoretical edge blunted by the dominant critical ideology in which it had been assimilated. Perhaps the story would have been somewhat different if Princeton University Press had not insisted on changing Frye's original title, which was, I was surprised to learn not so many years ago, "Structuralist Poetics."[8]

It ought now to be evident why I want to date the origins of North American literary theory in 1957, rather than, say, in 1966. Whatever its fate in the intellectual milieu of the late fifties and early sixties American academy, Frye's *Anatomy* was, as Frye himself perceptively recognized, a contribution

to theoretical poetics, the opening salvo in a barrage of texts that would fall upon literature departments with increasing intensity from the mid-sixties onward. If *Anatomy of Criticism* was in many ways continuous with the humanist ideology that dominated literary study throughout the first two postwar decades, it was at the same time a first breaching of the walls that had insulated literature from the broader field of general cultural production and the social conditions and forces underpinning it. The *Anatomy* had been stillborn as "structuralist poetics," but structuralism was not long in appearing *in propria persona*.

While it is probably too neat to locate the first detonation of the past quarter century's theory explosion in the infamous Johns Hopkins symposium, "The Languages of Criticism and the Sciences of Man," many of the major figures whose works would become the staple of every graduate student's reading from the early 1970s onward were either present at or were the principal topics of discussion in that conference. Barthes, Derrida, Lacan, Lévi-Strauss, de Man, Hillis Miller, Edward Said—all were there either physically or in spirit. Among the idols of contemporary theory, I can think only of the following who were conspicuously absent from Baltimore: Kristeva (perhaps because a woman; the theory boom in its first incarnation was still a male preserve), Foucault (whose reputation-making bestseller, *Les mots et les choses*, appeared in the same year), Jameson (then unknown and consigned to provincial exile in La Jolla), and Eagleton (a mere slip of a lad at the time, mired in his Catholic marxist phase and not yet liberated from discipleship to Raymond Williams).

But aside from the gliterati who attended and spoke, that event is perhaps most revealing for its very title: "The Languages of Criticism and the Sciences of Man." Precious few on the American scene in 1966—with the possible exception of the always eccentric and to this day generally unassimilated Kenneth Burke—would have even faintly envisaged literary study as a "human science." The term itself remains largely alien to our shores even now. Its French provenance was telling with regard to the bent the conference took, it being a heavily Gallic affair.[9] But that's how theory would come to us, and whatever good, principled, theoretical reasons there may have been to con-

ceive a new orientation for literary criticism in this manner, the historically important fact is that the finally successful challenge to New Criticism was mounted under the aegis of a method that was neither specifically literary nor bounded by the discourse of aesthetics. Henceforward, literary study would have to incorporate psychoanalysis (in a serious way; earlier Freudianism had been pretty much a bust), sociology, anthropology, and, preeminently, philosophy and linguistics. For structuralism, the general rubric under which this ferment was first experienced, embraced all these disciplines and claimed for itself pandisciplinary omnicompetence.

That things did not quite work out, that structuralism's bid for hegemony in the human sciences ultimately failed, was due less to any inherent limitations in the method itself—which is what lots of old-fashioned humanists, and, ironically, not a few poststructuralists, have always liked to claim—than to an underlying tension within French intellectual life that was already clear to the Parisians in 1966, but would become so here only much later. What, one might ask, united Derrida and Lacan with Goldmann and the Roland Barthes of that period (he would shift camps shortly) other than their common preference for the French language and their all having flown in from Paris for the occasion? For anyone who has read closely the texts in *The Structuralist Controversy*, or even Derrida's alone, it's obvious that nothing like a unified methodological program can be constructed from these competing projects.

What might have been discerned by a subtle listener at that time would become all too apparent in the ensuing decade, as the translations and public appearances in North America by Barthes, Foucault, Derrida, Lacan, and others multiplied: to wit, that the discourse of theory itself was deeply fissured, that something called poststructuralism was, as Perry Anderson has maintained, already contained within the structuralist controversy itself, that, as one might say, theory and antitheory were part of the same historical moment. Moreover—again I defer to Anderson's analysis—the apparent triumph of the latter after 1968 had a determinate political cause, or at least a political valence. Poststructuralism, I think it's fair to say, has exhibited a persistent, sometimes covert, but increasingly overt and strident, anti-marxist strain. Its purchase on Euro-American intellectual life (and not only there: it's making

headway in such places as Calcutta and Buenos Aires as well) has been much abetted by the general delegitimation of marxist politics since the Paris and Prague springs. The events in Eastern Europe and the Soviet Union over the past few years have only rendered this situation more acute.

There would of course be much to say about how theory mutated into what I take to be the current antitheoretical vogue in American literary study, above all how the intra-theoretical developments in literary study were subtly but inexorably determined by extratheoretical (i.e., political and general ideological) events and conditions like the implosion of the student antiwar movement, the collapse of Black Power, and the sad decline of the Civil Rights Movement as a whole, not to mention state repression against left groups of all sorts and stripes. For the sake of brevity, I shall omit that part of the story, asserting what would require detailed argument and demonstration: that certain shifts in domestic politics were the ultimate (and in some cases the proximate) cause of what became the antitheory onslaught.[10] Let me cut abruptly, then, to the present scene, to what I've dubbed "the war against theory."[11] This latter, I shall be arguing, is sufficiently general to encompass both a "left" and a "right" wing. Let me begin with the latter, since its partisans are less interesting and more vulnerable to summary dismissal.

The right-wing antitheory crowd has received the widest publicity, doubtless because their appeal to the traditional values (generally unspecified) of (always Western, meaning Euro-American) high culture is nothing more than the common sense of middlebrow editors and readerships for the Sunday book reviews and the mass circulation weeklies, themselves products of the pretheory epoch in American universities. Rebecca Sinkler at the *New York Times Book Review*, Paul Gray at *Time*, Robert Silvers and Barbara Epstein at the *New York Review of Books*, Karl Miller (formerly) at the *London Review of Books*, Ferdinand Mount at the *Times Literary Supplement*—all these people were educated prior to the late sixties or early seventies. Their literary culture was largely determined by the hegemony of the New Criticism and a Trilling-esque, Eliotic, or Leavisite humanism. They tend quite naturally to be sympathetic toward the views of William Bennett (now out of the education/culture

game, it seems), Bennett's successor at the NEH, Lynne Cheney, the late Allan Bloom, Roger Kimball, Frederick Crews, Denis Donoghue, and company. Deconstruction-bashing became something of a national pastime in the eighties, largely because each of the major organs just named—and many others as well—took its cue from a generation of senior scholars and pundits who were mostly their contemporaries and who shared their bewilderment over what all this odd writing and talk concerning the death of the subject and the author, the generality of the text, and so forth were about. The more or less natural fit in ideology between right-wing antitheorists and their media patrons is scarcely surprising; they all share a common conception of literature and high culture that is directly threatened by the claims of theory in most, perhaps nearly all, its manifestations.

But there is a difficulty with this easy explanation of why the right-wing antitheory forces have achieved such a high profile. Let me complicate the story a bit in the following way. The belletristic model of literary criticism was in fact already in deep crisis in Europe, particularly in France, during the immediate postwar period. Two decades before Barthes, Derrida, and de Man, Sartre had tried to put paid to it in *What Is Literature?*. His writings were widely available in English soon after their French publication, and as a figure he was extraordinarily present on the American scene, along with many other European writers and critics for whom the pieties of belletristic culture held no attraction. One thinks, for example, of Merleau-Ponty, Genet, Camus (before his drift toward Catholicism), Simone de Beauvoir, Ionesco, Beckett—all were quite prominent in the major North American high culture organs of the fifties and sixties. Moreover, to take a single case that I happen to know fairly well, during the mid-sixties, Paul de Man himself regularly wrote for the *New York Review of Books*, contributing articles on current trends in European intellectual life that were antithetical to the dominant discourse here. The *New York Review* was in those days seen as a highly radical organ, consistently opposed to the Vietnam War, publishing what would now be considered the work of "tenured radicals." But so was the *New York Times* against the war, at least from around 1967, as were the *New Republic*, and, in the end, the major television networks.

What I'm driving at is that, unlike the present epoch, the sixties were a time when European theory could get a reasonably sympathetic hearing in major high culture organs, largely because the political orientation of these latter was vaguely in tune with the generally left-leaning politics of many European intellectuals. What has changed, in my view, is less these journals' *cultural* politics than their, if you will, *real* politics. As the country has moved further and further to the right, so the mainstream reviews have been dragged along in the wake. A crude shorthand for what I'm saying is that the Reagan-Bush ascendancy (abetted by Thatcherism in Britain) has produced, on the level of culture, an increasingly shrill and combative corps of commentators who are out to destroy all the legacies and remnants of the sixties, among which theory is a prominent one. This is absolutely clear and programmatic in Bennett, Cheney, Bloom, and Kimball, somewhat more covert in Searle and Crews.[12] Among the academicians, I suspect the animus derives in large measure from their having had to cede some of their hitherto unchallenged power within their departments to women, nonwhites, and those of us white males on the left who are aligned with them (cf. Bové, *Wake* 1–4).

In addition—and this is quite clear in someone like Bloom—these revanchists exhibit a thoroughly familiar horror at the changing composition of the undergraduate student body, no longer lily-white and male-dominated, and, consequently, less willing to swallow so readily all the pieties about the greatness of Western culture that Bloom and others take for granted.[13] I had a chance to observe this phenomenon firsthand in my own department, when one senior professor lamented to a newly arrived junior colleague that Stony Brook just wasn't academically what it used to be, now that the Jews had stopped coming to the place and had been replaced by blacks and Latinos. The defense of Western culture is characteristically, when one peels away the thin veneer about "maintaining standards," a racist (and not infrequently sexist and class-biased) reaction to the democratization of American higher education over the past quarter century. To the extent that theory has aided and abetted this democratizing process—and I think it has, if not always and never unproblematically—it, too, has become the object of the yahoos' fury.

So much for right-wing demagogues. What about the antitheoretical bias

of what I've called left-wing theory itself? I'm thinking here of various developments in cultural studies, postcolonial discourse studies, feminism, new historicism, and the increasingly powerful strain of neopragmatism that has been urged by Barbara Herrnstein Smith, Richard Rorty, Stanley Fish, and the well-travelled duo of Steven Knapp and Walter Benn Michaels. I shall omit giving a full-blown account of each of these areas in recent literary study, or to distinguish finely among them—although I recognize that lumping them all together under the rubric of "left-wing antitheory" is pretty crude. In lieu of a more nuanced and authoritative account, I shall say some few things about the common sources that have, as far as I can tell, influenced many of these projects, and also indicate why, in my view, none of them can pursue their own problematic for long without positing a theory in the strong sense of the term. What I'm going to be arguing, in short, is that antitheoretical work is shot through with theories, albeit generally bad ones that require correction through rational critique.[14]

Let me focus briefly on the new historicism, for no particular reason other than that it's become a personal bugbear of mine over the past few years. On my understanding of Greenblatt, D. A. Miller, and the rest of the *Representations* crowd, their project is to show the sociohistorical determination of literature through an examination of nonliterary texts and events from the same epoch or general social ambience.[15] For example, Greenblatt's famous essay on *Twelfth Night*, "Fiction and Friction," argues for the constructedness of Renaissance sexuality by juxtaposing materials from an obscure trial in Normandy with the gender confusions that animate Shakespeare's play (*Shakespearean* 66–73). Greenblatt nowhere claims—how could he?—that Shakespeare knew about this trial. He does assert, however, that the ideology of sexuality it bespeaks was part of common cultural knowledge in Elizabethan England: "The relation I wish to establish between medical and theatrical practice is not one of cause and effect or source and literary realization. We are dealing rather with a shared code, a set of interlocking tropes and similitudes that function not only as the objects but as the conditions of representation" (86). But how, one cannot help asking, did this "shared code" come to be constructed in the first place; and how, to make the relevant point about the

relationship between Shakespeare's play and Renaissance medical discourse on hermaphrodism, did it come to be widely "shared"? To these standard questions that any historian worth his or her salt would pose at the outset of inquiry, Greenblatt offers no answer. In the manner of his master Foucault, he puts the two texts side by side and says, in effect, "See, they're one and the same." Just as the physical means employed to establish the sexual identity of the unfortunate French hermaphrodite left the matter of his/her gender ambiguous in the surviving textual record (the judgment of the experts was divided), so the gender of Shakespeare's boy-girls is equally indeterminate when considered in the full complexity of its dramatic presentation—and that's just the point. Gender is something we make, not something that is given to us by the zygote's chromosomal composition.

But can Greenblatt offer any substantive answer to the questions, posed above, that historians would inevitably ask of the events he relates? I think not, and this just because he has effectively adopted the view made popular in Britain by, as it happens, Margaret Thatcher, that society does not exist.[16] By that I mean Greenblatt simply lacks any strong concept of society and, *a fortiori*, of social causation. Very much like Stanley Fish, when this latter comes to account for change from one set of communally sanctioned interpretive conventions to another (or Thomas Kuhn, whose account of paradigmatic changes within the natural sciences leaves the causes of such changes crucially underspecified), Greenblatt can only assert that from epoch to epoch, things just got different somehow.[17]

This type of descriptive operation, which abandons any serious attempt to account for the causal mechanisms of sociohistorical mutation, has a name, and it's been around for over two centuries. Greenblatt and his cohorts are just garden-variety empiricists who, like their great forebear David Hume, can't give any reasons for why there seem to be more or less regular recurrences of similar phenomena and behaviors, why, for example, capitalists in aggregate tend to pursue profit maximization, or why, to take an instance closer to their own concerns, the private space of sexuality received such greatly enhanced importance in nineteenth-century European middle-class society.[18] They are precisely debarred from doing so because they reject the notion that social

phenomena result from any underlying causal powers explaining their occurrence. They reject such a concept of society as a hierarchically ordered complex of powers and limitations because Foucault, Lyotard, and others have taught them that all existing theories of society, but preeminently marxism, are inherently totalitarian and represent absolute constraints on human freedom.[19] Or so I surmise. To be blunt, their methodological empiricism is undergirded by a more or less flagrant political anarchism or libertarianism.[20]

Now let me consider in turn a related but slightly divergent current in the contemporary left antitheory coalition: namely, the neopragmatism of Herrnstein Smith, Fish, and Rorty. I would not want to say that this version of antitheory is grounded in a similar politics, and not only because none of the people just mentioned would cop to being either an anarchist or a libertarian—Fish perhaps least of all, since for him none of us is ever at liberty to choose one way of talking, thinking, and acting over another, because we are all of us, all of the time, absolutely constrained by the preexistent terms of the discursive community we inhabit.[21] I am tempted to say that if for the new historicists human beings are pretty much always free to refashion themselves in an effectively infinite number of ways (via Rortyan creative redescriptions), that there are virtually no constraints on what we can choose to be or become, the neopragmatists (Rorty excepted, in some parts of his writing) seem to claim that the constraints on our behavior are so powerful and pervasive that individuals are never in a position to do anything but repeat or reproduce what they already know. On a new historicist account, social choices are at most limitedly conditioned and thus pretty much up to individuals (talented ones like Shakespeare, at any rate) to make; on a neopragmatist account, choice—in the sense of rationally determined decision—is never possible.

For Fish, such a position does not imply that people don't change their views. He asserts, rather, that if and when one begins to inhabit a different interpretive community, one is immediately—and, as far as I can tell, totally mysteriously—governed by all the principles of the new community. In the introduction to *Doing What Comes Naturally*, Fish does concede, in a discussion of feminism, that it is possible to be a member of more than one interpretive

community—a seemingly major shift from what he had urged in the conclud-
ing chapters of *Is There a Text in this Class?* Nonetheless, he continues to
hold that one cannot be so multiply aligned *at any given moment*. One must
have given up all the conflicting values and rules from one's previous interpre-
tive community to occupy the new discursive space (*Doing* 31–32).[22]

I don't think it's necessary to argue systematically against Fish's extension
of the Rortyan dictum that "socialization goes all the way down,"[23] since I
assume it's obvious to anyone who stops to think about the matter that we
all, at every moment in our lives, possess a congeries of often-conflicting
identifications and opinions (as Fish himself concedes in the passage just
cited). It is perfectly possible for one to believe fervently in the necessity for
a socialist revolution and the redistribution of wealth and power that this
would in principle entail, while still wanting just as fervently to hang onto
the meager resources one has been able to husband prior to the revolution.
Or, it is equally likely that good liberals who believe genuinely in equality
of opportunity nonetheless feel that they want their children to have the best
education available, and thus would not wish their schools to be deprived
of resources so that other, less well-heeled institutions might be given a greater
share. One could say that such people are inconsistent, even hypocritical, but
then that's the way most of us are most of the time. As Eric Hobsbawm has
observed of late nineteenth- and early twentieth-century nationalism: "Men
and women did not choose collective identification as they chose shoes,
knowing that one could only put on one pair at a time. They had, and still
have, several attachments and loyalties simultaneously, including nationality,
and are simultaneously concerned with various aspects of life, any of which
may at any one time be foremost in their minds, as occasion suggests" (Hobs-
bawm 123).

What could a Fishian say in such a situation? He or she would, I take it,
maintain that as long as one continued to hold onto one's property or fought
to protect the fiscal well-being of one's children's schools, he or she would
not be part of the community that holds egalitarianism as an ideal. If one
did uphold that ideal, one would necessarily live out its consequences. The
question never raised, however, is this: How to decide which value is to be

honored? I don't think one has to be a Kantian to make such a choice, but I do think it's necessary, in a society where such decisions are reached at least in part through public discourse, that one be able to give reasons for preferring one position over the other. The real problem with the strong version of Fish's program (as with Rorty's valuation of poetic imagination over reasoned inquiry, or Kuhn's account of scientific revolutions) is that it gives up in principle on the possibility of rational adjudication between competing views; it hypostasizes—indeed it glories in—an ineluctably Hobbesian world. In *Doing What Comes Naturally*, this difficulty is evident in Fish's incapacity to distinguish between sophistry and deliberative rhetoric, between more or less venal, *ad hoc* rationalization and reasoning toward a conclusion not known in advance.[24]

In the domain of literary interpretation and understanding, the consequence of Fish's position is that one can never learn anything new, that one is forever condemned to know only what is given in advance, that one's beliefs are utterly incorrigible. I cannot produce a knock-down argument to prove that such is not the case, but I continue to hope that we are all, however pugnacious and attached to our own opinions we may be, capable of being persuaded of our errors. Absent this hope, I don't see what the purpose of teaching, writing, and talking can ever be. Fish's thoroughgoing nominalism—for that is what his position is in the end—renders inquiry at worst impossible, at best pointless. Given the choices, I'll opt for some version of realism every time. Fish's and others' tendentious (or perhaps just uninformed) reading of Kuhn notwithstanding, we do have the example of the empirical sciences to suggest that philosophical realism undergirds a manifestly successful intellectual practice.[25]

I've strayed a bit from my original topic. I want to return to it now and conclude with an assessment of where I think we currently stand in the theory wars, and where we might go next. First, it is reasonably clear to me that the antitheory forces, both left and right, have lousy arguments against theory as such. Worse, both tend to be underwritten by more or less dubious politics that hold out no hope for anything like a more emancipated society

than the one we inhabit. Right-wing cretins want freedom for the favored few, while left-wing rebels, those who speak on behalf of liberation at any rate, have no conception of how liberation might be realized.[26] If liberal education ever meant anything other than the maintenance of privilege for those already possessing it, surely it must have had some ideal of general human emancipation as its goal. Despite their rhetoric, the conservatives in the Bloom-Bennett-Searle camp don't really want to empower anyone (other than those like themselves already in power), while in various ways feminism, cultural studies, and the rest of the antitheoretical left do, sincerely I believe, wish to extend the intellectual—and probably the material—freedom of various people currently deprived of it in significant ways. I just don't think that these latter can reach their goal without theory. How, then, do we go about the most immediate task we face as university intellectuals, which is to help our students acquire greater knowledge in the hope that such knowledge will make them more free, at least in limited ways? To recall a famous title: What is to be done?

First, theory needs to be taught, but not as a smorgasbord of famous texts and figures. Instead, I would urge the teaching of a determinate number of well-defined methods for treating literature, all of which have the canonical authority of the Western tradition to support or validate them. These methods are, on my construal of the tradition anyway, limited to poetics, rhetoric, and aesthetics, which three pretty much exhaust the methodological options for specifically literary analysis. I recommend these three for two reasons. In the first place, as I've already suggested, they are just about the whole story in literary theory, from Plato and Aristotle down to Derrida and Barthes. In other words, there are good, principled, intellectual reasons for teaching these methods rather than others, and thereby training our students to deploy them knowledgeably and skillfully. In addition to the matter of principle, there is the pragmatic or tactical justification that it will be difficult for theory's right-wing critics to denounce the teaching of these methods, since, as I've said, they possess the authority of the very tradition the right claims to defend. I have found at Stony Brook that a certain number of my otherwise less enlightened colleagues can agree theory needs to be taught when I say theory means

Aristotle, Schiller, and Kant as well as de Man and Eagleton. It also helps to make the further claim that virtually all contemporary figures are themselves trying to grapple with problems already posed in the tradition.[27]

My second recommendation will probably not go down so well, although even here it may be possible to persuade some of one's colleagues (the ones who are not pure aesthetes, or simply anti-intellectual—not a few remain in the university, in literature departments especially) that they, too, are included in the kind of work one is advocating. On my view, which derives from a determinate theoretical position about what literature is and does, history is an indispensable tool in teaching literary texts. Literature is, as far as I can tell, a historical and not a natural kind of thing. It follows from this hypothesis that literary texts can only be understood as products of the social forces and conditions under which they come into existence. The useful—in the sense of tactically prudent—thing about this claim is that it captures one of the fundamental convictions of old literary historians, new historicists, certain (generally the nonpsychoanalytic) feminists, pragmatists, and people who profess cultural studies. Of course, having said that literature is a historical kind of thing, one is left with all the difficult questions about what sort of history one brings to bear on texts, the degree to which literary production is determined by its social moment, and so forth. I have elsewhere proposed some provisional answers to these questions.[28] I want to move on here, though, to my third recommendation for where literary theory and its attendant pedagogy should be going.

As I indicated earlier, among the signal achievements of the theory revolution that has been going on since the sixties is to have displaced the object of knowledge in literary study from the individually authored and putatively autonomous text. This theoretical shift has enforced the recognition that the aesthetic or poetic features manifestly there in literary texts are themselves products of a larger cultural ambience, without which they would not have been just what they are. Aristotle's view of tragedy as a natural kind can now be abandoned in favor of, for example, Raymond Williams's contention that tragedy assumes different forms in the modern period, that its subject matter will not be the same as it was for Aeschylus, Sophocles, and Euripides, and

that Aristotle's strictures on the social position of the tragic protagonist (he will be someone somewhat better than ourselves) need to be appropriately modified when one discusses Ibsen or O'Neill. It is no longer possible, in my view and in the view of many of the antitheory theorists I've mentioned, to conceive of literary study as discretely segregated from other disciplines in the cultural sciences. On this account, literature may still be a particular, distinctive kind of thing, having a different nature from, say, newspaper reports and television advertising. But to determine whether such is the case about literature, we need first to investigate the ways in which it is a product of determinate social, historical, cultural causes that make *Middlemarch* one sort of product, *Four Quartets* another. And before giving the obvious answer, "Well, one's a poem and the other is a novel," one ought to think long and hard about what the discrimination between poetry and novelistic fictions has meant over the last two centuries, about whether our familiar genre categories any longer capture the literary practice of even the major figures canonized by the tradition. For example, if we call *The Ring and the Book* a long narrative poem, are we licensed or forbidden to say the same about *The Waste Land* or *The Comedian as the Letter C*? Or if we agree that *Bleak House* is a novel, do we say the same of *Eugene Onegin* or *Ulysses*?

All of the questions I've been posing circle around a single claim: to wit, that in the study of literature, we are duty-bound to consider texts as objects of knowledge. Correlatively, if we are to gain knowledge of these complex and quite peculiar objects, we need (1) a concept of the object in question, and (2) some theory that accounts for how this object came to be what it is and not something else. In short, despite all the antitheory noise that surrounds us today, none of the antitheorists themselves can avoid posing theoretical problems or holding to generally quite well-defined (if most often tacit) theoretical views—with one notable exception, illustrated perfectly by one of my colleagues. He believes (or professes to believe) that nothing can be said about poetry, since poetry is per definition beautiful, and beauty is not something that can be talked about consecutively, rationally. Beauty can only be experienced, sensed, or intuited in some utterly mysterious way.[29] Perhaps he's right, but then one wonders how he justifies taking his rather substantial

salary, since he openly declares his incapacity to teach anything significant about the subject he has been assigned. Roger Kimball and company want to get rid of all us tenured radicals because he believes we have violated our compact with the state and the society it represents by teaching things contrary to the dominant ideology. I would say, rather, that people like my aesthete colleague are the ones who deserve to get the sack, if only because they have given up on what the university has claimed to be in the business of doing ever since its foundation in late medieval Europe: producing knowledge and disseminating it to students and others. Far from being barbaric (a favorite Kimball word) or anti-intellectual, those who take theory seriously are the ones who most prize the standards by which the achievement of academic intellectuals has been, and indeed ought to be, measured.

Professing literature, as Gerald Graff has shown so well, has always been a pretty contentious business. I would add to his admirable account only that the reasons for this contentiousness are not merely internal to the discourse of literary criticism and scholarship. Such is certainly the case today, as I've tried to indicate, with explicit political agendas motivating the different sides in the theory wars. I suppose by now my own political inclinations will have become pretty obvious. But so will the connections between my politics and my theoretical commitments. These latter separate me from left antitheory, and put me closer to someone like John Searle, at least in his current incarnation. This situation makes me uncomfortable at times, but if there is a contradiction between a thoroughgoing commitment to both philosophical realism and leftist politics, then it's one I share with Marx, Lenin, and Althusser. In such company, I think it will be possible to live with this contradiction awhile longer.

Notes

1. Since the sixties, the most unstinting foe of such Orwellian perfidy has been Noam Chomsky, whose *American Power and the New Mandarins* remains the classic diagnosis of the collusion between the mass media and technocratic intellectuals in effacing historical truths. More recently, Bruce Cumings has argued much the same point about the Korean War, with some interesting sidelights on television's role in prosecuting the Persian Gulf War.

2. This is to leave aside the publication of Wellek's and Warren's *Theory of Literature* just after World War II, since that book, unless I'm much mistaken, never achieved the same widespread currency in literary studies that the texts and figures I'm about to mention did.

3. The bibliography on the history of U.S. literary study since the World War II has grown exponentially in recent years. Useful surveys, from a variety of points of view emphasizing different figures and focal topics, include: Graff, ch. 11–15; Leitch; Arac, ch. 7, 9, 10–12; Bové, *Wake*; Fekete, pt. III and IV; and Lentricchia. Lentricchia selects roughly the same founding moment for theory as I have here; see ch. 1, "The Place of Northrop Frye's *Anatomy of Criticism*." As I shall indicate shortly, I'm less certain than he that Frye's monumental book marked a definitive turning point in academic literary criticism at its moment of publication. In my view, the break came later, and less punctually, than Lentricchia's story suggests.

4. Lentricchia makes much of the Kant–Schiller connection to Frye (see 18–21), but the stronger affinities to Kant's supposed autotelism are surely evident in the New Critics. Lentricchia relies at this point on Murray Krieger's utterly misleading dichotomy between a Platonizing Frye and an Aristotelian New Criticism.

5. Effectively out of print for a number of years, this classic study deserves republication and updating, since the scene Ohmann sketched in the early to mid-1970s has changed in some important ways, even if the fundamental structures of U.S. higher education have probably become more solidly entrenched in the interim. The "semiautonomy" of literary study from other university disciplines is perhaps among its most striking features, particularly in recent years. It explains, I think, the virulence of the right's attack, which has regularly focused on literature as the site of supposed subversion.

6. On Matthiessen, see Arac 157–75; on Trilling, see Chace, Wald, and Krupnick; on Blackmur, see Said.

7. There were some few women as well, Caroline Gordon most notably; but looking at old photographs of the Kenyon English School or any of the literature departments at major colleges and universities prior to the 1970s, one has to look very hard to locate the female faces.

8. This information came to me from the late F.W. Galan, who studied with Frye at Toronto and wrote a dissertation on the Prague School under his direction. Galan left Princeton, where he had been working on a doctorate in comparative literature, for lack of a sympathetic audience to read his admirable study of the Prague School, subsequently published as *Historic Structures*.

9. Ultimately, of course, the concept of the "human sciences" derives from the neo-Kantian, and linguistically German, distinction between the *Naturwissenschaften* and the *Geisteswissenschaften*. Still, the English phrase is a literal translation of the French. That

theory appeared on these shores first—and to this day in greatest quantity—from Paris seems an uncontroversial point.

10. One plausible version of this explanation with which I have some local disagreements is given in the first half of Ahmad.

11. Bové's account tells a similar story to the one related here. It opens with a Heideggerian critique of some of the antitheory theorists I take to task in the following paragraphs. The differences between his view of theory's situation in 1990 and my own may perhaps be inferred from the following observation: "In my work, I generally tell a sad story of the defeat of criticism by institutions, of knowledge and seriousness by posture and fashion, of memory by amnesia" (*Wake* 1). Despite professed allegiance to Gramsci, Bové tends toward a Weberian (via Foucault) view of modern society, rather than a marxian one.

12. Commentary on the first group would be superfluous, since their opposition to theory is well known. Searle is a more complex case, as a careful reading of "Storm" demonstrates. Searle is not against theory *per se* but against certain popular contemporary versions of what goes under that name: notably deconstruction and poststructuralism, which latter he glibly derides as "a silly but noncatastrophic phenomenon" (34). For a representative indication of Crews's current views, see "In the Big House of Theory."

13. The following citation from Bloom's diatribe against the famous events at Cornell in 1969, "The Democratization of the University," exemplifies a prejudice expressed more mutedly, but quite as insistently, throughout his writing:

> The democratic ruling body establishes, as do all ruling bodies, policies which further its interests. The substantive reforms, as I have said, have no basis other than they tend to the equality of all. Open admisssions is the new cry. All citizens must go to college; everyone must be allowed into the halls of learning. And this means, in effect, that everyone must graduate from college, for it will soon be found that it is impossible to fail great masses of students in the age of student power. It immediately follows that standards must be lowered, or rather, utterly abandoned, no matter under what shining banner this change is presented. (*Giants* 371)

Bloom's prophecy was not fulfilled. One might profitably scan the depressing recent statistics on graduation rates from public universities to see that baccalaureate degrees are not now, as he feared, given out like candy.

14. Although he would probably not agree to my exact formulation here, Paul Bové argues for much the same line against the antitheory crowd as I am urging (see *Wake* 5–24). A useful introduction to the arguments of the "antitheory theorists" is Mitchell, a reprint of articles that originally appeared in *Critical Inquiry* between 1982 and 1985. The pleonasm, "antitheory theorists," is only apparent, as Mitchell points out in his introduction (4, 8–9). The chief protagonists, Steven Knapp and Walter Benn Michaels, stipulatively define theory as any attempt to establish general criteria of interpretation, i.e., theory in

the Hempelian sense. But no such conception of theory need operate in the human sciences, any more than it ever has in the natural sciences (*pace* certain positivist philosophers of science). Knapp and Michaels are just beating a dead horse, philosophically speaking. For a more informed view on the limited scope of literary theory, see Graham, especially ch. 5, "The scope of poetics," and "Coda: Literature and the language of learning." Graham's stipulation of a strong theory of literature grounded in cognitive psychology does not foreclose other research programs, e.g., those proposed at the end of this essay.

15. Greenblatt's antitheoretical bias is patent in programmatic pieces, e.g., his "Intro-duction" to *Learning to Curse* (1–15) and "Towards a Poetics of Culture." *Learning to Curse* has been relevantly criticized by Siar.

16. The view has also achieved a certain currency on the Anglo-American left via the interventions of Laclau and Mouffe.

17. Greenblatt's methodological evasiveness is perfectly captured in the following quotation: "the transactions that enable the creation of Shakespeare's plays are possible only because of prior transactions. Theoretically, at least, the chain has no end, though any inquiry has practical limits and, moreover, certain moments seem more important than others" (*Shakespearean* 166). No limits, in short, other than those the inquirer imposes. But surely, on pain of self-contradiction, Greenblatt would have to concede that "importance" is as constructed a category as any other. His own attempts at self-analysis tend to be coy about how he came to have the enthusiasms he now exhibits; see the introductory essays to *Learning to Curse* and to *Shakespearean Negotiations*. Fish's position is outlined in the second half of *Is There a Text in this Class?* and refined, without altering its fundamental tenets, in *Doing What Comes Naturally*. I have criticized Fish's views in "Knowing, Believing, Doing." Kuhn's work is more complex, his constructivism less radical than his *epigoni* have generally understood. For a thorough assessment of the (largely unintended) impact of *The Structure of Scientific Revolutions*, written on the thirtieth anniver-sary of its publication, see Fuller.

18. The monument to this Foucauldian research program is the multivolume *History of Private Life* assembled by a distinguished group of French social historians; see especially Perrot, vol. IV.

19. Bové has protested what he calls "the California appropriation of Foucault's writ-ings." But Foucault's anti-marxism is surely beyond dispute. Greenblatt et al. may elide some of the complexity, but they have grasped the basic lesson. On the dominance of anti-marxist radicalism among metropolitan intellectuals, see Ahmad, ch. 1–4.

20. I owe the general point to the work of Roy Bhaskar, especially his *Reclaiming Reality*. See also his critical study of Richard Rorty, *Philosophy and the Idea of Freedom*, which expands on this theme and carefully disambiguates Rorty's libertarian notions of freedom from his professed (but unsustainable) liberalism (57–77). I see no reason to

dissociate those left antitheorists about whom I have been speaking from the following ringing denunciation, which brings Bhaskar's critique to a close:

> . . . Rorty provides an ideology for a leisured elite—intellectual yuppies—neither racked by pain nor immersed in toil—whose lives may be devoted to the practice of aesthetic enhancement, and in particular to generating self, other and genealogical descriptions. Their careers are a succession of poems, all marginally different; and a succession of paradigm shifts, for which no overarching or commensurating criteria can be given. . . . They are to be found especially in the "soft" disciplines—the social sciences and the humanities—where experimental closures are not possible and where there appear to be no criteria for rational criticism and change. . . . Rorty may be considered as the ideologue of unschematized categories and concepts for a leisured elite, in conditions of plenty. (*Philosophy* 134–35)

One should add: such conditions are not eternal and appear increasingly less likely to obtain, even among the OECD nations. Left antitheory may yet be overtaken by the very real structures and events it has systematically denied exist outside its own imagination.

21. The point should be uncontroversial, but for those whose charity toward Fish requires more specific evidence, consider the following two citations, taken more or less at random (with effort one could find many others) from *Doing What Comes Naturally*:

> [Antifoundationalism] is an account of what we have always been doing and cannot help but do (no matter what our views on epistemology)—act in accordance with the standards and norms that are the content of our beliefs and, therefore, the very structure of our consciousness. (323–24)

> To this thesis [that there exists a continuum of constraints, not all equally powerful] I would oppose the counterintuitive assertion that there is not a continuum because the degree of constraint—at least in relation to an ideal condition of freedom—is always the same and always total. (459)

22. On this point, Fish may be a more loyal follower of Kuhn than he knows. Kuhn's own position, as Feyerabend and Popper were quick to discern, tended to justify, indeed privilege, what he called "normal science" at the expense of Popperian (or just plain Enlightenment) reasoned criticism; see Popper's and Feyerabend's contributions to Lakatos and Musgrave. When science is running properly, on a Kuhnian construal, its practitioners are governed by powerful guild constraints, *viz.*, the infamous "paradigms." Also see Fuller, who situates *The Structure of Scientific Revolutions* in relation to the late fifties public demand for external controls over scientific research. He discerns in Kuhn's text a subtle defense of science's autonomy, therefore its immunity to nonexpert criticism—Kuhn as a more rhetorically effective Polanyi.

23. Fish is surely guilty of what is called in the sociology trade "over-socialization." Again, the congruence with Kuhn's conception of a scientific community is striking. Fish remarks it occasionally; see *Doing* 125–26. More generally, however, Fish hauls out Kuhn as a stalking horse for "antifoundationalism" (*Doing* 345), or, less grandly, the ineluctability

of rhetoric (*Doing* 486–88), reproducing thereby the standard account of Kuhn's work in the human sciences.

24. See *Doing*, especially "Rhetoric" (472–85), where Fish holds, in essence, that Plato was right about rhetoric but wrong about truth, and that Aristotle's more nuanced account simply dodges the issue. One would have thought that among the signal lessons taught by postempiricist philosophy of science (for which Fish professes enthusiasm) is that there is a broad middle ground to occupy between Platonic metaphysics and utter skepticism.

25. This is the point at which Rorty tends to part company with other neopragmatists: he continues to honor the practice and theoretical significance of the natural sciences, taking his cue from Dewey (rather than from his other hero, Heidegger). But like Feyerabend, Rorty holds that philosophy has nothing interesting or significant to contribute to their practice.

26. Rorty talks frequently as if he wants many of the same things as the left, and he expressly wishes to be on the same side as some of them: most notably of late, feminists. For this latter, see "Feminism and Pragmatism." On his alignment with traditional concerns of the left, see "Intellectuals in Politics." But Rorty's more abiding political enthusiasms betray him. He is entirely unabashed in cheerleading for North Atlantic liberal democracy and welfare capitalism, a conviction he shares with an otherwise unlikely bedfellow, Francis Fukuyama.

27. To stay with de Man and Eagleton for a moment, the former's respect for the European theoretical canon is manifest, nowhere more than in his programmatic essay, "The Resistance to Theory." Eagleton's engagement with the tradition has been more sporadic, but his recent *Ideology of the Aesthetic* is exemplary in this regard.

28. See my "Knowing, Believing, Doing"; the final chapter of *Imaginary Relations*; and "Reply to Paisley Livingston."

29. And even this is a theory, albeit one my colleague adheres to in total ignorance of its provenance or its consequences, as far as I can tell. His concept of literature is just a vulgarization of eighteenth-century sensationism of the Shaftesbury-Burke sort, the problematic of which descends from Plato's infamous divided line. Perhaps a thorough reading of Rorty would disabuse him of his prejudices—but then again, probably not. As Saint Thomas Aquinas opined, there is such a thing as invincible ignorance.

9

We've Done It to Ourselves

The Critique of Truth and the
Attack on Theory

Reed Way Dasenbrock

Most of the people I know who teach in the humanities at the college or university level have had a fairly similar set of reactions watching the discussion in the media over the past several years concerning theory, the canon debate, PC, and other such overlapping but not identical issues. First, we have been watching. We have not only not been able to set the terms of the debate; we have for the most part not been able to enter the debate, which has by and large been conducted by the pundits of the talk shows and by columnists in the print media. Even when academics are brought before the camera and allowed to say their piece, even when they say it well, I think few of us have felt adequately represented. A common reaction runs this way: who, after all, picked Catharine Stimpson or Stanley Fish to speak for me? Second, this failure to control how our work is represented has led to some serious misrepresentations of the positions at stake. No one attempting to get a sense of what is happening in literary studies today would get a very reliable picture if he or she relied on the coverage in the media.

I share both of these reactions, but where I disagree with most of what I hear and read along these lines is the next step, the analysis of why this misrepresentation has gained such currency so easily. The analyses I have read have tended in a fairly straightforward way to blame someone else, and blame has very much been the order of the day. In the words of Gregory Jay and Gerald Graff, "We still believe that the anti-PC assault was and is orchestrated by politically-minded operatives outside higher education who want to turn back the clock to the days of ivy-covered, white male prep schools catering to the American power elite" (1). This may be true, though the

172

underlying rhetoric of the sentence ("These barbarians outside the gate are trying to take over our universities") is close enough to the rhetoric of the "anti-PC assault" it ostensibly opposes to give one pause. In any case, this certainly cannot be the whole story, for it fails to explain why this representation of academia has seemed so plausible to those who are not part of any power elite and never attended schools with any ivy on the walls. Even if the debate has been staged, why is it that we have been able to make so few points? The answer doesn't lie in scapegoating the NAS in just the way they scapegoat others; it lies in analyzing why academic theorists typically are so remarkably unpersuasive when they seek to persuade others that the "anti-PC assault" misrepresents the true state of affairs.

When the question is posed in this way, the answer seems to me to be obvious, which is that theorists lack credibility complaining in this way given the critique of truth and of the possibility of accurate or objective representation that has dominated literary and cultural theory over the past generation. How can anyone committed to the notion that all representation is misrepresentation complain of misrepresentation? Gregory Jay has recently addressed this question in the following way:

> The original statement of principles of Teachers for a Democratic Culture, to cite one instance, objects to "a campaign of harassment and misrepresentation" aimed at proponents of new forms of knowledge and new practices in education. Some critics were of course quick to point out the apparent irony here, that a profession so lately charmed by the poststructuralist assertion that all representation was misrepresentation should insist on the importance of accurate accounts of its work. This irony, however, rested on the common misunderstanding of poststructuralism and deconstruction as theories which deny the possibility of meaning. (11)

But there is a crucial terminological slippage in Jay's account, a slippage from truth to meaning. It is indeed a misunderstanding of deconstruction and poststructuralism to see them as denying "the possibility of meaning," but it is not a misunderstanding to see them as denying the possibility of objective truth. It is not the "possibility of meaning" we need to secure to assert that

something is a misrepresentation, but the possibility of truth, and that has been a possibility consistently denied and critiqued by theorists of a variety of persuasions over the past generation.

Given this critique of truth, for most theorists to complain that their work has been misrepresented is to lapse into obvious incoherence, and the larger public interested in this debate has been able to see this clearly. The positions developed in contemporary theory thus permit—indeed, encourage—the kind of treatment theory has received over the past several years. Moving beyond a critique of a particular system of representation to a critique of the possibility of accurate representation itself, as literary and cultural theorists have done, has blocked those theorists from responding effectively to the critical attention their work has received. In other words, we have no one to blame—if blame we must—but ourselves. And if we as academics wish to change the views others have of us, the first thing to do is to change our own views, to move toward less defeating and self-contradictory theories. If we wish for theory to have a better image, we need to construct a better theory.

Given the remarkable variety of theoretical approaches in literary studies today, it is perhaps equally remarkable how little disagreement there is about the concept of truth. Theorists who agree on little if anything else unite to view the word and the concept with suspicion. Anyone who claims truth-value for a statement—so the contemporary orthodoxy has it—is deluded, caught in a system of ideology that has created the discursive structure in which the speaker is operating, and is probably deluding as well, seeking to obtain power over others. A softer version of this would say that to make truth-claims is just a waste of time. We say something is true when we believe it, but the claim to truth status is a rhetorical fifth wheel that doesn't add anything to the statement that we believe it.

The contemporary critique of truth-claims is one with the contemporary critique of objectivity, and the notion that objectivity is a myth plays as important a role in the self-representation of the humanities today as the notion of objectivity has traditionally played in the self-representation of the sciences. *Speaking for the Humanities,* a recent ACLS pamphlet intended as an

answer to attacks on the state of the humanities, provides a good example of this view. A section entitled "Ideology and Objectivity" begins as follows: "Perhaps the most difficult aspect of modern thought, even for many humanities professors and certainly for society at large, is its challenge to the positivist ideal of objectivity and disinterest" (Levine *et al.* 9). Modern thought here is presented as a seamless unity, united in its opposition to positivism, and what is particular to be objected to in positivism is its belief in objectivity and disinterest. No names need be mentioned, presumably because no one disagrees. Or rather, if anyone does disagree, we know that this is because his or her interests are at stake. As we are told a few pages later,

> As the most powerful modern philosophies and theories have been demonstrating, claims of disinterest, objectivity, and universality are not to be trusted and themselves tend to reflect local historical conditions. (18)

We are presented as having only two possible views on the question of objectivity: the old paradigm now seen to be naive in its "positivistic" stress on objectivity, and the new paradigm which inculcates an attitude of disdain or critique toward the old objectivism. These two possibilities are presented as an historical sequence, as if the old paradigm had no challenges in its day and the new "modern" one has no challenges (at least, no "powerful" ones) today.

There are two distinct currents of thought that have converged to give upholders of this view their sense that no serious challenges exist to it, one ultimately deriving from Nietzsche but more proximately from Foucault, which stresses how discursive systems formalize a will to power that claims truth-status as part of a strategy of power and domination, and the other deriving from American pragmatism and given currency today by Richard Rorty and Stanley Fish. There are obvious differences between these intellectual traditions, but the essential point on which they agree is that truth-claims are rhetorical. In Nietzsche's famous definition, "What therefore is truth? A mobile army of metaphors, metonymies, anthropomorphisms: . . . truths are illusions of which one has forgotten that they are illusions."

Talk of truth in Rorty's vision is one of philosophy's central legacies for

our culture, and it is in this vision a baneful legacy. When we say something is true, we are simply asserting that it is so, and we say so because we believe that it is so. The notion of truth doesn't do any real work in the act of assertion except to raise the rhetorical stakes of the assertion. Such claims to truth-status can, in Rorty's analysis, be deconstructed or shown to be contingent. All of us operate within received ways of seeing the world, and when we say that something is true, we are assenting to it because it fits that way of seeing, our interpretive framework. Philosophers since Descartes (really, since Plato) have presented philosophy as a way to move outside these local frames of reference and attain the truth, but this vision of philosophy as a mirror of nature, as a way of representing how things really are, is itself just one more framework, one more way of seeing. What counts as truth is thus as contingent, as tradition- or discipline- or community-specific, as what counts as great art, and we have no way to move outside these competing traditions to declare which one is "true."

Rorty argues that truth-claims are a rhetoric we are better off without, precisely because truth-claims are always community-specific in ways we may not be aware of: just as we put knives and forks in certain places, so too do we view the world in certain ways and consider such ways the truth. If we were switched at birth with someone else located in a different tradition of belief, we might call different things the truth in just the way we might eat with different implements. So much is obvious, but what Rorty goes on to claim is that the notion that we have any way to decide which of these is closer to the truth is based on a metaphysical notion of truth, on an illusion that somehow philosophers or scientists or whomever we think can decide what is true don't also represent a community of belief. There is no universal truth, no truth apart from speakers for whom things are true, and what is true-for-me, more precisely what is true-for-us, depends necessarily upon what my community has always held to be true. The unexamined life may not be worth living, but no one can examine all of his or her beliefs, which means all of our lives and belief-systems have unexamined contents. The social is assigned the primary role in causing our beliefs, which means that the content of those beliefs has an inescapably arbitrary component.

Rorty's analysis of the role the concept of truth has played in the Western tradition is broadly compatible with the other major contemporary negative theorist of truth, Michel Foucault. What Foucault adds to the critique is an analysis of why truth claims are made even though they are ultimately rhetorical and empty, and his analysis is essentially political:

> Each society has its regime of truth, its "general politics" of truth: that is, the types of discourse which it accepts and makes function as true; the mechanisms and instances which enable one to distinguish true and false statements, the means by which each is sanctioned; the techniques and procedures accorded value in the acquisition of truth; the status of those who are charged with saying what counts as true. (*Power/Knowledge* 131)

The discursive system of truth thus is—as always for Foucault—ultimately a system of power: talk of truth is one of the tools of power, for the claim "it is true that" or "it is false that" must be understood in terms of an entire discursive system in which certain things can be thought and said and others are firmly excluded.

What finally differentiates Foucault's critique of truth from Rorty's is Foucault's claim that every society inevitably possesses "a certain economy of discourses of truth"; "we are forced to produce the truth of power that our society demands" (93). For Rorty, in contrast, talk of truth is relatively optional, a feature of a society overly influenced by metaphysics. Rorty therefore has a reform proposal to make in addition to a critical analysis. What he proposes is a change in vocabulary. He thinks that we can move away from these bad old metaphysical ways of thinking and talking toward a postmetaphysical, indeed postphilosophical, discourse in which talk of truth and fitting the way things are would be abandoned. Recognizing the contingent and community-specific nature of our own discourse would encourage us to lower the epistemological stakes of our own assertions. For Rorty, this would be an entirely good thing, and the reform he recommends is that we talk about warranted assertibility instead of about truth. I have perfectly good reasons for asserting what I assert: I have—in Stephen Toulmin's vocabulary— warrants for the assertions I make. But the warrants I find convincing convince

me because they and I issue together out of a shared form of life; their validity is therefore as contingent or community-specific as the assertions they sustain.

I'm not here going to examine the question of whether this view of truth is itself true. Obviously, that way of putting the question lands one in paradox, for how can a view that there is no objective truth claim truth status? Hilary Putnam has, over the past decade, elaborated a sharp critique of Rorty's views from precisely this angle, arguing that Rorty's views are self-refuting because they land one in paradox from the beginning.[1] Much the same critique could be extended to Foucault: if Foucault's own statements are statements he is forced to produce by his society, then isn't their validity compromised by this complicity with power? If they somehow stand outside this discursive economy of domination, then isn't the completeness of his description undermined? And in the same spirit, one could wonder how Nietzsche would characterize his own claim that "truths are illusions of which one has forgotten that they are illusions." Is it too an illusion whose illusory status has been forgotten? If so, the possibility of truth remains intact. If not, then for Nietzsche at least one truth is not illusory. In either case, the dramatic claim loses a great deal of its force. Rorty's response to this line of argument has been to point out that this critique is an attempt to force a pragmatist such as himself back into the very metaphysical vocabulary he is trying to avoid. Rorty would surely prefer that his proposals be assessed on grounds appropriate to them, on pragmatic grounds, rather than on their truth or universal validity, categories foreign to the proposal.

But if we do that—and this is really the central point I would like to make—the assessment is equally negative. If we are asked to choose on pragmatic grounds between the "new pragmatist" conception of truth and objectivist notions of truth, the choice must clearly be for objectivism, particularly in the more sophisticated form it has been given by recent analytic philosophers such as Hilary Putnam. The pragmatic argument that truth-claims cannot claim universal validity and need to be assessed on pragmatic grounds—whether or not it is true and can claim universal validity—has had

pragmatic consequences we can trace in the PC debate. If we are to assess this claim, a claim central to antifoundationalism and what is often called the new pragmatism, on grounds it asks to be assessed on, we must judge it to be a pragmatic disaster. For if we say that there is no truth, only what counts as truth within interpretive communities, how can we protest against any "misrepresentation" of the contemporary academy by journalists and the popular media? If we argue for such a Nietzschean or Foucauldian concept of power, how can we articulate a principled objection against the apparent politicization of grant-making in the NEH during Lynne Cheney's tenure? If we say that talk about truth is only a cover for the operation of power, why should we be surprised that people outside the academy might actually begin to exercise power? We have left ourselves without principled grounds to object of any of these developments, and it is of no pragmatic or rhetorical value here to claim or insist that there are no such grounds, since we are trying to convince people solidly convinced that there are such grounds and that effective argument grounds itself in such general principles. Our pragmatism has proved highly unpragmatic.

Some years ago, well before anyone in the United States outside the academy was paying any attention to theory, Charles Taylor elaborated a critique of Foucault which made essentially this point on a broader and more abstract scale. Taylor's point is that even Foucault's essentially depersonalized structures of power and domination make no sense without the opposed concepts of freedom and truth: " 'power' belongs in a semantic field from which 'truth' and 'freedom' cannot be excluded" (175). Another way of putting this is that one needs a concept of Truth separate from the "truths" of discursive systems for Foucault's critical analyses of those "truths" to have any purchase. In *The History of Sexuality,* for example, Foucault speaks (almost in Gramscian language) of how power disguises or masks itself in order for its operation to be tolerated. As Taylor points out:

Mask, falsehood makes no sense without a corresponding notion of truth. The truth here is subversive of power: it is on the side of the lifting of

impositions, of what we have just called liberation. The Foucaultian notion of power not only requires for its sense the correlative notions of truth and liberation, but even the standard link between them, which makes truth the condition of liberation. (176–77)

Foucault's failure to use a positive concept of truth in this way against the "truths" he criticizes is why he cannot give liberation or freedom any positive content, only the negative role of resisting the imposition of power:

> transformation from one regime to another cannot be a *gain* in truth or freedom, because each is redefined in the next context. They are incomparable. And because of the Nietzschean notion of truth imposed by a regime of power, Foucault cannot envisage liberating transformations *within* a regime. The regime is entirely identified with its imposed truth. Unmasking can only destabilize it; we cannot bring about a new, stable, freer, less mendacious form of it by this route. (emphases Taylor's; 178–79).

Rorty disagrees here, for he considers that our "truth-regime" is a relatively benign one, and this constitutes perhaps the sharpest tension between the two forms of the Nietzschean critique of truth alive in theory today, between the Foucauldian version that sees us as living in the worst of times and the Rortyan version that sees us as living in the best of times. But the theory-world hasn't been sharply divided between Foucauldians and Rortyans, linked as they are by their comparable stress on the "regime-relativity of truth," as much as that it has oscillated between these two languages of analyses, using each for different occasions. In our conversation among ourselves and in our analyses of ourselves, we are by and large Rortyan liberals: we have taken Rorty's advice to heart, dropped talk of truth as an illusion, and prided ourselves on living in a postphilosophical age while the rest of society is still steeped in philosophical illusion. However, Foucault has been a much larger influence on our analyses of others, both of the world outside of academe and of the authors we study, perhaps the dominant recent influence in our analyses of literary texts, particularly in the (by now, rather monologic) stress on how authors from other times and with other assumptions were caught

up in the discursive systems of their times and cultures. The events of the past several years should serve to remind us that only those inside the academy have adopted Rorty's advice, that those outside have remained firmly committed to the older, "naïve" language of objective truth. Truth has been a Rortyan elective for us, an unfashionable course a few old-fashioned and naive professors have been allowed to go on teaching, but it's a firm and unshakable requirement for those outside the academy. We have responded to that in a Foucauldian mood, stressing how they are speaking the language of truth because of a will to power over us, in just the way we have always used the language of Foucauldian critique in our analyses of others.

Taylor's critique of Foucault is relevant to this situation, as his point that Foucault leaves one in a position of resisting other descriptions without a positive descriptive language of one's own has been distressingly confirmed in the war over the university of the past several years. Our commitment to a critique of "truth-regimes" without a compensating substantive vision of truth outside those regimes has been a large part of what has disabled the academy in its response to the outside criticism it has received. Taylor's emendation of Foucault and Putnam's critique of Rorty suggest to me the way theorists might go in order to develop such a more substantive position. The language of critique or the hermeneutics of suspicion is an immensely valuable tool in critical analyses (whether of literary texts or larger discursive systems) which theory has elaborated and should not abandon. But the language of critique as it has been recently elaborated is not a complete language: when we point out the situatedness of others, that is intelligible as a critique only if we have the notion of truth as a background notion or limit condition to contrast to their local "truths" which we have exposed to be far from the truth. As Putnam has said:

> Let us recognize that one of our fundamental self-conceptualizations, one of our fundamental "self-descriptions," in Rorty's phrase, is that we are *thinkers,* and that *as* thinkers we are committed to there being *some* kind of truth, some kind of correctness which is substantial and not merely "disquotational." That means that there is no eliminating the normative. . . . We don't have an

Archimedean point; we always speak the language of a time and a place; but the rightness and wrongness of what we say is not *just* for a time and a place. (*Realism and Reason* 246–47)

I expect many reading this passage will find Putnam's insistence on the possibility of truth beyond the truth of a community naïve, but only with such a concept is much contemporary ideological critique intelligible. Only by establishing my bias does the act of locating me constitute a critique of what I am saying, and the concept of bias makes no sense without the concept of unbiased truth. The notion of ideology found in ideological truth depends inescapably on the possibility of a nonideological truth, and there is nothing inherently conservative about this view, since implicit in marxist critique has always been a comparable if differently nuanced commitment to truth.

To abandon the language of truth, as theorists have over the past generation, is to abandon the sharpest weapon of critique we possess. If we take up that task of critique, moreover, it is incoherent not to expect it to be used against us, and it should occasion no surprise that a community devoted to pointing out the community-specific nature of beliefs about the world should be perceived as a community with community-specific beliefs of its own. Whether our eschewal of truth has a Foucauldian or a Rortyan inflection, as long as we insist on the community-specific nature of truth and stop there, we have no coherent response to any hostile description of our community, for that hostile description may be true to the beliefs and desires of the community responsible for the hostile description. If we respond to a hostile description by saying "that isn't true," then we must have a theory of truth that allows for the possibility of truth beyond the beliefs and theories of a given community. If we have such a theory, let us use it. Let us freely move beyond the negative moment of critique ("you consider that to be true because of the community you belong to") to a positive elaboration of values and beliefs ("I consider this to be true and here are my grounds for so claiming"). If we adopted such a new and less hostile attitude toward the concept of truth, we would be able to meet the challenge we are facing much less incoherently and much more effectively. We might even get closer to the truth.

Note

1. Putnam's critique of Rorty is elaborated in a number of different places, including "A Comparison," *Realism with a Human Face*, and *Renewing Philosophy*. Rorty has recently responded to Putnam in "Putnam."

10

Theory Against Itself

New Historicism's Return

to Practice

John S. Howard and James M. Lang

Steven Knapp's and Walter Benn Michael's definition of "theory," although obviously polemical, provides a perspective from which to examine the abandonment of theory by the new historicism:

> Our point has been that the separated terms are in fact inseparable. It is tempting to end by saying that theory and practice too are inseparable. But this would be a mistake. Not because theory and practice (unlike the other terms) really are separate but because theory is nothing else but the attempt to escape practice. It is the name for all the ways people have tried to stand outside practice in order to govern practice from without. Our thesis has been that no one can reach a position outside practice, that theorists should stop trying, and that the theoretical enterprise should therefore come to an end. (29–30)[1]

Although its battle with theory is relatively silent and not as explicit as this antitheory argument, we hope to show how the new historicism is allied with Knapp and Michaels in its disallowance of any governance of practice. The new historicism attempts to stand both within and outside practice, paradoxically claiming to recognize and confront the situated position of its speaking subject while forsaking the *necessity* of articulating its theoretical ground, avoiding theoretical interrogation. It sanctions an interpretive practice that speaks without responsibility by defining the field of interpretive discourse as an indeterminant web of connections. Despite claiming a position of theoretical insight, the new historicism has effectively disabled theory's ability to validate,

explain, and legitimate the possibilities of "practical" reading. Consequently, it has subtly undermined its own claims to interpretation.

Our argument here is not to be construed as applying to every form of historical criticism that might be considered to participate in what has generally been labelled "new historicist."[2] Instead, it should be read against certain hegemonic forms of literary and historical criticism that have arisen in response to a theoretically impoverished historical and literary scholarship, restricted only to the interpretation of rhetorical figures[3] (which is the same tradition Knapp and Benn Michaels were responding to). We will attempt to define these new historicisms by examining several, generalizable lines of thought pertaining to a type of theory that turns against itself, that is, which manifests a position from an apparent outside without obtaining to any role of governance or legitimation and which has subsequently enabled a free play of interpretive claims, distorting both the historical and literary texts that it claims to interrogate. In addition, our argument arises out of a critical milieu in which these antitheoretical effects have come to dominate certain areas of interpretive activity and have severely limited theory's ability either to redefine the conditions for knowledge or, to speak with Foucault, to think in a new way. Finally, we will argue that new historicism's assault on critical thinking has backhandedly cast the subject into a position of privilege, reading texts that she or he owns and controls.

The "practice" of new historicism is most strongly rooted in Renaissance studies, and the most visible and productive new historicist in that field has been Stephen Greenblatt. Greenblatt acknowledges that his relationship to theory has been confusing. He remarks rather candidly in his contribution to *The New Historicism*: "One of the peculiar characteristics of the 'new historicism' in literary studies is precisely how unresolved and in many ways disingenuous it has been—I have been—about the relation to literary theory" ("Towards" 1). But his subsequent response, that new historicism is "a practice rather than a doctrine," that it is "no doctrine at all" (1), does nothing to dispel the disingenuity of this relationship. Instead, Greenblatt goes on to imply that the new historicism subscribes to no one theory because it is

eclectic: recognizing the limitations of both Jameson's and Lyotard's histories of capitalism, and the limitations of a host of other "monologic" historical theories, new historicism represents a form of historicist bricolage. Consequently, new historicism claims a critically sophisticated superiority over its naive predecessors. Against this (neopragmatic) attempt to deny a relation between practice and doctrine, or to deny the existence of a doctrine altogether, we will contend that new historicism is a form of postmodern historiography that gains its momentum from a blurring of genre distinctions between historical and literary texts, a blurring of distinctions that allows it to evade demands for the kind of historical evidence which other methodologies are required to adduce.

In other words, it is evident that a theorist can make two claims about distinctions between, in Hayden White's terminology, "historical text" and "literary artefact" (*Tropics* 81). The weaker of the two claims, and the one to which we would assent, would be that literary artifacts are historical texts insofar as they are products of particular historical circumstances, and that as such they are able to yield to us information about the circumstances from which they arose; and that historical texts (historiography, political tracts, etc.) very often have literary aspects to them. The stronger claim, the one which we will attribute to the new historicism and which we will critique, is that there are no useful distinctions that critics ought to make between historical and literary texts when they are doing history: that both are expressions of some shared cultural code (which is what new historicists are *really* after). Although this latter, stronger claim is not usually made explicit, we will try to show that it informs and conditions at least some new historicist scholarship. And indeed, the fact that it remains implicit is part of the problem, for its hidden status prevents the new historicist from having to answer difficult questions about this "cultural code": How is it constituted? How can it undergo alterations? How does the code translate into textuality, historical or literary?

Discussions of postmodernism provide a useful analogue for the kind of genre blurring we see in the new historicism. Linda Hutcheon underscores the elision of boundaries typical of postmodernism by contrasting modern and

postmodern art. For Hutcheon, as for Charles Jencks and Paolo Portoghesi, architecture serves as a central model.[4] Hutcheon characterizes the rationale and consequence of modernist architecture in this way: "Faith in the rational, scientific mastery of reality implicitly—then explicitly—denied the inherited, evolved cultural continuity of history" (28). Postmodern architecture, on the other hand, "attempts to be historically aware, hybrid, and inclusive" (30). Postmodernism thus cannot be contrasted starkly with modernism, for postmodernism's relationship to any past—or its own present—is primarily characterized by treating every era or habit of mind as a source to be mined for new configurations (recall Greenblatt and the eclecticism of new historicism). These new postmodern configurations, though, are marked precisely by their awareness of past configurations, and by the often ironic and playful references they make to these past configurations. As Umberto Eco defines it in *The Postscript to the Name of the Rose,* "The postmodern reply to the modern consists of recognizing that the past, since it cannot really be destroyed, because its destruction leads to silence, must be revisited: but with irony, not innocently" (67).[5]

Postmodern literature can be described similarly, for Hutcheon, as "historiographic metafiction" (ix). Citing fiction writers such as Eco, Doctorow, Rushdie, Fowles, and Swift, Hutcheon argues that the historical turn in postmodern literature has the effect of blurring the boundaries between historiography and literature, of violating "the generic constructs of fiction and history" (110). Historiographic metafiction, in other words, is interested not so much in establishing or recognizing distinctions between fiction and history as it is in problematizing those distinctions wherever they are posited. Our concern does not lie with historiographic metafiction—except when it is taken as the model for "doing" history. But the link between new historicism and postmodernism (as postmodernism is defined by Lyotard and others) is not limited to analogies between this new form of historiography and a type of literature. Indeed, as a variety of critics have been quick to point out, new historicism and postmodernism draw, in similar ways, upon the same set of historical determinants. Anton Kaes, borrowing a phrase from Robert Venturi, writes that new historicism shares with postmodernism a "messy vitality":

New Historicism takes a skeptical stance vis-à-vis interpretive models that homogenize difference; it opposes, as well, the all too narrowly drawn boundaries between high and low cultures, between center and margins. New Historicism intersects with postmodernism in its stress on discontinuity and ruptures, eclecticism, heterogeneity, and decentered authority. (154)

If history has returned to the center of the stage, it has done so (at least in its new historicist forms) hand in hand with the eclecticism, the playfulness, and the unwillingness to respect traditional forms and boundaries that we commonly associate with postmodernism.

History should indeed assume a central position in our era, since one of postmodernism's important projects is the repudiation of transcendence, utopianism, and metanarratives.[6] Since literary theory cannot make its appeal for interpretive limits or boundaries to some transcendent truth, or some grounding foundation, or even to the inviolable structures of some hermeneutic or rational theory, then it can still appeal to history for a theoretically enabling paradigm.[7] History in the postmodern age becomes the only possible means for positing some hermeneutic limits or boundaries. In the new historicist paradigm, if we can no longer interpret Shakespeare's plays against an ideal of universal truth or an essential human nature, we can at least come to some understanding of them by understanding the historical context from which they arose and which they helped to shape.

Since a variety of ways are available to construct and understand a "historical context," we need a certain amount of theoretical sophistication in our historical criticism, especially if history establishes interpretive boundaries or limits for the new historicism. Given the relation we have been positing between history and literature in the postmodern age, theory should enter at precisely that moment when historical considerations are brought to bear on the literary text. What are the kinds of historical data, or texts, which we can legitimately bring to bear on literary texts? What are the criteria for adducing evidence (as the historian is required to do) to the effect that A (nonliterary text) had an influence on B (literary text)? What are the criteria for adducing evidence for the reverse process, that B had an influence on A?

Is it useful, even as a provisional heuristic device, to posit this distinction we are making between the literary text and those texts which form what has been traditionally construed as the historical context? If so, what should be the relation of literary text to historical context? These are the questions that historically-oriented literary theory should answer, and these are some of the questions that new historicists generally evade via economic metaphors of circulation and exchange or negotiation and acquisition.

A more challenging response to our articulation of the task of historically-oriented literary theory, however, would be the strong claim defined above, a claim that a variety of literary and social theorists have been making for some time now: that the generic categories we cite (literary and nonliterary) are false ones, and that we cannot fulfill the task of relating historical and literary texts, because all texts are in some senses both historical and literary. There are two distinct but related ways in which the blurring of these genres has allowed the new historicism to practice its particular kind of history: one kind of genre blurring occurs on the academic level, in university departments and hybrid scholarly texts; the other kind occurs in dealing with what historians call the primary sources—the texts, documents, data, etc.—from which historians in every field construct their accounts. The first kind of genre blurring or, in Clifford Geertz's terms, "refiguration of social thought," results from academics "more and more see[ing] ourselves surrounded by a vast, almost continuous field of variously intended and diversely constructed works we can order only practically, relationally, as our purposes prompt us" (166). Academic genres, in other words, have lost the sense they once had of being compartmentalized, fenced-off fields of specialization, and are increasingly seen and treated as provisional boundary lines to be crossed and recrossed by the new species of cultural critics, or cultural anthropologists (the latter designation giving proper credit to Geertz, whose influence in this area, and on many New Historicists, has been enormous). For example, Greenblatt tells us that in his radical youth he "wanted in fact to erase all boundaries separating cultural studies into narrowly specialized departments" (*Learning* 4).

While very few contemporary thinkers would dispute the claim that academic genres are nonessential, hermeneutically enabling constructs, this first

kind of genre blurring has led to an excess of the second kind, that of the historical texts themselves. With regard to the new historicism, it has thus led to a practical dispersal of generic boundaries between historical text and literary artifact. Greenblatt and other new historicists tend to deny this claim in their theoretical statements—"the poststructuralist confounding of fiction and nonfiction is important but inadequate" (*Learning* 15), Greenblatt asserts—but this denial rings hollow in the face of their actual scholarship. Greenblatt's essay on *King Lear* in *Shakespearean Negotiations* is exemplary in this regard. In it he treats two texts, Shakespeare's *King Lear* and Samuel Harsnett's 1603 *A Declaration of Egregious Popish Impostures*. He attempts to supersede the old literary historian's procedure of reducing history to the status of a backdrop by rejecting the traditional reading of *King Lear* as a fictional text against Harsnett's historical one. Greenblatt insists that "history cannot simply be set against literary texts as either stable antithesis or stable background" (95). His questions are more provocative: "When Shakespeare borrows from Harsnett, who knows if Harsnett has not already, in a deep sense, borrowed from Shakespeare's theater what Shakespeare borrows back? . . . And is there a larger cultural text produced by the exchange?" (95). These questions confound traditional distinctions between historical documents and literary texts by refusing to accept the formulaic one-way model in which historical texts "influence" literary texts.

Greenblatt's answer to these provocative questions is that both texts are the expressions of a cultural discourse in circulation at that time and in turn become productive of a new social discourse emanating from their appropriations and acquisitions. All texts—literary and historical—are thus simply expressions or appropriations of the "cultural text." Anton Kaes formulates Greenblatt's reasoning on this point in the following way: "Proceeding from the assumption that the historical 'background' is only accessible to us textually, it follows that the background itself becomes textualized and thus an object of interpretation, part of what Derrida calls 'le texte general.' " In Greenblatt's work, no functional distinction between text and context exists; text and context operate on the same interpretive level. Instead of learning how historical texts illuminate literary texts, or how literary texts are the

productions of a historical period, we learn the new set of economic metaphors coined by Greenblatt and endlessly repeated by new historicist scholarship: negotiation, circulation, and exchange. These economic metaphors drive home the notion of all texts being equal, and of all texts being the expressions of the cultural code. As Greenblatt explains in his introduction to *Shakespearean Negotiations*, all "textual traces . . . are the signs of contingent social practices" (5).

But what gets omitted in Greenblatt's article is the very question that constitutes it as new historicism: Was there reciprocal borrowing? Did Harsnett have any knowledge of or contact with Shakespeare? Any theory of the historical and the literary needs to articulate a cultural configuration that maps vectors of influence and borrowing. Greenblatt evades having to formulate any such cultural configuration by relying on qualifiers such as "in a deep sense" in the citation above, and considers it sufficient to point out Harsnett's references to the theater in general. Michael Sprinker notices this same rhetorical technique (in another essay in this volume), in which Greenblatt analyzes the play *Twelfth Night* in juxtaposition to an obscure trial from Norway. Greenblatt makes the argument that these two disparate events both testify to the same phenomenon, the Renaissance's highly constructed vision of human sexuality. Sprinker then cites Greenblatt's explanation that these two texts deal with a shared code, and responds:

> But how, one cannot help asking, did this "shared code" come to be constructed in the first place; and how, to make the relevant point about the relationship between Shakespeare's play and Renaissance medical discourse on hermaphrodism, did it come to be widely "shared"? To these standard questions that any historian worth his or her salt would pose at the outset of the inquiry, Greenblatt offers no answer. In the manner of his master, Foucault, he puts the two texts side by side and says, in effect, "See, they're one and the same." (this volume)

Like Sprinker, we are not criticizing Greenblatt for claiming that texts of different genres are the expressions of a shared cultural text; rather we are criticizing him for not offering a formulation of that cultural text, and for not making explicit the ways in which that cultural text gets translated into

both historical and literary texts.[8] What emerges from a close examination of Greenblatt's work is the disconcerting omission of a theory of sociocultural causality.

That Greenblatt shies away from any theory of causality ought not to surprise us, considering the way Foucault handled the problem. In *The Order of Things*, Foucault expresses his reluctance to adopt a theory of causality:

> It is not always easy to determine what has caused a specific change in a science. . . . It seemed to me that it would not be prudent for the moment to force a solution I felt incapable, I admit, of offering: the traditional explanations—spirit of the time, technological or social changes, influences of various kinds—struck me for the most part as being more magical than effective. In this work, then, I left the problem of causes to one side; I chose instead to confine myself to describing the transformations themselves, thinking that this would be an indispensable step if, one day, a theory of scientific change and epistemological causality was to be constructed. (xiii)

We see here the same kinds of difficulties that we are chronicling in this essay: an attempt to do practice without articulating or examining the underlying theory, a dissatisfaction with the old characterizations of causality without a formulated alternative, and a disingenuous attempt to dissolve these problems by confessing that the author is aware of them ("I felt incapable, I admit").

This same incapacity is displayed implicitly in Louis Montrose's " 'Shaping Fantasies': Figurations of Gender and Power in Elizabethan Culture," in which Montrose discusses *A Midsummer's Night's Dream* in the context of the cult of Elizabeth. Montrose makes the Greenblattian claim that not only did the culture (the cult) affect the literary text, but that the literary text reflected back onto the culture: "in the sense that the royal presence was itself represented within the play, it may be said that the play henceforth conditioned the imaginative possibilities of the Queen" (62). While this claim of exchange is the primary point of interest in Montrose's article, he adduces in support of it a reiteration of the claims, rather than any kind of evidence:

> it must be added that the Queen was as much the creature of her image as she was its creator, that her power to fashion her own strategies was itself fashioned by her culture and constrained within its mental horizon. . . . To the extent that the cult of Elizabeth informs the play, it is itself transformed within the play. (84, 86)

He simply restates rather than elucidates, and he cites Greenblatt for theoretical support. Such an argument seems to us to call for a well-developed cultural theory of relations between cultural imagination and literary texts, but Montrose is unwilling or unable to develop and articulate this kind of theory.

As Sprinker points out, Greenblatt and Montrose cannot answer these objections to their idea of history because they "manifestly lack[s] any strong concept of society and, a fortiori, of social causation" (this volume). David Siar, in a review of Greenblatt's *Learning to Curse,* cites new historicist Alan Liu, in a moment of "unflinching 'self-criticism' " (163), making explicit the theoretical underpinnings of this kind of history:

> A New Historical paradigm holds up to view a historical context on the one side, a literary text on the other, and, in between, a connection of pure nothing. Or rather, what now substitutes for history of ideas between context and text is the fantastic interdisciplinary nothingness of metaphor. (163)

The use of the word metaphor is telling here, for it returns us to the question of genre blurring between historiography and literature in postmodernism: to the question, that is, of whether postmodern criticism (in practice and theory) should be expected to be anything more than historiographic metafiction.

One historiographic metafictionist, Umberto Eco, has perhaps given the clearest explanation of the strange hermeneutic that underlies this new historicist "nothingness of metaphor." In *Interpretation and Overinterpretation,* Eco discusses what he calls Gnostic hermeneutics, in which the interpreter who sees a resemblance between texts A and B decides to read them both as the descendants of a lost text C, rather than as texts that might have influenced one another. In this way, the interpreter sets for him- or herself the endless

and endlessly diverting task of attempting to reconstruct text C (in the new historicism's case, the cultural code or social discourse). But this method of interpreting texts easily falls prey to what Eco calls "overinterpretation" (56). While we ought to acknowledge that literary texts can and do influence cultures at large, or that two similar texts can have a common lineage in a lost text, we also want to argue that it remains the historian's task to search for specific correspondences between discourses based on textual and historical evidence. New historicism has abandoned this kind of inquiry for specific and evidentially based correspondences, opting instead for discovering coincidences and randomly juxtaposing texts from any and every genre in pursuit of a cultural (hermetic) code.

We no longer practice hermetic hermeneutics, precisely because we are able to discern the confused theory that underlies it. New historicism seems to operate according to a similarly confused theory, but its evasive and disingenuous relationship to literary theory prevents us from seeing this. It prevents us from seeing—again—that we cannot simply treat different kinds of texts in the same manner, that the historical determinants which produce a literary text will function in different ways in the production of a legal text or a pamphlet. Distinctions between kinds of texts and the relationships between these different texts should play key roles in the reconstruction of a historical event or era, as well as in the interpretation of a literary text. Indeed it is the articulation of these distinctions and relations which ought to be a chief feature of theory in historical and historically-oriented literary criticism.

Greenblatt, again, provides an apt example of how this kind of theoretically naive refusal to admit genre distinctions can create interpretive difficulties. In his chapter from *Shakespearean Negotiations,* entitled "Invisible Bullets," he reads Thomas Harriot's *A Brief and True Report of the New Found Land of Virginia* (1588) in conjunction with Shakespeare's history plays. This is the article in which Greenblatt's oft-quoted "subversion and containment" formula receives perhaps its fullest treatment. "I want to suggest," he says, "that understanding the relationship between orthodoxy and subversion in Harriot's text will enable us to construct an interpretive model that may be used to

understand the far more complex problem posed by Shakespeare's history plays" (23). The desired end, therefore, is an interpretation of a literary text through a certain rubric; the means to that end will be Greenblatt's reading of this historical text.

His reading of Harriot focuses on passages in which Harriot discusses the positive effects that religion can have in assisting in the subjugation of the native Americans. He claims that these passages constitute "the very core of Machiavellian anthropology that posited the origin of religion in an imposition of socially coercive doctrines by an educated and sophisticated lawgiver on simple people" (27). This Machiavellian core, he argues, is a moment of atheistic subversion which is then contained by the urgent necessity of continuing to force this subjugation on the natives, and hence on the colonizers themselves. But Greenblatt's reading wants it both ways: while "Harriot's text is committed to record what I have called his confirmation of the Machiavellian hypothesis . . . the potential subversion of this confirmation is invisible not only to those on whom the religion is supposedly imposed but also to most readers and quite possibly to Harriot himself" (31). Harriot, in other words, would never have conceived of his subjugation of the natives in the Machiavellian terms in which Greenblatt couches it, and probably never doubted the truth value of the religion he espoused. If this moment of Machiavellian subversion was probably unrecognized both by the author of the text and by his readers, then how can it function even implicitly as subversion? Greenblatt reads these moments of subversion and containment in two completely different kinds of texts because, as we have suggested, he sees them as expressions of the shared cultural code. But when we realize, as he himself seems to do, that these moments of subversion in Harriot's text are more the product of Greenblatt's twentieth-century perspective than they are of the colonial discourse or of Harriot, Greenblatt's difficult position unravels. We are left with a rather interesting and possibly tenable hypothesis about Shakespeare's history plays, but a decidedly distorted reading of a historical text.

Although these problems of historical distortion in reading are prevalent in new historicism, we want to stress that valid critical methodologies must be historically grounded. With Michael Sprinker, we would contend that

"Literature is . . . a historical and not a natural kind of thing. It follows from this hypothesis that literary texts can only be understood as products of the social forces and conditions under which they came into existence" (this volume). But we also want to suggest, via Hayden White, that "to embrace a historical approach to the study of anything entails or implies a distinctive philosophy of history" (Veeser 302). This is exactly where new historicism falls short and assaults theory itself. It has relied on a complex process of genre blurring between historical text and literary artifact to evade articulating any "philosophy of history" that includes a causal theory of culture. As a result, although much new historicist scholarship seems to draw upon literary theory and other social theorists (like Foucault, Geertz, or Hayden White), much of it also evades having to articulate and claim responsibility for its theoretical claims and parameters. The new historicism offers instead scatter-shot readings of a variety of texts, connected not by the kind of evidence that we expect of history and that an articulated theory of social causality would produce, but by anecdotes, personal confessions, and loose methodology, which have helped it to gain such widespread popularity and which render it, in our estimation, an inadequate form of historical criticism.[9]

By exploring some of the limitations of the new historicism, we have reiterated some of the reflexive commentary offered by new historicists themselves. Historicist criticism of both American and Romantic literatures has expressed, in our view, a more genuine concern than Renaissance historicism for the critic's relationship to history and his or her understanding of what that history is.[10] By pointing explicitly to both the practices and critical positions of interpreters, these critics have demonstrated some of the same problems we have pointed to in Renaissance historicist scholarship: the evasion of valid, historical reference, the recapitulation of historiographic error, and, as we will discuss further, the resulting privilege of interpretive agency. In short, even these more self-conscious attempts to demonstrate a relationship between the literary and the historical abandon epistemological claims and return either to the relativism of the neopragmatists or to the subjectivism of a total history.

In his attempt to place history at the center of new historicist interpretation, Brook Thomas has borrowed the typically marxist (American) imperative from Fredric Jameson to "Always historicize." What strikes us as alarming in this association—between Thomas and Jameson specifically—is the willingness of Thomas to associate himself with writers clearly opposed to the type of haphazard readings proffered by new historicism. Moreover, Thomas's remark explicitly ignores the type of history that Jameson calls for: a history that is characterized and normalized by the continuing battle "to wrest a realm of Freedom from a realm of Necessity" (*Political* 19). The chasm separating Jameson's version of interpretation from Thomas's is marked by an underlying understanding of historical narrative. For Thomas, history is accessible as discrete episodes or events that are perceptible only in their immanent encounter with a "parallel" or chosen text. For Jameson, on the other hand, historical episodes are apprehensible only as part of a larger historical narrative that resides beneath the textuality of the event as the political unconscious. These two understandings of history seem so antipathetic to each other that we are left asking, again, what it means to "always historicize."

Thomas's association with Jameson is necessarily a product of false affiliation since it betrays any theoretical similarity. While Jameson totalizes the interpretive field because of certain beliefs allied with notions of a master narrative and of "untranscendable limits," Thomas claims immanent and local domains. He consistently argues, as any new historicist or pragmatist would, that "no inherent political valence adheres to particular modes of narration" (26). And while Jameson's critical project has failed to enlist the type of support he had hoped for—as the "absolute horizon" of interpretation—Thomas's work, insofar as it is representative of new historicism, has dominated the academic critical field where, in the very least, all critics of the British and American Renaissances must confront the new historicist readings that have become so pervasive over the past decade. Consequently, his citation of Jameson reads more like an echo than a historically concerned insistence for interpretive regulation. In other words, in the critical climate we face today—that is, the one created over the past fifteen years by a wave of

prevalent new historicist scholarship—to "always historicize" reads like a requirement for membership and the prerequisite for publication in such journals as *Representations*.

If our challenge to Thomas and the new historicism in general seems harsh, it is only because we are carrying out the rigorously critical interrogation that the new historicists themselves claim to do. New historicism's self-critique might be taken in one of two ways. On one hand, we could read this self-assessment as Stanley Fish does, describing it as a disingenuous attempt to avoid embarrassment. On this view, new historicists avoid the accusation of historical randomness "by making it first and then confessing to it with an unseemly eagerness. In this way, they transform what would be embarrassing if it were pointed out by another into a sign of honesty and methodological self-consciousness" (306). On the other hand, we could see these self-criticisms as an attempt to escape from an impoverished interpretive condition (i.e., a condition in which the sense of history is systemically absent) by generating a position from which to see *and articulate* the historical constructedness of every subject position. Jerome McGann, for example, argues that "[o]ne of the principal functions of the socio-historical critic is to heighten the levels of social self-consciousness with which every critic carries out the act of literary criticism" (*Beauty* 25).[11] Any social self-consciousness, however, must be relevant beyond a particularized temporal moment of vision. If the historical constructedness of every speaker is temporally isolated—that is, if his/her specific conditions of knowledge are never reproducible and therefore incommensurable—then any critical commentary is purely phenomenological, and it must abandon any notion of epistemological justification.

By espousing the necessary contingency of all subject positions, new historicism does two things that we would characterize as adversarial to the theoretical enterprise: (1) it creates, as we have briefly suggested, the purely relativistic and contingent circumstances of knowledge which we would align more with neopragmatism than with other forms of poststructuralism; and (2) it backhandedly privileges the subject position of the interpreter, placing him or her in a condition of superiority over both the past and the present insofar as it removes all governance over acts of interpretation. The first effect

has disabled claims for normativity and legitimation and has served as the site for interrogation by new historicism's reflexive criticism. The second effect is perhaps more puzzling, since it violates typical maneuvers of both postmodernism and poststructuralism either to decenter the subject or to see the subject position as always fragmenting and dislocating into momentary flows, schizophrenic connections, or nomadic identities.[12]

The first effect has served to invigorate some radical gestures by historicists engaged in political critique. For example, by noting that the new historicism "genuinely surpasses its nineteenth century namesake" only in its "specifically Marxian critical methods and values," Marjorie Levinson retrospectively comments on the lack of theoretical investigation present in new historicism's attempt to define its enterprise. Levinson's recent work, it seems to us, genuinely probes the problems of new historicist scholarship—including her own work—by attempting to reinvest critical and theoretical questions into the practices or "functionalist exercises" of reading. She argues that by strenuously rejecting the celebratory and ideologically blind readings of the Yale school, the new historicism turned to a range of social texts and their meanings:

> We regard these meanings as systematically interrelated within the period in question, but since we do not organize the system by a dynamic concept of ideology on the one hand, and of structural determination on the other, our inquiries do not give rise to a meaningful historical sequence. In the absence of some such model of epochal relatedness, questions concerning our own critical interest cannot materialize. By suppressing such questions, we do not, as we think, *surpass* the old historicism with its providential coherences and one-way dialectics, we install it at the heart of our practice. It is precisely our failure to articulate a critical field that sights *us* even as we compose *it* that brings back the positivism, subjectivism, and relativism of the rejected historicist methodology. (20)

In other words, new historicism's admission of an all-consuming contingency in the historical field turns against the position of interpreter and incapacitates his or her ability to see either the past or the present. By losing perspective on the past, we return to the present empty-handed, subjectively speaking

on and in an inchoate field. For Levinson and McGann, probably two of the more influential new historicists for Romantic scholarship in the eighties, the turn toward theory has entailed a return of materialism, and both of them continue to work for a sense of dialectical materialism, vis-à-vis Marx and the Frankfurt School, to articulate a theoretical position which can transcend its own historical moment of articulation.

Our sense of these recent self-criticisms by new historicist scholars is that the project of a sociological and cultural criticism holds possibilities if it works toward creating an interpretive space in the present without resigning itself to self-defeating historical relativism. In other words, the theoretical position—if indeed it is always outside—must regulate and limit the activities of the inside. Or, in terms of temporality, the position of the present must define both its own space *and* the past, offering possibilities to explain the vast matrix of multilateral influences involved in determining a future.

The second effect of new historicism has been to advance a privileged subjectivity for the interpretive agent. While this effect certainly derives, in part, from the rise of new historicism in the academy, it also inheres in the very structures of this form of historiography. The effect on the subject position here stems, on the one hand, from a freedom created by the lifting of limits and normative expectations (the denial of all claims to validity in interpretation), and, on the other, from the act of narrating history in each interpretive gesture. Every act of interpretation, as it has been generated and maintained by new historicist scholarship, has posited its own narrative history (e.g., bear-baiting, skimmingtons, travel journals, etc.) and assumed its dominance. In other words, to borrow a term from Raymond Williams, the "cultural dominant" is no longer determined by acts of history, but, instead, by acts of historiography performed by the critic. Here the critic becomes creator, emerging out of both the past and the present as the *One* who can stand beyond both.

Almost ironically, Foucault, who has been credited with offering the substantial model for new historicism (especially that of Greenblatt, Montrose, Rebhorn, etc.), warned critics against the problems of assuming superiority over history. Foucault, at least in the early work of the archaeologies, seeks

to define cultural development through discourse milieus, such as the discourses of life and labor. For Foucault, these discourses are always discrete and local sites of history, never aggregating to a totality that is apprehendable or articulatable. In part, Foucault's theoretical claims are designed to diffuse a growing tendency of the French left—specifically neo-marxist criticism—to use models of totality to offer interpretive critiques of culture and its discourses. Foucault admonishes these gestures:

> Continuous history is the indispensable correlative of the founding function of the subject: the guarantee that everything that has eluded him may be restored to him; the certainty that time will disperse nothing without restoring it in a reconstituted unity; the promise that one day the subject—in the form of historical consciousness—will once again be able to appropriate, to bring back under his sway, all those things that are kept at a distance by difference, and find in them what might be called his abode. Making historical analysis the discourse of the continuous and making human consciousness the original subject of all historical development and all action are the two sides of the same system of thought. In this system, time is conceived in terms of totalization and revolutions are never more than moments of consciousness. (*Archaeology* 12)

Although Foucault's remarks are explicitly directed against marxist schemes of totalization, it seems only fair to notice that the leveling of all historical narrative tends to erase the types of "distance by difference" necessary to maintain the various sites of local narratives. Moreover, Foucault's explanation of the system that conceives time as totality includes, rather ironically, the very practices of new historicism. It is not that the new historicism sees "historical analysis" as "the discourse of the continuous," but instead that it makes "human consciousness the original subject of all historical development." Indeed, the practice of citing local narratives as representative historical points that enable meaning and understanding smacks of a strange subjective recuperation where interpreting subjects reinscribe themselves in the past only to obtain it—to gain ownership. The result is a reordering of the historical, which explains the discontinuous past in the unity of the present by nothing

other than the subjective consciousness of the interpreter. Thus metanarratives are revived in the moment of interpretation where all relationships are ordered by the force of the interpretive argument. And, in the end, the historical relationships between discrete discourses of the past are lost in the synthesis of the present.

In our view, the new historicism has created its own type of historical totality: one that is made through the privilege of irresponsible agency.[13] Since new historicism has failed to articulate the limits of its own practice (not to mention its failure to approximate a sense of history), it offers free license to enlist any narrative, partial or complete, simple or complex, as the historical representative for a "moment" (a key term for new historicism to abrogate responsibility). For even though postmodernism's incredulity toward metanarratives challenges historical totality, new historicism's fiction of the moment masters interpretive practice. In this way, new historicism has returned to the basic tenet of neopragmatism: that "no one can reach a position outside of practice." And such a "belief" always privileges the subject, because it places the interpreter in a position that others cannot question, cannot interrogate, and cannot overthrow.[14]

Notes

1. We would hope that our citation of Knapp and Benn Michaels does not legitimate their facile claim and specious argument on the consequences and the end of theory. Instead, our citation indicates that even their oversimplified definition of theory points to the necessary concerns that any theory must address, and, consequently, defines the turn that new historicism has made from the theoretical field.

2. Our argument here is not attempting to challenge the complete range of new historicist criticism, which, we realize, is varied and diverse. Nevertheless, the new historicism, as it is practiced in the American academy, reproduces theoretical/practical maneuvers which we will attempt to identify here and which place it against a larger theoretical discourse.

3. See, for example, McGann's explanation of the necessity of historical and social criticism, which he argues compensates for positions like those of René Wellek. Wellek argued that historical hermeneutics is either "preliminary" or "extrinsic to" literary interpretation (6). See also Levinson, especially 19–20.

4. Hutcheon's turn to architecture as the exemplary site for studying postmodernism's

parodic relationship with the past is defended by her assertion that architecture is "the one art form in which the label [postmodernism] seems to refer, uncontested, to a generally agreed upon corpus of works" (22).

5. Visiting the past with irony means recognizing that history is accessible to us only through its prior textualizations, and that we cannot simply accept these narratives at face value. On this score, new historicism has generally demonstrated its awareness of, as Louis Montrose phrases it, "the textuality of history" (Veeser 20).

6. The reference here is, of course, to Lyotard's enormously influential *The Postmodern Condition,* in which he defines postmodernism as "incredulity toward metanarratives" (xxiv). It is important to recall that Lyotard was offering in this work both a definition and a call to arms: "Let us wage war on totality; let us be witnesses to the unpresentable; let us activate the differences and save the honor of the name" (82). As we will go on to suggest, new historicism is one methodology which has taken up this call without saving the honor of the name.

7. This realization of the connection between theory and history in a nonessential (postmodern) universe recalls the political philosophy of the later Sartre. As William McBride argues:

> Sartre, who had the courage never to yield to the ever-popular temptation of simply stipulating certain salient behaviours as constituting the core of an allegedly fixed temporal human nature realized very early in the politically conscious phase of his career that he had to approach the question of how individuals and collectives are interrelated (or, to put the same thought in different words, of what human collectivities *are*) from a *historical* point of view. (10)

8. Fredric Jameson's marxist hermeneutic at least offers ways for negotiating directions of influence. For example, his descriptions of a cultural dominant allow a theoretically inflected vision of difference to emerge in his analysis, even if this conception of difference is essentially flawed: "I have felt, however, that it was only in the light of some conception of a dominant cultural logic or hegemonic norm that genuine difference could be measured and assessed" (*Postmodernism* 6).

9. The arguments we have advanced in this section may strike some new historicists as familiar ones, and they should. In fact, Jean Howard, a leading new historicist, makes them in the form of a warning to other new historicists in a 1986 article in *English Literary Renaissance.* The new historicism may be one of the positive results of the rise of theory. On the other hand, Jean Howard also warns us:

> there is a real danger that the emerging interest in history will be appropriated by those wishing to suppress or erase the theoretical revolution that has gone on in the last several decades. Ironically, the "new history" may well turn out to be a backlash phenomenon: a flight from theory or simply a program for producing more "new readings" suited to the twenty-five-page article and the sixty-minute class. . . . There is nothing inherently wrong with doing readings, but if those readings are based on untenable or unexamined assumptions about literature and

history, then they are merely a form of nostalgia and not a serious attempt to explore what it means to attempt an historical criticism in a postmodern era. (19)

10. To be sure, American and Romantic new historicists hold a noticeably more involved relationship to the past than do Renaissance historicists. Our very embededness in the modern world—the very issues of emancipation, imagination, selfhood so typical of Romantic and nineteenth-century American thought—forces us as readers to respond more *critically* to the past.

11. While we realize that Jerome McGann and other readers of British Romanticism are noticeably different from Renaissance new historicists in both method and assumption, both groups of readers—or schools of critical practice—emerged historically against a critical climate of high theory and the dismissal of all referential and determinant points in the historical fields. Consequently, the "centering" of historical criticism was as essential for McGann as it was for Greenblatt. Put simply, the primary difference, as we see it, is in the allegiance to *critique* characteristic of Romantic historicists.

12. See, for example, Deleuze and Guattari, especially "The Treatise on Nomadology," for the political possibilities of schizophrenic nomadic subjectivities.

13. Our claim of irresponsibility here is meant generally—that is, it should suggest fundamental responsibility to acts of interpretation. So, much like Gadamer's claim for the limits of tradition on interpretive activity, new historicism should bear the responsibility of speaking within the horizon of any selected history and explain the relationships coded within various cultural productions.

14. We would like to thank Joseph Lewandowski for his advice in reading an earlier draft of this essay.

11

"Not Theory . . .

But a Sense of Theory"

The Superaddressee and the Contexts of

Eden

Frank Farmer

Paradise (Re)versed

One of the recurrent metaphors found in the continuing debate between theorists and antitheorists (a.k.a. New Pragmatists) is that of the biblical Fall, the moment when our mythical first ancestors disobeyed their Creator and promptly descended into sin, knowledge, and the burden of self-consciousness. On the last two of these misfortunes, at least, it is not hard to see why such an image is eagerly borrowed for the current debate about theory. What may be surprising, though, are the realms assigned to each camp in these discussions.

An outsider to the current debate would most likely refer the theoretical camp to those otherworldly, paradisaical realms commonly reserved for Laputans and other innocents who prefer to make their ideal home *elsewhere*. Correspondingly, pragmatists—new and old—would be assigned to the earthly realms of the fallen, the palpable, the mundane, where, happily for all concerned, the real work of the world gets done. Such would be a conventional, albeit broadly drawn, rendering of how the Edenic image might be deployed.

What's occurred, though, is precisely the reverse. *Theoria*, it turns out, is our fallen state, while *Pragma* is the Eden we have fallen from (or, as it is more likely put, forgotten). The ironic fall *into* theory occurred when those first ancestors imagined the pristine wholeness of our original state to be divisible and announced that only through such divisions can we know the world at all. The legacy of our Fall, then, is a kind of estrangement: the sundering of things whole and the misguided attempts at epistemology that

such divisions require. In their provocative essay, "Against Theory," Steven Knapp and Walter Benn Michaels put the same point this way:

> The theoretical impulse . . . always involves the attempt to separate things that should not be separated: on the ontological side, meaning from intention, language from speech acts; on the epistemological side, knowledge from true belief. Our point has been that the separated terms are in fact inseparable. (29)

In much the same way that Adam and Eve willingly chose to escape the delights of the garden, Knapp and Michaels point out that "theory is nothing else but the attempt to escape practice." The difference between the two is that where our mythical progenitors were fabulously successful in their endeavor, champions of theory are doomed to a project of eternal failure. This is because, as Knapp and Michaels explain, theory "is the name for all the ways people have tried to stand outside practice in order to govern practice from without" (30). Since for Knapp and Michaels (and Stanley Fish, Richard Rorty, and others), no position "outside" of practice exists, the attempt is not merely futile but utterly self-deceiving. Once we dispense with our illusions, though, we are free to return to the paradise we never left in the first place—namely, practice. That is the place where belief is thoroughgoing, a place where, as Jonathan Crewe points out, "no knowledge can transcend or replace belief, which accordingly constitutes the highest epistemological plane on which the human mind can function (as God in his own way said to Adam)" (63).[1]

Here, I will attempt to reverse the reversal I've just described. Simply put, there are blessings to be had in restoring theory—or more precisely, *a sense of theory*—to its rightful locus at a necessary remove from immediate contexts. The Edenic otherness that accompanies a sense of theory is an inevitable function of the very conversation which supposedly fills the *aporia* when foundational epistemology is abandoned for good. To elaborate this argument, I'll draw extensively on Mikhail Bakhtin's complex (and somewhat ambiguous) position on the question of theory, and conclude by showing how his ordinarily mute superaddressee may have something to say about the ongoing debate regarding theory.

By now, few observers of the present moment would be surprised that

Bakhtin's ideas have been tailored to fit this debate. Nor should anyone be surprised that such appropriations are able to encompass the various sides of the debate. Bakhtin, to echo a common observation, has been successfully employed as a kind of belated spokesman for a dazzling array of theoretical projects and agendas. Predictably, he has also been recruited as a latter-day antitheorist, a pragmatist in the strong sense of one who denies foundational arguments for objective knowledge. To the extent, for example, that Stanley Fish casts Bakhtin as a thinker partially responsible for the "twentieth-century resurgence" of rhetoric, and does so after claiming rhetoric as a strictly antifoundational concern, then clearly Bakhtin (for Fish and many others) is allied to the pragmatist camp (*Doing* 500).[2] Yet, while a good case can be made for Bakhtin the antitheorist, Bakhtin the theorist is never too far removed from his pragmatic double—an ambivalence succinctly captured in Bakhtin's own phrase: "not theory . . . but a sense of theory."

Bakhtin as Antitheorist

Bakhtin's very early meditation on ethics, *Toward a Philosophy of the Act* (1919–1921), is an appropriate place to begin establishing his pragmatist credentials. Here, Bakhtin refutes Kantian approaches to universal or categorical ethics, a position that he describes as "theoreticism." In contrast to the theoretical world, with its inevitable embrace of all that is generalizable and recurrent, Bakhtin speaks for the experiential domain of the act, the world he refers to as "once-occurrent Being as event." For Bakhtin, authentic ethics reside not in principles, rules, or dogmas abstracted from experience, but in the answerable, unrepeatable *eventness* of lived life. And it is precisely this realm to which the theoretical is necessarily indifferent. As Bakhtin explains, insofar as personal existence is concerned, the theoretical world is not inhabitable:

> In that world I am unnecessary; I am essentially and fundamentally non-existent in it. The theoretical world is obtained through an essential and fundamental abstraction from the fact of my unique being and from the moral sense of that fact—"as if I did not exist" . . . it cannot determine my life as an answerable performing of deeds, it cannot provide any criteria for the life

of practice, the life of the deed, for it is *not* the Being *in which I live*, and if it were the only Being, *I* would not exist. (9)

Another way to put this is that the theoretical is wholly alien to that which is particular and unrepeatable in my life as I live it; and so being, the theoretical must account for my life in ways that are not just ethically untenable but impossible. My life from a theoretical viewpoint must always be a generalizable entity, a finality. And *that*, Bakhtin points out, is not the life I live.

Bakhtin's animosity toward a theoretical ethics is unmistakable. But, Bakhtin would add, there should be no great surprise in discovering that such an ethics exists, for the most important—and lamentable—inheritance of post-Enlightenment rationalism is its exclusion of what cannot be generalized. He thus notes that "it is an unfortunate misunderstanding . . . to think that truth . . . can only be the truth . . . that is composed of universal moments; that the truth of a situation is precisely that which is repeatable and constant i it" (*Act* 37). *Toward a Philosophy of the Act* inaugurates Bakhtin's search for a version of truth that is neither universal nor repeatable, but rather one able to account for the particular and situational—the "once-occurrent event of Being" (61).

This search leads Bakhtin to formulate what he calls an "architectonics," a way to generalize the particular without compromising its very particularity, its concreteness, its humanity. Bakhtin thus wants to establish a means to link together the "concrete event-relations" that characterize the nontheoretical world of particularized experience, while avoiding the systematicity and indifference to lived life that characterizes the theoretical world. Gary Saul Morson and Caryl Emerson thus explain that "architectonics is not a matter of general concepts or laws," but instead a paradoxical attempt to find the "general aspects of particular acts" without surrendering their concrete quality as lived events (*Rethinking* 22). Bakhtin's project, according to Morson and Emerson, was how to answer the question, "What can we say in general about particular things except that they *are* particular?" (22).

Though his architectonics does not provide a satisfactory answer to that question, his early conceptualization of the problem leads him to think about it in terms of aesthetic as well as self-other relationships. These concerns

persist and find more development in other essays of the period, especially "Author and Hero in Aesthetic Activity." But it is in *Problems of Dostoevsky's Poetics* that Bakhtin first reconsiders the possibility for another kind of truth through what will become the central theme of his mature work, *dialogue*.

From a Bakhtinian perspective, a dialogic truth is obliged to resist all those other versions of truth that, say, locate it *above* us (as in theological certitude), *outside* us (as in empirical "findings"), *inside* us (as in Romantic and psychological constructions of essential selfhood), or *behind* us (as in the received wisdom of authoritative discourses). What these various *topoi* of knowledge share, Bakhtin might point out, are answers that neither require nor invite a response. Each posits a finished version of what the truth is (or how it will be found), and thus each precludes genuine exchange. Finalized conceptions of truth render dialogue unnecessary.

Where, then, does Bakhtin locate truth, and what are the special features of a dialogic truth? Keeping with this spatial metaphor, Bakhtin situates truth in the territory *between* us, thereby making our understanding of truth both a function and a product of social relations. Of course, not all social conceptions of truth are necessarily dialogic, but all dialogic conceptions of truth are social. To put this in the most basic of terms, *one needs an other for truth to be*.

One of the first illustrations of a dialogic truth, Bakhtin observes, can be found in the early Socratic dialogues. In particular, this genre exemplifies

> the dialogic nature of truth and the dialogic nature of thinking about truth. The dialogic means of seeking truth is counterposed to *official* monologism, which pretends to *possess a ready-made truth*. . . . Truth is not born nor is to be found in the head of an individual person, it is born *between people* collectively searching for truth, in the process of their dialogic interaction. (*Problems* 110)

For those accustomed to regarding Platonic epistemology as perhaps the most extreme foundationalism, Bakhtin's lauding of Socrates will likely come as a surprise. Yet Bakhtin emphasizes the point that, while the "content [of individual dialogues] often assumed a monologic character," Socrates himself did not assume the role of one who had exclusive possession of a "ready-made truth." What accounts for this disparity is that the early dialogues had "not

yet been transformed into a simple means for expounding ready-made ideas," but with the increasing monologization of later dialogues, the Socratic genre "entered the service of the established, dogmatic worldviews of various philosophical schools and religious doctrines" (*Problems* 110).

Again we sense Bakhtin's hostility to what he once called theoreticism, but now refers to as "philosophical monologism," that abstract plane of reasoning that promotes truth as something capable of excluding human beings altogether. In this familiar scheme of things, truth has no need for multiplicities, for concrete variations, for individual consciousness. It follows that "in an environment of philosophical monologism . . . genuine dialogue is impossible as well." What Bakhtin wants instead—and what he finds in the work of Dostoevsky—is a truth "born at the point of contact among various consciousnesses," one that "requires a plurality of consciousnesses, one that cannot be fitted into the bounds of a single consciousness" (*Problems* 81). This is a truth not of objects, abstractions, or subjective empiricism, but a truth created and sustained through dialogue. This is a truth that resists all absolute and monologic formulations. This is a truth with people in it.

For pragmatists and other antitheorists, it is also a truth that refuses the original sin of theory, that is, the temptation to imagine itself able to stand outside practice, or for Bakhtin, outside dialogue. On this matter alone, Bakhtin clearly establishes his worth as a pragmatist of the first order. But more than that, Bakhtin's lifelong resistance to "theoreticism" or "philosophical monologism," his efforts to identify "another kind of truth" through dialogic relations, and his understanding of truth as a mutual enterprise and as an unceasing process rather than a "ready-made" product would all seem to commend him thoroughly to an antitheoretical position.

What reason, then, to even consider the prospect of Bakhtin as an advocate of theory? Why is "a sense of theory" necessary to dialogue?

Bakhtin as (Recalcitrant) Theorist

Despite his polemics against abstraction, systematicity, and the theoretical, Bakhtin never dismisses theory as nonexistent or unimportant. Bakhtin acknowledges (implicitly or otherwise) that while theory runs counter to his

own projects, theory nevertheless helps to define and clarify those projects. However, Bakhtin's characteristic move is *to acknowledge the reality of theory in order to subsume its claims to the more important exigencies of dialogue.*

This move is apparent early on. Recall that Bakhtin takes care to show how the realm of theory is incapable of explaining the concrete realm of particularity, the "once-occurrent event of Being" which constitutes lived life, and further, that "all attempts to surmount—from within theoretical cognition—the dualism of cognition [theoreticism] and life . . . are utterly hopeless." Life cannot be lived in theoretical categories, and Bakhtin suggests that all our efforts to do so resemble "trying to pull oneself up by one's own hair" (*Act* 7).

But does this mean that the theoretical plane should be dismissed altogether, or that it can in no wise enter into the event of my life? Bakhtin answers *no* to both questions. As to the first, Bakhtin claims that theory's "autonomy is justified and inviolable" so long as it "remains within its own bounds." The problem arises, Bakhtin observes, when the theoretical "seeks to pass itself off as the whole world . . . as a first philosophy (*prima philosophia*)"—what we would call a foundational truth (*Act* 7–8). Bakhtin seems not merely to acknowledge but to endorse a nonfoundational brand of theory (an option not always granted to combatants in the theory wars, who *demand* an allegiance to one side or the other). As to the second question, while Bakhtin argues that "any kind of *practical* orientation of my life within the theoretical world is impossible," he does believe it possible for the theroretical to be interiorized as a "constituent moment" of life as event (*Act* 9). Possible, yes, but not easily realized, and certainly not to be confused with pragmatism's attempts to do the same. Indeed, Bakhtin avers that "pragmatism in all its varieties" tries to turn one theory

> into a moment of another theory, and not into a moment of actual Being-as-event. A theory needs to be brought into communion *not* with theoretical constructions and conceived life, but with the actually occurring event of moral being—with practical reason, and this is answerably accomplished by everyone who . . . accepts answerability for every integral act of his cognition. (*Act* 12)

Bakhtin makes clear that a pragmatist subsumption of theory is, in effect, nothing more than an instance of one theory attempting to contain (preempt? erase?) another—an argument that, not surprisingly, has found expression in the current debate (see, for example, Fish, *Doing* 315–41). Bakhtin, though, has little patience with either theoreticism or pragmatism on this count, since both share a predilection to conceptualize life from without. Still, it is possible for theory to become a constituent moment in the event of Being, but not exactly in the way a pragmatist might wish.

To fit itself to practice, for example, theory must surrender its claims to an "outside" truth, since practice "denies the autonomy of truth and attempts to turn truth into something relative and conditioned" (*Act* 9). Paradoxically, when that occurs, truth can no longer be incorporated into concrete existence, for as Bakhtin argues, "it is precisely on the condition that it is pure that truth can participate answerably in Being-as-event; life does not need a truth that is relative from within itself" (*Act* 10). Thus, truth must keep some quality of absoluteness for me to gather it into the event of my life, to make it something to which I am capable of answering with my Being. Anything less will require me to hand over my experience to a relativism whose equivalence of potential truths is just as indifferent to my "living historicity" as a theoreticism that offers external, moral guidelines.[3] When Bakhtin later rethinks this problem in terms of dialogue, he arrives at a similar conclusion, namely, "that both relativism and dogmatism equally exclude all . . . authentic dialogue, by making it either unnecessary (relativism) or impossible (dogmatism)" (*Problems* 69).[4]

Make no mistake, there is a place for theory in Bakhtin, but not in the fashionable impulse to redefine it as just another kind of practice. That proviso effectively robs theory of the one quality that makes it theory—namely, its claim to an outside knowledge, perspective, or truth. The place for theory, rather, is found when its very "outsidedness" is delivered into the event of living, when theory is subsumed not into practice, but into the unrepeatable texture of lived life, into that quality ("surplus") of existence which is beyond the generalizations of either theoreticism or pragmatism.

It would be convenient—and not entirely mistaken—to explain Bakhtin's

critique and defense of theory as the ruminations of a not yet fully matured thinker. That, unfortunately, does little justice to the decidedly mature task that Bakhtin poses for himself, namely, how to make theory human, how to make theory a constituent dimension of lived life, while avoiding the trappings of a relativism that trivializes being. The same problem, I believe, informs Bakhtin's search for a dialogic truth in *Problems of Dostoevsky's Poetics* and can be evidenced in other essays of the period as well. To dismiss these early arguments for a theoretical quality to lived life as simply immature is to ignore the fact that Bakhtin frequently returns to old problems and themes for the purpose of elaborating, developing, and recontextualizing those ideas as part of maintaining an ongoing dialogue with them.

The question, then, is whether Bakhtin returns to the problem of theory as a legitimate intellectual activity, and if so, whether he regards it favorably. My answer to both inquiries is a qualified *yes*, if first we grant Bakhtin his stated preference, "not theory . . . but a sense of theory,"[5] and second, we identify where the sense of theory is subsumed not merely as a constituent moment of lived life, but of *life lived in dialogue.*

First, what does Bakhtin mean by "a sense of theory"? Keeping in mind Bakhtin's search for a dialogic truth in the Dostoevsky book and his earlier antipathies to "fatal theoreticism," we can begin to surmise what Bakhtin means by "a sense of theory" through a closer look at the intratextual clues he provides. Shortly after his comment on theory, Bakhtin follows with a parallel statement about Dostoevsky's understanding of faith: to wit, "not faith . . . but a sense of faith." Fortunately, *this* comment is more developed and thus more illuminating. The full excerpt reads: "Not faith (in the sense of a specific faith in orthodoxy, in progress, in man, in revolution, etc.), but *a sense of faith*, that is, an integral attitude (by means of the whole person) toward a higher and ultimate value" (294).

Notice that *faith*, in its first sense, is a content-laden abstraction, something "ready-made" and available for immediate use, notwithstanding its existence on a plane utterly removed from the one where life is lived. Notice, as well, that *a sense of faith* is something quite distinct, not a recycling of hand-me-down assurances, but an "attitude" toward "an ultimate value," and thus

something fraught with difficulty. Bakhtin's distinction between "theory" and "a sense of theory" follows suit from his parallel distinction between "faith" and a "sense of faith." That is, in its first sense *theory* is all monologic truth that offers finalized knowledge from without, while *a sense of theory* is that "integral attitude" toward a truth that posits ultimate values to which our lives are answerable in some degree. Where, then, is this "sense of theory" to be found, especially after dialogue becomes the central motif of Bakhtin's work?

An "Invisibly Present Third Party"

Among the many features of Bakhtin's conception of the utterance, the one that receives least attention is no doubt the *superaddressee*. In a late essay, Bakhtin introduces this concept by observing that within every utterance there is a presumed *third* listener, one beyond the addressee, or second listener, to whom the utterance is immediately addressed:

> But in addition to this addressee (the second party), the author of the utterance, with a greater or lesser awareness, always presupposes a higher *superaddressee* (third), whose absolutely just responsive understanding is presumed, either in some metaphysical distance or in distant historical time (the loophole addressee). In various ages and with various understandings of the world, the superaddressee and his ideally true responsive understanding assume various ideological expressions (God, absolute truth, the court of dispassionate human conscience, the people, the court of history, science, and so forth). (*Speech* 126)

Those few commentators who take the trouble to gloss these passages at all seem to recognize, along with Bakhtin, that the superaddressee negates the prospect that what I utter may be meaningless, which is to say, without meaning for *another*. Michael Holquist, for example, explains that "poets who feel misunderstood in their lifetimes, martyrs for lost political causes, quite ordinary people caught in lives of quiet desperation—all have been correct to hope that outside the tyranny of the present there is a possible addressee who will understand them" (38). Morson and Emerson likewise see the

function of this third party as one of *hope*, or more exactly, the *necessity of hope* (*Prosaic* 135).

But why necessity? Bakhtin points out that the word, more than anything else, "always wants to be heard," and if that hearing is not to be found in immediate contexts, the word will press on "further and further (indefinitely)" until it locates a point of understanding. The profound importance of this observation is underscored when Bakhtin describes "the Fascist torture chamber or hell in Thomas Mann [as] an absolute *lack of being heard*, as the absolute absence of a *third party* [superaddressee]." One reason that Bakhtin passingly refers to the superaddressee as "the loophole addressee" is that the speaker (or author) can ill afford to "turn over his whole self and his speech work to the complete and *final* will of addressees who are on hand or nearby" (*Speech* 126–27). The risk here for the speaker (or author) is not only that what he or she says will be misunderstood, but rather that what is said will be misunderstood *utterly* and *forever*. The superaddressee thus offers a "loophole" for a perfect understanding *elsewhere* and a hedge against the dangers of a consummated misunderstanding *here*.

Now the temptation might be to regard the superaddressee—and the remote contexts in which he or she may be found—as a regrettable lapse into a naive idealism or transcendentalism. But to dismiss Bakhtin's formulation on that count would be too simplistic for a number of reasons. First, Bakhtin attempts to historicize the many forms the superaddressee may assume when invoked by a given speaker. Second, Bakhtin explicity denies that the super-addressee *must* be a "mystical or metaphysical being," but allows that "given a certain understanding of the world, he can be expressed as such." Finally, Bakhtin's catalogue of possible superaddressees appears, on balance, to be indifferent to the issue of foundational truth. While "absolute truth," "God," "science," and "human conscience" all seem to fit easily into a foundational paradigm, other superaddressees, such as "the people," or the "court of history," may just as easily be interpreted as constructionist or antifoundational (*Speech* 126). Indeed, the issue of foundational truth seems to have little to do with the actuality of the superaddressee (though it may have much to do with the form assumed by the superaddressee in any utterance).

For Bakhtin, what is important about the superaddressee is that "he is a constituent aspect of the whole utterance" and thus an inevitability of speaking or authoring (*Speech* 126–27). What is important for my purposes, though, is that *the superaddressee is the incarnation of that sense of theory when it is subsumed into the utterance, into living, dialogic relations.* As such, the superaddressee reveals an "integral attitude (by means of the whole person) toward an ultimate value," and thus constitutes that someone or someplace *else* to whom I am answerable—answerable now in at least two important senses.

First, in the sense that my construction of any utterance is determined by how I anticipate being received not only by my second listener, but also by my *third* listener, the superaddressee of my preference. Though not capable of an immediate response, the superaddressee is nonetheless manifested in my utterance by virtue of my need to posit an ultimate understanding beyond my present situation.[6] Bakhtin seems especially intrigued by that speaker who "fears the third party and seeks only temporary recognition . . . from immediate addressees," especially when one's immediates can at best offer only "responsive understanding of limited depth" (*Speech* 127). Put in terms of the present argument, when subsumed into living dialogue as *a sense of theory* and incarnated in the utterance as the *superaddressee*, theory provides what it has always claimed to provide: *other* vistas, *other* horizons, *other* contexts for understanding beyond those that occupy "the tyranny of the present." Bakhtin seems to find especially odd (if not superficial) those who remain content to be heard within their immediate context alone, who feel no apparent need to appeal to an ultimate listener of any kind.

But another sense of answerability is at stake here too, one that resurrects Bakhtin's early concern with responsible action. The positing of a superaddressee, of course, cannot help but to imply a certain ethical orientation toward the ultimate values embodied in the very superaddressee one chooses. Yet the ethics borne of the dialogic relationship with a superaddressee are *not* the ethics of theoreticism, *not* the ready-made principles, rules, edicts, of a hand-me-down morality. Though any utterance may well subsume aspects of a theoretical ethics as a "constituent moment" of life in dialogue, whatever truth the superaddressee holds *for me* is unrepeatable, just as every utterance

is likewise. Although Bakhtin's hint that superaddressees are historically formed suggests that there is reason to assume some continuity in the superaddressees one invokes, this does not alter the fact that, by definition, no particular super-addressee could possibly exist on the "theoretical plane." And because a super-addressee "embodies" my "integral attitude" toward a value (or values) that I regard as ultimate, the superaddressee always *requires* something from me.

A measure of commitment, then, inheres in the very concept of a super-addressee. To be sure, that measure may be quite innocuous, going no further than the tonalities that express a speaker's attitude toward what he or she regards most highly—keeping in mind, as Kenneth Burke pointed out some time ago, that our attitudes are always *incipient* acts (20). At the other end of the spectrum, though, the superaddressee may make very dramatic, severe demands on our "whole person." As I've mentioned, Michael Holquist refers to "martyrs for lost political causes," but it is not difficult to imagine other circumstances where, on behalf of a superaddressee who hears our pleas for justice, or freedom, or God, or love, countless individuals throughout human history have answered with their lives. It would be foolish, of course, to posit the act of giving up one's life as a requirement for authentic commitment. But I'm inclined to think that Bakhtin might point out that it is virtually impossible to conceive surrendering one's life on behalf of, say, the ontological proof for God or the categorical imperative (theoreticism). Just as impossible, in fact, as trying to imagine giving up one's life for the judgments of an interpretive community or the conversation of mankind (pragmatism).

Ironies of Eden

In *Philosophy and the Mirror of Nature*, Richard Rorty asks us to lay claim to a new Eden, one that exiles the philosopher as "cultural overseer who knows everyone's common ground . . . who knows what everyone else is really doing whether they know it or not, because he knows about the ultimate context (the Forms, the Mind, Language) in which they are doing it" (317–18). When this insurrection is accomplished, we will be free to return to what is the only ultimate context available: "If we see knowing not as having an essence to be described . . . but rather as a right, by current standards, to believe,

then we are well on the way to seeing *conversation* as the ultimate context within which knowledge is to be understood" (389).

Now, first, what does it mean to equate knowing with a right to believe? Are we not stumbling into the same tautological problems that Jonathan Crewe describes in reference to Knapp and Michaels, namely that "what is truly believed becomes equivalent to truth, while truth becomes equivalent to what is truly believed" (64n)? Crewe observes that, in this pragmatist vision of the world, belief has a "kind of fullness and immediacy" that makes it wholly sufficient to all believers. Which is to say (and to say ironically) that pragmatist believers are quite comfortable in their knowledge that what is believed is never anything more than a belief. In other words, they happily assent to the prospect that *in no other contexts* is it possible for their beliefs— say, in an unpublished poem, in a struggle against oppression, in that *too* controversial or unorthodox idea, etc.—to be in some way *true*. Crewe suggests that this is a rather idealistic formulation of belief, since belief has for us a decidedly "proleptic character." As Crewe puts it, "a *lack* . . . of justifying knowledge or 'groundedness' is implicit in the conception [of belief]" (64n).

I would argue that the "lack" alluded to by Crewe is the selfsame "lack" that Bakhtin mentions when he describes hell as an "absolute *lack of being heard*, as the absolute absence of *a third party*." It is the very *lack* that the superaddressee is called upon to fill when we speak to others. It is the very lack that a pragmatist version of believing must ignore or deny, since a belief in contexts where a more perfect understanding is possible smacks too much of epistemological foundations. Crewe, interestingly enough, understands this lack in terms remarkably similar to Bakhtin's. Prolepsis, after all, is from the Greek rhetorical tradition and refers to the speakerly practice of "foreseeing and forestalling objections in certain ways" (Lanham 120). In couching this lack in terms of prolepsis, Crewe echoes Bakhtin's favored word, *answerability*, thereby lending force to the notion that justification is always a function of a necessary third party in dialogue and in dialogic relations.[7]

But isn't Rorty's "conversation of mankind" an affirmation of dialogue as well? To be sure, Bakhtin is especially close to Rorty when searching for a dialogic truth to oppose "philosophical monologism." Here and elsewhere,

there are points of intersection that are indeed noteworthy.[8] But, as I have tried to show, one important difference between the two is that for Rorty "*conversation* [is] the ultimate context," whereas for Bakhtin an ultimate context may be found within every utterance, insofar as that utterance invokes a superaddressee who understands perfectly what one has to say. Every conversation (or dialogue) is teeming with ultimate contexts.

The irony here is that if the superaddressee is a "constituent aspect" of the utterance, as Bakhtin maintains, then Rorty's conversation owes a rather large debt to the ultimate contexts that it has repudiated. To put this a bit differently, a sense of Edenic otherness or *a sense of theory* makes possible the very conversation that denies the usefulness of theory and the ultimate contexts that theory (as *a sense of theory*) is able to offer. A conversation utterly bereft of superaddressees is not one that has divested itself of all unseemly idealism; it is one that has abandoned history and the temporal sense of experience. For such a conversation has foreclosed on Eden, has denied to its participants *a necessary elsewhere* and, in so doing, has curtailed the possibility for better understandings, deeper commitments, more promising visions.

Bakhtin's third party offers a third way out, a requisite loophole through the impasse that constitutes the theory wars. His move to subsume theory into living, dialogic relations tries to preserve something of theory's historical charge—namely, to challenge the "tyranny of the present" by offering Edenic contexts within which a greater understanding is possible. But this subsumptive move is also intended to challenge one of theory's traditional claims— that is, its putative ability to explain life from a position outside of life's living. The superaddressee may be read as Bakhtin's attempt to demonstrate the monologic tendencies of both theoreticism *and* pragmatism, to reveal how it is that, while we may be wise to rid ourselves of theory, life without *a sense of theory* would be profoundly diminished, if not unsayable.

Notes

1. Crewe here is paraphrasing Knapp's and Michaels's argument, a position with which he disagrees.

2. After de Man's early observation of the same, this acknowledgment might by now

seem to be an unnecessary one (*Resistance* 110–11). The enlistment of Bakhtin as antitheorist is a more recent development and, as I try to show, a more problematic one at that. No less concerned with the epistemological features of Bakhtin's thought, Michael Bernard-Donals has offered a somewhat dichotomized version of Bakhtin's ideas, one that posits a continual shifting between the marxist and phenomenological poles found in his works.

3. Bakhtin appears to be heading toward the same kind of ironic distinction that besets pragmatists when speaking of belief and true belief. Bakhtin (at least in this work) seems to want to have it both ways: an absolute truth subsumed into the unrepeatable event of being, yet somehow able to retain a quality of absoluteness. The implied distinction, of course, is between a *theoretical* absoluteness and an *experiential* absoluteness, the former imposed from without, the latter lived from within. The same distinction is at play in his later conception of the superaddressee.

4. Two key pragmatist answers to the charge of relativism can be found in Rorty (*Consequences* 166–69) and Davidson ("On the Very Idea of a Conceptual Scheme"). An excellent discussion of Davidson is offered by Thomas Kent, who, like many others, finds social constructionism (one version of antifoundationalism) to be particularly vulnerable to the relativist charge ("Discourse Community").

5. Bakhtin's distinction between "theory" and "a sense of theory" occurs in an appendix to *Problems of Dostoevsky's Poetics*. Written in 1961 and published posthumously, this appendix is a collection of notes presented in varying degrees of elaboration. One of the least developed ideas found here, in fact, is Bakhtin's cryptic distinction about theory.

6. There is an intriguing (though limited) parallel here with Jürgen Habermas' theory of communicative action. For Habermas, the conditions for a just understanding can be found in actual discourse, no matter how ideologically distorted any particular discourse may be. As Terry Eagleton points out, Habermas is thus able to "anchor the desirable in what is actual" to the extent that "the very *act* of enunciation can become a normative judgment." There is, in other words, a necessity for utterances (and the truth claims they imply or express) to "refer themselves forward to some altered social condition where they might be 'redeemed' " (*Ideology* 130–31).

This sounds very much like the function of Bakhtin's superaddressee, except for one crucial difference: Habermas moves from this observation to the search for a regulative model of the "ideal speech situation," for what Thomas Kent refers to as "the *langue* of *parole*" ("Hermeneutics" 284n). Habermas thus seeks to identify what is universal, rule-governed, and repeatable in instances of perfect communication. Bakhtin has no such desire, since to generalize such qualities is to fall prey to the very theoreticism that he disavows.

7. There is much in Bakhtin's idea of the superaddressee that merits further discussion: his intimation that superaddressees are, to some degree, historically constrained; his

problematic silence on the question of how people come to *share* a superaddressee, and whether or not it is possible to do so architectonically, that is, without yielding to the temptation to cast the superaddressee as a spokesperson for a generalized, monologic, truth; and finally, his claim that absolutes can be subsumed as "constituent moments" of unrepeatable lived experience. In all these aspects, Bakhtin's superaddressee should continue to pose interesting problems and useful challenges to come.

8. For one mapping of these intersections and departures, see Bialostosky 107–11.

12

Of Safe(r) Spaces
and "Right" Speech
Feminist Histories, Loyalties, Theories,
and the Dangers of Critique

Darlene M. Hantzis and Devoney Looser[1]

The language of opposition (against, anti, tyranny, backlash), even combat (war, campaign, attack), frames, shapes, and to some extent motivates this collection of essays. The significance of a feminist investigation of the issues in the "war against theory," and the implications, the strength, and audibility of feminist voices therein are left largely unexplored here. Instead, we are interested in locating what are perhaps some "effects" of that "war" when feminists speak to (and of) other feminists. We write as specific, historically situated feminists; to be certain we speak "for"—that is, in favor of, feminism—but not "for"—that is, as—all feminists or feminisms. Feminists writing today rarely, if ever, claim their voices to be "the" voice of feminism; however, as we will argue, the admission of a plurality of feminist voices, of feminisms, often functions as a prefatory remark—one that fails to complicate the analysis that follows. Sara Suleri has asked feminists to consider, "how singular are we in our apprehensions of the plural" (757)? We argue that the plurality of our apprehensions of feminisms is one of the stakes in the (anti)theoretical discourses of feminisms.

The location of this essay in oppositional discursive space—that is both about oppositional discourse and as oppositional discourse—marks its work as precarious. As an exploration of and perhaps a perpetuation of "theory against itself," this essay—like many others that have come before it (and many others that we hope will come after it)—is a call for change. The call for change articulated here locates this work *as* critical theory. As Della Pollock and Robert Cox define it, "[critical theory] marks the awareness that . . . categories are value laden and it opens implicit and explicit values to question,

examination, and, possibly, change" (172–73). Calls for change hold a certain amount of institutional currency, to be sure. This article could no doubt offend some readers if only because it figures as a potential "pandering" to academic rhetorical fashion (but that would not be the only offending point). Others may "hear" what follows as nothing new (thus muting the call for change); still others with whom we think we disagree will not "hear" what follows because they will obscure our differences into samenesses.

The collaborative process from which this essay—at least a double-voiced text—emerges reminded us of the inevitability of many "hearings" of our many "sayings." Our sense of the difficulty of this articulation led to the generation of a "Top Ten List." (Pause for a tangential moment: the Top Ten List is a discursive construct that itself occupies oppositional space at this historical moment; it is an uncitable form as its official "ownership" is being negotiated; the ground of dispute between the contenders—NBC and David Letterman—is instructive about legislation of production, performance, and propriety in popular cultural aesthetics; "unofficially" the form functions as metonymic for Letterman, whose name itself opens additional room for more complex and decidedly fun deconstructive activity.)

Top Ten Reasons Not to Write This Essay (we were able to articulate only five reasons; the other five remain unarticulated):

 5. The possibility of accusations "of inadequacy, of blindness, of neglect" (Dolan 436).

 4. The probability of scolding, name-calling, dismissal.

 3. The potential of being mistaken for Camille Paglia.

 2. It is difficult to avoid sounding "whiny."
 (Imagine musical preface)

 1. The inevitability of the partiality of our saying and of its hearing (Dolan 440).

Given, again, the oppositional flow of the essay, we generated an enabling counter list.

Top [Five] Reasons to Write This Essay:

5. Hey, it is a publication!

4. The hope of enacting "a community of activist thinkers and practical theorists" (Dolan 418).

3. Political theorists and activists should distrust the "desire for reciprocal recognition" (Dolan 438).

2. " '[T]he widespread belief in the possibility of understanding [sameness] has committed us, however unwittingly, to a concomitant narrative of betrayal, disappointment and rage. . . . It is perhaps past time that we begin to attempt to see misunderstanding as generative—opportunities for conversation rather than as a betrayal of a promise' " (Dolan 436).

1. We are feminists.

The identity claim that figures as the number one reason to write this essay foregrounds our sense that the feminist discourse about "theory" generates profound implications for theories of feminist subjectivity. One of the "victories" of the feminist movement is that the identity claim may be made by anyone; the name is available and has been made available. Literally anyone can say "I am a feminist." But can anyone "be" a feminist? If the naming fails to constitute a feminist subject position, what does? Does saying you are a feminist make you one? Contemporary critical theories of subjectivity locate (the) subject as enactment—we "are" not feminists; we "do" feminism. So, what does feminism do?

One of the "complaints" animating feminist discourse about feminisms seems to be that at one time there was a nearly transparent connection between the use of the name and the actions that accomplish it and that now there is not. You can't trust someone who claims to be a feminist to "be" one. In particular, "older" feminists in the academy repeatedly rehearse their concern about not being able to recognize the "young" women (sic) in the academy who make the feminist identity claim. Some of these "older" feminist scholars have suggested that "younger" scholars claim feminism as a means to achievement—access to "fields and markets" (which "they" created; Sprengnether 206) in which "we" pursue successful careers in the academy. It is tempting

to interrupt the logic already, at this point, to query whether the claim of feminism acts as a boon to professional advancement in the academy. It reminded one of us of a scene from the film, *The Untouchables* (1987). Elliot Ness meets a Chicago beat cop (Malone) late at night on a bridge; Malone asks why Ness is carrying a gun, and Ness replies, "I'm a treasury officer." When Malone turns away, Ness chastises him for turning his back on an armed man:

MALONE: You're a treasury officer.

NESS: How do you know that? I just told you I was.

MALONE: Who would claim to be that who was not?

Presumably, Malone believes Ness because he cannot imagine anyone in prohibition-era, Al Capone-controlled Chicago claiming such an identity unless it was "true." It is a risky claim, even to a cop, at that time, in that place. We argue that it remains risky to claim feminism as an identity in the academy—for "younger" and "older" feminists alike. But the risk derives from the doing of feminism that is associated with the being of feminism (as it is for Ness and Malone).

We move into this terrain mindful of the difficulty of navigating and hopeful that the journey will prove worthwhile for more than ourselves. We are aware particularly of the "devastating rhetoric of 'us and them' that beleaguers issues of identity formation today" (Suleri 756). Indeed, in this collection of essays, that binarism is already overdetermined (and it has already appeared in this essay). We will work to undermine it in our writing by destabilizing the positions marked as "us" and "them," while considering that one of the theoretical debates in feminism is about positional stability.

The collaborative process of this text has been noted already. This collaboration was a choice (they aren't all). Because this essay necessarily traverses "personal" territories, we thought it important to theorize our collaboration. We are two professors in a midsized, Midwestern university who do feminism. We are new colleagues, having known each other for one semester. One of "us" is a first-time assistant professor; one of "us" is the director of the Women's Studies Program (currently under review for tenure and promotion

to associate professor). According to Alice Jardine's model of a four-way generational split among academic feminists, we occupy the same genera- tion—those who received their doctorates between 1988 and 1998 (the other generations: before 1968, 1968–1978, 1978–1988). Jardine argues that "[o]nly the last two generations had any chance at all of training under explicitly feminist mentors" (qtd. in Landry 160) and "the penultimate genera- tion is very divided in its experience" (161). The implication could be that those of us who occupy the provisionally final generation are not divided in our experience. However, we occupy the specified generational space differ- ently; one doctorate was conferred in 1988, locating one of us in two genera- tions, the other in 1993, which constitutes the middle and (current) end of the lived experience of the "final" generation.

Our collaboration may be argued to have begun through our identification with feminism, articulated through expressed interest in the Women's Studies Program (a problematic association certainly). It seems to happen this way among "younger" feminists: first there is a kind of checking in, declaring one's identity to others one has reason to believe may make a similar claim ("I/you teach women's literature, *ergo.* . . .". This is followed by narrativization of our feminisms. We tell stories about our work—about our encounters with the unwritten but seeming official rules of feminist discourse, particularly for "young" feminists; we exchange essays (our own and others'); we exchange syllabi. This storytelling is motivated and deliberate. We have made identity claims, and now it is time to find out what that claim means—how do you do feminism? Our storytelling does not function as evidence of our identity claim. These stories do not prove that we are feminists; the response to the stories is not to affirm or deny the claim being made. Rather, these stories theorize the feminism being claimed. We suggest that this "greeting and getting to know you" process differs from the "welcome to the fold" that "older" feminists often extend to "younger" feminists.

We require the theorizing of "feminist" because we do not approach it as self-evident. The plurality of feminist subjectivities denies transparency to the sign. To paraphrase Isaac Julien, " '[feminism] as a sign is never enough. What does that [feminist] subject do, how does it act, how does it think

politically . . . being [feminist] isn't really good enough for me: I want to know what your cultural politics are' " (qtd. in Hall, "What" 32).[2] We have organized our essay around the issues our title sets out, placing them sequentially, to construct a kind of lexicon.[3] We use the form of a lexicon to highlight how we are structured by language, within shifting discourses. We offer the lexicon as an ironic "counterversion" (or countervision) of "right speech," of definitional praxis, in feminist theorizing, also noting the impossibility of all but provisional definition. The use of a lexicon is an attempt to map, and as Adrienne Rich observes in *Atlas of A Difficult World,* "where do we see it from is the question" (1).

Safe Spaces

Feminism has habitually and historically conflated itself with women. By this, we mean more than that feminists have been "concerned" with women. We mean to suggest that feminist subjectivity has repeatedly been grafted onto females. Much feminist theorizing continues to rely on a construction of the feminist subject as biologically derived from the category woman. This biological fallacy extended means that only women can be feminist because only women have experienced the experiences that motivate women to be feminists; therefore, all women are potentially feminist or perhaps "really" feminists, even if they don't know it. Such a construction disregards the historicism of "woman," of "biology." It disregards the unknowability of "gender"—a display that is read backwards to a perceived anatomy, that signifies a biological category, that is moved forward as cause, naturalizing feminism in/of women.

To extend this argument, in feminist theorizing the subject in and of danger has traditionally been conceptualized as female. The subject endangering has been conceptualized as male. Feminisms theorizing safe spaces, therefore, have frequently rendered them woman-only, feminist-only. "We" can only be "safe" (that is, can only speak "our" minds without retribution) among "ourselves." Those who disagree with "us" from a perceived-to-be-male subject position are labeled as antifeminist. Those who disagree with "us" from a perceived-to-be-female subject position are seen as pathetic—as "male-identi-

fied" women who have been duped by the patriarchal ideologies that have constructed them. Constructions of feminist safe space serve to keep out those who would endanger "real" (i.e., consciousness-already-raised) women, "real" feminists.

This notion of feminist safe space becomes highly problematic when contemporary theories conceptualize identities as provisional, as always already shifting and unknowable. Not surprisingly, this leads to the desire to regulate the meaning of feminism—to stabilize it so that it is recognizable and trusted. So we do. We invent a semiotics of feminism—we know what (a) feminist looks like; we know what she does, thinks, wants; we can be safe with her if we are also feminists because we would be the same, or at least similar enough, to warrant recognition and identification. Feminists are women; women are feminists. All women? Which women? Can feminists disagree about what feminists do and still grant each other the identity? If I am not a feminist according to your theory of feminism but I am according to my own, can our disagreement be about the theory of feminism while we allow each other to claim the identity, really (as in, she is a *real* feminist)?

Attempts to map, to locate, and to make safe spaces within feminism describe significant dimensions of feminist praxis. The assertion of a need for safety recognizes the presence of danger. We would like to question for whom feminist safe space is safe. On what assumptions is the safe space of feminisms predicated? As we've suggested, traditional apprehensions of feminist safe spaces create a "frightening singularity in our apprehension of plurals" (Suleri 757)—women as Woman. A related problem of safe space as a feminist enclave is the tendency to continually police and bolster borders, to construct elaborate rites of passage across thresholds, and to focus "outside" and neglect the "revisionary" reading "inside." All of the above, we suggest, results in the muting of "inside" as well as "outside" critique, because criticism is conceptualized as unsafe.

This creates and perpetuates the feminist belief that criticism directed "at us" rather than "at them" weakens us. To keep this feminist safe space safe, we must not "weaken" our borders. This binds feminisms in the seduction of the two grand narratives—of our victimage and of our success in spite of

our victimage (Hall, "What"). Furthermore, this makes (especially) women feminists who are critical of "feminisms" into traitors, betrayers—not simply enacting bad faith or bad manners. Feminists who critique feminisms should "know better" than to hurt "us." Muting their critique and other critiques of feminism becomes an important business of safe space feminist rhetoric. This also makes impossible a feminist critique of feminism.

As we have suggested, one function of contemporary critical theory is that it places the sign "feminist" in jeopardy—it can no longer carry its meaning. As Stuart Hall observes, positionalities are, "never final, they're never absolute. . . . They cannot be depended on to remain in the same space" ("Cultural" 278). We cannot compare our expectations of a feminist with his or her actions and deny the identity itself. We cannot mandate feminist identity. It is difficult to define, and its use is no guarantee of support. In contemporary critical theories, the meaning of feminism is unlocatable, constantly rearticulated—we do not/cannot own the term any more, really, than NBC can own the Top Ten List. So feminists are "fearful" of critical theory—because of the danger of misrecognition, because of the dissonance of unmet expectations, because of changes and changes to come, because it is difficult to conceive of successful political action outside some provisional unity—read legislated sameness, agreed upon goals. As Judith Butler has argued:

> Within feminism, it seems as if there is some political necessity to speak as and for women, and I would not contest that necessity. Surely, that is the way in which representational politics operates, and in this country, lobbying efforts are virtually impossible without recourse to identity politics. So we agree that demonstrations and legislative efforts and radical movements need to make claims in the name of women. But this necessity needs to be reconciled with another. When the category of women is invoked as *describing* the constituency for which feminism speaks, an internal debate invariably begins over what the descriptive content of that term will be. ("Contingent" 160)

We would extend Butler's point about the category "women" to the category "feminist." Critical theory calls into question feminist safe space and feminists' recognition of each other. See also "Feminist Theories," "Feminist Loyalties."

Right Speech

Scenario 1: You attend a session on theory at a conference for directors of women's studies programs and women's centers—your first. One of the presenters opens by complaining that the title of the session was changed; it was supposed to be called "I Can't Understand You, Sister." A discussion ensues filled with concerns about "these young women" entering the professoriate who are "enamored" by "theory" and haven't done any activist work because they are busy capitulating to the academy by trying to publish; and what they publish is unreadable by "ordinary" women—"I mean can working women understand these essays?" The women in the room identify themselves as being in the ranks of "senior" posttenure faculty who went "through" the women's movement. The women about whom they speak are described as "young Ph.D.s who either see feminism as a way to get ahead or have failed to understand that feminism requires grassroots service over publishing inaccessible jargon in masculinist academic journals." You realize that you are one of two people who fit the description being constructed. You want to respond, but you feel there is no response being called for.

This is not a conversation. This is an interrogation. "What is wrong with these young women? Don't they know the history?" And a complaint. "They have the luxury of publishing; I had to work when I entered the academy." "They are not good colleagues of mine." You want to ask what that would look like—being a good colleague in the sense being spoken, but you don't. You want to ask what language—what vocabulary—is accessible, but you don't. You want to ask who the "ordinary" women are, the "working women" are, and, if they are not you, who are you? But you don't. You want to talk about your good colleagues, but you don't. You want to talk about "imperialist nostalgia" about the tyranny of authentic, authorizing experience. You want to talk about your work. But you don't. Later, at another meeting, you talk about this experience of feeling excluded and attacked even while being ignored and muted—or, at least, not heard; about feeling that the only discursive contribution available to you at the session was (1) an apology and confession, and/or (2) an expression of gratitude. Another woman says, "Really? I attended that session and that was not what was happening at all." . . . But you don't.[4]

The concept of "right" speech circulates in many cultural discourses.

During the past several years, "political correctness" has come to (re)signify concerns about regulations on speech. Indeed, the current (seemingly unceasing) disputes over political correctness represent one point of entry for feminism into "right" speech. Many feminists find ourselves positioned to defend accusations of censorship while attempting to sustain enabling discussions of antisexism, antiracism, and antihomophobia. Informed conversations about speech rights acknowledge that regulations govern the sayable. These regulations are culturally, historically contingent as well as multiple and contestatory. They are official and unofficial. They are punitive.

The recognition of a kind of inevitability to the generation of "right speech(es)" alerts us to the need for vigilant scrutiny of the particular versions constituted in specific discursive contexts. The need for such care responds less from concern about specific "permitteds and prohibiteds" than in the knowledge of the performative function of speech. Regulations about speech do not constrain and allow "only words"; they constrain and encourage subjectivities, constituted by speaking. Elsbeth Probyn links concerns with speaking to contemporary critical theory, which challenges assumptions "about the task of speaking; of who speaks for whom, and why" ("Technologizing" 501).

Probyn's observation indicates another profound intersection of feminism and right speech. Although we cannot claim any singular motivation for feminism, one of its animating issues has been and continues to be the right to speak, understood as the right to *do* (to be). Feminism's investment in these concerns prefigured and, for a time, obscured one of the most significant contemporary critical theorizings of the right speech of feminism. Feminists of color and lesbian feminists interrupted the discourse of feminisms to enunciate its silencing effects (Capo and Hantzis). These critiques argued that feminist characterizations of women, particularly nonwhite and/or working class women and/or lesbians, constructed them as silent, and failed to acknowledge the difference between not speaking and not being heard. Further, those characterized as silent require others to speak *for* them, constructing a superior discursive position for white, middle class women (in particular) who "achieved" voice early in the feminist movement. Other "others" join the

struggle for discursive recognition of audibility by feminism, including "Third World" women and, increasingly, men.

Meanwhile, the theory debates occasion additional articulations of the right speech of feminism. While some feminists continue to protest that no right speech of feminism exists, that it is, indeed, an oxymoronic notion, the abundant complaints indicate something of its operation. Theorists/antitheorists voice the accusation that excluding lexicons are being deployed by the "others." Although we identify as feminist theorists, we are not willing to mount a defense of theory as the "truly" marginalized discourse in feminism. However, we are unwilling to: (1) accept representations of theory as *the* marginalizing discourse in feminism; (2) discount the power dynamics that mark the performance of feminist discourse in the academy and its institutional extensions (publishing sites, conferences, etc.)—when "right speech" is invoked at the site of theory/antitheory and the borders match the lines of professional generations (e.g., rank, tenure), we do not participate equally in the "contest"; or (3) leave stable the implication that all "older" feminists are antitheory and all "younger" feminists are theorists. Rather, our primary concern is with the use of right speech in support of constitutions of feminist subjectivity. Probyn explores tendencies for discursive fields to stabilize; this movement threatens to annex the space of identity as the space of the negative. She quotes Andrea Stuart's complaint, " 'Being a feminist had come to say more about what you didn't do—eat meat, fuck men, wear make-up—than what you did do' " ("Technologizing" 503).

The continual work to resist the nearly gravitational pull of normalization necessitates the production of different subjectivities—different speech, different ways of speaking, different places from which to speak.[5] Of course, these different speaking subjects will be welcomed, not to the fold, but to a struggle that traverses shifting and contradictory spaces and speeches. Probyn writes of feeling winded in the midst of competing, compelling, confusing discourses; "However, against and in the midst [of this] we need to use our imaginations, strike a pose for other positions. . . . We need to keep moving and . . . encourage other movements that will recreate alternative positions" (*Sexing*

172). Imaginative engagements in the contestatory zones of vocabularies and theories, and speakers and hearers, and speech contexts potentially generate, acknowledge, and celebrate differences—though not unproblematically—constructing not "right feminists speaking right(ly)" but a plurality of feminists speaking.

Feminist Histories

To construct a complaint about the difference in younger feminists from older feminists, we have to appeal to a history of feminism. Our appeals to history, used to bolster our revelations of contemporary differences, lend to history a presence that it cannot have. There is no feminism "there." We cannot point to a moment in time and call it "feminist past" and hold it still while we compare it to "now" even as "now" fast becomes "then." Many versions of history coexist with many other versions; different versions gain provisional status as "authentic" or "accurate" at different historical moments and in different cultural and political contexts. The author-izing of history is a present-day activity that is deeply enmeshed in ideological struggles over meaning.

When we point to glorious moments of community, collectivity, and sisterhood, "then," we deny other versions of that "then." We elevate our own experience, which we construct now, over others' constructions of their experiences, and then we use them as evidence for our claims of current shifts and sways. Claims to a past characterized by a harmonious community of collective action and support are displaced by claims that the feminist past practiced class elitism, racism, and heterosexism. This kind of historical contest leaves us to select the history we remember (as our lived experience or, sometimes, as our desired experience). When we attempt to locate "our" history as "the" history, we enact what Renato Rosaldo has named "imperialist nostalgia." We obscure the problems of the past—perhaps by suggesting that the difficulties were part of our growth and so not difficulties at all, or by saying there were no difficulties. Our vision erases the voices and bodies of the "others" who remember differently. Our vision indicts the voices and

bodies of the "others" whom we accuse of wounding, contaminating, derailing, stopping, that past practice now.

Other writers have interrupted the imperialist nostalgia of feminists who deny the differences and disagreements among feminists "then," and who fail to confront the racism, heterosexism, and class elitism in feminist practices then (and now). Charlotte Canning has suggested that, early in consciousness raising, "difference was viewed as negative and divisive," and that "Consciousness raising constructed and valorized specific kinds of experiences, and authorized a limited number of interpretations of those experiences" (532). Linda Kauffman has coupled this critique with the antitheory bent of some feminisms, concluding that it is an idyllic reading of the past. She argues, "But isn't it at least possible that rather than blaming ('Male') Theory, we must confront a totally transformed economic and historical moment? The only such thing about all idyllic epochs, as Raymond Williams once observed, is that they are always gone. Let's face it: that's true of feminist idylls, too" (136).

Feminist Loyalties

Scenario 2. At a well-known feminist conference, you and another graduate student have just given papers on a panel criticizing celebratory models of second-wave feminist criticism and its representations of race. The respondent, a feminist from a top-ranking university, makes a series of remarks that are at once defensive and hostile. She concludes, "I am sure that most of the critics disagreed with in these papers actually do not disagree with the authors of these papers. . . . I think it's very important, in the midst of criticism of one another, that we never forget that we are joined by the fact that women are a suppressed group." This last statement seems to imply your own forgetting. At the end of the session, the respondent and the session chair do not mingle with you. You approach the professors, who respond in a curt fashion. Confused, angered, and defensive, you later send a letter to the responding professor, asking for a copy of her response and for advice on revising your paper for possible publication. The professor sends a copy of the response; written in bold letters at the top of the page, she notes "Not for citation." In the letter, she answers your questions generously and frankly with, "The field is moving

quickly. Keeping up with it requires all one's energy. Surely friendly collegial exchange is the best way to discuss even metatheories. Why should this involve attacking other feminists? Why should your contribution to scholarly knowledge be at someone else's expense?"

We need to interanimate the terms "feminist," "theories," and "loyalties." Tacit in some current feminist discourse is the uninterrogated understanding that to be "loyal to feminism" is simply to "be" feminist. Therefore, those whom we define as feminists are feminists to whom we must be loyal. A question then becomes what are the actions of a loyal feminist subject (which is redundant)? A related issue involves the "disloyalties": those subjects who could be feminists (i.e., women) and are not being feminists are labeled disloyal to feminism; those who cannot be feminist (i.e., men) are often labeled antifeminist. Their disloyalties inspire a different kind of anger. Men opposing feminism makes feminist sense; women opposing feminism doesn't. Perhaps this "non-sense" of women opposing women contributes to the divide that is currently perceived, enacted, and perpetuated in many feminist circles with the rhetoric of youth and age. "Young" feminists have been subject to various versions of who "we" are or aren't—are we loyal? When are we most or least loyal? And among older feminists, the question of whether the "next generation" will be loyal to its foremothers (or if there will even "be" a next one) has been registered as an anxiety.

Loyalty is not a term to be easily unpacked in feminist studies. Central to the invocation of loyalty is the determination of who or what will count as feminist. As Donna Landry has argued: "Feminism looks more homogeneous or heterogeneous depending on where one stands. And as with other commodities, only a committed user can fully experience the fiercer forms of brand loyalty which can make other positions, other brands just disappear" (164). Often we are most "loyal" to those feminists who are constructed according to our particular "brand" of feminist subjectivity. If that brand denies the label feminist to some because they are theorists, or because they are "careerist" (see below), the question of loyalty no longer applies. Those who fall outside that brand are not considered feminist and therefore their disloyalty is always already assured.

"There Are No Young Feminists"

Those who question whether this issue of "loyalty" might make "young feminists" disappear (or appear only in certain guises) might begin by reading Cheris Kramarae and Dale Spender's *The Knowledge Explosion: Generations of Feminist Scholarship.* They write, "Another issue we would want to pursue now is, where are all the young women? They are virtually invisible in these pages" (15). One answer is that this anthology enacts their disappearance by constituting their presence as an issue of "visibility" to the editors. For Kramarae and Spender, a so-called lack of young women (here conflated with feminists) is traced back to the possibilities of ageism and, again, to the difficulties facing established feminists who are trying to transmit information to the next generation (15). The issue of "transmission" is one that comes up repeatedly when dealing with feminisms "young" and "old."

"Either They Are Bad Daughters or We Are Bad Mothers"

Age, or more specifically, "how it is that older and younger feminists relate to each other across generations," as Madelon Sprengnether has noted, is "[o]ne difference that is not much discussed . . . a process which can evoke troubled memories of mother-daughter conflict" (201). Granted, the terms older and younger are slippery. Jardine's model (cited above) attempted to pin down feminist generations. Even if one doesn't "buy into" these codified versions of "youth" and "age" in academic feminisms, it must be conceded that there are particular narratives circulating now about what it means to be an "old" or a "young" feminist. These versions usually seek to implicate "our generation" in the academy (whom we would identify as feminist graduate students and junior faculty) as the problem or as the solution. Dubbed "young turks," this "young" generation (when it is indeed located) is often characterized negatively, as improperly loyal, as undaughterlike. For some, it often comes down to "either they are bad daughters or we are bad mothers."

Marianne Hirsch claims that feminists today have "somehow not been able to raise a generation that builds on what came before," and she laments the passing of a feminist community in which it used to be a pleasure to work (Gallop *et al.*, 365). Hirsch's version of the field implies that bad

mothering is to blame for the state of feminism, but "young" feminists, this also suggests, may have proven defective, too. Although she acknowledges the related problems of today's "economy of scarcity" (Gallop *et al.* 366) and its effect on the academy, Hirsch, too, implies that the so-called feminist "impasse" rests on a family failure. Though Hirsch herself and many others have since questioned whether the "community" of seventies feminism was as unified and halcyon a sisterhood as many now claim, nostalgia for early second-wave feminist practices has proliferated. Much of this nostalgia (and its subsequent generational implications) has circulated informally, but some of it can be documented in print (see Looser).

Framing the historical situation of feminism using a filial piety model presents problems that have not gone unnoticed in feminist scholarship (Gallop *et al.* 366; Fox Keller and Moglen 495). As Linda Kauffman suggests, "While some warn against betraying 'mothers,' or trashing the 'sisterhood,' this merely reveals the relentless rhetoric of familialism (another staple of bourgeois ideology)" (143). The idea that the daughters began the "fight" has been dispelled by those who have argued that "Feminists have been attacking feminists from the beginning" (Gallop *et al.* 365). Any use of the "family" as a descriptor of social relations must proceed critically, reading the concept through gender, sexuality, ethnicity, and class. In addition, postcolonial theories compel that "family" be interrogated in terms of its use as a colonizing strategy. It is interesting that colonialism was often constructed as a family rescue drama (McClintock); the colonizing fathers moved to save the native "children" from their own failures to save themselves. Antoinette Burton's work with British feminist imperialism notes the involvement of British feminist women in this drama as they cast themselves as the appropriate rescuers of the colonial daughters.

This analysis becomes more interesting when read alongside the tendency of some "older" feminists to cast themselves as mothers to the "younger" feminist daughters. Such claiming reinforces the biological fallacy that haunts feminism, allowing the continual and dangerous conflation of woman with feminist; it allows the language of creation (and its accompanying implications of origin and ownership) to permeate theories of feminism; and finally, it

displaces real mothers. This has led at least one feminist scholar virtually to reduce intellectual, ideological, and political struggles about the meanings of feminisms to a version of the question: did you hate your mother? This can dangerously reanimate the historically convenient pathology of "maternal deprivation," with its shifting of blame from mothers who work and deny their children (as it was articulated at the end of World War II) to daughters who deny their mothers. Often, however, these "generational" differences have been packaged as a disagreement over the usefulness of feminist critical theory as a political practice.

Feminist Theories

"Young Feminists Have Been Poisoned By Theory"

The issue of theory, written through the lens of feminist "generations," involves constructing a straw-woman, because there are feminist theorists who were active in the seventies and feminist graduate students who avoid critical theory. An assumption about the "next generation" of feminists, however, is that we have been "infected" by theory. In the late eighties, it seemed that generational anxieties would take hold as a theory versus feminism debate. "Young" feminists practiced theory, and "older" feminists did not—and wouldn't want to. For Nina Baym, the phrase "feminist theorist" was written up as contradictory. There would be no future for a commonality of women if we could not "traverse the generations" (58). Baym suggested that she was a pluralist who lamented the 'musts' and 'shoulds' of feminist criticism (59). Theorists, however, "must" and "should" be expelled from Baym's own sisterhood. Somer Brodribb agrees, calling feminists who draw on poststructuralist theories "ragpickers in the bin of male ideas" (xxiii), and suggesting that "the feminist project must yet elaborate an ethics and aesthetics that is not filtered through or returned to a masculine paradigm, but expressed creatively and symbolically by a subject that is female" (146).

The chastising of feminist theories and theorists has been rehearsed among those who might otherwise see themselves as unaligned. Annette Kolodny suggests that today's feminisms have become less "political"—less of an "activ-

ism" than the "original energizing politics" of seventies feminism—as a result of morally bankrupt "theory" (36). Some feminists, like Kolodny, see "theory" as neoconservative, as diametrically opposed to politics or activisms (36). Others, like Paglia, see feminist theory as an anticonservative force that closes off thought and is consequently against creative "quality" and rigorous tradition, as well as against "nature." It is no accident that Paglia calls feminist theory "child abuse," tying feminist knowledge back into (in this case, "bad") mothering (Stanfill 28). We might note the paradox of defining a discourse as neoconservative not-politics (as Kolodny does). On the other hand, to call for the closing off of something perceived to close off in the name of preserving rigorous openness (as with Paglia) presents its own problems.

One response to these calls for the dissociation of "feminism" from "theory" is to suggest that neither is an inherently conservative nor an inherently progressive practice. To begin, both depend on the contexts in which they are deployed and the power relations at work. Another response is that "the political" must be seen as encompassing more than activities such as financing a local shelter for battered women (one example Kolodny promotes as "political feminism" [35]). But problematizing the ways these two terms, "theory" and "politics," are narrowly defined in some feminisms hasn't served to close the book on feminist history, loyalty, theory, and critique. Contemporary theory requires that all concepts and ideas be scrutinized, examined, interrogated, and, possibly, changed.

"Young Women 'Use' Feminism to Further Their Careers"

The issue is more entrenched, then, than a simple "theory" and "feminism" split. Even among those feminists who align themselves with "theory," there is a recurring complaint about young feminists. It would seem that we are "using" theory "wrongly." Some have suggested that former feminist politics have been supplanted by a yuppiedom in which studying feminism is now being "used" by graduate students. Kolodny has lamented that "the seminar in feminist theory [has become] solely a means to professional advancement" (30). Donna Landry admits that she is "slightly unnerved" by "young feminist critics whose introduction to feminism has been a course in graduate school,

usually one in 'French Feminist Theory' " (160). Madelon Sprengnether believes that "mutual respect" is necessary across generations, yet she feels that this may be impossible due to young feminists "careerist" impulses:

> Yet I feel some concern for our collective future. Whether or not older and younger feminists are friends matters less than that we be able to work together toward some agreed-upon aims. For this, we need to foster an atmosphere of mutual respect. Not only do we need to try to see each other as clearly as we can apart from our personal histories of mother-daughter relations, but we also need to acknowledge that some degree of cross-generational alliance is necessary for the continuing existence of our multiple feminisms. One painful contra-indication I see for this possibility is the phenomenon of what I will call "careerist feminism," the version of academic feminism that focuses on individual achievements as its primary goal, disavowing the very value of collectivity in its definition of feminism. (206)

While we, too, concede that feminists' individualisms carry dangers, isn't there something strange about closing the door on "careerist feminists" in the name of collectivity? How can we discern who is "really" doing feminism and who is just going through the motions? Is this even a helpful split? What does disloyalty here resemble? Speaking "wrong" speech? Betrayal? Treason? Raids? Theft?

We stop at different points in the nostalgia narrative. In particular, we move to interrogate the various accomplishments touted in the nostalgic narrative of feminism. To claim that feminism offers a career path to "young" scholars, to cite enrollments in feminist theory seminars as indicative of "bandwagon" action, to claim credit for creating a welcoming space for feminist research, is to construct a vision of the present that is difficult to find. Susan Faludi's *Backlash* documents repeatedly the dangers of occupying a feminist subject position. She reveals that a "big lie" has been promulgated, which argues that feminism (or, more accurately given her evidence, the women's movement) is unnecessary. Again and again Faludi proves that "we" have not come as far as "they" say; that social justice still eludes us. The articulation

of the machinery of the "big lie" includes the sophisticated ways in which feminists have been and continue to be punished for bad behavior.

Even in the academy. "Younger" feminist scholars engaged in teaching and research and service do not trip lightly down open roads toward tenure and promotion. Arguably, the presence of more feminist scholars (nationally and internationally, if not locally) as well as the continual proliferation of feminist publications and research make "our" journey different. Perhaps it is easier because the path is, in some cases, not unwalked ground; perhaps it is more challenging because antifeminists have been constructed alongside feminists, and "they" are better able to oppose. And perhaps it is more challenging because the "older" feminists represent a demanding group of critics—looking for dutiful daughters, successors who remember and are grateful or, at least, respectful enough to focus their critical gazes on "subjects" other than feminisms.

"Young Feminists Aren't Grateful Enough, or Young Feminists Haven't Suffered Enough"

Versions of a feminist past that argue, even implicitly, that the "way has been paved" fail to consider the very real possibilities of punishment that accompany walking that way. It must be possible to recognize that feminism has a history as a movement and that women (and men) occupy different positionalities as an effect of that movement. This recognition needs to occur without constructing a present in which feminists who weren't "there" are imagined to have incurred a debt that must be paid—even while "we" work against the same institutional oppressions that moved feminism historically.

We are also concerned by the invocation of a feminist past in which academic feminists were *also* community activists. This version of events sometimes stands as a challenge to a present in which "younger" academic feminists fail to "act." The argument perpetuates a violent split in which the work of/in the academy is somehow not activism in the community. One of the points of contention in the theory debates remains the status of theory as practice. If feminist theorizing resists dominant theories and rules about

"appropriate" methodologies, inquiries, and forms of "publishing," how is feminist theorizing not activist?

Leaving aside that point of interruption, the erasure of other kinds of activism by "younger" feminists enacts another violence as it denies the experience of many "younger" feminist scholars. Many of "us" are "out there" doing "political feminism"—not only by donating money (which for many "younger" feminists, particularly graduate students and some adjunct or junior faculty, is nearly impossible), but by spending time: at planning meetings for "take back the night" marches, with coalitions to bring the Names Project Quilt to our community, with collectives attempting to respond to violence and fear, in residence halls, in university forums, with administrators, and with members of the community within which the university community is located.

In these sorts of activities, with "older" feminist colleagues there are moments of praise, ostensibly: "I'm glad you are doing that now; I did it for so many years." There are also strangely approving moments when we are told by our "older" colleagues that we have done well, that we are taking our place in the order of things. These moments play against our sense of our motivation for such actions; we recognize a need for cultural change and action and do not experience that recognition as something other than feminist theorizing. "Older" feminist colleagues would make us understand that we are their successors around the tables; we make them proud (of themselves and of us); they have enabled us to fight on, and we enable them to take a well-earned rest. One of the difficulties of this logic—in addition to its participation in the logic of family and generations—is that more bodies are needed around the tables.

Dangers

Two cautionary images animate this entry in our lexicon. Recently we were fortunate to once again participate in a concert performance by "Sweet Honey in the Rock." As anyone who has heard these women knows, all of their enunciations resonate beyond any historically specific stage. One lyric lingers, still, at this moment, "This is a mean world for you to live in." Given the

innumerable *known* daily dangers with which we live and allowing for the other unknown (and unknowable) dangers, it seems almost ridiculous, and certainly presumptuous, to attempt to index "danger."

However, risking absurdity, we proceed, because the discourse of danger is deployed in and around feminisms in ways that compel our interest and attention, despite (as with every lexical entry) the partiality of its definition. We enter this discourse, then, agreeing with Hall, who asserts that "dangers are not places you run away from but places that you go towards" ("Cultural" 285). (We believe this is one of the lessons Sweet Honey sings as well.) We take as implicit in Hall's argument that movements that seek to remedy unjust dangers construct dangerous spaces. We further read that the work of these movements is not to keep themselves safe but to *move* deliberately on. We do not do feminism to make the world safe for *feminism;* the safety of feminism would indicate that it was not doing the dangerous and endangering work of "intervention in a world in which it would make some difference" (Hall, "Cultural" 286). However, the safety and danger that mark feminist subjects are important texts for feminisms.

We are concerned with the dangers constructed by enforcing "right speech" or policing "safe spaces" at the cost of bracketing differences—muting or dismissing critique. If, as Kauffman claims, the capacity for self-critique represents the best attribute of feminism, the potential for muting critique seems to reside in the boundaries that define the feminist self which are marked by what a feminist self speaks as a critique of feminism. We have argued for the widest possible margins for feminist critical discourse. A constrained, narrowed self-critique threatens feminists with incapacity. We are disenabled when we stifle the growth that accompanies even difficult or controversial or disagreeable critique. We are diminished—literally and otherwise—when we shrink the space of the self through discursive proscriptions. We weaken our commitment, passion, and joy when we fail to measure even the most subtly nuanced differences as different. Hall talks about the problem of failing to record nuanced changes, to "name-call" them "the same," which does not help. Rather, such name-calling works to protect a version of history and to quiet revisionary challenges ("What" 25).

When feminist critique is quieted, we must ask why? We cannot keep from endangering ourselves and others *and* do feminism; we do not seek to keep feminism out of danger, to hold it still, but to move toward dangers— shifting and changing feminisms and the worlds in which it moves. We have written throughout this essay about some of the dangers we discern in aspects of contemporary feminist praxis. Our second cautionary image—the Montréal murders—carries different and complex implications for consideration of danger and feminist subjectivity. Its analysis here should be read as unfinished; the image continues to compel interpretation, investigation, and critical theorizing.

The image that circulates about December 6, 1989 is of Marc Lepine entering the Université de Montréal School of Engineering, separating the men from the women, and shooting the women. The image lingers, unsettles us, in the present—not in the least because one of us was teaching less than two hours from Montréal when it "happened" and team-teaching with a feminist man who is Québecois and felt the event in deep and complex ways. "Perhaps because anytime schools are invaded and students are killed it becomes part of the inheritance of students (present and former) and professors" (Hantzis). For this essay, the murders in Montréal issue difficult challenges to feminists' conceptualizations of feminism and to "real-world" danger.

When Marc Lepine shot the women, he reportedly yelled, "You're all a bunch of fucking feminists."[6] How did he know that? The women made no such identity claim. Indeed, they protested, "no, we are not feminists; we are students." Marc Lepine constructed those women as feminists *primarily* because they were women. He reasoned from their gender display to a perception of their anatomy and read both against the cultural norms of the spaces they were occupying: women do not belong in engineering school; these (apparent) women are in engineering school; feminists are women who do it wrong; these women are feminists.

With the exception of the conclusion that these women deserved to be murdered, Lepine's argument about their identity is hard to refute within much feminist discourse. Habitual theories of feminist subjectivity would

enact a similar reading—women enrolled in engineering schools are feminists; they may not know it yet and might be described as unaware—or they may deny it and be described as ungrateful. If they live.[7]

In Montréal, the fourteen women died. And the popular media, when it acknowledged feminism as a contributing circumstance at all, said feminism was to blame because it made men angry and created the danger documented on the women's bodies.[8] If doing feminism affected access policies in the schools of engineering so that the expectations of men were frustrated as women were admitted and men were not, isn't feminism implicated in these murders? Certainly, we rehearse to and among ourselves the dangers of feminist activism—that it can cost you your life. But, then, these women were not feminists; they claimed they were not feminists. How do we understand the subject positions enacted by these women? Some feminists deployed "Montréal" as evidence of the continuing hostility against feminism, and some feminists deployed "Montréal" to argue that women should be able to pursue safely any field they choose. And we continue to wonder about those women who rejected the identity claim "feminist" and figure now often as feminist victims/heroines. In the story above, Marc Lepine went looking for feminists to kill because he said feminism had ruined his life. One irony, among many, is that he didn't kill any. He killed women living in a space made dangerous, at least in part, by a feminism that laminates "feminist" onto the bodies of women even without their knowledge.[9]

We agree that it remains important to recognize the ways that feminists are endangered—physically, emotionally, professionally, and personally. But so are women and men and children who are not feminists. And feminisms construct and confront dangers as well. But those dangers are/should be theorized in terms of their location in and articulations with a dangerous world. We need to cite repeatedly the dangers that compel and accompany doing feminism—not to revel in our "victimhood" but to move toward dangers with courage and sorrow and imagination and passion for change. There is no sufficient response to danger in the changeless space marked by an absence of critical theorizing.

Critique

Some argue that anytime feminists criticize each other, it necessarily plays into "their" hands—divide and be conquered, stage cat fights, and misunderstand those who are our "real" enemies. But such feminist disagreements are not or need not be a one-way ticket to "male-stream" complicity. As Landry concludes:

> We had better remember that the exchange of women is an old, old story, and that competition amongst ourselves as women, in a market of gender quotas and fiercely contested professional status, is the most "natural" form of complicity in the world. Feminist critique as political criticism, however, can be our means of resisting that complicity, though no critique can hope to escape in a totalizing way some complicity with its structural context. (170)

Where does critique begin and complicity end? Where does the staging of our disagreements become a means of resisting and where a means of annihilation?

When Katie Roiphe's *The Morning After: Fear, Sex, and Feminism on College Campuses* appeared in the fall of 1993 amid much media fanfare, her (mis)representations of "rape-crisis feminism" angered many. On the Internet, discussants on WMST-L strategized how "we" women's studies scholars might prevent Roiphe, a Princeton graduate student in English, from getting a job. In their productive dialogue on "criticizing feminist criticism," Jane Gallop, Marianne Hirsch, and Nancy Miller conclude that what we need now is an "ethics of criticism" (368). It is difficult to imagine what this "ethics" might look like, as well as how it would be enforced. Kathleen Jones has fruitfully discussed these issues by turning to the enactment of authority in feminist praxis, asking:

> To what extent has feminist theory been captivated by this same conceptualization of authority as sovereignty? To what extent have we fallen into the "sovereignty trap"? A number of features evidence the quest for sovereignty within feminism. These include: the centrality of gender as a category of analysis in feminist theory, the quest for unity within the feminist movement, the effort to create authoritative texts and interpretations of "female experience,"

the construction of a feminist canon, and the establishment of sovereign leadership within the feminist movement and in feminist theory. (114)

Jones further suggests, "If we displace sovereignty—the desire to control difference by representing it as unity—what happens to the coherence of the feminist project in theory and practice? Authority, instead of ending discussion, becomes its beginning" (123).

Likewise, feminist critique, we suggest, might serve as the beginning—and not the shutting down—of feminist speaking. Linda Kauffman has argued, "Feminism's greatest strength has always been its capacity for self-critique, and it would be a great pity to see that capacity muted by the insistence on consensus. . . . I think we still have the most to learn from the ruptures, limitations, and contradictions in our thinking" (142).[10] There is no question that confronting these ruptures, limitations, and contradictions can be a form of violence (see Tompkins). There is also no question that *not* confronting these ruptures, limitations, and contradictions can be a form of violence.

Safe(r) Spaces

Feminism is not safe; it will not be safe. It's not safe to do feminism or to be thought a feminist in the world. But can we or should we make it safer to be a feminist among feminists in the world? To answer "yes" is to affirm that such a space must be continually created and recreated—not established and enforced. If that space is to be constructed, the only way to make that space is by identifying feminists; this places us in the identity-formation business. Talking about safer space, rather than safe space, means recognizing that danger articulates with safety.

We do not wish, we did not set out, to propose an alternative or an expanded "right" speech. As Jane Tompkins has said in regard to violence and critique: "I believe in peace and I believe in the Golden Rule, but I don't believe I've earned the right to such pronouncements. At least not yet. It's difficult to unlearn the habits of a lifetime, and this very essay has been fueled by a good deal of the righteousness it is in the business of questioning" (590). This essay has also been fueled to some extent by what it is in the business

of questioning: feminist subjectivity. We, however, would celebrate and perpetuate the "not yet" of these earnings and yearnings. We would advocate a continual dismantling of "right" speech, along with a vigilant guard against standardization or a loss of delight—pleasure—in improvisation, in critique.

One possibility of conceiving of this safe(r) space is as anagrammatic: not unmindful of what is here and what has been here, but not unwilling to rearrange and to play. This would involve constructing an interrogative space and "an urgent intellectual duty would surely be to subject not merely our others but ourselves to the rigors of revisionary scrutiny" (Suleri 758). Again, in the words of Kathleen Jones:

> We accuse each other of trespassing on each other's property—our identities and experiences; of not quite understanding us, of not "getting it," yet without seeing that in doing so we affirm experience as private property, knowledge as total, exclusive control, and understanding as loneliness. Perhaps we need to insist on our own elusiveness except when we name ourselves. This may be a political strategy with which the "dispossessed" can powerfully displace and disrupt sovereignty. But who counts among the "dispossessed" and how do we know that our (their) motivations are not coup d'états that will lead to the next benevolent dictatorship? (120).

We name ourselves here. We are feminists. We do feminisms. And this is not the end, the answer, the lonely understanding that we've reached. It is an elusive beginning, an opaque statement of motivations, a "gift-giving," for which we "prepare ourselves for the disappointment of possible refusal" (Jones 123), even as we hope for the pleasures of enacting community.[11]

Notes

1. The ordering of our names does not reflect our respective levels of contribution to the piece. We list them alphabetically as the nearest way to signify our equal participation in this essay's writing. In addition to our conversations with each other, this essay benefitted greatly from conversations with Antoinette Burton, Linda Frost, Craig Gingrich-Philbrook, E. Ann Kaplan, Mona Narain, and our current and former students.

2. This paraphrase of Isaac Julien entails substituting "feminist/feminism" for "black." Our willingness to do this does not indicate our belief that such translations or replacements

make the issues and concerns of black subjectivity synonymous or secondary to those of feminist subjectivity.

3. Although the lexicon is an old form, recent inspiration to use it in this context came from Gingrich-Philbrook.

4. We would like to acknowledge Kathleen B. Jones's "The Trouble With Authority." Our use of scenarios is modeled on her use of scenes in that piece. We were taken with her use of the second person there and replicate it here.

5. Tania Modleski, for one, has stated her commitment to a feminism that enables new subjectivities rather than reproducing already made ones.

6. Many versions of Lepine's enunciations are available; he spoke in French. All of the versions we have seen note that he referred to the women as feminists.

7. In "What is this 'Black' in Black Popular Culture?" Hall writes about "habits of difference" and the need to break habitual constructions of difference, to look in different places, and to construct other differences.

8. Media responses were interesting in their choice to erase the presence of feminism in the murders; many reports "failed" to mention that the victims were women or to cite Lepine's own speech; other responses erased feminism by pleading with feminists not to make a big feminist deal of another homicidal maniac. But, as the Québecois colleague mentioned above, Louis DuPont, said, "He did not shoot like a madman wildly in the streets." Probyn notes the choice of some media reports to blame feminism ("Technologizing" 502).

9. We recognize that all identity claims are strategic and political; it is possible that some of the fourteen women lied to Marc Lepine in an attempt to be spared. It is also possible that they did not understand themselves to be doing feminism; we support their rights to name themselves and challenge ourselves to articulate carefully the mechanisms by which they were held accountable—made to represent—feminist subjects despite their theories of self.

10. While we credit Kauffman's argument, we contend that feminism's capacity for self-critique hasn't been as wide-ranging as some have claimed. We believe there has been a "right speech" of feminist self-critique, in other words.

11. Jones writes, "We can think of authority not as border-patrolling, boundary-engendering, but as meaning-giving; and, as with all gift-giving, we should prepare ourselves for the disappointment of possible refusal" (123).

III

Othering the Academy

13

Russell Jacoby, Antiprofessionalism, and the Politics of Cultural Nostalgia

Barry W. Sarchett

Let me begin with three quotations from three different writers who have been highly visible in their stance against "professionalization" and the rise of theory in the academy:

> critics and interpreters of literature during the last twenty years, . . . like many sociologists, have tried to give themselves elite status by constructing a special, allusive (and elusive) vocabulary, but this runs counter to the healthful, anti-jargonistic stance of literary studies at their best, from ancient Greece to the present.

> The new continental critical fashions first crept into the academic village in the late 1960s, dazzling professors of literature with an array of abstruse, intimidating, and impressive-sounding terminology like metatexis, paralogic, non-referential, and logocentrism. The new theories were ideal for academics who . . . were bored by traditional approaches . . . or . . . latched onto the new fads as a way to fast-track themselves into academic glory.

> We [sociologists] are disarming ourselves: We can no longer speak to the public. . . . [New theories] incapacitate practitioners from political and intellectual action beyond the grazing fields of academe. The jargon does not convey illusive concepts, but rather the writer's pleasure in club membership. It has become a credential that certifies to crusty academe that Marxism or poststructuralism is a safe acquisition—because it is incapable of rallying the rabble.

These three statements originate from three different political/cultural perspectives, left, middle, and right (not in that order, however), but what

interests me most is that it seems so difficult to tell them apart: they share a common target criticized by way of a common rhetoric inscribed in a common narrative of decline. In addition, also by way of beginning, I must admit that I take these accusations very personally, for their common target is in fact *me* and people like me: a younger generation of academics weaned on the politics of the sixties, graduate-schooled in the theory boom of the seventies and eighties, and now disseminated in universities and colleges throughout the U.S. and the world.

Frankly, my first response to such statements, if I can be forgiven for using a bit of street "jargon" here—a kind of jargon of which the "left" probably approves as much as the right would disapprove—is to get pissed off. *Ad hominem* attacks and narratives of a Fall from a Higher State from the right I simply accept as inevitable, given that "theory" has been almost exclusively appropriated by the cultural left, and for very compelling reasons. But if those on the left also accuse the new professoriate of cynical elitism, career-ladder climbing, and other forms of "selling out" (the last of the statements above was written by Todd Gitlin, SDS veteran and now himself a sociology professor—qtd. in Winkler A10), as if becoming an English professor can be dismissed as politically equivalent to investment banking, then I think we're all caught up in a plot that needs reevaluating. That plot, which must be tiresome to almost everyone by now, might be best described as a long-running soap opera on the theme of "Whatever Happened to the Baby Boom?" The three statements above remind me of nothing so much as being forced to watch endless showings of *The Big Chill* and *thirtysomething* until I confess tearfully that all my sins are either in the past (my torturers thus being a Deprogramming Deputation from the Heritage Foundation) or all my sins are in the present (my torturers then being the Purge Patrol of the local Justice and Peace Coalition). Of a few things I do willingly confess: yes, I am a professor, and I am actually a theorist (or at least I was hired as a "specialist"— another curse word common to the left and the right—in Literary Theory); I also confess that I usually read, and sometimes even produce, some very difficult and jargonized prose. I even confess to enjoying much of this prose, but "pleasure" is another suspicious category for the right and much of the

left. Finally, I confess that this essay is an attempt to counter the discourse of antiprofessionalism from a position I would call "oppositional" and that at the very least feels to me like a position from the progressive left.

But this paper is not a direct attack on the antiprofessionalists and/or antitheorists of the right, most of whom—Bennett, Bloom, Bellow, D'Souza, Charles Sykes (the author of the best-selling *Profscam,* from which the second statement above was taken [181]), Roger Kimball, *et al.*—long ago forsook the strategy of rigorous and theoretically informed argument for the *métier* of the self-evident, often hysterically reductive assertion.[1] In other words, the conservatives' diatribes are intellectually irresponsible because they violate *professional* standards. As Jerry Herron (in his unfortunately ignored book *Universities and the Myth of Cultural Decline*) remarks of Bloom, his "cheap reductionism . . . would cause him no end of grief if it were to occur in his real work, which is philosophy" (30). The conservatives thus become rather easy targets because, as Russell Jacoby demonstrates in *The Last Intellectuals,* they "inch toward anti-intellectualism" (198). This does not mean that I think the conservatives should not be contested both intra- and extraprofessionally, but that I have another agenda in this particular essay.

Instead I take as my primary subject here Jacoby—a leftist who has been too casually associated with Bloom and the other High Sheriffs of Western Civilization[2]—and his much-reviewed book, *The Last Intellectuals: American Culture in the Age of Academe.* In general, Jacoby's text, a critique of the academization of the latest generation of leftist intellectuals, is well-researched and documented, and he carefully eschews the usual right-wing rhetoric of moral panic for a more modulated tone: he repeatedly asserts that he is not making moral judgments (a questionable assertion he *does* share with Bloom), but engaging in an historical inquiry into "complex factors [that] stamp or undercut the formation of an intellectual generation" (4). That is, the book's virtues directly result from its adherence to *professional* standards of evidential and argumentative discourse.

Jacoby's history of American intellectual life roughly since the rise of the New York Intellectuals in the forties traces a number of intersecting narratives, all of which add up to a single narrative of decline: "The impoverishment of

public culture" (ix). The first narrative limns the devolution of urban space—primarily Greenwich Village—in postwar America: from a "cheap and pleasant urban space that might nourish a bohemian intelligentsia" (21), the processes of suburbanization and gentrification have resulted in the fragmentation and dispersal of intellectuals, who have essentially become economic refugees in campuses and suburbias throughout the land. Given the closing of what Jacoby revealingly calls the "cultural frontier" (19) of café society, independent bohemianism, and the subsistence economy of free-lance writing, his second narrative traces the institutionalization of intellectuals in academe. This is a narrative of domestication, of a move from alienation to conventionality, from independence to professionalism, which "spells privatization, a withdrawal from a larger public universe" (118).[3]

After a lengthy and very compelling discussion of the recent sordid history of American universities in dismissing highly competent radical professors (including John Silber's cynical power-play to deny tenure to Henry Giroux at Boston University [136–37]), Jacoby embarks upon his final subnarrative of decline. Here he finds the "privatization" of intellectuals expressed most vividly in their turn to the jargon-laced prose and arcane rhetorical strategies of theory, a style no longer conducive to a general audience of educated readers. Having argued that radical academic intellectuals are inevitably "mainstreamed" through the continual threat of unemployment (135), Jacoby unfortunately resorts to a repetition of the *ad hominem* attacks that began this essay. "Self-contained theorizing" (119) not only isolates the professionalized intellectual from a larger public, Jacoby narrativizes it as self-aggrandizing careerism: "The accumulation of jargon in the field registers not the needs of truth but academic empire-buiding, where professors can lord over microfields" (156). Yet for Jacoby this is not only a narrative of power-mongering, it is at the same time a narrative of the selfish descent from hardy work to leisurely security; intellectuals "exchanged the pressures of deadlines and free-lance writing for the security of salaried teaching and pensions—with summers off to write and loaf " (14). Apparently, despite his earlier disclaimers, Jacoby has not escaped the habit of easy moral reductionism that marks other critics of the new professoriate.

It is important to realize, however, that, whatever his simplifications, Jacoby's narrative carries a great deal of historical explanatory power. So much so, in fact, that he has found essentially the same master-narrative at work in another group of urban intellectuals earlier in the century. His 1983 book, *The Repression of Psychoanalysis*, traces the history of psychoanalysis from its origins in the rebellious and bohemian culture of turn-of-the-century Vienna (which Jacoby specifically equates to the youth movements of the sixties) to its ultimate academization, institutionalization, and thus cooptation in America. In place of an originally oppositional, politically engaged movement, second-generation Freudians increasingly regarded psychoanalysis less as a "cause" than as a "quiet career choice" (46). And of course with professionalization comes the decline of language and a public style: where once "Freud wrote simply and elegantly for a wide cultural audience, . . . [now] in a technical and medical prose, contemporary analysts write for one another" (xi). While Jacoby concedes that Freud's bold and subversive theoretical project has been kept alive in America, primarily in English departments, as we should expect by now he derides Freudian literary theoreticians (especially Harold Bloom) for writing "unreadable self-promoting textual studies." Fittingly, he represents this "corrosion of prose" in terms of suburban dispersal and even malls: "it reflects the fragmentation of a larger cultural universe into intellectual specialties and chain stores" (139).

By way of engaging in a critique of Jacoby, I first want to establish two provisions to the remarks that follow. First, I don't pretend to be a disinterested analyst of these matters; Jacoby's attack, as I stated earlier, is essentially a challenge to my own life. To engage his arguments necessarily entails a strategic *defense* of the way I have chosen to channel my own time and energy. Second, I have no factual quarrel with his narrative of institutionalization; as Bruce Robbins, a leftist academic, notes, "Everyone seems to agree that intellectuals today . . . are bound to or bound up in institutional circumstance as never before" ("Introduction" x). This is no longer a question, but a fact. Yet like all facts, its facticity is banal. My quarrel is with the historical and cultural *meanings* and *consequences* of this fact that Jacoby has deployed. After all, one could easily argue, *pace* Foucault, that intellectual life (like any

discursive regime) becomes possible only when institutionalized: apposite examples would include Plato's academy, the School of Raphael, the Vanderbilt Fugitives, the Bloomsbury Group, and the Frankfurt School.

Thus, what looks to Jacoby like decline and withdrawal, feels to me like a remarkable, if necessarily less than total, success. Jacoby asserts that, for "the sixties as a whole, success was part of the undoing" (*Last Intellectuals* 229). But if this is so, at least in terms of the academization of an entire generation of leftists, then what are we to make of the concerted, spectacularly funded, and highly public right-wing assaults in recent years on the new academy? Given this fact, Robbins has some stern advice for leftists like Jacoby who long for the glory days of alienation and opposition. For the left, Robbins states, defensive strategies are now necessary:

> Enough of the cool but invigorating comforts of pure marginality to which [the left] had become accustomed. . . . In the face of the right's offensive, it is no longer possible to deny that something palpably grounded in reality, something realized and accomplished, exists for the right to attack, and the left to defend. All this public recognition, however critical, is forcing left intellectuals to acknowledge what they have most often not wanted to acknowledge: their own cultural and institutional *achievements*. (x)

In his Plenary Address to the Rocky Mountain MLA conference of 1989, Jacoby stated that "the larger public no longer cares about literary critics." But another narrative account, more empirically plausible, would ask first if the "larger public" (leaving aside how one would define the vague modifier "larger") has ever cared much about literary critics and would then wonder why, for the last decade or so, academic literary practice has become such a ubiquitous public issue. From William Bennett and Lynne Cheney to a recent *Newsweek* article graced with a photo of Stanley Fish ("Learning to Love the PC Canon")—the same *Newsweek* which ten years ago ran a story on deconstruction with a photo of Jaques Derrida looking every inch the French matinee idol ("A New Look")—academic literary practice has been the subject of a massive public debate. When was the last time the Stanford cultural curriculum was the subject of newspaper editorials from coast to coast?

Yet in *The Last Intellectuals*, Jacoby mocks the "conservative nightmare" of leftists invading the universities with this airy dismissal: "What happened to the swarms of academic leftists? The answer is surprising: Nothing surprising" (118). Given recent developments, especially the crescendoing national flap over "PC" in higher education, such a statement—even for a book published in 1987—smacks of an almost pathological misreading.

To understand the ideological structures of Jacoby's narrative of decline then, I submit that we have to account for the discrepancy between his narrative and Robbins's diametrically opposed narrative of achievement. This is essentially an issue of competing visions of the proper sphere of intellectuals, the space they occupy and their function in culture, which in turn demands an historical inquiry.

The Jacoby/Robbins schism is a current manifestation of a debate within Western bourgeois culture over the control and legitimation of what Jürgen Habermas has called the "public sphere" which emerged with the decline of the authoritarian state in the seventeenth and eighteenth centuries. This public sphere, as Terry Eagleton describes it in his short history of the social function of English criticism, "comprises a realm of social institutions—clubs, journals, coffee houses, periodicals—in which private individuals assemble for the free, equal interchange of reasonable discourse," and which ostensibly formed an ideal discursive space: "it is supposedly no longer social power, privilege, and tradition which confer upon individuals the title to speak and judge, but the degree to which they are constituted as discoursing subjects by sharing in a consensus of universal reason" (*Function* 9). Among other attributes of these "discoursing subjects" whom Eagleton (like Arnold) calls "critics" but whom Jacoby would call "public intellectuals," were "civilized skills" that must be "incurably amateur" because the critic's only claim to authority and superiority is paradoxically that "all men possess the capacity" for reasoned judgment. Thus "it follows that the critic . . . is merely a speaker from the general audience and formulates ideas that could be thought by anyone" (21–22). The critic therefore represents the Universal Subject.

From the perspective of French rather than English history, Zygmunt Bauman has traced an originary narrative of modern intellectuals remarkably

similar to Eagleton's.[4] With the emergence of a new type of state power in the Enlightenment, "the . . . monarchy faced administrative tasks of an unprecedented magnitude, which could not be handled by traditional means. . . . [T]his called for a grand design for a better society; experts, specialists, advisors—those who 'know better'—were needed" (*Legislators* 36–37). Because "legitimation of political influence . . . [had] been sundered from heredity and pedigree," it was relocated in "those who know," teachers and writers (32–33). Thus arose the Philosophes, the precursors of what came to be known as the "intellectuals" once the term came into usage during the Dreyfus Affair. Bauman, quoting Augustin Cochin, observes that membership in *la république des lettres* required that " 'the participants appear free, liberated from all attachment, any obligation' . . . The only power which was explicitly allowed to be invoked inside *la république* was the power of idea, of argument, of logic, measured by the yardstick of consensus" (36).

Both Eagleton's and Bauman's accounts of intellectuals in Western European culture reveal a paradox that has been the source of conflict and adjustments ever since. As Bauman notes, the noun "intellectuals" signifies a group of people set "apart from the rest of the population, but also determin[ing] a certain similarity in their rights and duties. Most importantly, it gave the incumbents of intellectual roles a right (and a duty) to address the nation on behalf of Reason, standing above partisan divisions and earth-bound sectarian interests" (21). That is, these people represented all people; they were universal and transterritorial. Thus Bauman's term for the intellectual in its classic modern role: the "legislator."[5] Yet at one and the same time intellectuals emerged in order to help fill a power vacuum created by the demise of traditional authoritarian states. They managed culture, defining the terms of discourse in which judgment and power would be deployed, and in which their own discourse is legitimized. Bauman argues, in fact, that the intellectuals' social role in modernity is structurally homologous to the role of the shaman in tribal societies: "they elevate the priestly ways" while necessarily "downgrading" the discourse of the laity; "and they present the resultant relationship of domination as one of service and self-sacrifice" (13). Therefore, intellectuals, to borrow the Foucauldian pun that gives the title to Paul Bové's

recent book, have always been "in power," but have been represented as above power.

One of the most troubling shortcomings of Jacoby's analysis of contemporary intellectuals is that, despite his historicist claims, he insists on defining intellectuals categorically rather than seeing them as functionally occupying a space in a set of material relations. Thus "real" intellectuals are alienated, independent; "real" intellectuals write with vigor, clarity, and "style"; "real" intellectuals seek and find a "larger audience." Given this binary and unhistoricized logic, he can thus lament the fact that there are no more intellectuals, for academic intellectuals can be defined only in a position of lack or absence.[6] But all of Jacoby's categorical attributes, as well as the noun "intellectual," are *relational* terms, incribed within discursive formations that themselves need interrogating.

Following Bauman, I propose that we avoid what he calls the "finger pointing method" of discussing intellectuals (there's one over there, but this one isn't) in order to locate "the category of the intellectual within the structure of the larger society as a 'spot,' a 'territory' within such a structure; a territory inhabited by shifting populations, and open to invasions, conquests and legal claims as all ordinary territories are" (19). Such a contextualizing method allows us also to locate the generic and historical situation of Jacoby's book itself.

Robbins has noticed that *The Last Intellectuals* perfectly accords (as does *The Closing of the American Mind*) with the genre of the jeremiad, calling the fallen back into the fold of an originally unified body ("Introduction" xvi). But Bauman finds that the term "intellectual" itself originated "so to speak, as an act of propaganda" (*Legislators* 23), a "rallying call" during the Dreyfus Affair addressed to the descendants of the Philosophes, by now "divided into specialized enclaves with their partial interests," in order to resuscitate a lost "unity of truth, moral values and aesthetic judgement" (1). It seems that the dialectical tension between universalism and particularity, disinterestedness and interestedness, unity and dispersal, is constitutive of the life of Western intellectuals, the first term in the series always lost in the past and the second term always present and lamented. Jacoby's master-narrative turns out to be

the master-narrative intellectuals keep repeating to themselves as they try to regain a space that never existed.

In some ways, Jacoby even understands this. He knows that "intellectuals have always been obsessed with themselves, regularly bemoaning their impotence, corruption, or imminent demise." Yet he goes on with his story of imminent demise because "skepticism must always be skeptical of itself" (73), thus ceasing, I would argue, to be skeptical enough. He even understands that the New York Intellectuals, his chosen models for the eclipsed world of the public intellectuals, don't really make the grade as an independent, alienated force. Lionel Trilling and Sidney Hook, for example, made their careers by moving from opposition to opposing opposition, and thus contributing to the deradicalization of the intelligentsia in the fifties (91). Finally, Jacoby acknowledges that the New York Intellectuals supplied little "compelling theoretical work" for their supposedly ungrateful heirs. So Jacoby is left with his only unqualified terms of praise: they still wrote, even as professors, to a larger public about larger public affairs. Yet if this is all that remains to be said of them, is it any wonder that a new generation of leftist intellectuals has found different ways to constellate its energies and to renegotiate the site of intellectual life?

So obsessed is Jacoby with the cooptive force of professionalization that he neglects a rigorous analysis of the academy as such a site. Eagleton reminds us, for example, that by Arnold's time, the dissolution of the classical public sphere of intellectual journals into a cacophony of partisan and localized interests drew Arnold into the academic sphere precisely to protect the disinterested "play of the mind" that has traditionally sanctioned the moral and political authority of intellectuals (60–61). Arnold, of course, promulgated his own narrative of decline with different political motives from Jacoby's. But Jacoby's suggestion that "public culture is warped by money and politics" (23) could have come directly from Arnold's mouth; they both share a revulsion at a supposed decline from freedom to affiliation in the intellectual sphere, yet for Arnold, hopes for such freedom reside in academe, not outside it.

Given the triumph of Arnoldian discourse as the basis for the modern liberal arts tradition, it should not be surprising that Jacoby's own opposition

between an ideal of "general culture" and degraded forms of specialization has also been the focus of intense conflict in the academic profession itself. Gerald Graff reminds us that, in literary academe since the last half of the nineteenth century, there has been a continual debate between generalists and specialists played out in terms that echo Jacoby: generalists have repeatedly attacked research scholars for favoring "scientism, preference for nit-picking analysis over direct experience of literature itself, and favoring the special interests of a professional coterie over the interests of general readers and students" (*Professing* 249). In fact, as Graff demonstrates, prominent academic generalists since Charles Eliot Norton have championed "the professor as a kind of internal *émigré* from American culture" (83–84), thus functionally connecting the professoriate to the "voluntary exile from the middle class" which characterizes Jacoby's cherished bohemia (*Last Intellectuals* 20). In addition, Jacoby's complaint about cultural dispersal and the lack of an intellectual center (by which he usually means New York), which he also connects, in Arnoldian fashion, to an uncontrollable proliferation of voices— "there are too many journals . . . and they seem to have lost their zeal and direction" (xi)—can be read as a repetition of the academic rallying call for general education as a return to a lost unity in the face of heterogeneity and fragmentation (Graff, *Professing* 239).

All of which I would argue should make us very skeptical of all easy distinctions between a "real" public world and a "merely" academic one. If, as Althusser has argued, in mature bourgeois societies, "the educational apparatus . . . has in fact replaced in its functions the previously dominant ideological State apparatus, the Church" (153–54), then it would be hard to imagine a more public space than the university. One of the most blatant omissions from Jacoby's account is a discussion of the classroom, a primary site of socialization, as a public space. I would suggest that this might be because, for Jacoby, socialization and classroom teaching have assumed the cultural codifications of the "private" feminine sphere, as opposed to the masculine sphere of "leathery independence" which he posits as both "public" and rebellious (15).[7]

Even more importantly, he fails to take into account the vast social and

demographic currents that have transformed higher education, including the professoriate. Jacoby is fond of quoting from Veblen's and Mencken's venomous attacks upon academics as "dull," "monkish," "prudent," and "skittish" (142–43). But the university of today is a very different creature from the university of the teens and twenties (or even the fifties). Once the exclusive home of the genteel and cultured class, the professoriate (and the student body even more) is now likely to include sons and daughters of the working class, people of color, feminists, and even Russell Jacoby. Much to the consternation of Arnoldian elitists like Bloom, the democratization of academe, as well as its rapid expansion since the sixties, has made it a virtual embodiment of the "larger public." In addition, as Derrida has pointed out, the university in advanced technological societies is now fully "oriented": all that was once represented as outside the university, especially the state security apparatus—can and has appropriated the discourses of the university, including the humanities (12–13). The university is thus irremediably "inside." To Jacoby, this of course suggests that academia cannot serve as a site for the "independent" intellectual; for others, however, this might suggest that it is now at least as appropriate a site for oppositional intellectual work as any other: simply put, one might want to go where the action is—and where the public is.

The latter option flies directly in the face of the traditional notion of the intellectual site since the Enlightenment, which, to repeat once more, has gained its legitimacy by representing itself as outside and above all sectarian, local, or personal interests. Once this extraterritorial territory has been invaded by actual territorial interests, then, once again, the intellectual no longer exists *qua* intellectual. And it is most important to realize that, under the discourse of modernity, this territory has been and must be claimed by both the right and the left, both the defenders of Culture, from Arnold and Newman to Bennett and Bloom, and the "radical" voices for "social transformation," like Jacoby or the Frankfurt Schoolites. This explains why, even though Jacoby and Bloom do not share similar political positions, they do share a common discursive formation that demands a narrative of decline as a rallying call for a lost authority. (And it explains the similar features of the three passages that began this paper.) This rallying call, as Bauman has explained, has in

fact always constituted the term "intellectual," since the unsituated site of the intellectual is always located in the past. To be a modernist intellectual on the left or right is to be by definition nostalgic.

But in the present historical moment of what Fredric Jameson has called the "cultural dominant" of postmodernism, which means at least the simultaneity of advanced technological/consumer capitalism and the range of theoretical discourses loosely labelled "poststructuralist," the privileged site of the modernist intellectual has been challenged both by cultural mutations and by a sustained critique. In the cultural realm, a situation presents itself in which, as Bauman notes:

> the discourses of truth, judgement and taste, which seemed to be fully administered by intellectuals (and in which only the intellectuals were the rightful participants), are now controlled by forces over which the intellectuals, the meta-specialists in the validation of truth, judgement and taste, have little, if any, control. (*Legislators* 158)

These forces include precisely those institutions of specialized research and learning that generalists (academic and otherwise) have always exorcised, but they are in turn subsumed under what Bauman calls "the new validating meta-authority" of truth and taste: the market. Under these conditions, if intellectuals claim authority under the old dispensation, they simply become "redundant" (122).

The old dispensation of course has always sought validation by opposing itself to the self-interested economic sphere of bourgeois society. In the academy, for example, Arnoldian generalists have continually seen themselves "as the upholders of spiritual values against the crass materialism of . . . business life" (*Professing* 85). A similar gesture animates the valorization of bohemia, a differential space that can exist only as long as it defines itself against the bourgeoisie. As Jacoby states, bohemia is a utopian promise of "unregulated time" and an escape from "the bondage of money and drudgery" (29). (Although we should remember that Jacoby privileges the bohemian intellectual who flaunts bourgeois values by "thinking too much and doing too little" [29] at the same time that he disdains academics because they want

summers off to "write and loaf.") Jacoby's argument against professionaliza-tion, as well as those of the three writers with whom I began, rests on the premise that professors have simply reentered the bourgeois race for personal gain and glory. Thus they have ceased to be "public" precisely because they have ceased to be exiled from "the messy melee of actual collective and overlapping identities that is society" (Robbins, "Introduction" xiv).

This antiprofessional stance ignores, however, the *ethos* that made the historical rise of the professional possible. That *ethos* in many ways duplicates the legitimating claims of the traditional disinterested intellectual. As Samuel Weber reminds us, "the professional disposes over a body of systematic . . . knowledge . . . reposing on founding *principles*. . . . The objectivity of such knowledge is invoked as the basis of a power, privilege, and authority that claims to transcend the limited partialities of social life. . . . But perhaps above all, professional competence is felt to transcend the self-interest of business and market relations" (26–27). In other words, from a historical perspective, critics of professionalism berate academic intellectuals because they don't adhere to the idealized behavior of the professional.

Thus, as Stanley Fish demonstrates in his widely known response to Walter Jackson Bate's 1982 *Harvard Magazine* attack on the professionalization of "English Studies" (from which the first passage at the beginning was taken [47]), humanistic professionals are always put in a bind. As long as professors of literature engage in those activities which actually constitute the material practices of the profession, activities "which smack of the marketplace"— "publication, tenure, and professional power"—they can be accused of vio-lating some originary sacred trust of the profession itself. So, as Fish says, "it will always be possible to attribute to [professionals] some base or impure motive" (*Doing* 198). Fish makes his case in terms of literature professors, but I would add that it applies to all professions that have traditionally legitimized their activities as rendering a *service* rather than *selling* a product. Thus doctors always make too much money (especially the dreaded *specialists*), and lawyers, who can now trade in the most self-interested of all discourses— advertising—long ago forfeited the public trust.

Returning to Bate, however, Fish rightly finds that his antiprofessionalism

stems from the Arnoldian humanist assumptions that have privileged literature as a transcendent site of universal and disinterested truth in exactly the way that has validated intellectuals and professions as sites beyond economy. That is, Bate's narrative, like Jacoby's, is about "selling out." Yet for Bate "selling out" does not simply mean, as it does for the left, trading in a set of ideal and progressive political beliefs for mere selfish gain (the yuppie syndrome that I think is really Jacoby's subject), it means simply "selling" at all. Fish realizes that Bate's anger is primarily directed at "the greatest outrage of all, the pollution of literature by the despised world of commerce" (204).

Yet this describes Jacoby's key objection to what we might call post-Culture culture as well. His anxiety proceeds from his discovery that "what is publicly visible registers nothing but market forces," which would imply that "cultural studies vanishes into economics" (5). Like Bate, he feels that the extraterritorial territory of Culture ceases to exist once it is invaded by commerce. Therefore bohemia (as we should expect by now, the same story being told over and over again), a utopian site of authentic community rather than merely commodified relations, can exist only in the past. Jacoby's chapter on "The Decline"—what else?—"of Bohemia" reveals a succession of points at which "success is killing bohemia," and about which, in one of his most striking insights, Jacoby knows that "notices bemoaning [bohemia's] commercialization or demise reach back almost to its origin" (34). I would revise that comment only to add that bohemia's demise marks *exactly* its place of origin.

We can describe, then, the common claim of authority for both intellectuals and professionals under modernism: while they offer their services for some sort of remuneration, they "nonetheless claim for them a *value* irreducible to that determined by the market" (Weber 26). In other words, what they produce—authoritative knowledge—claims for itself a value outside the relations of production and consumption. What Samual Weber says of the professional can be repeated verbatim for the intellectual:

The professional . . . seeks to define his services as exclusively determined by public need, and hence, as predominantly a *use-value*, not an exchange-value. It is precisely in the effort to distinguish himself from the businessman, on

the one hand, and from the worker, on the other, that the professional finds it necessary to cultivate the professional ethos and "culture." (27)

If one accepts this traditional notion of the site of the intellectual as a space opened up between the businessman and the worker, then academic intellectuals are vulnerable to attack on two flanks, both of which Jacoby includes in his strategy. As we have seen, if academics engage in any activities that seem to stake out power in their profession, they can be reduced to the self-interested careerist motives of the market. If, on the other hand, professors, especially in the humanities, engage in difficult and esoteric theoretical work, then they are reduced to elitist and irrelevant eggheads. Thus Jacoby characterizes Derrida and poststructuralists in general (in the typical counterfactual manner of most leftist antitheorists) for "surrender[ing] attention to social and material contexts" (172–73). That is, by straying too far from workaday reality, as Fish notes, professors are continually chided for not doing "real work in the the real world" (*Doing* 201). Obviously, this all adds up to a classical case of "damned if you do, damned if you don't."

The problem, which should be apparent by now, lies not in what intellectuals, academic or otherwise, do or don't do, but in the relational and privileged space they have claimed beyond interest and economy. And it is precisely this space that has been subjected to a rigorous critique by that continuum of theory that usually goes by the name of poststructuralism. Simply put, this theoretical continuum has inquired into the discourses of knowledge, truth, and aesthetic value in order to understand how they are always already institutionalized and, to the consternation of both humanist left- and right-wingers, it has asked the most subversive question of all: What is and has been the market value (or exchange value) of discourses that claim to transcend the market itself?

In the first place, as Barbara Herrnstein Smith has stated:

The traditional—idealist, humanist, genteel—tendency to isolate or protect certain aspects of life and culture, among them works of art and literature, from consideration in economic terms has had the effect of mystifying the nature—or more accurately the dynamics—of their value. (*Contingencies* 33)

In other words, the claim of disinterestedness and Universal Reason moves precisely to mystify its own interested and local agenda. This insight is certainly nothing new, given the volume of critical work since the sixties that has taken it as the virtual basis for cultural and social analysis. I would go so far as to say that this may be a crucial legacy of the sixties: "we learned," in Morris Dickstein's words, "and are unlikely to forget . . . to be skeptical of the pose of objectivity. When we hear words of wisdom, we want to know who is talking. When the voice of reason speaks, we're inclined to ask what unconscious needs are at work" (248).

"Leftist" critics like Jacoby who taunt the new professionalized and "situated" intellectuals, no matter how much they frame the argument in terms of a decline from a once politically oppositional and independent stance to depoliticalization and institutionalization, are really calling for a reinstitution of a supposedly extrapolitical and pure space from which one can speak with self-authenticated authority. Jacoby's quarrel with "a public culture warped by money and politics" (23) makes this clear. Poststructuralism, if it has accomplished anything at all, keeps reminding us that public culture *is* money and politics.

Thus, for example, Bauman's Foucauldian genealogy of Western intellectuals traces not decline but a series of social relations in which knowledge and power are realigned and renegotiated as the modern bourgeois state emerges and evolves. Experts and educators—those in the know—were born under this new regime as a salient feature of the technology of "surveillance," a way to distinguish who will watch and who will be watched, who can speak and who will be spoken to/for. This required new institutions and discourses both validating and defining the terms of the asymmetry of power, a differential relation in which the majority of human beings would realize their own "insufficiency, incompleteness or intrinsic immaturity" and a minority would speak from a position of "the common good," the name assigned, of course, to a proper mode of behavior "required by the social order" (*Legislators* 47–48). The history of the Enlightenment charts a repression of local, "interested," and "passion-led" cultures and people in the name of a Universal Reason only a handful could claim (60), and education assumed a central role for

the first time as a force of social management and control. Reason, in other words, was represented as a scarce commodity, even though ostensibly "universal," which required time and leisure to acquire. Those whose lives were more constrained by necessity (the vast majority of human beings) literally could not *afford* such time, and thus forever forfeited the right to speak as authorized subjects.

In this light, Jerry Herron's analysis of the exchange value of disinterestedness as Arnold and Newman defined it is very apposite. With the rapid expansion of the middle class in the nineteenth century, and the concomitant rise in leisure time, Herron traces what is, in effect, a more widespread access to the commodity of Reason. Arnold's and Newman's university as the space of disinterested and universal Reason—what Arnold called "Culture"—was so successful, according to Herron, because it was "the product of ideological necessity" (68). Knowledge and culture, which Newman described as transcending the circuits of exchange (it is valued for its own sake), were in fact very exchangeable: for a class now entering public space, knowledge now became desirable "because it got you around in the world" (66). In other words, as the middle class sought to transcend its own history as merely self-interested, "they found themselves in need of an idiom, an ideology, with which to economize their social and political identity, and with which to remove from that identity—as from their money—the taint of having been recently 'made' " (66). Arnold's Culture became exactly the hard currency that was needed. It bestowed on the middle class a tradition and a privilege by way of the university.[8] Pierre Bourdieu has made this process widely known as the accumulation of "symbolic capital," accrued through education and aesthetic consumption. The latter, especially,

> symbolizes a squandering of *time* and a competence which can only be acquired
> by long frequentation of old, cultivated people and things, that is, membership
> of an ancient group, the sole guarantee of possession of all the properties
> which are endowed with the highest distinctive value because they can only
> be accumulated over *time*. . . . The exclusive appropriation of priceless works
> is not without analogy to the ostentatious destruction of wealth; the irreproach-

able exhibition of wealth which it permits is, simultaneously, a challenge thrown down to all those who cannot dissociate their "being" from their "having" and attain disinterestedness, the supreme affirmation of personal excellence. (*Distinction* 281–82, emphasis added)

Arnold's and Newman's representations of knowledge and culture whose reward is itself thus becomes a kind of gold standard, a value of values, which authorized an entire class as it became a public entity. The imputed timelessness and universality of liberal learning "endows [it] with special status and power . . . because [it] is distinct from the shifting currency of everyday life" (Herron 35). For the middle class, and for Arnold himself as a member of that class, people who "had to make their way in the world [but] had to be wary of appearing too much of it," Arnold's disinterested knowledge became the only way to "preserve the value of their representations" of themselves and the world (Herron 76–77).

Thus "Reason," "disinterestedness," "culture," "independence," and "bohemia"—all those terms that mark out an intellectual site prior to and uncontaminated by the processes of economic exchange—can claim their considerable market value *only* if they retain the patina of being outside the market, of being, in both senses of the word, "priceless." In the postmodern world, this mystification is harder and harder to maintain because less and less people are "buying" it.

But Jacoby and many others are still trying to sell it, and it's not hard to see why. Power and authority are at stake. Despite Jacoby's putative anti-institutional and anti-elitist stance, he is defending the traditional paradigm of the intellectual as self-evident authority. His primary concern, therefore, is that the intellectual is losing a general audience, someone to speak to and for. However, one of the primary concerns of poststructuralist thought has been who has and who has not been authorized to speak at all. Jacoby worries that intellectuals now speak only to one another and ignore the wider public. But Janice Doane and Devon Hodges warn us that "attacks on the 'New Class' of knowledge producers and heartfelt claims to speak for ordinary people are expressions of hostility to representation," that is, to poststructuralist

critiques of a privileged site of Truth or Reason prior to language, interest, or power (48).

Nostalgia can in fact best be described, as Doane and Hodges inform us, as a "tremendous desire for a 'natural' grounding principle, that is, a stable referent" (8). I have represented this "ground" as an extraterritorial territory, or a gold standard outside the circuits of exchange. Whatever metaphor one uses, the ground must be "outside" or "above" the specific or contingent processes of material and cultural life. As Derrida puts it in his epochal essay "Structure, Sign and Play in the Discourse of the Human Sciences," this ungrounded ground is a "*center,* which is by definition unique, constitut[ing] that very thing within a structure which governs the structure, while escaping structurality" (248). Deconstruction, as everyone knows by now, decenters any claim to such a "structure outside of structurality," any "reassuring certi-tude" that places one in a space outside which is in effect insulated from, yet governs the "inside." But Derrida has also described perfectly the "certitude anxiety" that drives Jacoby and other antiprofessionalists: "anxiety is invariably the result of a certain mode of being implicated in the game, of being caught by the game, of being as it were from the very beginning at stake in the game" (248). Jacoby's longing for the "autonomy" of the old intellectuals, "iconoclasts . . . who deferred to no one" (*Last Intellectuals* 17) living in a bohemia of unregulated and uncommodified discourse, expresses another version of a center to which, of course, all other benighted and merely self-interested folk must defer.

Perhaps nowhere is there a better example of the self-contradictory site of the intellectual as ungrounded ground than in Mannheim's oft-repeated phrase, which Jacoby also appropriates, the "free-floating intellectual" (55). At first this figure suggests absolute independence, freedom, and autonomy, a place that is placeless, representing no particular place, and thus, in traditional terms, sanctioning access to truth that no merely "grounded" or specific site can claim. It is the perfect center that is always outside. More importantly, however, it also suggests a site of "sight," where one can gaze and watch, but because of its unfixed place, one cannot be monitored or gazed at in turn. This is the site of power: Foucault's unseen watcher in the Panopticon, a

rule-deploying space outside any game. Finally, however, the metaphor undoes itself, because a free-floater, directionless and unpredictable, is actually powerless (Bauman notes a similar contradiction: intellectuals have perceived their own powerlessness as autonomy [*Legislators* 36]); people in a large boat, by comparison, might seem constrained or grounded, but we could suggest that they are the ones who have the power to move and resist the force of winds and tides. Free-floaters, however, only *appear* free; in actuality they are at the mercy of large forces like winds and tides (or, more concretely, discursive, social, and psychophysiological contingencies and variables) that cannot be seen, but they must always represent their necessity as "Freedom" or "Reason" while everyone else's necessity is just that.

Doane and Hodges note, when speaking of Christopher Lasch, one of the most prolific of today's nostalgic traditional intellectuals (a redundant phrase, remember), that his "mode of representation gained its authority by asserting the inauthenticity of the speech of others while denying its own artifice" (61). And this is exactly the tack that Jacoby takes when he discusses the "private language" of the new radical academic theorists: it is "crabbed," "dreary," written as "communiques" rather than essays (16), "technical, unreadable, and . . . unread" (141); intellectuals have gone "high tech" (x). Against this institutionalized, implicitly artificial and mechanical prose, Jacoby posits a natural, organic prose of real intellectuals doing real work in the real world: they speak in "the vernacular" with "vigor and clarity" (ix–x); they "cherish direct and elegant writing" (16); most importantly they possess and cultivate a "style" and not "jargon." Theirs is a prose with its sleeves rolled up; professionalized prose has its collar buttoned down. Graff has commented that hostility to theory originates in the Romantic critique of industrial society, "which associated abstract modes of thought with the nihilistic and corrosive rationalism that had supposedly destroyed the earlier organic unity of culture" (252). This describes Jacoby's master-trope of his master-narrative.

In Jacoby's account of theoretical prose, its admitted reliance on neologisms, jargon, ironic and arcane rhetorical strategies, he never engages in an *argument* with the theoretical movements loosely gathered under the "critique of the sign" that have questioned the very notion of a transparent, direct, or

mimetic real language of the real world emanating from a self-present and authentic "voice." Under this (anti)epistemological regime, "difficulty" or periphrasis may have a distinct and even intellectually defensible purpose. Instead, Jacoby is more apt to simply quote an arduous passage from Stanley Aronowitz, for example, and invite his readers to smirk at it. Of course he adds that "this is unfair" (124), thus inviting us also to admire his generosity in the face of such technocratic gobbledygook.

Jacoby's agenda in valorizing the "voice" and "style" of past "independent" intellectuals is in fact to recuperate the author (and thus *authority*) in his old humanist guise as the prelinguistic originator and transmitter of meaning, once again representing a stable referent or center-which-is-outside from which truth emanates. But it is exactly this paradigm that poststructuralism has questioned on a variety of fronts, thus offering the possibility that language itself is a social system—an institution, if you will—that inscribes subjects. Theory has not just appeared like magic as some convenient route to tenure and glory, which seems to be the preferred mode of explanation by antiprofessionalists. Instead,

> "An increase in theoretical activity," Elizabeth Bruss writes, "arises whenever the function of criticism itself is in doubt." Theory, that is, does not emerge at just any historical moment; it comes into being when the traditional rationales for a social or intellectual practice have broken down and new forms of legitimization for it are needed. (Eagleton, *Function* 90)

In his most insightful moments, Jacoby realizes that the old forms of legitimization have broken down. He notes, for instance, by way of Edmund Wilson, that even for the New York Intellectuals, "writing was a commodity like any other" (14); he realizes that bohemia itself helped create the consumption ethic (38). But he still insists on the "traditional rationales" despite these disquieting possibilities.

But perhaps most revealing are his continual references to decline which posit professionalism in opposition to a quasi-religious calling. In his book on psychoanalysis he has this to say about the early Freudians: "they never viewed psychoanalysis as a medical theory or trade, but as a *mission*. . . .

Their lives did not possess the coherence or stability that would allow them to think of psychoanalysis as a quiet career choice; rather, they embraced it as a *cause*" (46, emphasis added). In *The Last Intellectuals* he laments (quoting political scientists) the fact that "political science is now an institution, not a crusade" (155).

In this context, Fish has noticed that Bate and other antiprofessionalists also have adopted the theological vocabulary of a "calling" or "vocation" as preferable to a mere "profession" of literary study. He chides them for reinstalling a priestly caste or "community of *illuminati*" (*Doing* 205) as rationale for their expertise. Fish's historical sense serves him well here. Bauman's study of intellectuals continuously alludes to the Philosophes and their descendents as embarking on a "cultural crusade" to stamp out localized traditions (always coded as parochialism or superstition) in order to impose a "uniform and universally binding cultural model" to be administered and managed by the learned groups (60). Knowledge was thus deployed in two ways: it was a "pastoral power" (a term borrowed from Foucault, meaning power exercised for the subject's own good as defined by, of course, the pastoral power) and a "proselytizing power" (49).

It was, thus, as they say, "no accident" that the modern intellectual emerged in Europe simultaneously with the rise of colonial practices. Traditional intellectuals have always assumed it is their right and duty to "speak for others"; as "legislators" they assume the power to represent the Other. Jacoby himself rightly regards with suspicion the rise of the New Class or "dominating class" of intellectuals, but it is his own strategy of legitimizing intellectual activity as a "mission" and "crusade" that smuggles an imperial/colonial rhetoric back into the discussion.[9]

It is precisely this problematic knowledge of the will-to-power/knowledge that has animated the new academic intellectuals in their interrogations of the canon and the institutions of knowledge production. In order to replace the colonialist agenda of the "universal intellectual," new paradigms of the site of the intellectual borrowed from Foucault ("partial" or "specific intellectuals") and Gramsci ("organic intellectuals") and others have been offered as an alternative legitimation of oppositional intellectual work which allows the

"other" somehow to speak for him or herself. As Khachig Tölölyan has recently stated, with reference to Jacoby:

> Poststructuralism required the acknowledgment of some facts that economic realities had already dictated, namely, that the site from which the intellectual can speak with authority is that of the university (as Russell Jacoby complains), and that the theoretical object about which one can speak is no longer the aesthetic or social totality. (768)

This presents a situation of astounding difficulty for the postmodern/ postcolonial intellectual, especially given the assault by conservatives advocating the self-evident superiority of Western culture, a claim that always coincides with a recuperation of the detached and disinterested site of the intellectual. Both claims are colonialist in practice, a form of domination for the sake of the dominated and thus mystified as "service." I would hope that leftists like Jacoby, who stakes out a putatively oppositional stance, would join the battle against them. But in these "culture wars," good intentions and self-congratulations for doing "real" work in the "real" world count—as they should—for nothing. Intellectuals gain nothing, and in postmodern culture they stand only to lose, by invoking their own missionary zeal in what Tony Bennett has called a "politics of grand gestures" (vii). Committed intellectual practice first of all demands institutionally specific *work*: historically informed, rigorous, sustained, reflexive argument. I would suggest, therefore, that, as a professional, Jacoby needs a little Theory.

Notes

1. A particularly revealing example of this declamatory style, of which Bloom is surely the unacknowledged master, comes instead from the less sophisticated Sykes (quoting disgruntled professor Phillip Anderson): "I *know* that the reading of Homer, Dante, Wordsworth, Shakespeare, or Yeats is of great and unique value not because of any argument, not from theory, nor from training, but rather from deeply felt experience" (194). I have great sympathy for this anti-argument argument (ultimately an argument based on pleasure) because I have used a less naive form of it myself to declare, for example, why I *know* the Rolling Stones are "better" than Bach. But I doubt that Sykes or Anderson realizes, so oblivious are they to argument or theorizing, that appeals to "deeply felt experience"—

particularly an occulted "experience" existing prior to "training"—may provide the strongest possible case in support of the aesthetic relativism they deplore. Amazingly, in the very next sentence Sykes continues his attack on the Duke University English Department for devoting study to their "personal interests of the moment." With know-nothing allies like Sykes, the conservatives may have no need of enemies.

2. See Garafola for a particularly unconvincing example.

3. One possible way of leveraging a critique of Jacoby's rhetorical strategies would be through feminism, which has instructed us to be very wary of the ideologies permeating the binaries of public and private, frontier "freedom" and domesticity. See my comments below.

4. But with an important difference: Eagleton, unlike Bauman and like Jacoby, has his own narrative of decline to recount. In fact, Eagleton's *The Function of Criticism* eventually engages in a nostalgic antiprofessionalism in many way as facile as the right's. For a superb critique of Eagleton in this regard, see T. Bennett 225–32.

5. In English literary history, both eighteenth-century Neo-Classicism and nineteenth-century Romanticism appropriate the role of "legislator" for the poet as well, thus revealing their common discursive ground. In *Rasselas* (ch. 10), Dr. Johnson charges the poet to write "as the legislator of mankind, and to consider himself as presiding over the thoughts and manners of successive generations." And in "The Defense of Poetry," as we all know, Shelley wanted it acknowledged that poets are "the unacknowledged legislators of the World."

6. In this regard, even though I added the modifier "real" in my sentence about Jacoby's "real" intellectuals, Jacoby again is quite similar to Allan Bloom, who might best be defined as the quintessential "reality-monger" in the recent debates about education. It would be very interesting—and certainly revealing—to actually count the many, many times in which Bloom serenely and quite self-evidently employs the two adjectives "true" and "real" in *The Closing of the American Mind*. My own cursory glance reveals these examples from the first 75 pages: "true community," "real teacher," "truly serious life," "true scientific vocation," "real religion," "real privacy," "real taste," "real diversity," and "real art." And this from a man who of course tells us in his preface that "I am not moralizing" (22).

7. For more on the question of Jacoby's highly gendered account of intellectual life and his eliding of the rise of academic feminists as public intellectuals, see Robbins, "Introduction" xviii; Garafola 128; and Brantlinger 129.

8. For a lively historical account of this same dynamic in late nineteenth century American culture, wherein the rising middle class appropriated Arnoldian "Culture" as an "avenue to cultural legitimacy," see L. Levine 171–242.

9. By invoking the thorny and contested concept of "colonialism" at this point, I do

not mean to simply invoke the latest buzzword in some catchy and unrigorous manner. I am using the term not simply in relation to the concrete economic and political practices of colonialism, but as the name of a discursive formation with a particular representational economy. Abdul R. JanMohamed refers to the "colonialist cognitive framework" as "the manichean allegory—a field of diverse yet interchangeable oppositions between white and black, good and evil, superiority and inferiority, civilization and savagery, intelligence and emotion, rationality and sensuality, self and Other, subject and object" (63). I am implying that the power- and interest-relations in colonial societies operate homologously to the relations between Universal intellectuals and the Others they claim to represent and "administer."

14

Othering the Academy

Professionalism and Multiculturalism

Bruce Robbins

To know what "culture" means, consider those who are counted as its enemies. When the wanton destruction or criminal neglect of culture is reported, as it frequently is these days, and the call goes out among the literati for steps to be taken, the first roundup of suspects is sure to include the academics. The charges have been repeated so often that suspicion has come to seem guilt. Here are a few representative samples: "The cosmopolitan and metropolitan sensibility" that once made New York a great cultural capital, according to Thomas Bender, has now succumbed to the "academicization of intellectual and artistic life," a process that is "most clearly evident in literary criticism" (342–43). "By the 1960s universities virtually monopolized intellectual work," Russell Jacoby writes. "As professional life thrives, public culture grows poorer and older" (*Last Intellectuals* 8). Irving Howe: "Today, the whole idea of the common reader—whether an actual reader whom we might specify as part of a social group, or a projected desire of an ideal audience—has virtually been abandoned in the academic world. A tremendous and, I think, disastrous change. . . . My complaint about a lot of what's going on in the academy is that it is insulated . . . and, so far as I can tell, not deeply engaged with literature" ("Interview" 561–62).

These accusations are not as monotonously straightforward as they may appear. In fact, Howe's parting shot about "literature" hints at a certain duplicity in them. On the one hand, the academic's insularity or "fatal parochialism" is condemned in the name of an expansive culture which is imagined to be open to the public at all hours, which "knows no boundaries"—in Thomas Bender's words, a culture which "engages deeply felt issues in the

common life in the public and accessible language of that life" (342, 3). On the other hand, culture is exemplified by "literature," a highly selective body of difficult, complex masterpieces. Academic critics had *better* be "deeply engaged" with culture in this monumental, frankly elitist sense, the implication goes, since the nonexpert reader cannot be expected to struggle through it unaided. It is their duty to this version of culture that academics are held to fall away from by their recent and much-publicized turn to "mass" or "popular" or "ordinary" culture, to "deciphering Victorian underwear" (the title of a characteristically sarcastic piece in the *New York Times Magazine* [Matthews]). If culture suggests that academic critics are too parochial, that is, it also suggests, on the contrary, that their tastes are too catholic, even if they turn attention only to such undeniable issues of "the common life" as advertising, AIDS, and *The New Republic*'s trimming of Saddam Hussein's moustache to make him look like Hitler.

There is a paradox here: culture stands for an elite set of texts and standards, now perceived to be threatened by academia's bizarrely populist taste for the all-too-public products of a commercialized "culture industry," while at the same time culture also stands for the democratic domain of the common, including the "common reader," which serves as a club with which to batter the university's supposed overspecialization, self-enclosure, and narrow self-interest.

These two counts in culture's indictment against the academic critic cannot be upheld at the same time. But this paradox is not interesting only because, as an example of incoherence in the usual anti-academic diatribes, it suits my self-interest as an academic in defending what I do. It also suggests that something more is at stake in the recent spate of journalistic academy-bashings than territoriality and name-calling. In raising the issue of whether culture does or does not belong to the public, this paradox poses the obvious question of what is and is not culture, but it also poses a less obvious but perhaps riskier question about who is and who is not to count as a member of the public.

Professional critics, at least *as* professionals, are not, it seems, members of the public. Like other professionals, they are assumed to conspire against

the laity. And critics, more than other professionals, are apostates from the commonness of culture, hence are doubly private. They are attacked, that is, as one more local constituency defending its own interests at the expense of any serious engagement with the interests of society as a whole.

Surprisingly, these are also the terms in which popular and non-European cultures seeking curricular representation under the banner of "multiculturalism" are attacked as well—as local constituencies blindly seeking an institutional reflection of their numbers and cultural particularities, without concern for the *value* of the cultural exhibits offered as judged by some more general standard. And it is precisely the academy's willingness to march under the banner of multiculturalism that has called down on it the fiercest rage and incredulity. "Multiculturalism, which now reigns in the universities," Edward Rothstein writes in *The New Republic,* has "an obsession with diversity of presentation" (34). "It takes other cultures seriously only as representations of the merely particular" (32). The *New York Times Magazine* strikes the same note. "At times, it would seem that multiculturalism—the drive to include non-Western materials in every possible course—has superseded all other issues in American higher education." The sensational overstatement ("every possible course") is evidence that the *Times Magazine* is shooting to kill—as it does again, in its summary of current dogma in the Modern Language Association, when it pretends that culture and multiculturalism are natural antagonists locked in a one-on-one struggle to the death: "The 'classic books' approach to literary study is bankrupt. Multiculturalism is essential" (Matthews 7).

There is some reason to be cautious about any remapping of "the public" that can make two such unlike terms as "non-Western cultures" and "American professions" seem to share a common relegation to "the private." And the Gulf War, recently ended as I write, offers further motive for suspicion. It is perhaps a coincidence that the period of the Vietnam War was also the period in which the singular "high" or "Western" culture of Matthew Arnold and T.S. Eliot first began to be replaced, in academic humanities departments, by versions of the anthropological premise that many different cultures can coexist without being arranged hierarchically. Now, by which I mean before

the Gulf War as well as after it, we seem to be witnessing a backlash. With the end of the (largely fictive but immensely convenient) Cold War and the triumphant declaration of a "New World Order," the reasserting of what V. S. Naipaul calls "our universal civilization" once again seems to be on the agenda. Which means a retreat from the multivoiced cosmopolitanism—an unfashionable term that needs defending—which had been slowly and unevenly advancing, in and out of educational institutions. In a time when the United States has been bloodily asserting a new claim to the role of world policeman, the war machine's journalistic cheerleaders seem to be hastily redrawing the cultural boundaries so as to foreclose even the possibility of cosmopolitanism. Thus human concern can be withdrawn from given areas of the globe, like Iraq, which may one day prove to be of strategic concern, and the operational callousness of foreign policy can then (once again) meet with no public, cultural resistance there.

The backlash is not just directed against the academy, in other words. The "othering" of the universities, in the nonspecialist press and in the name of a public culture, belongs to a move to *restrict* influence over culture that *is* public: influence that has come to include other voices and citizenships in its definition of the public, yet influence that has largely been expressed (for reasons that can't be discussed here) in the academy, in the study of culture, and via slogans like "multiculturalism." At any rate, the current drive to reprovincialize American culture, to tighten up the limits of who will be counted in its pertinent public, is my best answer to the mystery of why academic critics of culture suddenly seem worthy of mass-circulation trashing.

In an article on T. S. Eliot in *The New Yorker,* Cynthia Ozick offers another version of the familiar narrative that presents the professionalization of literary criticism as a Fall from Culture. In 1929, she writes, Edmund Wilson couldn't stomach Eliot's Anglo-Catholicism. "Twenty five years later, when the American intellectual center had completed its shift from free-lance literary work like Wilson's—and Eliot's—to the near-uniformity of university English departments, almost no one in these departments would dare to voice such unfastidious thoughts about Eliot" (121). Eliot's repulsive opinions, including

his anti-Semitism, will matter to the independent intellectual whose only allegiance is to culture, but they will not matter, indeed will disappear from view entirely, in the technocratic emptiness of "English Lit."

No sooner has Ozick announced this Fall, however, than she announces another one. Commemorations of the Eliot centenary in 1988, she observes, had the "subdued and bloodless" feeling of "a slightly tedious reunion of aging alumni, mostly spiritless by now." She herself writes as an alumna, recollecting the "exultation" of her own youth, or that of "anyone who was an undergraduate in the forties or the fifties (or possibly even in the first years of the sixties)" (119). She recollects these undergraduate memories against an academic climate for which, as she declares: "High art is dead. The passion for inheritance is dead. Tradition is equated with obscurantism. The wall that divided serious high art from the popular arts is breached; anything can count as 'text' " (152). "Undoing the canon is the work of a later time—of our own, in fact, when universal assent to a central cultural standard is almost everywhere decried. For the moderns, and for Eliot especially, the denial of permanently agreed-on masterworks—what Matthew Arnold called 'touchstones,' a notion now obsolete beyond imagining—would have been unthinkable" (120). "Elitism ruled," she remembers. "[I]n some respects, I admit to being arrested in the Age of Eliot, a permanent member of it, unregenerate. The etiolation of art seems to me to be a major loss. I continue to suppose that some texts are worthier than other texts. The same holds for the diminishment of history and tradition: not to incorporate into an educable mind the origins and unifying principles of one's own civilization strikes me as a kind of cultural autolobotomy" (124). Finally: "I would not wish to drop Homer or Jane Austen or Kafka to make room for an Aleutian Islander of lesser gifts, unrepresented though her group may be on the college reading list" (125).

Before commenting on this female Aleutian Islander and her relation to the Jews, let us pause to note that Ozick's narrative of the Fall from the Age of Eliot is somewhat inconsistent with her earlier narrative of the Fall into the University. In the first sequence, which runs from Edmund Wilson in 1929 to the academy in the 1950s, culture is apparently betrayed by profession-

alization. The implication is that Eliot's anti-Semitism could slip by without comment precisely because culture had been subordinated to the bloodless technical machinery of academic criticism. In the second sequence, however, which runs from academic criticism in the 1950s to academic criticism today, the subordination of culture in the 1980s is clearly contrasted with an earlier state of affairs, also academic—Ozick's own undergraduate years—in which culture had *not* been subordinated: when there *were* "permanently agreed-on masterworks," when "literature could genuinely *reign*" (120). Well, which is it? Did culture disappear when it passed into the academy in the 1950s, or on the contrary did it "reign" in the academy of the 1950s, thanks to Eliot's influence there, only to disappear into the "secularism" and "nihilism" of the theoretical, multicultural 1980s?

Trivial as the point may seem, it is something more than the inconsistency one might expect from belletristic sloppy thinking. It illustrates how the politically motivated effort to exclude from culture those academics who are trying to include other cultures trips over its own premises. But it also suggests, against Ozick's apparent intentions, that neither critical professionalism nor multiculturalism can in fact be properly understood as a privacy opposed to culture's publicness, a self-enclosed particular opposed to culture's universality.

It should be evident to even the most hard-nosed observer that culture is not something the humanities could ever afford to treat with utter disrespect. Without it, professional humanists would be hard pressed to explain why society should continue paying their salaries. One favored means of making this case to society—one might call it a case for professional legitimation—has been the narrative of cultural decline, much as we find it in Ozick and, for that matter, in T.S. Eliot. "The culture of professionalism," Burton Bledstein remarks, "tended to cultivate an atmosphere of constant crisis—emergency—in which practitioners both created work for themselves and reinforced their authority by intimidating their clients" (Bledstein 100). This sense of crisis was provided by T.S. Eliot's vision of history as decay and degeneration and of the present as an urban-industrial wasteland where we totter on an unnameable brink, desperately shoring up history's ruins with the fragments

of distant cultural monuments. Eliot's success in the academy did not depend on a formulation of apocalyptic pessimism that happened to strike the right chord in the disillusioned post-war generation; it was a useful means of letting society know what it needed (culture) and who could provide it (those who could read the footnotes to *The Waste Land*). For would-be professionals of the first half of the century, struggling to displace the gentleman-scholar's tasteful, unhurried, independently funded appreciation of the finer things, Eliot's despair was enabling and invigorating. It declared in effect that their more rigorous and earnest professional activities were urgently required. If the society of the present is fallen and degenerate, then it hungers, however unknowingly, for acquaintance with values, ideals, and achievements that by definition are not accessible within it—except to a corps of experts specialized in retrieving such knowledge from the culture of the past.

Eliot's specific historical thesis of a "dissociation of sensibility" around the time of Cromwell is no longer taken very seriously in the profession. But indifference to his explicit catastrophism and even to Eliot himself coexists quite comfortably with the professional assumption—the valuation of the culture of the past over a present seen as degraded—that Eliot's catastrophist narrative legitimates. Once it had established itself within the unconscious tact of the profession, or once the profession had established itself around it, this reverential attitude toward the cultural heritage could take its pick among any number of competing hypotheses about particular historical events, and even choose to do without one. When Leavis set out to professional-ize British literary studies, Lawrence served his purpose as well as Eliot: it mattered little finally *which* tradition had been lost, a Catholic hierarchical order or the blood instincts of the English countryside, so long as the loss of *some* tradition set its elite salvagers apart from their benighted, traditionless contemporaries. And the same role could be played, obviously enough, by leftist visions of an artisanal, precapitalist "organic community."[1]

As a legitimating myth for the still newly professionalized study of vernacu-lar literature, this story of the Fall from Culture retains a certain power even now. Yet to some extent it has also always been shaky. For if culture is defined as the wholeness of a valued past, set against the fragmentations of the modern

city and division of labor, then a professional discipline that takes culture as its object must seem to have fallen from culture, to be untrue to culture, to be in a state of contradiction, from the very moment it *becomes* a discipline, that is, one discipline among others within a division of intellectual labor.[2] This is one reason why academic critics have tended to tell stories *about themselves* that very much resemble Ozick's story about them: stories in which, with some combination of pride and self-loathing, they see themselves as fallen from culture in order to see themselves as representing it.

Louis Menand, reviewing Roger Kimball's *Tenured Radicals: How Politics Has Corrupted Our Higher Education* in *The New Republic,* offers a representative formulation. It is not surprising, Menand writes, "that so little of what gets passed around bears much useful relation to life as people outside the profession know it . . . as humanistic study has become increasingly professionalized, its practitioners have become less and less disposed to respond to any intellectual challenges except those presented by the work of their colleagues within the discipline" (39). This argument goes down easily; we have all heard a certain number of arguments that are not too dissimilar. Yet on second thought there is something paradoxical in this familiarity. For if what Menand says is true, then how is it that he himself and so very, very many others seem willing and able to observe "their colleagues within the discipline" from a position outside it? How is it that so much discursive space inside the profession is devoted to such observations, that is, to criticizing the profession from the perspective of a "useful relation to life as people outside the profession know it"? How is it, in short, that criticism of the discipline in the name of *outsiders* can be so characteristic an act of the disciplinary *insider?* The answer would seem to be that Menand, Ozick, and the others are ill-advised, after all, to trust the familiar assumption that professional means private, exclusive, esoteric, inaccessible. For the easy, habitual antithesis between the professional and the public excludes just what Menand himself exemplifies: the professional's own will, *as* professional, to test out the discipline's "useful relation to life," to take over and mobilize the point of view of "people outside the profession," to enter into some sort of dialogue with the extraprofessional public.

As I tried to suggest above, the paradoxical way in which culture seems to shift location back and forth, one moment appearing to lie inside the profession and the next moment outside it, belongs to its role in criticism's professional self-legitimation, in the stories the profession tells the public (and itself) about what it does and why. As part of the discourse that passes back and forth between public and profession, it is further evidence, in other words, that the inside/outside opposition does an injustice even to so apparently self-enclosed an institution as academic criticism.

All of which is not to say that culture, at least in Eliot's and Ozick's sense, remains professionally indispensable. Of late its drawbacks for cultural criticism have been frequently noted. It has been observed, for example, that in a sense "culture" made true "criticism" impossible. While the very concept of culture was critical in relation to the "society" it was defined against, as Raymond Williams showed in *Culture and Society,* by the same token anything that fell *into* the category of culture was protected from all but relatively superficial criticism, and certainly from any dismissive intepretation that threatened its ultimate preservation. In relation to the actual cultural texts under discussion, that is, critics have been largely forced by their premises into a rhetoric not of criticism but of praise. For the presence of any such text, transported from outside the lived "society" of the student and placed before her as an object worth discussing, had to be justified. And since it was, by definition, a mere memory, the more distant the better, without present social force—which would have put it into the category of "society"—it could not be justified by the ostensible social need to criticize it. Culture as such, then, must always be lost and must always be praised.

This is of course a logic that extends beyond the walls of the university. Indeed, it is also at the heart of Cynthia Ozick's resolutely nonacademic contribution to *The New Yorker*. Beginning with Eliot's anti-Semitism, which threatens to compromise him, Ozick's essay turns into a survey of the academic disaster area, reporting on how all respect for artistic excellence and belief in standards of judgment have been eroded. Against this backdrop, a ringing endorsement of Eliot's message—"the power and prestige of high art"—can thus work the essay back to an endorsement, after all, of Eliot himself.

This is mimicry of the most repetitive, self-promoting structure of academic argument: it rescues a once-venerated figure from his now unsightly opinions, thereby reaffirming both the timeless value of culture and the timely legitimacy of its present transmitters.

It is harder to claim the proud title of critical outsider than Ozick supposes. By the same token it is harder to accuse critical insiders of committing unspeakable acts against culture in the darkness of their professional secrecy. Nor does the inside/outside line work much better when brought to bear against multiculturalism.

The sentence in which Ozick does her line-drawing is worth quoting again: "I would not wish to drop Homer or Jane Austen or Kafka to make room for an Aleutian Islander of lesser gifts, unrepresented though her group may be on the college reading list" (125). This is not a Polish joke. However questionable the assumption may be that there exists a single standard of cultural merit ("of lesser gifts") applicable to Aleutian Islanders today and to Greeks in 800 BC, Ozick means no apparent disrespect to Aleutian Islanders. The attempt at wit comes not at the expense of their character or capabilities, but rather at the expense of their *particularity*. Ozick's Aleutian Islander is a self-consuming synecdoche. It is a part taken for the whole—the whole of culture—but a part so incongruously infinitesimal in comparison with the magnitude of the whole it tries to represent that the point becomes, on the contrary, how little right it has to represent anything other than itself. With no more than a geographical place on the globe, no more than a numerical place in national population statistics, the implication goes, the Aleutian Islander is in effect a part *without* a whole; she is the particular itself, the very principle of particularity.

Which is precisely how Ozick and other conservative critics see multiculturalism: as a chaotic agglomeration of individual cultures (in the anthropological sense) which lack any common standard of value or principle of synthesis—in short, any culture in the true sense. Multiculturalism's "calls for equity derive not from recognized unity, but from enforced difference," Edward Rothstein writes. "It takes other cultures seriously only as representations of the merely particular" (32). But "how can cultures be compared once a

standpoint outside them all is rejected? . . . The multiculturalist is a universalist without universalism" (34). Universalism, equated with a standpoint *outside* all cultures, becomes the one true culture. Or, equally, culture becomes the one claimant to disinterestedness and universality in a world otherwise given over to mere particulars, to blinkered, selfishly self-affirming interest groups.

My point here, in brief, is that each term of this opposition is a treacherous invention. Each is supported by the other, but by little else. It is only by suggesting, falsely, that constituency X makes no claim on curricular representation *other than* the claims of body count and difference that Ozick can present true culture as offering the one hope for a unifying or cosmopolitan perspective. And it is only by presenting her singular "high" culture as universal (rather than, say, a particular and even peculiar Anglo-American creation) that Ozick can present all other (low or plural) cultures as if they were nothing but affirmations of their own unique difference, closed to all converse with *other* cultures, and constitutionally incapable of any comparative, self-critical, or cosmopolitan viewpoint.

To expose the narrow chauvinism of this vision, it is enough to consider Ozick's own example of the particular. The argument that embodies multiculturalism in the Aleutian Islander begins, closer to home, with Eliot's anti-Semitism. But if we substitute Jews for Aleutian Islanders in the polemic that sets a transcendent universal culture over and above private and particular ethnic cultures, the opposition breaks down right away. For as the recent spate of articles about Eliot's anti-Semitism has made abundantly clear, what Eliot hated about the Jews in particular was what he saw as their rootless cosmopolitanism—not their ethnic inability to think universally, in other words, but on the contrary their dangerous tendency to *lay claim* to universality, to an alternative, skeptical version of universality. Jews, Eliot wrote, are "more deracinated" than Christians, and that is what makes them "dangerous," what makes "any large number of free-thinking Jews undesirable" (qtd. in Howe, "Exercise" 30).

Irving Howe, who quotes these lines, remembers with some personal pain how the appeal of Eliot's own deracination—the exemplary "journey from provincial St. Louis to cosmopolitan London" (31) and the "proud root-

lessness" that followed—encouraged himself and others in a shamed neglect of their Jewish heritage. Now, however, having passed beyond shame at his cultural origins, he continues nonetheless to admire the cosmopolitanism. For as Eliot saw correctly, though through the dark glass of his anti-Semitism, cosmopolitanism is indeed part of Jewish culture. After all, who ever said that cultural particularity and the aspiration to a comparative, cosmopolitan viewpoint *cannot* coexist in the same people?

The answer is of course that they can and do, both in Jewish culture and in other cultures. The interests of Jews, Aleutian Islanders, and professionals may well include just the sort of broad, roving, comparative perspective that is implied, in the *New Yorker* rubric "Critic at Large," by the phrase "at large." As it happens, Claude Lévi-Strauss found a salient instance of cosmopolitanism, not in the Aleutian Islands, but in the nearby Chinook Indians of the Pacific Northwest. As a result of their "commercial activities . . . as traders and intermediaries between near and distant tribes," these Indians gave their name to "the jargon known as 'Chinook,' which served as a lingua franca from the coast of California to that of Alaska, even before the arrival of the first white men" (184–85). And their myths (in particular, one which follows a child of divorced parents) became "markedly eclectic." "The mythology of the Chinook—who had repeated contacts with tribes having different languages, life styles, and cultures—seems less like an original corpus than an ensemble of secondary elaborations . . . to adapt the ones to the others and reconcile, by transforming them, miscellaneous mythic materials" (184). The resulting vision of the world parallels that of the schizophrenic. Like European high modernism, one might say, it "echoes the political, economic, and social experience of a world in a dissociated condition" (184).

What Lévi-Strauss aptly calls "the cosmopolitanism of the Chinook" suggests, once again, that the opposition between universal and particular culture is a false one on both sides. "We" are arguably quite particular in the specific claims we make to universal knowledge and value. On the other hand, "they" too engage in a routine practice of universalizing. Thanks to critics like James Clifford, anthropology has been learning to see that its own habits of travel and comparison also belong to the cultures it studies. Its constitutional respect

for cultural difference *as* difference was often a respect that held the other at a distance, froze it in time, and fixed it within given borders, thus monopolizing all mobility in time, space, and perspective on behalf of the Western observer. There was no room for even the conception of a non-Western anthropology about the West. This was respect, but at the cost of exclusion from common or cooperative history, from transcendence of its boundaries, from the prerogative of picking and choosing values among other cultures (see Clifford).

Indeed, this relativizing respect within anthropology's plural concept of culture shares a great deal with the "praise" required by Arnoldian culture. In both cases, culture means an earlier or non-Western wholeness, set against a later or Western historical fragmentation. In both cases, to put culture into the flux of history is to see it as disappearing. In both cases, then, the professional salvagers of culture find a myth useful in legitimating their work. What is wrong with multiculturalism, when it does on occasion descend into mere collective self-assertion, should perhaps be seen less as a betrayal of Arnoldian culture than as an extension of what was wrong with Arnoldian culture to begin with.

Belief in the desirability of social fragmentation for its own sake, in the political correctness of an infinite regress into pure particularity, seems to emanate less from a new infatuation with the multicultural than from a continuation of literary criticism's older sense of culture—as a privileged place of the particular, the unique, and the incommensurable, a mystified haven from public debate. In *Uncommon Cultures,* Jim Collins writes: "Culture is no longer a unitary, fixed category, but a decentered, fragmentary assemblage of conflicting voices and institutions. Whether described as the dissolving of the 'mainstream' into a delta by an avant-garde composer like John Cage or the loss of a 'common legacy' by the Secretary of Education, a widespread awareness exists that an 'official,' centralized culture is increasingly difficult to identify in contemporary societies" (2). Contrary to what the adverb "increasingly" suggests, there is in fact no good historical reason to believe that such

a centered, unitary culture once actually existed, even as an evil hegemonic force. Why do so many critics who resist nostalgia for any good old "organic society" nevertheless cling to the myth of a *bad* cultural unity? If one pretends that a centralized, homogeneous, singular culture has been the dominant historical reality, then one produces the illusion that simply by decentering culture, making it heterogeneous, pluralizing it, one is shaking the dominant order. This is a pleasant if cheap way for critics to generate enthusiasm and arguments. But to be effectively oppositional is not so easy as manufacturing a whole that will make mere plurality look like dissent. In the United States, it is arguable that for some time pluralism itself has been hegemonic, and not its contrary.

Rather than "uncommon cultures," then, we might do better to think in terms of "public culture." The new review that goes by this title also chooses the plurality of cultures as its point of departure. It sets itself against "the view that the emergent transnational cultural forms and flows of today's world are radically homogenizing" (Appadurai and Breckenridge 1). Taken up in countries outside the West, even Western consumerism finds itself "harnessed to the idiosyncracies of their own traditions" (1). Accordingly, *Public Culture* warns against "two traps: the traditional anthropological trap of focussing on distant cultures, and thus exceptionalizing the West through its absence from the discursive stage; and the inverse trap, which characterizes a good deal of the discourse that accompanies 'cultural studies' in the academy, especially in the United States: treating the Third World (and such other forms as race and gender) as interchangeable with one another, and as providing a convenient instrument for debates over such issues as 'decanonization' " (3). Yet the warning to avoid these forms of homogenization does not imply a celebration of the fragmentary as such, nor a refusal of all collective unities on behalf of unique, authentic subcultural particularity. On the contrary, the adjective "public" in the title suggests the aim of bringing together, in a common, democratic space of discussion, diversities that had remained unequal precisely because they had remained apart. A negotiated solution to the culture wars will come a step closer when professionalism and multiculturalism are reconceived, not as undemocratic and excessively democratic respec-

tively, but as entangled with each other within a common project, or at least a possibility, of rejuvenated democracy.

Notes

1. The preceeding paragraphs draw on my "Modernism and Professionalism."
2. For further elaboration, see Graff and Robbins.

15

Academics as Public Intellectuals
Rethinking Classroom Politics

Henry A. Giroux

Higher education is in the midst of a crisis over the relationship between authority and knowledge. Manifestations of this crisis reflect, in part, a deep-rooted fear of some of the challenges that have been lodged against modernism's "dream of order and the practice of ordering . . . the rule of reason visualized [as] a world without margins, leftovers, the unaccounted for—without dissidents and rebels" (Bauman, *Intimations* xv). For neoconservatives, the alleged threat to the social order has come from the subversive power of subordinate groups who have challenged the political effects of canonicity, the class, racial, and gender specific forms of discrimination in the university, and the narrating of what constitutes public culture and national identity.[1]

In response to those intellectuals and critics who have redefined higher education as an embattled public sphere, neoconservatives have mobilized around the ideological banner of "political correctness" and launched a counter-offensive designed to remove the university from the "messy" relations of power and ideology that connect it with the institutions and problems of modern society. For neoconservative hardliners writing in *American Spectator*, the *New Criterion,* and similar publications, this position translates into the unproblematic, self-serving assumption that social criticism has no place in the university and that those who engage in it are, as Paul Hollander has suggested, radical intellectuals who are anti-American.[2] Somewhat moderate conservatives and liberals take a more cautious line and argue that universities should simply impart knowledge that is outside of the political and cultural whirlwinds of the time. But within both discourses, politics is eschewed as part of a broader attempt to either vocationalize the university or establish

it as a gatekeeper for dominant Western cultural values while simultaneously calling for the professionalization of its resident intellectuals. In this perspective, culture serves as trope to decouple knowledge from power, and to reduce the university's role to the Arnoldian imperative to teach the "best that has been thought and known in the world."

In responding to the assault by neoconservatives on the university as a critical public culture, left theorists such as Joan Scott have recognized that what is at stake in this battle goes far beyond the specific issues of freedom of speech in the academy, affirmative action, or challenging the canon.[3] More pointedly, the neoconservative, Reagan-Bush assault waged during the last decade has attempted to undermine those aspects of public culture that are fostered by and in turn promote critical and oppositional agency. It comes as no surprise that neoconservatives have chosen schooling as the central site on which to wage such a battle.[4]

Of course, the debate over both the necessity and possibility of an active democratic public is not new and can be found in the writings of John Dewey, Walter Lippmann, and more recently Jürgen Habermas, Rita Felski, Nancy Fraser, and others. Regardless of the theoretical differences among these theorists, they all view the development of the public sphere as an essential condition for animating democratic life. What is startling about the current debate over higher education is that the language of the public sphere is labeled as inconsequential if not disruptive to many conservative and liberal critics.

The current hostility to the concept of the public sphere may be due, in part, to the critical legacy that informs it primarily as an arena for debate, discursive interaction, and deliberation rather than as a site for the transmission of fixed and privileged forms of cultural capital.[5] Viewed as a critical public sphere, the university is defined as a site of contestation and potential instability marked by the democratic possibility for unpredictable collisions, diverse relations of representation, and what Miriam Hansen calls "multiple forms of community and solidarity" (208). In opposition to this view, conservatives posit the university either as a replica of the modernist museum housing and displaying the privileged artifacts of a Western tradition, or as an adjunct of the marketplace infused with the principles of commerce and competition.

By abstracting higher education from a discourse of power, politics, and moral accountability, neoconservatives such as Roger Kimball, Lynne Cheney, Charles Sykes, William Bennett, Chester Finn, Jr., and others have been able to argue forcefully against the university as a critical, public sphere actively engaged in addressing either the social problems of the larger society or broader global landscape. Lost in this discourse are the moral and political referents for accentuating the relationship between the university and the larger society through the imperatives of public service rather than the dynamics of professionalism, competition, and social mobility.

While the heavy guns waging this attack on the university are wielded by neoconservative intellectuals and the mainstream populist press, its ideological appeal has increasingly been taken up by liberals. For instance, David Rieff, writing from a liberal perspective in *Harper's Magazine,* argues that most academic battles over ideas are as hollow as they are irrelevant. For Rieff, "Reality is elsewhere. For better or worse, ours is a culture of consumerism and spectacle, of things and not ideas" (63). Rieff echoes what has become a popular sentiment among a stratum of American intellectuals. Academics have once again become intellectual eggheads who cannot communicate to a wider general public. Charged with being hopelessly theoretical, academics are viewed as ill prepared to address the real problems of everyday life. Ideas that matter, if we are to believe Rieff and the liberal reformers who write for the *Wall Street Journal* and *Harvard Business Review,* are not to be forthcoming from universities with their idle talk about domination and power but from corporate financed think tanks and foundations that forcefully address the problems facing the world of commerce and the New World Order.

Lacking any critical content, the call to pragmatism by such critics slides too easily into a galloping form of anti-intellectualism. Coupled with the problematic assumption that the appropriate measures for intellectual work are those indices that propel the relations of the museum and marketplace, the notion of the university as a public sphere loses its critical utopian edge, and the restricted language of corporate capitalism takes center stage as the sole condition for educating students about freedom and self-determination.

What is so alarming about this attack is that it singles out with a vengeance

those intellectuals who display "a critical, skeptical approach to all that a society takes most for granted" (Scott, "Multiculturalism" 12). Moreover, underlying dominant critiques of higher education and public schooling is an attempt to vocationalize all but the most elite universities while simultaneously turning the public schools over to the logic of the marketplace.[6] In the first instance, the universities are undergoing severe financial crises that have spawned cutbacks in those programs in the humanities, liberal arts, and social sciences that are deemed irrelevant to a society and global world increasingly defined in technological and instrumental terms. In part, this move toward vocationalization is abetted by liberal arts programs that have become increasingly privatized through their concentration on highly specialized, theoretical discourses and methodologies. In the second instance, public schools have increasingly come under the influence of corporate interests that attempt to link learning not only to the production of a new generation of consumers but also to the reconstruction of public schools as sites for capital accumulation. For example, Whittle Communications offers public schools high tech audio and video equipment in exchange for twelve minutes of school time each day, during which students watch prerecorded news broadcasts interlaced with two minutes of commercial advertising.

In addition to shaping the content of the curriculum, many businesses have developed lucrative markets through their takeover of the extracurricular functions of the schools such as the food services. Not only do these corporate ventures rake in an enormous profit, they also provide on-site training for potential workers within an expanding service sector. Increasingly, corporate interests are also setting the agenda for shaping the curricula to match the future demands of a labor market heavily dictated by the need for low-skill, low-wage jobs.

What is at stake in the neoconservative attack on schools is the role that the university and other forms of schooling might play as crucial public spheres, on the one hand, and what the responsibility of the academic as a public intellectual might be on the other. While I will focus on both of these issues specifically as they apply to higher education, I think that many of the points to be developed could be applied just as readily to public schooling.

Higher Education as a Crucial Public Sphere

I believe that higher education must be defended as a vital public sphere in its own right, that is, as a public sphere whose moral and educative dimensions impact directly on the renewal of civic life. For instance, this can be seen in terms of the influence that large numbers of students in professions such as nursing, social work, and teaching exercise in the health care system, social services, and public schools. This is not meant to suggest that higher education can be justified as a crucial public sphere only through the practical education it provides to students who work in important social services. This is an important issue, but the more relevant consideration at work in justifying the public nature of the university emerges out of the role higher education plays in educating students as critical agents who are equipped to understand, address, and expand the possibilities for deepening and sustaining democratic public life.

Defending higher education as a vital public sphere in its own right means refusing to reduce the concept of the public to the imperatives of cultural uniformity, elitism, or the imperatives of the job market. On the contrary, as a public space whose moral and educative dimensions impact directly on the renewal of everyday life, the university becomes indispensable for rendering students accountable to their obligations as critical citizens who address what role knowledge and authority might play in the reconstruction of democracy itself. In this instance, knowledge and power intersect with ethical discourses attentive to the ravages of racism, corporate greed, sexism, and other injustices, not as the privileged preserve of identity politics, but as a threat to democratic public life.

By legitimizing higher education in these terms, teachers can play an important pedagogical role in redefining for their students the myriad political linkages that mutually inform the relationship between the university and the larger society. In this sense, the institutions of higher education must be seen as deeply moral and political spaces in which intellectuals assert themselves not merely as professional academics but as citizens whose knowledge and actions presuppose specific visions of public life, community, and citizenship. Higher education must be defended through intellectual work that

self-consciously recalls the tension between the democratic imperatives or possibilities of public institutions and their actual formation in everyday practice.

On one level this suggests that academics assume the role of specific intellectuals working within local contexts and institutional sites in order to expand the spheres of critical learning, social justice, and human agency. In this context, the public nature of intellectual work can be developed through teaching, research, and collaboration aimed at challenging the diverse forms of domination that link the university to the wider society. But in a world where the boundaries between the public nature of the university and the spheres of public power are difficult to separate, academics must not define themselves exclusively as specific intellectuals. Rather, they must address what it means to move between the university and other arenas, whether they be the media, labor organizations, or insurgent social movements, in order to speak and struggle in a number of public spaces that are actively engaged in the production of knowledge, values, and social identities. In what follows, I want to make some suggestions regarding what role university teachers might play as public intellectuals, and how this might redefine in more critical terms the relationship between the university and the wider society.

Teachers as Public Intellectuals

The criticism expressed toward the role of teachers as public intellectuals has a long tradition in the United States.[7] In its contemporary form, it is a critique that cuts across ideological lines. For example, neoconservatives argue that university teachers who address public issues from the perspective of a committed position either violate the spirit of academic professionalism, or as ideologues left over from the 1960s, represent a dangerous threat to the freedom and autonomy of the university. This being the case, there is a deep suspicion of any attempt to open up the possibility for educators to address pressing social issues and to connect them to their teaching. Attempting to license and regulate pedagogical practice, conservatives argue that universities are apolitical institutions whose primary goal is to create a select strata of technical

experts to run the commanding institutions of the state, to prepare students for the workplace, and to reproduce the alleged common values that define the "American" way of life.[8] In this discourse, politics is subordinated to management, and political activity is displaced by the imperatives of "objectivity" and "appropriate academic standards."

At the same time, many liberals have argued that, while university academics should address public issues, they should do so from the perspective of a particular teaching methodology or pedagogy, rather than from a particular political project. This is evident in Gerald Graff's call for university educators to teach the conflicts. In this view, the discourse of objectivity and methodology runs the risk of replacing an ethical discourse concerned with the political responsibility of university professors or with the issue of how such educators might help students identify, engage, and transform relations of power that generate the material conditions of racism, sexism, poverty, and other oppressive conditions (Graff, "Teaching"). Lacking a political project, the role of the university intellectual is reduced to that of a technician repeating formalistic rituals devoid of any pressing commitment to engage the disturbing and urgent problems that confront the larger society.

While there may be an element of truth in both of these positions, each one displays enormous theoretical shortcomings. Conservatives often refuse to problematize their own version of what is legitimate intellectual knowledge and how it works to secure particular forms of authority by simply labelling as politically correct individuals, groups, or views that challenge the basic tenets of the status quo. Liberals, on the other hand, inhabit a terrain that wavers between rejecting a principled standpoint from which to teach and staunchly arguing for a pedagogy that is academically rigorous and fair. Caught between a discourse of fairness and the appeal to provocative teaching methods, liberals have no language for clarifying the moral visions that structure their views of the relationship between knowledge and authority and the practices it promotes. Moreover, they increasingly have come to believe that teaching from a particular standpoint is tantamount to imposing an ideological position upon students. This misconception has led in some cases

to a form of "red baiting" in which radical educators are summarily dismissed as being guilty of ideological indoctrination.

From a different ideological perspective, some radical feminists have argued that the call for teachers to be public intellectuals promotes pedagogical models that are largely patriarchal and overly rational in the forms of authority they legitimate and secure. While the feminist critique is the most interesting, it rests on a reductionistic view of authority and undermines the possibility for using authority in ways that allow university teachers to be more self-critical while simultaneously providing the conditions for students to recognize the possibility for critical agency in both themselves and others. Operating out of a language of binarisms, some feminist education critics essentialize the positions of their opponents and, in doing so, present a dehistoricized and reductionistic view of critical pedagogy.[9]

All of these positions neutralize the role that teachers might play as public intellectuals by discounting the notion that authority, knowledge, and politics can intersect in order to expand the possibilities for critical learning and human agency. In these discourses, the ethical and political assumptions that underlie what it means for academics to function oppositionally as public intellectuals are reduced to the notion that the only pedagogical outcome of such practices is political correctness, indoctrination, or the production of left master narratives.

In opposition to this view, I want to argue that public intellectuals need to become provocateurs; they need to take a stand while simultaneously refusing either a cynical relativism or doctrinaire politics. In part, this means such intellectuals need to challenge forms of disciplinary knowledge and social relations that promote material and symbolic violence, while simultaneously being deeply critical of their own authority and how it structures classroom relations and cultural practices. Pedagogically, this suggests that the authority they legitimate in the classroom become both an object of autocritique and a critical referent for expressing a more "fundamental dispute with authority itself" (Radhakrishnan). In addition, as public intellectuals, academics must move beyond recognizing the partiality of their own narratives

so as to address more concretely the ethical and political consequences of the social relations and cultural practices generated by the forms of authority used in the classroom. Autocritique, or interrogating one's own experiences, is important, but it is imperative to guard against a confessional politics in which the interrogation of experience becomes tantamount to speaking a transparent version of truth. Such a mode of self-reflexivity must become part of a wider strategy of crossing and transgressing the borders between the self and others, theory and practice, and the university and everyday life.

As public intellectuals, university educators must bring to bear in their classrooms and other pedagogical sites the courage, analytical tools, moral vision, time, and dedication that is necessary to return universities to their most important task: places of critical education in the service of creating a public sphere of citizens who are able to exercise power over their own lives and especially over the conditions of knowledge acquisition. Central to any such effort is the recognition that democracy is not a set of formal rules of participation, but the lived experience of empowerment for the vast majority. Moreover, the call for universities as democratic public spheres should not be limited to the call either for autonomy for intellectuals or for equal access to schools, equal opportunity, or other arguments defined in terms of the principles of equality. Autonomy and equality are crucial elements in the democratization of schools, but they are not the sole elements in this process. Instead, the rallying cry of university educators should be organized around the practice of empowerment for the vast majority of students in this country who need to be educated in the spirit of a critical democracy (see Giroux, *Schooling*).

This suggests that questions of autonomy and access be supplemented with concerns over issues of purpose and meaning regarding the role of higher education, the exercise of power in deciding who is represented in the curriculum and under what conditions, and how power is distributed among administrators, faculty, and students around the day-to-day workings of the university and classroom.

A related consideration in defining the role of university teachers as public intellectuals must address combining the mutually interdependent roles of

educators and citizens. This implies finding ways to connect the practice of classroom teaching to the operation of power in the larger society. For example, university teachers should be attentive to those broader social forces that influence the workings of schooling and pedagogy. Pierre Bourdieu has rightly argued that "intellectuals must learn, at the risk of compromising themselves, to use the state to liberate themselves from it, to obtain their share of the goods the state assures them in order to assert their independence from the state" (Bourdieu, "Corporatism" 105). What is at issue here is a refusal on the part of intellectuals to be incorporated by the university while simultaneously working within it, without giving up a commitment to extend the principles of social justice to all spheres of economic, political, and cultural life. Within this discourse, the experiences that constitute the production of knowledge, identities, and social values in the university are inextricably linked to the quality of moral and political life of the wider society. Hence, the reform of higher education must be seen as part of a wider revitalization of public life.

This should not suggest that, as public intellectuals, university teachers represent a vanguardist group (universal intellectuals) dedicated to simply reproducing another master narrative. In fact, as public intellectuals, it is important for them to link their role as critical agents to their ability to be critical of their own politics while constantly engaging in dialogue with other educators, community people, various cultural workers, and students. As public intellectuals, teachers need to be aware of the limits of their own positions, make their pedagogies context specific, challenge the current organization of knowledge into fixed disciplines, and work in solidarity with others to gain some control over the conditions of their work. At the very least, this points to the necessity for university teachers to struggle on many different fronts in order to transform the conditions of work and learning that go on in higher education. This means not only working with community people, colleagues, students, and social movements in order to open up progressive spaces within classrooms but also forming alliances with other cultural workers from diverse public spheres in order to engage pressing social, economic, and cultural issues that can be addressed in both political and pedagogical terms.

As public intellectuals, university teachers need to provide the opportunities for students to learn that the relationship between knowledge and power can be emancipatory, that their histories and experiences matter, and that what they say and do can count as part of a wider struggle to unlearn dominating privileges, productively reconstruct their relations with others, and transform, when necessary, the world around them. More specifically, such educators need to argue for forms of pedagogy that close the gap between the university and everyday life. The curriculum needs to be organized around knowledge that relates to the communities, cultures, and traditions that give students a sense of history, identity and place. This is a call for transgressing the often rigid division between academic culture and popular/oppositional culture; it is also expanding pedagogical practice as a form of cultural politics by making all knowledge subject to serious analysis and interrogation, and in doing so making visible the operations of power that connect such knowledge to specific views of authority and cultural practice.

This suggests pedagogical approaches that do more than make learning context-specific and, in effect, challenge the content of the established canon; it also points to the need to expand the range of cultural texts that inform what counts as "really useful knowledge." As public intellectuals, university teachers need to understand and use those electronically mediated knowledge forms that constitute the terrain of popular culture. I refer to the world of media texts—videos, films, music, and other mechanisms of popular culture constituted outside the technology of print and the book. Put another way, the content of the curriculum needs to affirm and critically enrich the meaning, language, and knowledge forms that students actually use to negotiate and inform their lives. This is not an argument for expanding the canon; on the contrary, it is a discourse that challenges the very nature of canonicity by raising such questions as: Whose authority is secured through the form and content of specific canons? What does it mean to organize the curricula in ways that decenter its authority and power relations? What social relations have to come into play to give university teachers and students control over the conditions for producing knowledge?

While it is central for university teachers to expand the relevance of the

curriculum to include the richness and diversity of the students they actually teach, they also need to correspondingly decenter the curriculum. That is, students should be actively involved with issues of governance, "including setting learning goals, selecting courses, and having their own, autonomous organizations, including a free press" (Aronowitz, "A Different Perspective" 24). Not only does the distribution of power among teachers, students, and administrators provide the conditions for students to become agents in their learning process, it also provides the basis for collective learning, civic action, and ethical responsibility. Moreover, such agency emerges through a pedagogy of lived experience and struggle, rather than as the empty, formalistic mastery of an academic subject.

In addition, as public intellectuals, university teachers need to make the issue of cultural difference a defining principal of knowledge production, development, and research. In an age of shifting demographics, large-scale immigration, and multiracial communities, university teachers must make a firm commitment to cultural difference as central to the relationship of schooling and citizenship. In the first instance, this means dismantling and deconstructing the legacy of nativism and racial chauvinism that has defined the rhetoric of school reform for the last decade (Giroux, *Living Dangerously*). The Reagan and Bush eras witnessed a full fledged attack on the rights of minorities, civil rights legislation, and affirmative action, as well as the legitimation of curriculum reforms pandering to Eurocentric interests. University educators can affirm their commitment to democratic public life and cultural democracy by struggling in and outside of their classrooms in solidarity with others to reverse these policies in order to make schools more attentive to the cultural resources that students bring with them to all levels of schooling. At one level, this means working to develop legislation that protects the civil rights of all groups. Equally important is the need for university teachers to take the lead in encouraging programs that open school curricula to the narratives of cultural difference, without falling into the trap of merely romanticizing the experience of Otherness. At stake here is the development of an educational policy that asserts university education as part of a broader ethical and political discourse, one that both challenges and transforms those

curricula reforms of the last decade that are profoundly racist in context and content. In part, this suggests changing the terms of the debate regarding the relationship between schooling and national identity, moving away from an assimilationist ethic and the profoundly Eurocentric fantasies of a common culture to an ethic that links national identity to diverse traditions and histories.

In short, as public intellectuals, academics need to expand the meaning and purpose of the university; that is, they need to define higher education as a public resource vital to the moral life of the nation and open to working people and communities that are often viewed as marginal to such institutions and its diverse resources of knowledge and skills. At stake here is restructuring the knowledge, skills, research, and social relations constructed in the university as part of a broader reconstruction of a critical tradition that links critical thought to collective action, knowledge and power to a profound impatience with the status quo, and human agency to an ethic of social responsibility. In part, this means addressing how universities can create the conditions for students to be social agents willing to struggle for expanding the critical public cultures that make a democracy viable in an age of shrinking possibilities.

Notes

1. Outside of Allan Bloom, who produced the most influential manifesto declaring war on tenured radicals, popular culture, and other postmodernist misgivings, a new generation of neoconservatives has emerged around the now familiar voices of Roger Kimball (the editor of *The New Criterion*), Dinesh D'Souza, Christina Hoff Sommers, Arthur Schlesinger, Jr., and others, whose spirited defense of high culture in the arts, traditional canonicity in the university, and cultural uniformity in social life ties them directly with the anti-immigrant, anti-Catholic, nativist forces of the 1920s and 1930s in the U.S.

2. For a representative example of neoconservative attacks on the university along with some responses, see Berman, Keefer, and Aufderhiede. For an example of neoconservative critiques used in the arts, see various articles in Bolton. For a trenchant analysis of the history and nature of the right wing use of political correctness to attack higher education, see Messer-Davidow. The latter piece contains an excellent bibliography.

3. Scott is worth quoting on this issue:

What we are witnessing these days is not simply a set of internal debates about what schools and universities should teach and what students should learn. Journalists and politicians have

joined the fray and added a new dimension to it. There is much more at stake in their campaign against "political correctness" than a concern with excessive moralism, affirmative action and freedom of speech in the academy. Rather, the entire enterprise of the university has come under attack. ("Multiculturalism" 12)

4. For an analysis of this issue, see Giroux, *Border Crossings,* ch. 10, "Writing Against the Empire."

5. It is important to note that the notion of the public sphere that has become the scourge of mainstream critics is not Jürgen Habermas's version of a homogeneous public sphere based on a theory of communicative action in which conflict is seen as a barrier to understanding. In fact, as Stanley Aronowitz points out, by "bracketing the 'power' and 'interest' from the public sphere and specifying that 'reason' is a presupposition of public communication, Habermas provides a moral justification for a conception of the public that is fundamentally exclusionary." It is precisely around the refusal to analyze the bourgeois public sphere in relation to alternative or counter-public spheres that Habermas's view offers support for neoconservatives who argue against a politics of difference. See Aronowitz, "Democracy" 91. For a more radical view of what Rita Felski has called counterpublic spheres, see Eley, Fraser, and Felski.

6. This issue is taken up in Giroux, *Disturbing Pleasures.* See especially my chapter on Whittle Communications. See also Aronowitz and Giroux.

7. There is a long tradition of anti-intellectualism in American society that has both excluded intellectuals from public debate and dismissed them when they attempted to influence public policy; see Hofstadter. Of course, the left has a long history of being dismissive of the role that academics might play as public intellectuals; see Chomsky, "Responsibility"; see also, Jacoby, *The Last Intellectuals.* For a different view of academics as public intellectuals, see Mills, especially "The Social Role of the Intellectuals" (292–304); Bourdieu, *Homo Academicus;* and Aronowitz and Giroux.

8. For a trenchant analysis of the political correctness movement, see Aronowitz, *Roll Over Beethoven,* ch. 1.

9. Examples of feminist theorizing that embodies this type of discourse can be found in Gore and in Ellsworth.

16

A Paradox of the Culture War

Gerald Graff

In the sound and fury of the culture war, a paradoxical situation has escaped notice: it is the academic left that has arguably made the major contributions to scholarship in literary studies over the past three decades, profoundly affecting fields as remote from literature as law, architecture, anthropology, and the social sciences. Yet it is the right that defends the virtues of disinterested scholarship, while the left debunks disinterestedness in the name of politics and power. The producers of the best objective scholarship defend partisanship, while the defenders of objectivity produce mostly partisan political polemics.

Recent attacks on the latest trends in academic literary studies have depicted these trends as little more than a nihilistic attack on reason, objectivity, and truth. The crude and ill-informed nature of most of these attacks has made them easy to dismiss by those on the receiving end. To take just one example, the accounts of deconstruction given in journalistic books like David Lehman's *Signs of the Times,* or even in presumably more scholarly ones like John Ellis's *On Deconstruction,* are so clearly incompetent that deconstructionists can hardly be blamed for ignoring rather than answering them.

Even at their crudest, however, the attacks do raise questions that have not been satisfactorily addressed: Can one dismiss an attack as "crude and ill-informed" without invoking something like a traditional concept of truth and representational accuracy? To put it another way, what *should* one say when a Dinesh D'Souza or a Roger Kimball characterizes recent theory as a radical denial of the possibility of truth? Should the response be, "No, that misses the point of recent theory, which is not to junk the concept of truth

but to complicate it, or to show that it is not natural but a social construction?" Or should one say something like, "Yes, and it was about time somebody put the concept of truth into question?" Like others who have been misrepresented by the Kimballs and D'Souzas, I want to be able to call a lie a lie without having to take it all back somehow by putting my discourse under erasure.

Granted, "recent theory" does not speak with one voice about the concept of truth, and granted this fact is simply brushed aside by the Kimballs and D'Souzas as well as by more sophisticated academics who ought to know better. But pointing to the too-often overlooked diversity within the world of theory does not completely address the problem. It is not just that common themes do link recent theories despite their many differences. It is also that these theories are indeed often evasive about the key questions they raise.

What, finally, does it mean, for example, to "put truth in question," or to put anything in question, for that matter? Do we claim to discredit what is put into question or not? The fact is, it is rarely easy to be sure just what follows from the dominant recent theories, with respect not just to the question of truth but other ideas and institutions that have come under critique. It is all very well to say that deconstruction "problematizes" (or puts into question) the idea that *Middlemarch* conveys a profoundly true picture of nineteenth century English culture (or of human nature), or—in what is really the state of the art deconstructive gesture—that it problematizes that idea "while reinscribing it with a difference." But what does this mean, and what has been done or not done to the idea of the truth of *Middlemarch* in the process?

Perhaps the most ultrahip of current theorists would reply that the question of *Middlemarch's* truth to reality simply doesn't interest them, having gone out with Samuel Johnson. The problem persists, however, and leaves unanswered questions not only about deconstruction, but also the various forms of Foucauldian discourse analysis and Althusserian ideological critique, all of which tend to "problematize" the idea of truth as well, not to mention concepts like narrative coherence, the subject, agency, authorial intention, and so forth.

Catherine Belsey, for example, tells us in *Critical Practice* that, from the "post-Saussurean perspective," it "is clear that the theory of literature as

expressive realism is no longer tenable. The claim that a literary form reflects the world is simply tautological." For what we call "the world," Belsey argues, can mean only "the world differentiated by language," which is to say, the world "constructed by language," and "this is a tautology." In the wake of Saussure, we now know that signs "signify by means of their relationship to each other rather than to entities in the world." Therefore it follows that "if literature is a signifying practice, . . . all it can reflect is the order inscribed in particular discourses, not the nature of the world" (46).

Belsey sounds self-assured, but what she says is equivocal to the point of incoherence. Though Belsey claims that language refers not to "the nature of the world" but only to the "order inscribed in particular discourses," this very statement unavoidably asserts something about "the nature of the world." From what standpoint could Belsey possibly claim to *know* that our knowledge is a knowledge only of linguistic differences and not of what they claim to denote? In an example that unwittingly undermines her position, Belsey observes that "it is no accident" that women have challenged the sexist use of "man" to mean "people" in a period "when women are becoming increasingly conscious of the effects of patriarchy" (43). The example would seem to be one in which language does not operate independently of "the world" at all, but responds to a prior change in the world—women's increasing consciousness of patriarchy.

Therefore, Richard Levin seems to me quite right to complain that feminist critics are trading on the objectivist standards that they claim to repudiate when they go on to make characterizing statements about Shakespeare, such as that the tragedies "repeatedly and poignantly ask what it is 'to be a man' " (16). Levin is right to suggest that such statements inevitably presuppose that the gendered characteristics described by the critic are "there" in Shakespeare's text, not simply "constructed" by the critic. In her excellent book, *Essentially Speaking,* Diana Fuss argues that essentialism, so glibly debunked in recent literary theory, inevitably reappears in the assumptions of the debunkers themselves. (It should be noted that Fuss draws on deconstructive arguments to make this point.) What Fuss says about the inevitable return of essentialism in the arguments of those who would repress it might also be said about

referentiality. That is, language use, as Habermas argues, entails making "validity-claims," and while it may not be possible to demonstrate that such claims correspond to any ultimate reality, it does not seem possible without paradox to avoid making such claims.

Here, I take it, is the grain of truth in "naïve," common sense rejoinders to poststructuralist dismissals of referentiality. Even attacks on "political correctness" may have a salutary effect if they should force poststructuralists to explain the consequences of their arguments more clearly.

Of course nothing of the sort is likely to happen. For some time now, the worst thing anyone could be called, according to recent academic theory, is "naïve," and academic theory itself has been a kind of sweepstakes competition whose goal is to prove how far beyond naïveté the theorist is. This post-Hegelian ethos of avoiding naïveté at all costs has led to an impressive stretching of the boundaries of thought and perception to which theory-bashers are simply oblivious. Its blind spot, however (as that winner of the non-naïve sweepstakes, Paul de Man, might have pointed out), is a failure to take its own lesson seriously, that there is no ultimately demystified position immune from naïveté. This is a way of saying that naïveté can be a useful standpoint from which it is dangerous to think we can be liberated. Having operated in a world remote from the layperson, current theory has been able to avoid dealing with naïve (or "uninteresting") questions such as, "What is the truth-status of *Middlemarch* in the wake of poststructuralism?" and "What does it mean to say that truth, narrative coherence, or anything has been 'put into question'?" I am suggesting, then, that one of the harsh lessons of the culture war may turn out to be that the academic vanguard cuts itself off from naïve questions at its own peril, that it needs those naïve questions in order to clarify itself to itself, as well as to others, to know what it is talking about.

One would think that such a point would be obvious to people who spend a good deal of their time *teaching,* for teaching presumably affords practice at dealing with naïve questions. But like other academic factions, the academic vanguard is screened by classroom and other walls from having to argue with those who might challenge their most comfortable assumptions.

One is about as likely to hear Matthew Arnold's idea of culture defended in a cultural studies program today as to hear the assumptions of free market capitalism challenged in a law and economics program.

Very much like its counterparts in economics and political science, vanguard criticism exists as a proliferation of in-groups and coteries of the like-minded, which preach to the already converted. To anyone outside the charmed circle, the message seems to be: "We represent the cutting edge, so why should we have to take your naïve questions seriously?" Such an attitude is disastrous to any group that hopes to defend itself against a witch-hunt, much less transform the consciousness of its generation.

I started out by noting the paradox that the best recent scholars debunk disinterested objectivity in the name of partisanship, while the defenders of disinterested objectivity produce partisan political propaganda. Perhaps it is time these groups began to listen to each other.

Bibliography

Adler, Jerry, *et al.* "Taking Offense: Is This the New Enlightenment on Campus or the New McCarthyism?" *Newsweek* 24 Dec. 1990: 48–54.

Ahmad, Aijaz. *In Theory: Classes, Nations, Literatures.* London: Verso, 1992.

Althusser, Louis. "Ideology and Ideological State Apparatuses." *Lenin and Philosophy and Other Essays.* Trans. Ben Brewster. New York: Monthly Review Press, 1972. 127–86.

Anderson, Perry. *In the Tracks of Historical Materialism.* Chicago: U of Chicago P, 1984.

Appadurai, Arjun, and Carol A. Breckenridge. "Why Public Culture?" *Public Culture* 1.1 (1988): 1–4.

Aquinas, St. Thomas. *Introduction to St. Thomas Aquinas.* Ed. Anton C. Pegis. New York: Modern Library, 1945.

Arac, Jonathan. *Critical Genealogies: Historical Situations for Postmodern Literary Studies.* New York: Columbia UP, 1987.

Arendt, Hannah. *The Origins of Totalitarianism.* 2nd ed. Cleveland: World Publishing, 1958.

Arnold, Matthew. *Culture and Anarchy: An Essay in Political and Social Criticism. The Complete Prose Works of Matthew Arnold.* Vol. 5. Ed. R. H. Super. Ann Arbor: U of Michigan P, 1962. 85–256.

———. "The Function of Criticism at the Present Time." *The Complete Prose Works of Matthew Arnold.* Vol. 3. Ed. R. H. Super. Ann Arbor: U of Michigan P, 1962. 258–85.

Aronowitz, Stanley. "A Different Perspective on Educational Equality." *Review of Education/ Pedagogy/Cultural Studies* (1994).

———. "Is a Democracy Possible? The Decline of the Public Sphere in the American Debate." *The Phantom Public Sphere.* Ed. Bruce Robbins. Minneapolis: U of Minnesota P, 1993. 75–92.

———. *Roll Over Beethoven: The Return of Cultural Strife.* Hanover: Wesleyan UP, 1993.

Aronowitz, Stanley, and Henry A. Giroux. *Education Still Under Siege.* Westport: Bergin and Garvey, 1993.

313

Aufderheide, Patricia, ed. *Beyond PC: Toward a Politics of Understanding.* St. Paul: Graywolf, 1992.

Bagdikian, Ben. *The Media Monopoly.* 3rd ed. Boston: Beacon, 1990.

Baker, Herschel. Introduction to *Richard III.* In *The Riverside Shakespeare* 708–11.

Baker, Houston. "What's Left of Anxieties in the Humanities?" *MLA Newsletter* Spring 1992: 2–4.

Bakhtin, M. M. *Art and Answerability: Early Philosophical Essays by M. M. Bakhtin.* Trans. Vadim Liapunov and Kenneth Brostrum. Ed. Michael Holquist and Vadim Liapunov. Austin: U of Texas P, 1981.

————. *Problems of Dostoevsky's Poetics.* Trans. and ed. Caryl Emerson. Minneapolis: U of Minnesota P, 1984.

————. *Speech Genres and Other Late Essays.* Trans. Vern W. McGee. Ed. Caryl Emerson and Michael Holquist. Austin: U of Texas P, 1986.

————. *Toward a Philosophy of the Act.* Trans. Vadim Liapunov. Ed. Vadim Liapunov and Michael Holquist. Austin: U of Texas P, 1993.

Balch, Stephen H., and Herbert I. London. "The Tenured Left." *Commentary* 82 (1986): 41–51.

Bartlett, Donald L., and James B. Steele. *America: What Went Wrong?* Kansas City: Andrews and McMeel, 1992.

Bate, W. Jackson. "The Crisis in English Studies." *Harvard Magazine* 85 (1982): 46–53.

Bauman, Zygmunt. *Intimations of Postmodernity.* New York: Routledge, 1992.

————. *Legislators and Interpreters: On Modernity, Post-Modernity and Intellectuals.* Ithaca: Cornell UP, 1987.

Bawer, Bruce. "Beautiful Dreamers." Rev. of *Operation Wandering Soul,* by Richard Powers. *Washington Post Book World* 13 June 1993: 2.

Baym, Nina. "The Madwoman and Her Languages: Why I Don't Do Feminist Literary Theory." *Feminist Issues in Literary Scholarship.* Ed. Shari Benstock. Bloomington: Indiana UP, 1987. 45–61.

Belsey, Catherine. *Critical Practice.* London: Routledge, 1980.

Bender, Thomas. *New York Intellect: A History of Intellectual Life in New York City, from 1750 to the Beginnings of Our Own Time.* Baltimore: John Hopkins UP, 1987.

Bennett, Tony. *Outside Literature.* New York: Routledge, 1990.

Bennett, William J. *Our Children and Our Country: Improving American's Schools and Affirming the Common Culture.* New York: Simon & Schuster, 1988.

————. *To Reclaim a Legacy: A Report on the Humanities in Higher Education.* Washington: National Endowment for the Humanities, 1984.

Berman, Paul. "Introduction: The Debate and Its Origins." In Berman, ed. 1–26.

Berman, Paul, ed. *Debating P.C.: The Controversy over Political Correctness on College Campuses.* New York: Dell, 1992.

Bernard-Donals, Michael. "Mikhail Bakhtin: Between Phenomenology and Marxism." *College English* 56 (1994): 170–88.

Bernstein, Richard. "The Rising Hegemony of the Politically Correct." *New York Times* 28 Oct. 1990: D1.

Bérubé, Michael. "Discipline and Theory." In Edmundson, ed. 171–92.

———. "Public Image Limited: Political Correctness and the Media's Big Lie." *Village Voice* 18 June 1991: 31–37.

Bérubé, Michael, and Cary Nelson, eds. *Higher Education Under Fire: Politics, Economics, and the Crisis of the Humanities.* New York: Routledge, 1994.

Bhaskar, Roy. *Philosophy and the Idea of Freedom.* Oxford: Basil Blackwell, 1991.

———. *Reclaiming Reality: A Critical Introduction to Contemporary Philosophy.* London: Verso, 1988.

Bialostosky, Don H. "Dialogic, Pragmatic, and Hermeneutic Conversation: Bakhtin, Rorty, and Gadamer." *Critical Studies* 1 (1989): 107–19.

Bledstein, Burton. *The Culture of Professionalism: The Middle Class and the Development of Higher Education in America.* New York: Norton, 1978.

Bloom, Allan. *The Closing of the American Mind: How Higher Education Has Failed Democracy and Impoverished the Souls of Today's Students.* New York: Simon & Schuster, 1987.

———. *Giants and Dwarfs: Essays, 1960–1990.* New York: Simon & Schuster, 1990.

Bolick, Clint. "Clinton's Quota Queens." *Wall Street Journal* 30 Apr. 1993: A12.

Bolton, Richard, ed. *Culture Wars: Documents from the Recent Controversies in the Arts.* New York: New Press, 1992.

Bourdieu, Pierre. "The Corporatism of the Universal: The Role of Intellectuals in the Modern World." *Telos* 81 (Fall 1989): 99–110.

———. *Distinction: A Social Critique of the Judgement of Taste.* Trans. Richard Nice. Cambridge, MA: Harvard UP, 1984.

———. *Homo Academicus.* Trans. Peter Collier. Stanford: Stanford UP, 1988.

Bové, Paul A. *In the Wake of Theory.* Middletown: Wesleyan UP, 1991.

———. *Intellectuals in Power: A Genealogy of Critical Humanism.* New York: Columbia UP, 1986.

Brantlinger, Patrick. *Crusoe's Footprints: Cultural Studies in Britain and America.* London and New York: Routledge, 1990.

Brodribb, Somer. *Nothing Mat(t)ers: A Feminist Critique of Postmodernism.* North Melbourne: Spinifex, 1993.

Brombert, Victor. "Presidential Address 1989; Mediating the Work: or, The Legitimate Aims of Criticism." *PMLA* 105 (1990): 391–97.

Bromwich, David. *Politics by Other Means: Higher Education and Group Thinking.* New Haven: Yale UP, 1992.

Brooks, Peter. "Western Civ at Bay." *Times Literary Supplement* Jan. 1991: 5–6.

Brooks, Peter, Jonathan Culler, A. Bartlett Giamatti, and Norman Podhoretz. "Excerpts from the Symposium on 'The Humanities and the Public Interest,' Whitney Humanities Center, April 5, 1986." *Yale Journal of Criticism* 1.1 (1987): 183–91.

Brown, Elsa Barkley. "African-American Women's Quilting: A Framework for Conceptualizing and Teaching African-American Women's History." *Signs* 14 (1989): 921–29.

Brustein, Robert. "Dumbocracy in America." *Partisan Review* 60 (1993): 526–34.

Buckley, William F. *God and Man at Yale: The Superstitions of Academic Freedom.* Chicago: Regnery, 1951.

Burd, Stephen. "Chairman of the Humanities Fund Has Politicized Grants Process, Critics Charge." *Chronicle of Higher Education* 22 Apr. 1992: A1, A32+.

———. "Hackney Atacked and Praised for Criticizing Literary Theory." *Chronicle of Higher Education* 14 June 1993: A21.

———. "Hackney Clears Hurdle in Run for the NEH." *Chronicle of Higher Education* 7 July 1993: A26+.

Burke, Kenneth. *A Grammar of Motives.* Berkeley: U of California P, 1969.

Burton, Antoinette. "The White Woman's Burden: British Feminists and The Indian Woman, 1865–1915." *Women's Studies International Forum* 13.4 (1990): 295–308.

Bush, George. "Excerpts from His Address at the University of Michigan." *New York Times* 5 May 1991: 32. Rpt. in Aufderheide, ed. 227–28.

Butler, Judith. "Contingent Foundations: Feminism and the Question of 'Postmodernism.' " *Praxis International* 11.2 (1991): 150–65.

Calhoun, Craig, ed. *Habermas and the Public Sphere.* Cambridge, MA: MIT, 1993.

Callinicos, Alex. "Marxism and Imperialism Today." *International Socialism* 50 (1991): 3–48.

Canning, Charlotte. "Constructing Experience: Theorizing a Feminist Theatre History." *Theatre Journal* 45 (1993): 529–40.

Capo, Kay Ellen, and Darlene M. Hantzis. "(En)Gendered (and Endangered) Subjects: Writing, Reading, Performing, and Theorizing Feminist Criticism." *Text and Performance Quarterly* 11 (1991): 249–66.

Chace, William M. *Lionel Trilling: Criticism and Politics.* Stanford: Stanford UP, 1980.

Cheney, Lynne V. *50 Hours: A Core Curriculum for College Students.* Washington: National Endowment for the Humanities, 1989.

———. *Humanities in America: A Report to the President, the Congress, and the American People.* Washington: National Endowment for the Humanities, 1988.

———. *Telling the Truth: A Report on the State of the Humanities.* Washington: National Endowment for the Humanities, 1992.

———. *Tyrannical Machines: A Report on Educational Practices Gone Wrong and Our Best Hopes for Setting Them Right*. Washington: National Endowment for the Humanities, 1990.

Chomsky, Noam. *American Power and the New Mandarins*. New York: Pantheon, 1969.

———. "The Responsibility of Intellectuals." *The Chomsky Reader*. Ed. James Peck. New York: Pantheon, 1987. 59–82.

Clarke, Stuart Alan. "Fear of a Black Planet." *Socialist Review* 21 (1991): 37–60.

Clifford, James. "Notes on Theory and Travel." *Inscriptions* 5 (1989): 177–88.

Clymer, Adam. "Clinton Nominee Defends Himself." *New York Times* 26 June 1993: A6.

Cockburn, Alexander. "Bush & PC—A Conspiracy So Immense . . ." *The Nation* 21 May 1991: 686+.

Cohen, Robby. *When the Old Left Was Young: Student Radicals and America's First Mass Student Movement, 1929–1941*. New York: Oxford UP, 1993.

Collins, Jim. *Uncommon Cultures: Popular Culture and Post-Modernism*. New York: Routledge, 1989.

"Community and Factionalism." *Texas Observer* 29 Nov. 1991: 14.

Cooper, Kenneth J. " 'Political Correctness' Conflicts Not Widespread, College Administrators Say." *Washington Post* 29 July 1991: A5.

Crewe, Jonathan. "Toward Uncritical Practice." In Mitchell, ed. 53–64.

Crews, Frederick. "In the Big House of Theory." *New York Review of Books* 29 May 1986: 36–42.

———. *Skeptical Engagements*. New York: Oxford UP, 1986.

Culler, Jonathan. *Framing the Sign: Criticism and its Institutions*. Norman: U of Oklahoma P, 1988.

Cumings, Bruce. *War and Television*. London: Verso, 1992.

D'Amato, P., and L. Selfa. *The 1992 Elections: Is Bill Clinton the Lesser Evil?* Chicago: Bookmarks, 1992.

Davidson, Donald. "On the Very Idea of a Conceptual Scheme." *Inquiries into Truth and Interpretation*. Oxford: Clarendon P, 1986. 183–98.

Decter, Midge. "More Bullying on Campus." *New York Times* 10 Dec. 1985: A31.

Deleuze, Gilles, and Felix Guattari. *A Thousand Plateaus: Capitalism and Schizophrenia*. Trans. Brian Massumi. Minneapolis: U of Minnesota P, 1987.

de Man, Paul. *The Resistance to Theory*. Minneapolis: U of Minnesota P, 1986.

Dembner, Alice. "Silber Says New Theories Can Put Limit on Freedom." *Boston Globe* 30 Nov. 1993: 1, 10.

———. "Silber's Words Leave Sting." *Boston Globe* 24 Nov. 1993: 27, 30.

Denning, Michael. "The Academic Left and the Rise of Culture Studies." *Radical History Review* 54 (1992): 21–47.

de Palma, Anthony. "Campus Ethnic Diversity Brings Separate Worlds." *The New York Times* 18 May 1991: A7.

"The Derisory Tower." *New Republic* 18 Feb. 1991: 5–6.

Derrida, Jacques. "Structure, Sign and Play in the Discourse of the Human Sciences." *The Structuralist Controversy: The Languages of Criticism and the Sciences of Man.* Ed. Richard Macksey and Eugenio Donato. Baltimore: The Johns Hopkins UP, 1970. 247–65.

Diamond, Sara. "Endowing the Right-wing Academic Agenda." *Covert Action Information Bulletin* Fall 1991: 46–49.

———. "Managing the Anti-PC Industry." In Newfield and Strickland, ed.

———. "Readin', Writin', and Repressin'." *Z Magazine* Feb. 1991: 45–48.

Dickstein, Morris. *Gates of Eden: American Culture in the Sixties.* New York: Basic Books, 1977.

"A Diverse Student Body Towards A Diverse Society." *Los Angeles Times* 7 July 1992: B7.

Doane, Janice, and Devon Hodges. *Nostalgia and Sexual Difference: The Resistance to Contemporary Feminism.* New York and London: Methuen, 1987.

Dodge, Susan. "Campus Codes That Ban Hate Speech Are Rarely Used to Penalize Students." *Chronicle of Higher Education* 12 Feb. 1992: A35–36.

Dolan, Jill. "Geographies of Learning: Theatre Studies, Performance, and the 'Performative'." *Theatre Journal* 45.4 (1993): 417–42.

D'Souza, Dinesh. *Falwell, before the Millenium: A Critical Biography.* Chicago: Regenery Gateway, 1984.

———. *Illiberal Education: The Politics of Race and Sex on Campus.* New York: Free Press, 1991.

———. "Sins of Admission." *New Republic* 18 Feb. 1991: 30–33.

Eagleton, Terry. *The Function of Criticism: From the Spectator to Post-Structuralism.* London: Verso, 1984.

———. *Ideology: An Introduction.* London: Verso, 1991.

———. *The Ideology of the Aesthetic.* Oxford: Basil Blackwell, 1990.

———. *Literary Theory: An Introduction.* Minneapolis: U of Minnesota P, 1983.

Eco, Umberto. *Postscript to* The Name of the Rose. Trans. William Weaver. San Diego: Harcourt Brace Jovanovich, 1984.

Eco, Umberto, *et al. Interpretation and Overinterpretation.* Ed. Stefan Collini. Cambridge: Cambridge UP, 1992.

Edmundson, Mark, ed. *Wild Orchids and Trotsky: Messages from American Universities.* New York: Penguin, 1993.

Educational and nonprofit institutions receiving prime contract awards for R, D, T & E for F.Y.

19xx [sic]. The Pentagon: Directorate for Information, Operations, and Reports, 1987–1990. Cited in *Z Magazine* Sept. 1991: 26.

Ehrenreich, Barbara. "The Challenge for the Left." In Berman, ed. 333–38.

Eley, Geoff. "Nations, Publics, and Political Cultures: Placing Habermas in the Nineteenth Century." In Calhoun, ed. 289–339.

Ellis, John. *Against Deconstruction*. Princeton: Princeton UP, 1989.

Ellsworth, Elizabeth. "Why Doesn't This Feel Empowering?" *Harvard Educational Review* 9 (1989): 297–324.

Faludi, Susan. *Backlash: The Undeclared War against American Women*. New York: Crown, 1991.

Fekete, John. *The Critical Twilight: Explorations in the Ideology of Anglo-American Theory from Eliot to Mcluhan*. London: Routledge, 1977.

Felski, Rita. *Beyond Feminist Aesthetics: Feminist Literature and Social Change*. Cambridge, MA: Harvard UP, 1989.

Ferguson, Thomas, and Joel Rogers. *Right Turn: The Decline of the Democrats and the Future of American Politics*. New York: Hill and Wang, 1986.

"Few Colleges Have Had 'Political Correctness'." *Chronicle of Higher Education* 7 Aug. 1991: A23-A24.

Fields, Barbara Jeanne. "Slavery, Race and Ideology in the United States of America." *New Left Review* 181 (1990).

Fish, Stanley. "Commentary: The Young and the Restless." In Veeser, ed. 303–16.

———. *Doing What Comes Naturally: Change, Rhetoric, and the Practice of Theory in Literary and Legal Studies*. Durham: Duke UP, 1989.

———. *Is There a Text in This Class? The Authority of Interpretive Communities*. Cambridge, MA: Harvard UP, 1981.

Foucault, Michel. *The Archaeology of Knowledge & The Discourse on Language*. Trans. A. M. Sheridan Smith. New York: Pantheon, 1972.

———. "Governmentality." *The Foucault Effect: Studies in Governmentality*. Ed. Graham Burchell, Colin Gordon, and Peter Miller. Chicago: U of Chicago P, 1991. 87–104.

———. *The Order of Things: An Archaeology of the Human Sciences*. New York: Random House, 1970.

———. *Power/Knowledge: Selected Interviews and Other Writings 1972–1977*. Trans. Colin Gordon *et al*. Ed. Colin Gordon. New York: Pantheon, 1980.

Fox Keller, Evelyn, and Helen Moglen. "Competition and Feminism: Conflicts for Academic Women." *Signs* 12 (1987): 493–511.

Fraser, Nancy. "Rethinking the Public Sphere: Contribution to the Critique of Actually Existing Democracy." In Calhoun, ed. 109–42.

Fuller, Steven. "Being There with Thomas Kuhn: A Parable for Postmodern Times." *History and Theory* 31.3 (1992): 241–75.

Fuss, Diana. *Essentially Speaking: Feminism, Nature, and Difference.* New York: Routledge, 1989.

Fynsk, Christopher. "Community and the Limits of Theory." In Miami Theory Collective, ed. 19–29.

Galan, F.W. *Historic Structures: The Prague School Project, 1928–1946.* Austin: U of Texas P, 1985.

Gallop, Jane, Marianne Hirsch, and Nancy K. Miller. "Criticizing Feminist Criticism." *Conflicts in Feminism.* Ed. Marianne Hirsch and Evelyn Fox Keller. New York: Routledge, 1990. 349–69.

Garafola, Lynn. Rev. of *The Last Intellectuals,* by Russell Jacoby. *New Left Review* 169 (1988): 122–28.

Gates, Henry Louis, Jr. "On the Rhetoric of Racism in the Profession." *Literature, Language, and Politics.* Ed. Betty Jean Craige. Athens: U of Georgia P, 1988. 20–26.

Geertz, Clifford. "Blurred Genres: The Refiguration of Social Thought." *The American Scholar* 49 (1980): 165–79.

Genovese, Eugene D. "Heresy, Yes—Sensitivity, No." *New Republic* 15 Apr. 1991: 30–35.

Gingrich-Philbrook, Craig. "Pee Wee Herman and the Right Speech of Faggotry: Making Sense of the Playhouse in a Funeral Home." Unpublished manuscript, 1993.

Giroux, Henry A. *Border Crossings: Cultural Workers and the Politics of Education.* New York: Routledge, 1992.

———. *Disturbing Pleasures: Learning Popular Culture.* New York: Routledge, 1994.

———. *Living Dangerously: Multiculturalism and the Politics of Difference.* New York: Peter Lang, 1993.

———. *Schooling and the Struggle for Public Life.* Minneapolis: U of Minnesota P, 1988.

Gitlin, Todd. "On the Virtues of a Loose Canon." In Aufderheide, ed. 185–90.

Glazer, Nathan. "On Being Deradicalized." *Commentary* 50 (1970): 74–80.

González, Mike. "Can Castro Survive? *International Socialism* 56 (1992): 83–124.

Goodman, Walter. "The Question of Repression." *Commentary* 50 (1970): 23–28.

Gordon, Larry. "Papers Proliferate: The Right Presses Case on Campus." *Los Angeles Times* 1 May 1989: 1, 16–17.

Gore, Jennifer. *The Struggle for Pedagogies.* New York: Routledge, 1992.

Graff, Gerald. *Beyond the Culture Wars: How Teaching the Conflicts Can Revitalize American Education.* New York: Norton, 1992.

———. *Professing Literature: An Institutional History.* Chicago: U of Chicago P, 1987.

———. "Teaching the Conflicts." *The Politics of Liberal Education.* Ed. Darryl J. Gless and Barbara Herrnstein Smith. Durham: Duke UP, 1992. 57–73.

Graff, Gerald, and Bruce Robbins. "Cultural Criticism Old and New." *Redrawing the Boundaries of Literary Study*. Ed. Stephen Greenblatt and Giles Gunn. New York: MLA, 1992. 419–36.

Graham, Joseph. *Onomatopoetics: Theory of Language and Literature*. Cambridge: Cambridge UP, 1992.

Greenberg, Douglas. "Fellowships in the Humanities, 1983–1991." Occasional Paper. New York: American Council of Learned Societies, 1991.

Greenberg, Paul. "As It Happens, 'Water Buffalo' Is an Equal Opportunity Insult." *Greensboro News & Record* 6 June 1993: F4.

Greenblatt, Stephen. *Learning to Curse: Essays in Early Modern Culture*. New York: Routledge, 1990.

——. *Shakespearean Negotiations: The Circulation of Social Energy in Renaissance England*. Berkeley: U of California P, 1988.

——. "Towards a Poetics of Culture." In Veeser, ed. 1–14.

Greene, Gayle, and Coppelia Kahn, eds. *Changing Subjects: The Making of Feminist Literary Criticism*. New York: Routledge, 1993.

Grizzard, Lewis. "The Speech Police." *I Haven't' Understood Anything since 1962 and Other Nekkid Truths*. New York: Villard Books, 1992. 3–32.

Grossberg, Lawrence, Cary Nelson, and Paula Treichler, eds. *Cultural Studies*. New York: Routledge, 1992.

Habermas, Jürgen. *The Theory of Communicative Action*. 2 vols. Trans. Thomas McCarthy. Boston: Beacon, 1984.

Hacker, Andrew. *Two Nations: Black and White, Separate, Hostile, Unequal*. New York: Scribner's, 1992.

"Hackney Watch." *Wall Street Journal* 24 May 1993: A10.

Hall, Stuart. "Cultural Studies: Its Theoretical Legacies." In Grossberg *et al.*, eds. 277–94.

——. "What Is this 'Black' in Black Popular Culture?" *Black Popular Culture*. Ed. Gina Dent. Seattle: Bay Press, 1992. 21–33.

Hansen, Miriam. "Early Cinema, Late Cinema: Permutations of the Public Sphere." *Screen* 34.3 (1993): 197–210.

Hantzis, Darlene M. "Feminist Performance Research: What Next?" Unpublished presentation, Speech Communication Association, 1993.

Harman, Chris. "The Storm Breaks." *International Socialism* 46 (1990): 3–93.

——. "The State and Capitalism Today." *International Socialism* 51 (1991): 3–54.

Hart, Jeffrey. "The Ivory Foxhole." *National Review* 26 Sep. 1986: 48.

Harvey, David. *The Condition of Postmodernity: An Inquiry into the Origins of Cultural Change*. Cambridge, MA: Basil Blackwell, 1989.

——. "Flexibility: Threat or Opportunity?" *Socialist Review* 21 (1991): 65–77.

Henry, William A. III. "Upside Down in the Groves of Academe." *Time* 1 Apr. 1991: 66–69.

Henson, Scott. "Funding the Right: Olin Provides Foundation for Conservative Infrastructure." *Texas Observer* 20 Sept. 1991: 8.

Henson, Scott, and Tom Philpott. "The Right Declares a Culture War." *Humanist* Mar.–Apr. 1992: 10+.

Herman, Edward S., and Noam Chomsky. *Manufacturing Consent: The Political Economy of the Mass Media*. New York: Pantheon, 1988.

Herron, Jerry. *Universities and the Myth of Cultural Decline*. Detroit: Wayne State UP, 1988.

Hobsbawm, E. J. *Nations and Nationalism since 1870: Programme, Myth, Reality*. Cambridge: Cambridge UP, 1990.

Hofstadter, Richard. *Anti-Intellectualism in American Life*. New York: Vintage, 1963.

Hollander, Paul. *Anti-Americanism: Critiques at Home and Abroad, 1965–1990*. New York: Oxford UP, 1992.

Holquist, Michael. *Dialogism: Bakhtin and his World*. New York: Routledge, 1990.

hooks, bell. "Dialectically Down with the Critical Program." *Black Popular Culture*. Ed. Gina Dent. Seattle: Bay Press, 1992. 48–55.

Howard, Jean E. "The New Historicism in Renaissance Studies." *English Literary Renaissance* 16 (1986): 13–43.

Howe, Irving. "An Exercise in Memory." *New Republic* 11 Mar. 1991: 29–32.

———. "An Interview with Irving Howe." By William Cain. *American Literary History* 1 (1989): 544–64.

Hutcheon, Linda. *A Poetics of Postmodernism: History, Theory, Fiction*. New York: Routledge, 1988.

Iacocca, Lee, and Sonny Kleinfield. *Talking Straight*. New York: Bantam, 1988.

" 'In' Box." *Chronicle of Higher Education* 28 Apr. 1993: A15.

Iannone, Carol. "PC with a Human Face." *Commentary* June 1993: 44–48.

Jacoby, Russell. *The Last Intellectuals: American Culture in the Age of Academe*. New York: Basic Books, 1987.

———. *The Repression of Psychoanalysis: Otto Fenichel and the Political Freudians*. New York: Basic Books, 1983.

Jameson, Fredric. *The Political Unconscious: Narrative as a Socially Symbolic Act*. Ithaca: Cornell UP, 1981.

———. *Postmodernism, Or the Cultural Logic of Late Capitalism*. Durham: Duke UP, 1991.

JanMohamed, Abdul R. "The Economy of Manichean Allegory: The Function of Racial Difference in Colonialist Literature." *Critical Inquiry* 12 (1985): 59–87.

Jay, Gregory. "Knowledge, Power, and the Struggle for Representation." *College English* 56 (1994): 9–29.

Jay, Gregory, and Gerald Graff. "Some Questions about Critical Pedagogy." *Democratic Culture* 2.2 (Fall 1993): 1, 15–16.

Jones, Kathleen B. "The Trouble with Authority." *differences* 3.1 (1991): 104–27.

Kaes, Anton. "New Historicism: Writing Literary History in the Postmodern Era." *Monatshefte* 84 (1992): 148–158.

Kantrowitz, Barbara. "A is for Ashanti, B is for Black." *Newsweek* 23 Sept. 1991: 46.

Kauffman, L. A. "The Anti-Politics of Identity." *Socialist Review* 20.1 (1990): 67–80.

Kauffman, Linda S. "The Long Goodbye: Against Personal Testimony or, An Infant Grifter Grows Up." In Greene and Kahn, eds. 129–46.

Keefer, Michael. "Political Correctness': An Annotated List of Readings." *ACCUTE Newsletter* (Fall 1991): 1–13.

Kennan, George F., *et al. Democracy and the Student Left.* Boston: Houghton Mifflin, 1968.

Kent, Thomas. "Hermeneutics and Genre: Bakhtin and the Problem of Communicative Interaction." *The Interpretive Turn.* Ed. Davis Hiley *et al.* Ithaca: Cornell UP, 1991. 282–303.

———. "On the Very Idea of a Discourse Community." *College Composition and Communication* 42 (1991): 425–45.

Kerr, Clark. *The Uses of the University.* Cambridge, MA: Harvard UP, 1963.

Kerrigan, William. "The Falls of Academe." In Edmundson, ed. 151–70.

Kimball, Roger. "The Contradictions of Terry Eagleton." *The New Criterion* Sept. 1990: 17–23.

———. "Fredric Jameson's Laments." *The New Criterion* June 1991: 9–16.

———. "The Periphery v. the Center: The MLA in Chicago." In Berman, ed. 61–84.

———. *Tenured Radicals: How Politics Has Corrupted Our Higher Education.* New York: Harper & Row, 1990.

Kimmelman, Michael. "Exhibition of Works by Those the Nazis Hounded and Scorned." *New York Times* 25 Feb. 1991: C11.

King, Patricia, and Bob Cohn. "Why Won't Packwood Quit?" *Newsweek* 15 Mar. 1993: 36.

Knapp, Steven, and Walter Benn Michaels. "Against Theory." In Mitchell, ed. 11–30.

Kolodny, Annette. "Dancing Between Left and Right: Feminism and the Academic Minefield in the 1980s." *Language, Literature, and Politics.* Athens: U of Georgia P, 1988. 27–38.

Kramarae, Cheris, and Dale Spender, eds. *The Knowledge Explosion: Generations of Feminist Scholarship.* New York: Teacher's College P, 1992.

Krauthammer, Charles. "Annals of Political Correctness." *Washington Post* 8 Feb. 1991: A19.

———. "An Insidious Rejuvenation of the Old Left." *Los Angeles Times* 24 Dec. 1990: B5.

————. "Spineless at Penn." *Washington Post* 25 June 1993: A25.

Kristol, Irving. *Two Cheers for Capitalism.* New York: Basic Books, 1978.

Krupnick, Mark. *Lionel Trilling and the Fate of Cultural Criticism.* Evanston: Northwestern UP, 1986.

Laclau, Ernesto, and Chantal Mouffe. *Hegemony and Social Strategy: Towards a Radical Democratic Politics.* London: Verso, 1985.

Lakatos, Imre, and Alan Musgrave, eds. *Criticism and the Growth of Knowledge.* Cambridge: Cambridge UP, 1970.

Landry, Donna. "Commodity Feminism." *The Profession of Eighteenth-Century Literature: Reflections on Institution.* Ed. Leo Damrosch. Madison: U of Wisconsin P, 1992. 154–74.

Lanham, Richard A. *A Handlist of Rhetorical Terms.* 2nd. ed. Berkeley: U of California P, 1991.

Lauter, Paul. " 'Political Correctness' and the Attack on American Colleges." In Bérubé and Nelson, eds. 73–90.

"Learning to Love the PC Canon." *Newsweek* 24 Dec. 1990: 50–51.

Lehman, David. *Signs of the Times: Deconstruction and the Fall of Paul de Man.* New York: Poseidon, 1991.

Leitch, Vincent B. *American Literary Criticism from the Thirties to the Eighties.* New York: Columbia UP, 1988.

Lentricchia, Frank. *After the New Criticism.* Chicago: U of Chicago P, 1980.

Levin, Richard. "Ideological Criticism and Pluralism." *Shakespeare Left and Right.* Ed. Ivo Kamps. New York: Routledge, 1991. 15–21.

Levine, George, Peter Brooks, Jonathan Culler, Marjorie Garber, E. Ann Kaplan, and Catharine Simpson. *Speaking for the Humanities.* New York: American Council for Learned Societies, 1989.

Levine, Lawrence W. *Highbrow/Lowbrow: The Emergence of Cultural Hierarchy in America.* Cambridge, MA: Harvard UP, 1988.

Levinson, Marjorie. "The New Historicism: Back to the Future." *Rethinking Historicism: Critical Readings in Romantic History.* Ed. Marjorie Levinson. New York: Basil Blackwell, 1989. 18–63.

Lévi-Strauss, Claude. "Cosmopolitanism and Schizophrenia." *The View from Afar.* Trans. Joachim Neugroschel and Phoebe Hoss. New York: Basic Books, 1985. 177–85.

Looser, Devoney. "This Feminism Which Is Not One: Women, Generations, Institutions." *minnesota review* n.s. 41–42 (1993/4).

Lyotard, Jean-François. *The Postmodern Condition: A Report on Knowledge.* Trans. Geoff Bennington and Brian Massumi. Minneapolis: U of Minnesota P, 1984.

Matthews, Anne. "Deciphering Victorian Underwear and Other Seminars." *New York Times Magazine* 10 Feb. 1991: 43.

McBride, William. *Sartre's Political Theory*. Bloomington: Indiana UP, 1991.

McClintock, Anne. "Family Feuds: Gender, Nationalism and the Family." *Feminist Review* 44 (1993): 61–80.

McFadden, Robert D. "Political Correctness: New Bias Test?" *New York Times* 5 May 1991: A32.

McGann, Jerome. *The Beauty of Inflections: Literary Investigations in Historical Method & Theory*. Oxford: Clarendon Press, 1985.

Menand, Louis. "Books: Illiberalisms." *The New Yorker* 20 May 1991: 101–07.

———. "Lost Faculties." Rev. of *Tenured Radicals*, by Roger Kimball. *New Republic* 9–16 July 1990: 36–40.

Messer-Davidow, Ellen. "Manufacturing the Attack on Liberalized Higher Education." *Social Text* 36 (1993): 40–80.

Miami Theory Collective, ed. *Community at Loose Ends*. Minneapolis: U of Minnesota P, 1991.

Mills, C. Wright. *Power, Politics, and People*. New York: Ballantine, 1963.

Mitchell, W. J. T., ed. *Against Theory: Literary Studies and the New Pragmatism*. Chicago: U of Chicago P, 1985.

"Mr. Hackney's Nomination." *Wall Street Journal* 25 June 1993: A10.

Modic, Stanley J. "Corporate Giving Aids 'The Enemy.' " *Industrial Week* 6 Mar. 1989: 51.

Modleski, Tania. "Some Functions of Feminist Criticism: Or, the Scandal of the Mute Body." *Feminism Without Women: Culture and Criticism in a "Post-feminist" Age*. New York: Routledge, 1991. 35–58.

Mohanty, Chandra Talpade. "On Race and Voice: Challenges for Liberal Education in the 1990s." *Cultural Critique* 14 (1989–90): 179–208.

Mohanty, S. P. "Us and Them: On the Philosophical Bases of Political Criticism." *Yale Journal of Criticism* 2.2 (1989): 1–31.

Montrose, Louis. "Professing the Renaissance: The Poetics and Politics of Culture." In Veeser, ed. 15–36.

———. "Shaping Fantasies: Figurations of Gender and Power in Elizabethan Culture." *Representations* 1 (1983): 61–94.

Morson, Gary Saul, and Caryl Emerson. *Mikhail Bakhtin: Creation of a Prosaics*. Stanford: Stanford UP, 1990.

———. eds. *Rethinking Bakhtin: Extensions and Challenges*. Evanston: Northwestern UP, 1989. 80–83.

Naisbitt, John, and Patricia Aburdene. *Re-inventing the Corporation: Transforming Your Job and Your Company for the New Information Society*. New York: Warner Books, 1985.

"A New Look at Lit Crit." *Newsweek* 22 June 1981: 80–83.

Newfield, Christopher, and Ron Strickland, eds. *After Political Correctness: The Humanities and Society in the 1990s*. Boulder: Westview, 1994.

Novak, Michael. "Back to School." *Forbes* 2 Sep. 1991: 132.

Ohmann, Richard. *English In America: A Radical View of the Profession.* New York: Oxford UP, 1976.

Olson, Gary A. "Fish Tales: A Conversation with 'The Contemporary Sophist.' " *Journal of Advanced Composition* 12 (1992): 253–77.

Omi, Michael, and Howard Winant. *Racial Formation in the United States: From the 1960s to the 1980s.* London: Routledge and Kegan Paul, 1986.

One Nation, Many Peoples: A Declaration of Cultural Interdependence. Report of the New York State Social Studies Review and Development Committee. Albany: State of New York, 1992.

"The Other Guiniers." *Wall Street Journal* 9 June 1993: A12.

Ouchi, William G. *The M-Form Society: How American Teamwork Can Capture the Competitive Edge.* Reading, MA: Addison-Wesley, 1984.

Ozick, Cynthia. "A Critic at Large: T.S. Eliot at 101." *New Yorker* 20 Nov. 1989: 119–54.

Palumbo-Liu, David. "Discourse and Dislocation: Rhetorical Strategies of Asian-American Exclusion and Confinement." *Lit: Literature Interpretation Theory* 2 (1990): 1–7.

Peller, Gary. "Race Consciousness." *Duke Law Journal* (1990): 758–847.

———. "Race Against Integration." *Tikkun* 6 (1991): 54–70.

Perrot, Michelle, ed. *A History of Private Life.* Vol. IV. Trans. Arthur Goldhammer. Cambridge, MA: Belknap Press, 1990.

Peters, Tom. *Liberation Management: Necessary Disorganization for the Nanosecond Nineties.* New York: Knopf, 1992.

Peters, Thomas J., and Robert H. Waterman, Jr. *In Search of Excellence: Lessons from America's Best-Run Companies.* New York: Harper & Row, 1982.

Phillips, William. "Comment." *Partisan Review* 59.1 (1992): 12–13.

Plotke, David. "What's So New about New Social Movements?" *Socialist Review* 20.1 (1990): 81–102.

Podhoretz, Norman. "Laws, Kings, and Cures." *Commentary* 50 (1970): 30–31.

Pollock, Della, and Robert Cox. "Historicizing 'Reason': Critical Theory, Practice, and Postmodernity." *Communication Monographs* 58 (1991): 170–78.

Powers, Richard. *Operation Wandering Soul.* New York: William Morrow, 1993.

Probyn, Elspeth. *Sexing the Self: Gendered Positions in Cultural Studies.* London: Routledge, 1993.

———. "Technologizing the Self: A Future Anterior for Cultural Studies." In Grossberg *et al.*, eds. 501–11.

Putnam, Hilary. "A Comparison of Something with Something Else." *New Literary History* 17.1 (1985): 61–79.

————. *Realism and Reason*. Cambridge: Cambridge UP, 1983.

————. *Realism with a Human Face*. Ed. James Conant. Cambridge, MA: Harvard UP, 1990.

————. *Renewing Philosophy*. Cambridge, MA: Harvard UP, 1992.

Radhakrishnan, R. "Canonicity and Theory: Toward a Poststructuralist Pedagogy." *Theory/Pedagogy/Politics: Texts for Change*. Ed. Donald Morton and Mas'ud Zavarzadeh. Urbana: U of Illinois P, 1991. 112–35.

Radosh, Ronald. "McCarthyism of the Left." *Partisan Review* 60 (1993): 677–84.

Radway, Janice. "The Aesthetic in Mass Culture: Reading the 'Popular' Literary Text." *The Structure of the Literary Process*. Ed. P. Steiner *et al*. Amsterdam: Johns Benjamins, 1982. 397–429.

————. *Reading the Romance: Women, Patriarchy, and Popular Literature*. Chapel Hill: U of North Carolina P, 1991.

Ravitch, Diane. "The War on Standards." *Partisan Review* 60 (1993): 685–92.

"Return of the Storm Troopers." *Wall Street Journal* 10 Apr. 1991: A16, A22.

Rich, Adrienne. *Atlas of a Difficult World: Poems, 1988–1991*. New York: Norton, 1991.

Rieff, David. "Multiculturalism's Silent Partner." *Harper's* Aug. 1993: 62–72.

The Riverside Shakespeare. Ed. G. Blakemore Evans. Boston: Houghton Mifflin, 1974.

Robbins, Bruce. "Introduction: The Grounding of Intellectuals." *Intellectuals: Aesthetics, Politics, Academics*. Ed. Bruce Robbins. Minneapolis: U of Minnesota P, 1990. ix–xxvii.

————. "Modernism and Professionalism: The Case of William Carlos Williams." *On Poetry and Poetics*. Ed. Richard Waswo. Turbingen: Gunter Narr Verlag, 1985. 191–205.

Roiphe, Katie. *The Morning After: Fear, Sex, and Feminism on College Campuses*. Boston: Little, Brown, 1993.

Rorty, Richard. *Consequences of Pragmatism: Essays 1972–1980*. Minneapolis: U of Minnesota P, 1982.

————. "Feminism and Pragmatism." *Radical Philosophy* 59 (1991): 3–14.

————. "Intellectuals in Politics." *Dissent* 38 (1991): 483–90.

————. *Philosophy and the Mirror of Nature*. Princeton: Princeton UP, 1979.

————. "Putnam and the Relativist Menace." *Journal of Philosophy* 90.9 (1993): 443–61.

Rosaldo, Renato. *Culture and Truth: The Remaking of Social Analysis*. Boston: Beacon, 1989.

Rosmarin, Adena. "On the Theory of 'Against Theory.'" In Mitchell, ed. 80–88.

Rothstein, Edward. "Roll Over Beethoven." *New Republic* 4 Feb. 1991: 29–34.

Said, Edward W. "The Horizon of R.P. Blackmur." *Raritan* 6.2 (1986): 29–50.

Schlesinger, Arthur. *The Disuniting of America*. Knoxville: Whittle Direct Books, 1991.

Schrecker, Ellen W. *No Ivory Tower: McCarthyism and the Universities*. New York: Oxford UP, 1986.

Scott, Joan W. "Muticulturalism and the Politics of Identity." *October* 61 (1992): 12–19.

Searle, John. "Is There a Crisis in American Higher Education?" *Partisan Review* 60 (1993): 693–709.

———. "Rationality and Realism: What Is at Stake?" *Daedalus: Journal of the American Academy of Arts and Sciences* 122.4 (1993): 55–83.

———. "The Storm Over the University." *New York Review of Books* 6 Dec. 1990: 34–42. Rpt. in Berman, ed. 85–123.

Selfa, L., and A. Maass. *What's Behind the Attack on Politically Correct.* Chicago: Bookmarks, 1991.

Shawki, A. "Perspectives." Unpublished ms., 1989.

Siar, David. Rev. of *Learning to Curse,* by Stephen Greenblatt. *minnesota review* n.s. 37 (1991): 160–64.

Silber, John. "President's Report to the Trustees, April 15, 1993." Excerpted in the *Boston Globe* 24 Nov. 1993: 30.

———. *Straight Shooting: What's Wrong with America and How to Fix It.* New York: Harper, 1989.

Simon, William. *A Time for Truth.* New York: McGraw-Hill, 1978.

———. "To Reopen the American Mind." *Wall Street Journal* 8 July 1988: 14.

Sirkin, Gerard, and Natalie Sirkin. "Oh, Where Have All the Values Gone? Thought Police and Political Correctness; Orwellian 90s?" *UC-Santa Barbara Daily Nexus* 15 Feb. 1991: 9.

Smith, Barbara Herrnstein. *Contingencies of Value: Alternative Perspectives for Critical Theory.* Cambridge, MA: Harvard UP, 1988.

———. "Presidential Address 1988; Limelight: Reflections on a Public Year." *PMLA* 104 (1989): 285–93.

Smith, David N. *Who Rules the Universities? An Essay in Class Analysis.* New York: Monthly Review, 1974.

Smith, Hallett. Introduction to *The Tempest.* In *The Riverside Shakespeare* 1606–10.

Smith, Sharon. "Twilight of the American Dream." *International Socialism* 54 (1992): 3–43.

Soley, Lawrence C. *The News Shapers: The Sources Who Explain the News.* New York: Praeger, 1992.

Specter, Michael. "Anger and Regret in Aspen as Boycott Grows." *New York Times* 30 Dec. 1992: A1+.

Sprengnether, Madelon. "Generational Differences: Reliving Mother-Daughter Conflicts." In Greene and Kahn, eds. 201–08.

Sprinker, Michael. *Imaginary Relations: Aesthetics and Ideology in the Theory of Historical Materialism.* London: Verso, 1987.

————. "Knowing, Believing, Doing: How Can We Study Literature and Why Should We Anyway?" *ADE Bulletin* 98 (1991): 46–55.

————. "Reply to Paisley Livingston." *ADE Bulletin* 100 (1991): 58–59.

Stanfill, Francesca. "Woman Warrior: Sexual Philosopher Camille Paglia Jousts with the Politically Correct." *New York Magazine* 4 Mar. 1991: 22–30.

Steinfels, Peter. *The Neoconservatives: The Men Who Are Changing America's Politics.* New York: Simon & Schuster, 1979.

Stephens, Mitchell. "Deconstruction and the Get-Real Press." *Columbia Journalism Review* Sept.–Oct. 1991: 38–42.

Stimpson, Catharine. "On Differences: Modern Language Association Presidential Address 1990." In Berman, ed. 40–60.

Suleri, Sara. "Women Skin Deep: Feminism and the Postcolonial Condition." *Critical Inquiry* 18 (1992): 756–69.

Sykes, Charles. *Profscam: Professors and the Demise of Higher Education.* New York: St. Martin's, 1988.

Taylor, Charles. "Foucault on Freedom and Truth." *Philosophy and the Human Sciences: Philosophical Papers.* Vol. 2. Cambridge: Cambridge UP, 1985.

Taylor, John. "Are You Politically Correct?" *New York* 21 Jan. 1991: 32–40.

Teachers for a Democratic Culture. "Statement of Principles." 1991. In Aufderheide, ed. 67–70.

Thernstrom, Stephan. "McCarthyism Then and Now." *Academic Questions* 4.1 (1990–1): 14–16.

Thomas, Brook. *The New Historicism and Other Old-Fashioned Topics.* Princeton: Princeton UP, 1991.

Thompson, Richard H. *Theories of Ethnicity: A Critical Appraisal.* New York: Greenwood, 1989.

Tölölyan, Khachig. "The Second Time as Farce: Postmodernism without Consequences." *American Literary History* 2 (1990): 756–71.

Tompkins, Jane. "Fighting Words: Unlearning to Write the Critical Essay." *The Georgia Review* 42 (1988): 585–90.

Toner, Robin. "Long-Running Culture War Opens New Front on Arts Nomination." *New York Times* 22 June 1993: A20.

Townsend Humanities Center Newsletter. University of California, Berkeley. Sept. 1991.

Trescott, Jacqueline. "The Next Nominee Plays Offense." *Washington Post* 4 June 1993: D1+.

Tribe, Laurence H. *Abortion: The Clash of Absolutes.* New York: Norton, 1990.

Tuchman, Gaye. "Objectivity as a Strategic Ritual: An Examination of Newsmen's Notions of Objectivity." *American Journal of Sociology* 77 (1972): 660–79.

Van Den Abbeele, George. "Introduction." In Miami Theory Collective, ed. ix–xxvi.

Veeser, H. Aram, ed. *The New Historicism*. New York: Routledge, 1989.

Wald, Alan. *The New York Intellectuals: The Rise and the Decline of the Anti-Stalinist Left from the 1930s to the 1980s*. Chapel Hill: U of North Carolina P, 1987.

Wards Cove Packing Co. v. Atonio, 490 U.S. 642, 645–46.

"Ways and Means." *Chronicle of Higher Education* 2 June 1993: A18.

Weber, Samuel. *Institution and Interpretation*. Minneapolis: U of Minnesota P, 1987.

West, Cornel. "Diverse New World." In Berman, ed. 326–332.

————. "Minority Discourse and the Pitfalls of Canon Formation." *Yale Journal of Criticism* 1 (1987): 193–201.

White, Hayden. "New Historicism: A Comment." In Veeser, ed. 292–302.

————. *Tropics of Discourse: Essays in Cultural Criticism*. Baltimore: Johns Hopkins UP, 1978.

Wiener, Jon. "The Olin Money Tree: Dollars for Neocon Scholars." *The Nation* 1 Jan. 1990: 12–14.

Will, George. "At Penn, Principle or Political Fashion?" *Washington Post* 29 Apr. 1993: A23.

————. "Catechism of Correctness." *Washington Post* 20 Oct. 1991: C7.

————. " 'Compassion' on Campus." *Newsweek* 31 May 1993: 66.

————. "Curdled Politics on Campus." *Newsweek* 6 May 1991: 72.

————. "Literary Politics." *Newsweek* 22 Apr. 1991: 72.

Williams, Patricia J. "Lani, We Hardly Knew Ye." *Village Voice* 15 June 1993: 25–31.

Williams, Raymond. *Marxism and Literature*. Oxford: Oxford UP, 1977.

Winkler, Karen. "Sociologists Accused of Forsaking Problems of Society, Abandoning 'Critical Bite.' " *Chronicle of Higher Education* 7 Sept. 1988: A1, A10.

Wood, Ellen Meiksins. *The Retreat from Class: A New "True" Socialism*. London: Verso, 1986.

Index

Contributors

MICHAEL BÉRUBÉ is Associate Professor of English at the University of Illinois at Urbana-Champaign. He is the author of *Marginal Forces/Cultural Centers: Tolson, Pynchon, and the Politics of the Canon* (1992) and *Public Access: Literary Theory and American Cultural Politics* (1994). He has co-edited *Higher Education Under Fire: Economics and the Crisis of the Humanities* (1994), also published by Routledge.

REED WAY DASENBROCK is Professor of English and Head of the English Department at New Mexico State University. He has edited *Redrawing the Lines: Analytic Philosophy, Deconstruction, and Literary Theory* (1989) and *Literary Theory After Davidson* (1993).

FRANK FARMER teaches rhetoric and composition at East Carolina University. He is currently completing a book on imitation.

HENRY A. GIROUX holds the Waterbury Chair Professorship at Penn State University. His books include *Border Crossings* (1992), *Between Borders* (1994), and *Disturbing Pleasures: Learning Popular Culture* (1995).

GERALD GRAFF is George M. Pullman Professor of English and Education at the University of Chicago. He is the author, most recently, of *Beyond the Culture Wars: How Teaching the Conflicts Can Revitalize American Education* (1992).

DARLENE M. HANTZIS directs the Women's Studies Program at Indiana State University, where she is Associate Professor of Communications.

JOHN S. HOWARD is completing doctoral work at Saint Louis University on Romantic notions of subjectivity and autonomy.

JAMES M. LANG is a doctoral student at Northwestern University working on modern drama and on contemporary hermeneutics.

TOM LEWIS teaches Spanish at University of Iowa. He has published widely on Althusser and marxist theory.

DEVONEY LOOSER is Assistant Professor of English at Indiana State University.

JIM NEILSON is a doctoral student in English at the University of North Carolina, Greensboro working on history and ideology in the Vietnam War novel.

CHRISTOPHER NEWFIELD is Assistant Professor of English at UC-Santa Barbara. He has recently co-edited *After Political Correctness: The Humanities and Society in the 1990s* (1994).

RICHARD OHMANN teaches English and American studies at Wesleyan University. He works on the magazine *Radical Teacher* and his latest book is *Politics of Letters* (1987).

BRUCE ROBBINS is the author of *The Servant's Hand* (rpt. 1993) and *Secular Vocations: Intellectuals, Professionalism, Culture* (1993). He has also edited *Intellectuals: Aesthetics, Politics, Academics* (1990) and *The Phantom Public Sphere* (1993). He teaches English at Rutgers University and is co-editor of *Social Text*.

BARRY W. SARCHETT teaches literary theory, popular culture, and American literature at Colorado College.

JOAN W. SCOTT is Professor of Social Science at the Institute for Advanced Study. She is the author of *Gender and the Politics of History* (1987) and *Women Who Have Only Paradoxes to Offer: French Feminists 1789–1945* (1994).

MICHAEL SPRINKER is the author of *History and Ideology in Proust* (1994) and *Imaginary Relations: Aesthetics and Ideology in the Theory of Historical Materialism* (1987). He is Professor of English and directs the Comparative Studies program at SUNY-Stony Brook.

JEFFREY WILLIAMS is the author of *Narratives of Narrative: Reflexivity in Several English Novels* (1995). He teaches critical and cultural theory at East Carolina University. He also is the editor of *the minnesota review*.